REFRAMING QUALITY ASSURANCE IN CREATIVE DISCIPLINES

Evidence from Practice

J. Joseph Hoey IV
Jill L. Ferguson

REFRAMING QUALITY ASSURANCE IN CREATIVE DISCIPLINES

Evidence from Practice

J. Joseph Hoey IV
Jill L. Ferguson

COMMON GROUND PUBLISHING 2015,

First published in 2015 in Champaign, Illinois, USA
by Common Ground Publishing LLC
as part of the Arts in Society book imprint

Library of Congress Cataloging-in-Publication Data

Hoey, J. Joseph, IV, author.
 Reframing quality assurance in creative disciplines : evidence from practice / J. Joseph Hoey IV, Jill L. Ferguson.
 pages cm
 Includes bibliographical references and index.
 ISBN 978-1-61229-771-2 (pbk : alk. paper) -- ISBN 978-1-61229-772-9 (pdf)
 1. Arts--Study and teaching--Evaluation. 2. Arts--Study and teaching--Case studies. I. Ferguson, Jill L., author. II. Title.
 NX282.H64 2015
 700.71--dc23

 2015006273

Cover Art Credit: The Bedroom, an original acrylic by Jill L. Ferguson

Table of Contents

ACKNOWLEDGEMENTS

We would like to thank the higher education arts and design community who saw a need for this book as a follow-up to our previous book *Assessment in Creative Disciplines: Quantifying and Qualifying the Aesthetic* (Common Ground, 2014) with David Mills Chase, and to Managing Editor Ian Nelk and Common Ground Publishing for putting out this volume. Thank you also to all of the institutions who hired us as consultants over the last year and all of the conferences that invited us to speak on assessment in the arts. Your support is appreciated.

This book would not have been possible without all of the case study contributors around the world, those faculty and administrators who are in the trenches of assessment of student work, who are willing to be transparent and to talk about their challenges, failures, and successes so that we can all learn, grow, and better serve our students.

Most of all, we would like to thank our spouses for giving us the time and space to research and write, for reading drafts of this volume while it was in progress, for editing and making comments, and for taking care of pets and household chores as our deadline drew near. We're grateful for your partnership and love.

Introduction

Change your opinions, keep to your principles;
change your leaves, keep intact your roots.
 --Victor Hugo

At various points in our lives, change is thrust upon us. It is how we respond positively or negatively that determines the outcomes. As a seasoned classical guitarist and studio instructor, in 1990 I was faced with a daunting prospect: the need to assess student learning outcomes not just individually as I had always done, but across students, based on a common set of competencies. I believed strongly in the primacy of frequent, formative assessment between student and expert instructor as the cornerstone of individual musical instruction, and still do. At that point in the development of national student learning outcomes assessment practice, most of the assessment methods being put forward centered on standardized exams and indirect methods such as student surveys – hardly suitable for assessment of student learning in music! As a natural first instinct, I began looking around for examples of good assessment practice in other institutions—back then, there was a dearth of good examples available from other schools. Eventually I got wind of the American Association of Higher Education's (AAHE) annual assessment forum, and from attending those conferences as well as meetings of the South Carolina Higher Education Assessment (SCHEA) network, I began to gather examples of assessment in disciplines besides music. In the intervening decades, a solid body of assessment theory and practice has been developed that works for most disciplines – but again, it is surprising and disappointing that creative disciplines such as music, architecture, fashion design, and film have been largely neglected in the assessment literature, and the first attempt of any consequence to bring together assessment of creative disciplines in an interactive conference did not take place until the 2009 MUSE (Measuring Unique Studies Effectively) conference at the Savannah College of Art and Design in Savannah, Georgia.

Since the creation of our first mutual, comprehensive work on assessment in the creative disciplines (*Assessment in Creative Disciplines: Quantifying and Qualifying the Aesthetic,* published by Common Ground in 2014), my co-authors and I have received numerous requests for a work that brings together promising assessment practices across the creative disciplines. This current work is a direct consequence of those requests. Having experienced first-hand the frustration of

not being able to find good examples of assessment practice, we have brought together in this volume a number of case studies across the spectrum of visual, performing, and design arts. Our intention in doing so is to provide a common basis for not only furthering student learning outcomes assessment in each of the creative disciplines, but also advancing assessment practice and quality assurance within the creative disciplines overall. It is our conviction that as ideas such as competency-based education steadily advance within Academe, the creative disciplines, with our long traditions of authentic assessment of student competence, have much to offer.

New creations stand on the shoulders of what has come before, and to not acknowledge that heritage in this context would be inauthentic. Specifically, we owe a large debt of gratitude to Dr. Trudy Banta and her colleagues who in 1996 published *Assessment in Practice*, a purposeful compendium of case studies in assessment that showcased good practices and related those practices to the AAHE *Principles of Good Practice in Assessment* (1992). Furthermore, in 2001, Banta and Palomba published an edited volume, *Assessing Student Competence in Accredited Disciplines: Pioneering Approaches to Assessment in Higher Education,* that included a chapter by Kristi Nelson, Sr. Vice Provost at the University of Cincinnati, on assessing student competence in the visual arts. Since the advent of those ground-breaking publications, organizations such as the Association for Institutional Research (AIR) have also produced several volumes dedicated to assessment within specific disciplines, such as Engineering, Chemistry, Writing, Mathematics, and Business. But a substantial gap remained until now in the availability of a meaningful collection of case studies to showcase successful assessment and quality assurance practice within the visual, performing, and design arts. We hope our readers will judge that the results contained herein are worthy of consideration, reflection, and adaptation to other programs and institutions.

J. Joseph Hoey IV,
San Diego, February 1, 2015

CHAPTER 1

Reframing Quality in Creative Disciplines: Evidence from Practice

Quality is never an accident; it is always the result of high intention, sincere effort, intelligent direction and skillful execution.

--William A. Foster

This volume brings together a number of streams of thought and practice in assessing the arts within higher education. Assessment of student learning has been a growing trend over the last three decades as one facet of general advances in teaching and learning, developments in cognitive science, and the widespread use of information technology in higher education – for teaching and learning as well as for the creation of cogent knowledge management systems. Regional accreditors and higher education quality assurance authorities have developed and promulgated criteria for institutions to create and utilize systems that yield information on the extent to which students are meeting learning goals, and to steadily improve their institutions based on the findings of systematic study of student outcomes. For institutions, there are now fiscal consequences to be considered in an institution's ability to demonstrate mission fulfillment and achievement of appropriate student outcomes. Increasingly, funding decisions are affected by an institution's ability to demonstrate the efficacy of student learning. The stakes are as high as the need for workable approaches to facilitating student learning and demonstrating its positive effects.

ASSESSMENT IN THE ARTS IS DIFFERENT

We approached the development of this volume from several standpoints. One standpoint with which we share a number of concerns is articulated in *Assessment on Our Own Terms,* published in 2009 by the National Association of Schools of Art and Design (NASAD), a volume itself based on a presentation in 2007 and positions articulated even earlier. As noted in the NASAD (2009) work, assessment and quality assurance in creative disciplines is bound to be different both in theory and practice from other fields of endeavor. We acknowledge the primacy of expert judgment in assessment and the historical precedent of an exclusive focus on individual student achievement. As Nelson (2001) notes, "A

critical problem that persists is how to take efforts that are individually based and focus on self-reflection and make these programmatically centered" (p.196). We understand the need for holistic appraisal of student works, and value the role of informed experts in defining what constitutes varying levels of performance and achievement. Including students' artistic intentions and the process by which they develop artistic works is important as part of an assessment schema. Affective, psychomotor, and cognitive learning outcomes are all vital in art making and any reasonable assessment/quality assurance framework should take that into account.

ADVANCES IN TEACHING, LEARNING, AND ASSESSMENT

In this work, we also take the standpoint that the deepened literature on assessment that reflects thirty years of endeavor has resulted in the development of approaches that permit authentic, valid, and reliable assessment to take place in a way that permits us to utilize assessment information at individual and collective levels. Three decades ago, the United States Department of Education (USDOEd) first articulated a shift in the requirements for accreditation agencies from input-based criteria such as the number of buildings and faculty to the outcomes of education. Accreditation agencies, in turn, began to translate the USDOEd requirements into criteria for assessing student learning as part of initial or reaffirmation of institutional accreditation, but the availability of assessment instrumentation, especially as relevant and palatable to faculty sensibilities, was scarce. As recently as 1987, "Only a handful of instruments were available designed specifically to assess the effectiveness of undergraduate education. As a result, most institutions engaging in assessment used a mixture of surveys (both commercial and home-grown) and a collection of cognitive examinations like the ACT Assessment or the Graduate Record Examination that were designed for something else" (Ewell, 2009, p. 7). In the intervening years, teaching, learning, and assessment in higher education have made notable advances, spurred on in part by the ascendance of differing modes of thought about scholarship, for example Boyer's classic *Scholarship Reconsidered* (1990). New, disruptive educational models have appeared. Online education has exploded. Competency-based models of education -- a time-honored educational cornerstone for the arts -- have also gained wider acceptance. Assessment practice has matured as well, for example as demonstrated by the current prevalence of faculty development initiatives for assessment, faculty-developed rubrics for assessing student learning, national initiatives such as the Association of American Colleges & Universities (AAC&U) VALUE rubrics, and the efforts of the National Institute on Learning Outcomes Assessment (NILOA).

IMPORTANT LEARNING OUTCOMES

There are several learning outcomes we posit as fundamental to creative disciplines and artistic development and that deserve mention at the outset. Creativity, for example, is fundamental. While creativity is multifaceted and complex, we believe that the assessment of student creativity must be included in any meaningful assessment schema within arts assessment, and we expand upon concepts first laid out in by Chase, Ferguson, and Hoey (2014) in describing models and practices to understand the assessment of creativity. The reflective and metacognitive aspects of higher education, always crucial to the lifelong artistic development of our students, have become a true focal point of education and must also be included. Reflection and metacognition can be furthered through known teaching strategies, and can be assessed with methods now available. We believe that the ubiquity of content availability, the ease with which students can search for information, and the deconstruction of traditional notions of higher education are all factors that are leading us as educators to the point where we are no longer exclusively content experts, but mentors who actively push our students to expand their mental boundaries, their capacity for self-critique, and their capacity to solve artistic problems as they occur. As Jose Antonio Bowen notes, "Your job is to increase the complexity of their mental models" (2014, oral communication).

OUTLIERS

Unlike most traditions of assessment where measures of central tendency received the lion's share of focus, in assessing the arts the case can easily be made that a different paradigm is also highly informative: the assessment of exceptions and outliers. This type of assessment is important, since exceptions to the rule, statistical aberrations, and other outliers point the way for new insights and may represent a potential focus for further inquiry, a different formulation of theory, or improvement of practice. Malcolm Gladwell (2008) devoted an entire volume to outliers in various fields, named appropriately enough *Outliers*. Speaking in the context of statistical analysis, Osborne and Overbay (2004, p.4) observe:

> We all know that interesting research is often as much a matter of serendipity as planning and inspiration. Outliers can represent a nuisance, error, or legitimate data. They can also be inspiration for inquiry. When researchers in Africa discovered that some women were

living with HIV just fine for years and years, untreated, those rare cases were outliers compared to most untreated women, who die fairly rapidly. They could have been discarded as noise or error, but instead they serve as inspiration for inquiry: what makes these women different or unique, and what can we learn from them?

USING APPROPRIATE TECHNOLOGY

Another standpoint we take is that technology in higher education has advanced to the point where meaningful, direct, and nuanced assessment of student learning in the arts is not only possible at individual and collective levels but highly feasible for faculty. Rich, deep, and connected pedagogical content can be presented in ways that were not feasible several years ago. Significant data can be collected, both actively and unobtrusively through online systems, as Prineas and Cini (2011) point out. The advent of widely available, flexible ePortfolio platforms with copious storage capacity has meant that previously prohibitive barriers to direct assessment of student growth and development have receded; for example full-length videos of student performance can be uploaded, annotated, and commented upon at specific points in time, used by students as part of their evidence of growth and mastery in a reflective analysis, and referenced back to an assessment rubric for grading. Extraordinary amounts of data can be collected, stored, and compared longitudinally in online assessment management systems to permit assessment at the individual and collective levels of student growth and development across a number of facets of expertise in the discipline – we don't have to just sample and approximate any more. We can now use hard performance evidence. The power of social media, peer commentary and critique, and the social construction of meaning can be harnessed and utilized to better understand how our students are interacting, growing, and developing as artists. In short, the forces that once constrained assessment and kept it on a narrow path have begun to go the way of the Pony Express and the telegraph.

OUR AIM IN THE VOLUME

Our aim in this work is not only to showcase the current state of practice, but also to open up new paths and possibilities that demonstrate ways in which colleagues in creative disciplines have taken creative steps forward, to incorporate assessment at multiple levels within their teaching practice, and to develop systems for quality assurance that achieve their intended ends. Accreditors and quality assurance agencies have the dual roles of being on the one hand partners

in the advancement of higher education standards, and on the other hand of assuring that those standards are being met. Our intention in this volume is to include and highlight the advancements in quality for which they have acted as catalysts, as well as those advances for which they continue to advocate. With those aims in mind, we organized this volume to present a useful, robust, and high-quality set of case studies in assessment and quality assurance across the visual, performing and design arts, which we refer to collectively as the creative disciplines.

ORGANIZATION OF THE BOOK

Similar to Caesar's division of ancient Gaul, this book is divided into three parts to sufficiently cover the territory: (1) Reframing student learning outcomes assessment and quality assurance in the context of the creative disciplines, (2) Presentation of case studies of assessment and quality assurance in the arts, and (3) Setting assessment and quality assurance in creative disciplines in the context of specialized and regional accreditation and international recognition of competencies.

Section One sets both practical context and theoretical grounding, we designed the first section of the book as an overview of how we are considering quality assurance and assessment in the artistic context, how that links to teaching and learning in the creative disciplines, and the importance of considering affective and psychomotor outcomes as well as cognitive outcomes in creative disciplines. Building upon the extant assessment and creative arts literature bases and positions outlined in our first book, this section also advances a conceptual model of principles of good practice in assessment and quality assurance for the creative disciplines and a discussion of how those principles may be exemplified in practice.

Instead of limiting the paradigm to assessment, chapter one sets out to broaden the scope of consideration to quality assurance in creative disciplines, and to present ways in which we may take a more inclusive, systemic approach to making sure our students are learning what faculty have specified, can demonstrate their learning, and that college systems are working in concert to optimize student learning and success. Chapter two continues that discussion with a specific focus on what we know about successful teaching and learning models in the arts. While atelier/master-apprentice models have dominated the field for a long time, the emergence of collaborative, constructivist, and other approaches are increasingly finding currency. Chapter three delves into the triumvirate of learning domains: cognitive, affective, and psychomotor, and provides examples

of how each domain is critical to effective assessment of learning in the arts. Drawing on earlier principles of good practice in teaching, learning, and assessment in general, chapter four provides a set of principles and a model of what might constitute good practice in assessment and quality assurance within the creative disciplines. The chapter features a discussion of each aspect of what we might consider good practice and provides examples. Chapter five takes up quality assurance in the rapidly expanding field of online learning as it is being applied to creative disciplines, looking at changes to teaching practice, incorporation of universal design principles to facilitate online learning in the arts, new opportunities for students to create works online, and how those works might be assessed.

Section Two of the book explores the heart of the matter: the varied approaches brought by a number of our colleagues in the international higher education arts community to the task of assessing student learning, and to designing, implementing, and evaluating quality assurance systems for doing so. Within each discipline represented, we have sought to showcase promising and established good practice within both two-year and senior institutions. We present the case studies grouped by cognate or related disciplines to facilitate comparisons, as follows:

1. Performing Arts: Music, Theatre, Dance, Musical Theatre
2. Fine Art: Photography, Illustration, Sculpture, Painting, and Printmaking
3. Art History and Art Therapy
4. Film, Video, and Recording Arts: Film, Sound Design, Production Design, Set Design
5. Architecture, Landscape, and Interior Design
6. Industrial/Product Design
7. Fashion Design, Illustration, Accessory Design, Textile and Fibers, Jewelry, Costume Design
8. Digital and Graphic Design (Game Design included)

Section Three takes up the threads of quality assurance in creative disciplines at the institutional level, covering the topic of assessment and quality assurance from the standpoint of the requirements of regional and national accreditors and quality assurance agencies. In Chapter fourteen we review the requirements of the regional accreditors in the United States and specialized accreditors in creative disciplines relative to assessment and quality assurance in student learning – including the National Architectural Accrediting Board (NAAB), the Council for

Interior Design Accreditation (CIDA), the National Association of Schools of Art and Design (NASAD), the National Association of Schools of Music (NASM), and the National Association of Schools of Dance (NASD). In Chapter 15 we explore quality assurance in creative disciplines in the international context, covering applicable standards, and exploring joint recognition of competencies in the arts across geographical and political boundaries.

Summary

The design, performing, and visual arts occupy a unique place in higher education and have until recently been outside of the mainstream of the assessment and quality assurance movement that has grown so decisively in higher education over the last three decades. Over that time period, the theory and practice of college teaching, learning, and assessment have greatly advanced, as has the availability of appropriate information technologies to support those advances. The time is right to move forward in assessment and quality assurance in the creative disciplines. Not only do we have much to gain, but we also have much to offer in terms of how we in the creative disciplines develop and assess student competence. As creative practitioners ourselves, we respect the creativity and diverse talents of our colleagues and hope this book becomes a useful guide to your own assessment adventures. As a side note, it seems appropriate to mention that the dissemination of a book without pictures or conversation strikes us as an unnecessary constraint. To provide multiple ways of accessing the appropriate information, the case studies herein have provided pictures, graphs, charts, tables, and graphics, as necessary to enhance each department or college's story. This book and our website www.assessmentincreativedisciplines.com are parts of the larger conversation about assessment in creative disciplines. We'd love to hear what you are doing on your campus. Feel free to e-mail us.

References

Bowen, J., 2014. Teaching Naked: How Moving Technology Out of Your College Classroom Will Improve Student Learning. Presentation at Association of American Colleges and Universities conference, Washington, D.C., January 24, 2014.

Boyer, E., 1997. *Scholarship Reconsidered: Priorities of the Professoriate.* San Francisco: Jossey-Bass.

Ewell, P. 2009. *Assessment, Accountability, and Improvement: Revisiting the*

Tension. National Institute for Learning Outcomes Assessment Occasional
 Paper #1. Champaign, IL: Author.

Foster, W.A. 2000. Poor Man's College. Apex software.

National Association of Schools of Art and Design. 2009. *Assessment on Our
 Own Terms*. Reston, VA: Author.

Nelson, K. 2001. Assessing Student Competence in the Visual Arts. In Palomba,
 K., and Banta, T. (Eds.), *Assessing Student Competence in Accredited
 Disciplines: Pioneering Approaches to Assessment in Higher Education*.
 Sterling, VA: Stylus Publishing.

Prineas, M., and Cini, M. 2011. *Assessing Learning in Online Education: The
 Role of Technology in Improving Student Outcomes*. National Institute
 for Learning Outcomes Assessment Occasional Paper #12. Champaign,
 IL:Author.

CHAPTER 2

Quality Assurance and the Link to Teaching and Learning

Education is a playing with fire, not a taxidermist's stuffing of dead animals, and until we choose to acknowledge the difference between the two pedagogical techniques, we do ourselves no favors. Awaken the student to the light in his or her own mind, and the rest of it doesn't matter—neither the curriculum nor the number of seats in the football stadium, neither the names of the American presidents nor the list of English kings.

--Lapham's Quarterly v1 #4 Preamble

INTRODUCTION

In assessing learning in creative disciplines, no one style matches all applications. Different performances, creations, projects, and other artistic tasks demand appropriate learning strategies; different learning strategies call for different instructional and assessment approaches. Students encounter a variety of academic subjects and ways of knowing as they progress through their degree programs. This chapter discusses the connection of the craft of the practicing artist to teaching, learning, and assessment; it explores the teaching and learning models used in creative arts education, and reviews constructivist theories of learning that we examined in chapter three of *Assessment in Creative Disciplines: Quantifying and Qualifying the Aesthetic* (Chase, Ferguson, and Hoey, 2014). The chapter also connects assessment strategy to the design and intentionality of the curriculum within programs of study in the arts—using proficiency as a guide. Thus, in this chapter we focus on where and what to assess, in relation to pedagogical practices in use and the underlying learning theories in use, and how to assess using the tools most appropriate for the task.

TEACHING AND LEARNING MODELS USED IN ARTS EDUCATION

A growing body of research and literature on university faculties' approaches to teaching (Lindblom-Ylanne, Trigwell, Nevgi, and Ashwin, 2006; Biggs, 2009; Kember and Kwan, 2002; Trigwell, 2002) distinguishes between an instructor- or content-centered and a student-centered approach. The former approach is used

mainly for the transmission of knowledge. "These teachers concentrate on the content of teaching and on what they doing in teaching" (Lindblom-Ylanne, et al., 2006, p. 285). The latter student-centered approach is used by instructors when they see their role as "facilitating student learning or students' knowledge-construction processes or as supporting students' conceptual change" (Lindblom-Ylanne, et al., 2006, p. 286). The same professor may use one approach one day and the other a different day, depending on the teaching context. Neither approach is better than the other. Both are used in arts education; for example, a content-centered approach may be a more efficient and effective way for students to learn art, design, or music history; how to master a particular artistic, design, or musical technique; and to learn theory. A student-centered approach may be better for hands-on art-making or music-making, such as in studio classes.

These two approaches can be further categorized into four primary teaching and learning models that are used throughout artistic disciplines. These are the master-apprentice, the atelier, the ensemble, and the critique (commonly called the crit). Each model has its positive aspects and its challenges, which we will discuss in this section, and we will discuss assessment methods in each model.

Master-apprentice

The master-apprentice is one of the oldest models of arts and craft education, and it is primarily teacher- and content-centered. Centuries ago a child or teenager would move into the home of a "master" and work as a helper, learning the ins and out of an art or a craft and developing a certain level of skill or proficiency along the way. In the master-apprentice teaching model in fine arts, performing arts, and design, the "master's 'ways' are expected to be acquired by the apprentice through long and close association and emulation" (Cowdroy and Williams, 2006, p. 101). This model is seen in the Bauhaus modernist approach (to design, architecture, engineering, and industrial design) and the Beaux Arts neoclassical approach (to classical fine arts, such as sculpture and painting) "in which students emulate the works of the masters until the gift of the masters is recognized in the students" (Cowdroy and Williams, 2006, p. 101). This approach is also seen today in music master classes, where an expert performs with selected students and a critique is given by the expert from which the students are expected to learn; it is also seen in professional glass studios where experts, like Dale Chihuly, for example, take on younger more inexperienced glass artists who blow his designs on which Chihuly then puts his name (Hackett, 2006). After apprenticing with Chihuly many artists leave his studio and open their own studios and produce art under their own names (Hackett, 2006).

The master-apprentice model is used by most studios, whether the lessons are individual, such as in a music studio, or in a group setting, such as in a fine arts or design studio. Critics of this teaching model say it "may result in students being more likely to take a passive approach to their learning, to look to the lecturer for design ideas and [to] 'wait for faculty approval before making design decisions'" (de la Harpe and Peterson, 2008, p. 1, referencing Ehmann, 2005, p. 107). Similarly, Bose, Pennypacker, and Yahner (2006) write the "traditional master/apprentice model of studio instruction fosters greater student dependence on faculty for decision-making guidance" (p. 33).

Corley (2010) in the presentation "Why Johnny Can't Play: Expanding the Master/Apprentice Model" given to the International Clarinet Association's Clarinetfest, provides these common characteristics of the master-apprentice model:

- Indigenous to education мес m rₜ₁˷
- Master (teacher) is a performer of consummate skill whose work serves as a model
- Apprentice learns through practical experience from the master
- The Master (teacher) is committed to the development and progress of the apprentice
- Instruction: there is a plan to build a knowledge and skill set
- The apprentice observes the skills and attitudes of the master and can ask questions
- Apprentice has the opportunity to practice knowledge and skills through performance
- The master critiques the work of the apprentice (p. 2)

Corley (2010) says that for this model to work well, a plan must be developed for the instruction, a plan that includes learning objectives, a curriculum that challenges but does not overwhelm (Csikszentmihalyi and Nakamura, 2002), teaching that is based on assessment with continual feedback, not on assumptions, and teaching that is based on deliberate practice. Echoing that theme, Jorgensen (2008) adds that each lesson much be planned with clear objectives. The lesson objectives must be realistic given the student's aptitudes, capabilities at that point in time, and within the expected time frame. While this advice comes from Jorgensen's *The Art of Teaching Music,* the advice extends to all creative disciplines. One of the challenges of assessment in the master-apprentice model is that traditionally the feedback has been informal and oral as opposed to more

formal, written communication that many institutions are now collecting and analyzing.

Atelier

Another teaching and learning model often found in design education is the *atelier,* French for "workshop". The model was established by the private Florentine art schools of the Renaissance from around the 15th century, and this style of art instruction was carried over to the schools in England and other countries throughout Europe (King, 2003; Barker, 2010).

In the atelier teaching and learning model (sometimes referred to as a design collective) students "are allocated their own desk and workspace often with storage and are expected to spend their entire time while not in lectures working in this environment. In this model design is taught in a vocational manner to mirror industrial activity and practices" (Barker, 2010, p. 3). Often atelier spaces are large rooms with or without partitions filled with tables and chairs, cabinets and filing drawers, and lots and lots of light. The rooms and spaces are designed to facilitate both collaboration and competition, in a student-centered teaching approach.

In this type of collective environment, teaching can occur with the instructor formally addressing the whole cohort, in small group tutoring or critique, and in one-to-one tutoring or critique for individual projects. Atelier style learning is also ripe for peer review processes where students discuss and assess their own work providing formal or informal feedback to each other.

Ateliers are common in fashion and accessory design and furniture and product design studios, and similar to the master-apprentice model, the collective might work on a project for the "whole" that then bears the name of the master. A "challenging studio learning environment contains many aspects: relating knowledge to studio experience and vision, a multiplicity of pedagogical and learning styles, a variety of student-faculty and student-student encounters, an ability to take risks, and an opportunity to share power to construct new knowledge and transform thinking" (Koch et al, 2002, p.16).

The atelier model often involves group work and project-based learning (PBL) or inquiry-based learning (IBL), where the group works a common project, question, or issue. These two aspects, group work and PBL or IBL, can add challenges to assessment, especially if we are more apt to assess the product without assessing the process by which the product was derived. Some researchers recommend breaking down the group project into smaller parts, each

of which would then be assessed (McPeek and Morthland, 2002; Winchester-Seeto, 2002).

Assessment of work in a collaborative environment requires "a unified design process" shared by all of the collaborators (McPeek and Morthland, 2002, p.2) which could be affected by each collaborator's understanding of the course material and by the collaborator's willingness to contribute to the team environment.

The following tables represent some options for evaluating group work and processes. Note that the term "mark" is used to refer to a grade throughout the examples.

Table 2.1: Options for lecturer/tutor assessment of group product

	Assessment option	Some possible advantages	Some possible disadvantages
Shared Group Mark	The group submits one product and all group members receive the same mark from the lecturer/tutor, regardless of individual contribution.	Encourages group work - groups sink or swim together.	Individual contributions are not necessarily reflected in the marks.
		Decreases likelihood of plagiarism more likely with individual products from group work.	Stronger students may be unfairly disadvantaged by weaker ones and vice versa.
		Relatively straightforward method.	
Group Average Mark	Individual submissions (allocated task or individual reports as described below) are marked individually. The group members each then receive an average of these marks.	May provide motivation for students to focus on both individual and group work and thereby develop in both areas.	May be perceived as unfair by students.
			Stronger students may be unfairly disadvantaged by weaker ones and vice versa.
Individual Mark-	Each student completes an allocated task that	A relatively objective way of ensuring individual	Difficult to find tasks that are exactly equal

Allocated task	contributes to the final group product and gets the marks for that task.	participation.	in size/complexity.
		May provide additional motivation to students.	Does not encourage the group process/ collaboration.
		potential to reward outstanding performance.	dependencies between tasks may slow progress of some students.
Individual Mark - Individual report	Each student writes and submits an individual report based on the group's work on the task/project.	Ensures individual effort.	Precise manner in which individual reports should differ often very unclear to students.
		Perceived as fair by students.	Likelihood of unintentional plagiarism increased.
Individual Mark - Examination	Exam questions specifically target the group projects, and can only be answered by students who have been thoroughly involved in the project.	May motivate students more to learn from the group project including learning from the other members of the group.	May diminish importance of group work.
			Additional work for staff in designing exam questions.
			May not be effective, students may be able to answer the questions by reading the group reports.
Combination of Group Average and Individual Mark	The group mark is awarded to each member with a mechanism for adjusting for individual contributions.	Perceived by many students as fairer than shared group mark.	Additional work for staff in setting up procedure for and in negotiating adjustments.

Source: Adapted from Winchester-Seeto (2002).

Table 2.2: Options for student assessment of group product

	Assessment option	Some possible advantages	Some possible disadvantages
Student distribution of pool of marks	Lecturer/tutor awards a set number of marks and let the group decide how to distribute them.	Easy to implement.	Open to subjective evaluation by friends.
	For example, the product is marked 80 (out of a possible 100) by the lecturer. There are four members of the group. Four by 80 = 240 so there are 240 marks to distribute to the four members. No one student can be given less than zero or more than 100. If members decide that they all contributed equally to the product then each member would receive a mark of 80. If they decided that some of the group had made a bigger contribution, then those members might get 85 or 90 marks and those who contributed less would get a lesser mark.	May motivate students to contribute more.	May lead to conflict.
		Negotiation skills become part of the learning process.	May foster competition and therefore be counterproductive to team work.
		Potential to reward outstanding performance.	Students may not have the skills necessary for the required negotiation.
		May be perceived as fairer than shared or average group mark alone.	

Students allocate individual weightings	Lecture/tutor gives shared group mark, which is adjusted according to a peer assessment factor. The individual student's mark comes from the group mark multiplied by the peer assessment factor (e.g. X 0.5 for 'half' contribution or X 1 for 'full' contribution).	As above.	As above.
Peer Evaluation - random marker, using criteria, moderated	Completed assessment items are randomly distributed to students who are required to complete a marking sheet identifying whether their peer has met the assessment criteria and awarding a mark. These marks are moderated by the staff member and together with the peer marking sheets are returned with the assessment item.	Helps clarify criteria to be used for assessment.	Time may have to be invested in teaching students to evaluate each other.
		Encourages a sense of involvement and responsibility.	Staff moderation is time consuming.
		Assists students to develop skills in independent judgment.	
		Increases feedback to students.	
		Random allocation addresses potential friendship and other influences on assessment.	
		May provide experience parallel to career situations where peer judgment occurs.	

Source: Adapted from Winchester-Seeto (2002).

Table 2.3: Options for lecturer/tutor assessment of group process

	Assessment option	Some possible advantages	Some possible disadvantages
Individual mark - based on records/observation of process	Each individual group member's contribution (as defined by predetermined criteria) is assessed using evidence from team log books, minutes sheets, and/or direct observation - and they are awarded a mark.	Logs can potentially provide plenty of information to form basis of assessment.	Reviewing logs can be time consuming for lecturer/tutor.
		Keeping minute sheets helps members to focus on the process - a learning experience in itself.	Students may need a lot of training and experience in keeping records.
		May be perceived as a fair way to deal with 'shirkers' and outstanding contributions - and they are awarded a mark.	Emphasis on second hand evidence - reliability an issue.
			Direct observation by a lecturer/tutor likely to change the nature of interaction in the group.
Group average mark - based on records/observation of process	Each individual group member's contribution (as defined by predetermined criteria) is assessed using evidence from: team log books, minutes	Makes students focus on their operation as a team.	Reviewing logs can be time consuming.
		Logs can provide plenty of information to form basis of	Students may need a lot of training and experience.

	sheets and/or direct observation of process. The group members each then receive an average of these marks.	assessment.	
		Keeping minute sheets helps members to focus on the process - a learning experience in itself.	Emphasis on second hand evidence - reliability an issue.
			Averaging the mark may be seen as unfair to those who have contributed more than others.
Individual mark -- for paper analyzing process	Marks attributed for an individual paper from each student analyzing the group process, including their own contribution that of student colleagues	Helps students to focus on the process.	Information from students may be subjective and/or inaccurate.
		Minimizes opportunities for plagiarism.	May increase assessment burden for lecturer/tutor.

Source: Adapted from Winchester-Seeto (2002).

Table 2.4: Options for student assessment of group process

	Assessment option	Some possible advantages	Some possible disadvantages
Peer Evaluation - average mark, using predetermined criteria	Students in a group individually evaluate each other's contribution using a predetermined list of criteria. The final mark is an average of all marks awarded by members of the group.	Helps clarify criteria to be used for assessment.	May increase lecturer/tutor workload in terms of - briefing students about the process - ensuring the criteria are explicit and clear - teaching students how to evaluate each other.

		Encourages sense of involvement and responsibility on part of students.	Students may allow friendships to influence their assessment - reliability an issue.
		May assist students to develop skills in independent judgment.	Students may not perceive this system as fair because of the possibility of being discriminated against.
		Provides detailed feedback to students.	
		Provides experience parallel to career situations where group judgment is made.	
		May reduce lecturer's marking load.	
Self evaluation-moderated mark, using predetermined criteria	Students individually evaluate their own contribution using predetermined criteria and award themselves a mark. Lecturers/tutors moderate the marks awarded.	Helps clarify criteria to be used for assessment.	May increase lecturer/tutor workload in terms of - briefing students about the process - ensuring the criteria for success are explicit and clear - teaching students how to evaluate themselves.
		Encourages sense of involvement and responsibility on part of students.	Self evaluations may be perceived as unreliable.
		May assist students to develop skills in independent judgment.	

Source: Adapted from Winchester-Seeto (2002).

Inquiry-based learning is "a pedagogy which best enables students to experience the processes of knowledge creation and the key attributes are learning stimulated

by inquiry, a student-centered approach, a move to self-directed learning, and an active approach to learning" (Spronken-Smith et al, 2008, p. 5). This type of teaching and learning is at the core of all design curricula (and of much of the group work in these studios), the backbone of student *charrettes* and competitions, and mirrors the realities of these professional practices. Lee and her colleagues present this table suggesting assessment methods for various stages of inquiry- or problem-based learning.

Table 2.5: Assessment Methods in PBL or IBL Art and Design Education

Pedagogical Approaches/Stages of Inquiry	Selected Methods of Assessment
• Content	• Quizzes, exams • Outlines • Concept maps • Briefing (paper) • (Mini) Papers, reports • Oral presentations • Annotated bibliography
• Develop question	• Research proposal
• Design/frame experiment/study	• Study design/plan
• Select raw data	• Problem statement
• [Design/represent problem]	• Chart, diagram, flowchart
• Observe	• Log
• Record	• Lab/field notes
• [Explore, generate strategies]	• Observation lists • Idea lists • Tables, charts • Alternative draft solutions
• Organize	• Charts, tables, diagrams, flowcharts
• Analyze	• [Mini] papers
• [Analyze alternative strategies]	• Memo • Taxonomy/set of categories • Journal

• Interpret	• Briefing paper
• Evaluate	• Abstract
• [Select strategy]	• [Mini] paper • Statement of assumptions • Performance (e.g., clinical, artistic) • Reflective journal • Case analysis • Diagnosis • Regulation, law, rule • Plan (e.g., nursing, construction)

Source: Adapted from Lee et al. (2004).

Ensemble

Teaching and learning in creative disciplines also takes place in ensembles. The ensemble method takes place on student film projects (for example when directing, producing, acting, screenwriting, and other students get together to create a film), in videogame development, in product design, and in many other creative disciplines where a product or concept is carried out by a team of people working together and learning together from each other, or sometimes following the lead of one particular individual (like an orchestra conductor).

Donald E. Casey (2010), dean of the DePaul University School of Music, writes: "collaborative settings, where individuals learn collectively and from one another as participants in some common project, have particular promise for efficient higher order learning" (p.1) He is referring to ensembles, and how vital they are in music curriculum.

Horenstein (2008) called a holistic music or arts ensemble "a vehicle for a disciplined learning process of shared action (the 'doing'). In such a vehicle, skill-based success combines with guided self-reflection and community belonging, leading to enhanced attitudes and, ultimately, a change in values" (p. 37).

The case study by Buchholz in chapter seven of this book talks about the benefits (developing leadership skills and individual responsibility and promoting student recognition) and challenges (students may have little prior experience working in or leading groups and may all be at varying levels of skill and competency) of ensemble work and assessment. Zanutto (2011) advises to assess only what is being taught in the class, assess the students both individually and as

a collective, and to be prepared to change instruction once "each student's strength and weaknesses are revealed" (p. 6).

Both the atelier and ensemble models of education provide a fertile environment for the constructivist theory of learning, which has three levels (Moshman, 1982): exogenous (knowledge is derived from the environment), endogenous (the learner constructs new knowledge based on previous knowledge), and dialectical (knowledge is found in continual interaction between the individual and the environment). Constructivist pedagogy includes the notion of the student as co-creator of new knowledge, especially in interaction with other students. The role of community, the use of authentic tasks, and the use of tools— all of which are found in art and design studios and collaborative work—are essential in the constructivism (O'Donnell, 2012).

The Critique

Within the master-apprentice and atelier models is embedded the critique. Three basic types of critique exist in art and design studio education: desk critiques, formative group critiques, and summative panel critiques. Desk critiques are where a single professor reviews student work, often in progress, in a formative way. A Columbia University graduate architecture student described the process this way, "Our professor sits with each of us individually to discuss our project, probes our thesis with difficult questions, and helps us push forward to make more potent design arguments (this happens every MWF, when there is no pinup or presentation)" (Nguyen, 2013, p. 1). The strengths of a desk crit are its informality so students feel like it is less threatening than a more structured critique, and how the process can trigger deeper critical thinking. The challenges of the desk crit lie mainly in how a student interacts with the evaluation by and questions from the instructor. Nguyen (2013) wrote that she wished she recorded each session since her memory was faulty when she revised the work. Another "archinect" student blogger recommends taking copious notes, though said the instructors do not require this (Oakhay, 2013). These comments echo the challenge of assessing the desk crit: faculty often lack assessment data unless they use a rubric at the desk crit, like the kind used as an example in chapter eleven of this book in the case study "Learning Design Wisdom by Augumenting Physical Studio Critique with Online Self-Assessment" (Kulkarni and Klemmer, 2012).

Another kind of critique is the formative group critiques, often weekly, where students present work and then receive feedback from their classmates and the instructor. Formative group critiques are used for evaluating works in progress. The idea behind this type of critique is to mimic the atmosphere

experienced by architectural and interior design professionals (McPeek and Mortland, 2011).

The third type of critique is the summative panel crit, described as "one of the most important forms of formative assessment in art and design education" (Horton, 2007), and over the last decade this type of crit has been one of the most commented on, criticized, and lauded forms of assessment, in everywhere from mainstream newspapers (*The New York Times)* to conference proceedings to academic journals.

The summative panel crit can be the culminating experience in either a master-apprentice or a atelier teaching model; this experience is when an artist or designer or composer gets to display or play his/her work and explain the context in which it was created and the purpose of its creation to classmates and his/her teacher. The summative panel crit of a portfolio or major project can be for a final class grade or to determine if the student gets to continue with his or her design studies, which makes it very high stakes. Percy (2004) writes, "the crit is widely considered to provide a key moment of critical debate and intervention..." (p. 143). (It is similar to the annual jury in the study of music.)

In the panel crit, classmates and the teacher have the opportunity to ask questions and to interject to gain understanding of the work (Percy, 2004). Painter Lisa Yuskavage, in *The New York Times* article "Tales from the Crit: For Art Students, May is the Cruelest Month" described the crit as "Think about the general nightmare of standing nude in public...but add something else you fear, like standing nude on a scale" (Finkel, 2006).

This is a very student-centered approach to teaching and learning, as it combines both self-assessment and peer assessment. University of California Los Angeles Professor John Baldessari sees his role as being a good moderator or navigator (Finkel, 2006).

Reflection on ideas raised by others in the crit give students "a view to improving their practice" (Horton, 2007, p.2) once the students get over how raw, exposed, or humiliated they might feel during the critique experience. Because of the crit format—vocally contributing one's thoughts, feedback, questions, comments, and justifications—students may feel afraid or intimidated.

Day (2012) states that many students, prior to university, have little experience with the crit model of teaching and learning, and sometimes requirements or parameters set up to make the crit successful are unclear. Because of this, the University of Albany provides written instructions for students engaging in studio art group critique. A very abbreviated form of those basic

instructions are as follows, but the full instructions can be found at the URL at the end of the passage.

Guidelines for Group Critique

Your critique should address form **and** content, and should consider the work of art in and of itself, and in the context of issues discussed in the reading assignments.

1. Describing the work (what does it look like? what is it made of?).
2. Interpreting the work (what does it mean?)
3. Evaluating the work (is it art? is it interesting? does it "work"?).
 (http://www.albany.edu/faculty/dgoodwin/shared_resources/critique.htm l)

Assessment during any type of crit is most effective when it involves self-assessment, as well as peer and/or professional assessment (Brown and Glasner, 1999; Horton, 2007; Race, 2001; Roach, 1999). Rubrics given to students ahead of time help them understand what will be evaluated.

THE ROLE OF THE ARTIST AS TEACHER AND THE IMPLICATIONS FOR QUALITY ASSURANCE

So far this chapter has explored the various teaching and learning methods employed in creative discipline education. One of the unique aspects of art and design education is that the instructor is often a practicing artist or designer, making assessment activities within the classroom or studio not by a "teacher" but by an expert who teaches. The evaluation of the expert (teaching faculty) provides the basis for knowing about student development and defines "quality".

Classroom or studio assessment is inherently geared to an "n of 1" (the individual student), or in a collaborative context, a creative expression (painting, musical performance, film, design model, etc.). The assessment process begins with a diagnosis of where the student is at a particular point in time. Criterion referencing is essential to this process – as in the studio, the contours of quality need to be intentional; that is identified, defined, and explained to students.

Good arts assessment and quality assurance should then attend to development over time; the measurement component is a matter of student progress from where they were at a beginning point to where they arrive. But then as instructors we also use this data to look across students, based on a recognized

set of expert-derived and shared criteria (learning outcomes) that are now basic to good arts assessment, and to the improvement of teaching and learning practices and from where a cohort of students was when they entered the program to what levels of proficiency they have reached upon graduation.

But the assessment of creativity is sometimes limited and not as robust as it could be because educators and students alike are unsure what to assess. "A key issue facing architecture, art and design educators is what to focus on in order to effectively assess creative work. The issue of whether assessment is about process, person and/or product in creative practices remains under debate today" (de la Harpe et al, 2009 referencing AIAS Studio Culture Taskforce, 2003; Ellmers, 2006; Ehmann, 2005; Goldschmidt, 2003). Or as Ellmers (2006) writes, assessment of creativity tends to focus on "what is produced rather than the process that led to it" (p. 6).

In a study of over one hundred articles on art and design assessment, de la Harpe et al (2009) found 11 Key Indicators Underpinning Studio Assessment:

1) product
2) process
3) person
4) content knowledge
5) hard skills
6) soft skills
7) learning approach/style
8) technology
9) reflective practice
10) professional and innovative practice
11) interdisciplinary collaboration

These indicators vary in order of priority per discipline, with product being most important in architecture and process in art and design.

PROFICIENCY AS A GUIDE TO PROGRAM AND CURRICULUM DESIGN

One quality that all forms of summative art and design assessment possess is a look at proficiency or the levels or degrees of mastery of content and task (Stern, 1983; Llurda, 2000; McFall, 2006). Over the past 25 years, psychologists and educators have developed a deep understanding of the role of deliberate practice in developing expert performance capabilities. Ericsson and Charness (1994), for example, wrote that practicing a skill in a deliberate way over time is central to

becoming an expert. More recently, Gladwell (2008) makes explicit that link, for example in discussing the long internship of the Beatles in British clubs and especially their time in Hamburg where they constantly performed together, focused on their group sound, and moved ever closer to mastery. The findings both reinforce what many in arts education already know about developing artistic mastery and challenge conventional ideas about teaching and learning.

Proficiency is the ability to apply knowledge and to address meaningful problems, and it is comprised of knowledge/skill in the discipline, knowledge of the self as a learner, and organization of knowledge/skills into a big picture or model (McFall, 2006). Proficiency has four main components: domain specific knowledge, procedural knowledge, metacognitive skills, and mental models. Domain-specific knowledge is the kind of information, facts, and concepts that are traditionally emphasized in classroom instruction, especially in lecture formats (Alexander, 2003; Chase and Simon, 1973; Eckert, 2003; Ericsson and Lehman, 1996). This type of knowledge is easiest to assessment with conventional quizzes and tests.

Procedural knowledge is knowledge and skill in the practical aspects of the discipline; and this type of knowledge also encompasses interdisciplinary skills such as collaboration and leadership. (McFall, 2006; Eckert, 2003; de Jong and Ferguson-Hessler, 1996). As individuals become more adept, procedural knowledge can become almost automatic. At the expert level it may become tacit knowledge—that which can be known but not explained (McFall, 2006). Procedural knowledge in the arts and in design is developed in private instruction and in studios. It may also be enhanced in internships and externships.

Metacognitive skills refers to awareness of one's own knowledge—including acknowledgement of what one doesn't know—and one's ability to understand, control, and manipulate one's cognitive processes (Meichenbaum, 1985). Metacognitive skills are developed through experiential learning and practice with feedback, and through coaching and mentoring, but can also be developed through active learning in the classroom and co-curricular activities. (Chapter three in this book explores metacognitive skills more thoroughly.)

Mental models are psychological representations of real, hypothetical, or imaginary situations. Mental models can be the result of beliefs, perception, imagination, knowledge, and comprehension (Byrne, 2014). Students develop workable mental models through instructor and practitioner coaching, mentoring, and feedback, especially on case studies, problem-based or inquiry-based learning, art and design projects, research and experiential learning. Individuals develop models of their fields of study and of themselves acting within their

fields of study. Musicians often development mental models of themselves playing through a piece of music and sometimes they create this model without their instruments, but by mimicking the proper fingering and techniques and playing the music in their minds.

ACTIVITIES THAT SUPPORT THE DEVELOPMENT OF PROFICIENCY

Students develop proficiency through high-quality formal instruction, study, active and experiential learning, deliberate practice, trial-and-error with reflection and guidance, discovery learning, and problem solving (McFall, 2006). Two crucial factors that contribute to the development of proficiency are targeted feedback and a supportive ecology, such as one often found in art and design studios. Effective targeted feedback supports the development of proficiency by helping the learner prioritize what's important, is about the work of the student not the student him or herself, and supports self-direction and autonomy in learning (McFall, 2006). The supportive ecology includes relationships with peers and instructors, class size, the academic program and support services provided by educational institutions, experiential learning opportunities, and the students' family and community not on campus.

INTEGRATING TEACHING, LEARNING, AND ASSESSMENT

The unique, authentic nature of fine, performing, and designing arts education allows for rich opportunities to observe student learning and to connect pedagogy to student achievement in a direct way. New knowledge and skills are integrated with existing ability in a social environment of shared values and meaning-making as the learner is provided with a structured system of feedback, modeling, and support that diminishes in intensity over time. By using appropriate assessment techniques such as the ones mentioned in this chapter, we can evaluate individual students and across groups of students.

SUMMARY

Art and design curriculum strives to "awaken the student to the light in his or her own mind" as our opening quote in this chapter states, through a variety of educational models, including the master-apprentice, the atelier, and the ensemble, and through the use of various forms of critique. The end aim is to assist the student in a journey from one level of proficiency to a higher level of knowledge and skill within discipline-specific and more general educational areas, and

assessment is the process by which we document this growth, on an individual student level and across cohorts of students. Ultimately, we understand how much our students master with how well they succeed in their chosen professions and life.

The next chapter delves more deeply into the triumvirate of cognitive, affective and psychomotor learning domains, expands on the notion of learning domains to other areas, and provides examples of how each domain is critical to effective assessment in the arts.

REFERENCES

AIAS Studio Culture Taskforce. 2003. Studio Culture Discussion. Paper by the American Institute of Architecture Students discussed at the NAAB Validation Conference, 24-25 October, Santa Fe, New Mexico.

Alexander, P.A. 2003. The Development of Expertise: The Journey from Acclimation to Proficiency. *Educational Researcher.* 32(8). 10-14.

Barker, T. and Hall, A. 2010. Design Collectives in Education: Evaluating the Atelier Format and the Use of Teaching Narrative for Collective Cultural and Creative Learning, and the Subsequent Impact on Professional Practice. Alternative Practices in Design: The Collective—Past, Present & Future: Symposium Proceedings 2010. Melbourne, Vic.: RMIT University- Design Research Institute. 2010: 5-15.

Biggs, J. 1999. *Teaching for Quality Learning at University.* Buckingham, UK: Open University Press.

Bose, M., Pennypacker, E. & Yahner, T. 2006. Enhancing Critical Thinking Through Independent Decision Making In The Studio. *Open House International,* 31(3). 33-42.

Brown S. and Glasner, A. 1999. *Assessment Matters in Higher Education: Choosing and Using Diverse Approaches*, Buckingham, U.K.: Open University Press.

Byrne, R. 2014. Mental Models And Reasoning: What Are Mental Models? Princeton University Website Report. http://mentalmodels.princeton.edu/about/what-are- mental-models/

Casey, D. Spring 2010. Learning Great Repertoire Together. *Con Brio: The Journal of the DePaul School of Music.*

Chase, W.G. and Simon, H.A. 1973. Perception in Chess. *Cognitive Psychology, 4, 55-81.*

Chase, D.M., Ferguson, J.L, & Hoey IV, J.J. 2014. *Assessment in Creative Disciplines: Quantifying and Qualifying the Aesthetic.*, Champaign, IL: Common Ground.

Corley, P. 2010. Why Johnny Can't Play: Expanding the Master/Apprentice Model. Presented at the International Clarinet Association's Clarinetfest 2010. 22 July 2010, University of Texas.

Cowdroy, R. and Williams, A. 2006. Assessing Creativity in the Creative Arts. *Art, Design & Communication in Higher Education.* (5)2. 97-117. doi: 10.1386/adch.5.2.97/1.

Csikszentmihalyi, M. & Nakamura, J. 2002. *Handbook of Positive Psychology.* Oxford: Oxford Press.

Day, P. 13 July 2012. The Art Group Crit. How do you make a Firing Squad LessScary? BrightONLINE Issue 18. Retrieved December 10, 2014. http://arts.brighton.ac.uk/projects/networks/issue-18-july-2012/the-art-group- crit.-how-do-you-make-a-firing-squad-less-scary

de Jong, T. and Ferguson-Hessler, M.G.M.1996. Types And Qualities Of Knowledge. *Educational Psychologist, 31*(2), 105-113.

de la Harpe, B. and Peterson, F. 2008. 'A Model For Holistic Studio Assessment In The Creative Disciplines', in Andrea Duff, Diana Quinn, Margaret Green, Kate Andre, Trim Ferris, Scott Copeland (ed.) *ATN Assessment Conference*

2008 Engaging students in assessment. Conference Proceedings, Adelaide, SA, 20-21 November 2008, pp. 1-8.

de la Harpe, B., Peterson, J.F., Frankham, N., Zehner, R., Neale, D., Musgrave, E. & McDermott, R. 2009. Assessment Focus In Studio: What Is Most Prominent In Architecture, Art And Design? *International Journal of Art and Design Education.* 28(1), p. 37-51.

Eckert, E. 2003. Proficiency-development spirals: Occupational learning among farmers. *Doctoral Dissertations.* Paper AAI3101686. http://digitalcommons.uconn.edu/dissertations/AAI3101686/

Ehmann, D. 2005. Using Assessment to Engage Graphic Design Students in Their Learning Experience. Paper presented at the 2005 Evaluations and Assessment Conference, 30 November-1 December, Sydney.

Ellmers, G. 2006. Assessment Practice In The Creative Arts: Developing A Standarised Assessment Framework. Teaching and Learning Scholars Report,

Faculty of Creative Arts, University of Wollongong.

Ericsson, K. A. & Charness, N. 1994. Expert Performance: Its Structure And Acquisition. *American Psychologist.* (49)8. 725-747. doi: 10.1037/003-066X.49.8.725

Ericsson, K. A., and Lehmann, A.C. 1996. Expert And Exceptional Performance: Evidence Of Maximal Adaptation To Constraints. *Annual Review of Psychology, 47*, 273-305.

Finkel, J. April 30, 2006. Tales from the Crit: For Art Students, May is the Cruelest Month. *The New York Times.* www.nytimes.com/2006/04/30/arts/design/30fink.html

Goldschmidt, G. 2003. Expert Knowledge Or Creative Spark? Predicaments In Design Education. Paper presented at the Expertise in Design, Design Thinking Research Symposium 6, 17-19 November, University of Technology Sydney.

Guidelines for Group Critique. University of Albany. Retrieved March 10, 2014. http://www.albany.edu/faculty/dgoodwin/shared_resources/critique.html

Gladwell, M. 2008. Outliers: The Story of Success. New York: Little, Brown, and Company.

Hackett, R. 2006. Chihuly Victimized By His Own Success? *Seattle Post-Intelligencer.* Retrieved 14 December 2014. http://www.seattlepi.com/ae/article/Chihuly-victimized-by-his-own-success-1201229.php#page-1

Horenstein, S.H. 2008. Promoting Values Through the Arts. *Min-Ad: Israel Studies in Musicology Online.* Retrieved December 10, 2014. *http://www.biu.ac.il/hu/mu/min-ad/10/03-%20Horenstein.pdf*

Horton, I. January 8-10, 2007. The Relationship between Creativity and the Group Crit in Art and Design Education. Paper presented at Creativity or Conformity? Building Cultures of Creativity in Higher Education, University of Wales Institute, Cardiff, UK.

Jorgesen, E. 2008. *The Art of Teaching Music.* Bloomington: Indiana University Press.

Kember, D. & Kwan, K. 2002. Lecturers' Approaches To Teaching And Their Relationship To Conceptions Of Good Teaching. N. Hativa & P. Goodyear (Eds) *Teacher Thinking, Beliefs and Knowledge in Higher Education.* Dordrecht, Kluwer, 255-275.

King, M. 2003. *The Renaissance in Europe*. McGraw-Hill: New York.

Koch, A. Schwennsen, K., Dutton, T., & Smith, D. 2002. *The Redesign Of Studio Culture*. A report of the AIAS Studio Culture Taskforce, American Institute of Architecture Students, Washington, D.C.

Kulkarni. C. and Klemmer, S.R. 2012. Learning Design Wisdom By Augmenting Physical Studio Critique With Online Self-Assessment. *Technical Report*, Stanford University.

Lee, V.S., Greene, D.B., Odom, J., Schechter, E. & Slatta, R.W. 2004. What Is Inquiry-Guided Learning? In V.S. Lee (ed.) *Teaching And Learning Through Inquiry: A Guidebook For Institutions And Instructors*. Sterling, VA: Stylus.

Lindblom-Ylanne, S., Trigwell, K., Nevgi, A., & Ashwin, P. June 2006. How Approaches to Teaching are Affected by Discipline and Teaching Context. *Studies in Higher Education*. 31: 3, 285-298.

Llurda, E. 2000. On Competence, Proficiency, And Communicative Language Ability. *International Journal of Applied Linguistics*. 10(1), 85-96.

McFall, E. 2006. Proficiency as a Guide to Program and Curriculum Design. University of the Pacific. http://www.pacific.edu/Documents/provost/acrobat/02_The_Big_Picture _110906.pdf

McPeek, K.T. and Morthland, L.M. July 2011. Making The Grade: Assessing Group Work In The Design Studio. Paper read at the 2011 International Conference, The Future of Education, Florence, Italy

Meichenbaum, D. 1985. Teaching Thinking: A Cognitive-Behavioral Perspective. In S. F., Chipman, J. W. Segal, & R. Glaser (Eds.), *Thinking And Learning Skills, Vol. 2: Research And Open Questions*. Hillsdale, NJ: Lawrence Erlbaum Associates.

Moshman, D. 1982. Exogenous, Endogenous, And Dialectical Constructivism. *Developmental Review*, 2, 371-384. doi: 10.1016/0273-2297(82)90019-3.

Nyugen, K.V.K.H. 2013. Desk Crit Notes. Retrieved 12 Dec 2014. http://archinect.com/gsapper/desk-crit-notes

Oakhay. 2013. Desk Crit Notes. Retrieved 12 Dec 2014. http://archinect.com/gsapper/desk-crit-notes

O'Donnell, A.M. 2012. Constructivism. Harris, Karen R. (Ed); Graham, Steve (Ed); Urdan, Tim (Ed); McCormick, Christine B. (Ed); Sinatra, Gale M.

(Ed); Sweller, John (Ed), (2012). APA Educational Psychology Handbook, Vol. 1: Theories, Constructs, And Critical Issues. (pp. 61-84). Washington, DC, US: American Psychological Association, xxx, 621 pp. doi:10.1037/13273-003.

Percy, C. 2004. Critical Absence Versus Critical Engagement. Problematics of the Crit in Design Learning and Teaching. *Art, Design, and Communication in Higher Education,* 2:3, 143-54.

Race, P. 2001. A Briefing On Self, Peer And Group Assessment. Retrieved 14 December 2014. http://www.heacademy.ac.uk/resources.asp?process=full_record§ion=ge neric&id=9.

Roach, P. 1999. Using Peer Assessment And Self-Assessment For The First Time. In Brown, S. and Glasner, A. *Assessment Matters In Higher Education: Choosing and Using Diverse Approaches.* Buckingham U.K.: Open University Press.

Spronken-Smith, R.A., R. Walker, W. O'Steen, H. Matthews, J. Batchelor, & T. Angelo. 2008. Reconceptualising Inquiry-Based Learning: Synthesis Of Findings. Wellington, NZ:Ako Aotearoa, The National Centre for Tertiary Teaching Excellence. akoaotearoa.ac.nz/ project/inquiry-based-learning/resources/books/reconceptualisinginquiry-based-learning-synthesis-fi.

Stern, H.H. 1983. *Foundational Concepts Of Language Teaching. Oxford:* Oxford University Press.

Trigwell, K. 2002. Approaches to Teaching Design Subjects: a Quantitative Analysis. *Art, Design, and Communication in Higher Education.* 1, 69-80.

Winchester-Seeto, T. April 2002. Assessment Of Collaborative Work – Collaboration Versus Assessment. Invited paper presented at the Annual Uniserve Science Symposium, The University of Sydney, 5th April.

Zanutto, D. 2011. Instrumental Assessment Strategies: Including All Standards in Your Program. http://csulb.edu/depts/music/wordpress/dzanutto/files/2011/07/Instrumental-Assessment.pdf

Cognitive and Affective Learning in Creative Disciplines

For the mind does not require filling like a bottle, but rather, like wood, it only requires kindling to create in it an impulse to think independently and an ardent desire for the truth.

<div align="right">–Plutarch, Moralia. On Listening to Lectures</div>

In chapter one, we discussed the importance of intentionality, and understanding what it is we want students to learn as a fundamental first step of instructional and learning design. Chapter two dealt with teaching and learning in the arts, the theories undergirding specific pedagogic practices, teaching practices, and appropriate assessment methods. This chapter takes as a point of departure that good instruction begins with clearly articulated learning goals. In our earlier work (see Chase, Ferguson and Hoey, 2014) we dealt extensively with domain expertise, deliberate practice, and expert performance within artistic disciplines, situated within learning theories relevant to the arts such as constructivism. The present chapter serves to provide a practical overview of a number of the taxonomies we may use in creative disciplines to articulate the array of expectations we have for student learning as we guide students in their artistic and professional development. Foremost among those taxonomies are the triumvirate of learning domains as described by Benjamin Bloom (1956) and his colleagues (cognitive, affective, and psychomotor). More recent taxonomies developed under the auspices of the National Research Council (2012), by Vinson (2009), and by Reeves (2006) are also explored. The chapter provides examples of how each domain is critical to effective assessment of learning in the arts. The chapter includes an exploration of the role of metacognition and self-reflection in professional artistic formation, two areas that are frequently mentioned as crucial for professional artistic formation across artistic disciplines.

CRAFTING LEARNING OBJECTIVES

As discussed in Chapter two, arts instructors have over the years used pedagogical practices, mostly applied in nature, to effect behavioral change in what students can do or can produce. If we want to focus on just the student

product, as we have traditionally done in the arts, then little of this notion of reflective teaching practice informed by assessment of student learning makes much sense. The predilection would be to continue to view student success or lack thereof as a function of innate student talent, rather than to reflect on the effectiveness of our pedagogical practice or to concern ourselves with students' varied information processing styles. Contrary to that exclusively 'innate talent' viewpoint, we specified our standpoint at the outset of this work: we take as axiomatic that good learning begins with good teaching, and that good teaching begins with good educational design - where we think through and describe the ends or goals we expect students to achieve at levels that will help articulate and give us the ability to redirect student efforts towards mastery in their respective disciplines. Reeves (2006) refers to this as alignment among a set of critical aspects of teaching and learning: "The success of any learning environment is determined by the degree to which there is adequate alignment among eight critical factors: 1) [learning] goals, 2) content, 3) instructional design, 4) learner tasks, 5) instructor roles, 6) student roles, 7) technological affordances, and 8) assessment" (p.294). He notes that the most frequently misaligned aspect among these, not surprisingly, is assessment.

Beginning from our articulated standpoint, the task of being clear about what we expect students to achieve includes the necessity of developing and articulating our expectations concerning aspects of student learning, to include aspects such as the mental processes by which students arrive at a design, interpret a piece of music, or create a work of art. We have to define in observable terms what we mean by student thinking and learning, since if we cannot specify it and in some sense measure or capture a sense of it, then we cannot improve our practice as arts instructors nor can we hope to optimize the specificity with which we approach the learning and development of each of our students. Defining what it is we are looking for in terms of student accomplishment starts with stating and refining learning objectives – the goals we have for instruction – and student learning outcomes, or the behavioral change we hope to see in students as a result of one or more learning experiences.

Widely-used yet distinct sets of guidelines for crafting learning objectives have been articulated by both Mager (1984) and Gronlund (2000). Of the two approaches, Mager's (1984) approach is the more behavioristic and defined at a granular level. He recommends that learning objectives include three components to reach the necessary specificity: First, the conditions under which we would expect to see a specific student behavior exhibited; second, a description of what the behavior should be; and third, the standard or criterion by which we would

judge a student's performance to be acceptable or not. A somewhat tongue-in-cheek example of a learning objective for playing musical scales on a single-line instrument might be something like this, according to Mager's guidelines: *Given a poorly-insulated practice room and a radio in the practice room blaring inane top 20 hits and commercials at no less than 60 db, the student will perform three-octave scales in all major and minor keys at a metronome marking of 120 with not more than two mistakes performing scales across all the major and minor keys.*

A similar but purposefully less behaviorally defined approach to crafting learning objectives is advanced by Gronlund (2000), who outlines several important roles and qualities for instructional objectives. Good learning objectives, he says, should provide a clear focus for instruction, guidelines for the students to work towards, targets for assessment, a way to communicate instructional intent to internal and external bodies, and a way for us to determine what instructional strategies worked well or less than expected (2000, p.5). In contrast to Mager's (1984) approach, Gronlund clarifies that

> What is needed for most classroom instruction is a limited, manageable set of instructional objectives, with each objective defined by a list of specific types of performance that students are able to demonstrate when they have achieved the objective. This enables us to describe intended learning outcomes ranging from simple to complex, and provides us the freedom to use a variety of instructional methods and materials to help students achieve the objectives (2000, p.4).

Gronlund specifically eschews the use of conditions and performance levels, preferring to retain the flexibility of being able to vary these as warranted by specific groups of students and situations. As an example from music composition, following Gronlund's (2000) guidelines, might be something like this: *The student crafts a 32-measure melody in AABA form, using standard musical notation, time signature, volume, and phrasing.* Note that while the outcome is stated, the conditions are not stated under which the melody is to be written, nor have we specified a specific performance standard. Both of these approaches to creating learning outcomes are useful, depending on the context. In creating an Architectural design assignment using Revit software, for example, a very closely specified set of Magerian (1984) learning objectives might be appropriate to the technical and defined tasks to be performed. Learning objectives that are used to further specify course-level learning outcomes, such as solving an open-ended design problem as part of a work group, might be more

appropriately stated using Gronlund's (2000) guidelines. To provide guidance in crafting instructional objectives that are both pegged at the right level of student competence and within the general area of thought we want to develop in our students, taxonomies of learning objectives provide relevant and useful frameworks.

DESCRIBING TAXONOMIES OF LEARNING OBJECTIVES

The development of descriptive taxonomies or classification systems to help educators specify our expectations for student learning and achievement with sufficient granularity to mirror the precision we demand in the arts (and in other disciplines) was undertaken by Benjamin S. Bloom (1956) and his colleagues, who over a number of years and several volumes delved deeply into the nature of thinking and intellectual behavior, and in the process developed specific taxonomies of student learning objectives that have exerted a powerful influence over the years (Forehand, 2005). Bloom and his colleagues described educational objectives in three overlapping yet distinct domains, as presented in Table 3.1 below. First is the cognitive or thinking domain, consisting of six levels, concerned with how we obtain, process, and utilize knowledge (Bloom et al., 1956). Second is the affective, or attitudinal domain, consisting of five levels, that deals with emotions, values, and feeling (Krathwohl et al., 1964). Third is the psychomotor, or action domain, consisting of six levels and dealing with manual or physical skills (Harrow, 1972; Simpson, 1966). The levels in each domain were arranged in order of ascending complexity, such that "Mastery of each simpler category was prerequisite to mastery of the next more complex one" (Krathwohl, 2002, p.212). An in-depth discussion of each of these original domains and their relevance to assessment in the arts is presented in Chase et al. (2014).

Table 3.1: Taxonomies of learning objectives.

Cognitive	Affective	Psychomotor
Knowledge	Receiving	Perception
Comprehension	Responding	Set
Application	Valuing	Guided Response
Analysis	Organizing	Mechanism
Synthesis	Characterizing	Complex Overt Response
Evaluation		Adaptation
		Origination

Source: Adapted from Anderson and Krathwohl (2001).

UPDATES TO BLOOM'S TAXONOMY OF LEARNING OBJECTIVES

An important re-visioning of Bloom's original taxonomy of the cognitive domain appeared in 2001, undertaken by Anderson and Krathwohl. The nomenclature changed, moving from nouns to verbs, to reflect an evolving understanding of how the taxonomy is put into use to create learning objectives and student learning outcomes. The two most complex levels in the taxonomy exchanged places such that Creating/Synthesis takes precedence of place over Evaluating/Evaluation. See Table 3.2 below for comparison and definition of terms under Anderson and Krathwohl's (2001) updated version of the Cognitive Domain.

Table 3.2: Comparison of Original and Revised Cognitive Domain Taxonomies

Original Version of Cognitive Domain (Bloom et al., 1956)	Updated Version of Cognitive Domain and Definitions (Anderson and Krathwohl, 2001)	Examples of Verbal Descriptors
Evaluation	**Creating**: Putting elements together to form a coherent or functional whole; reorganizing elements into a new pattern or structure through generating, planning, or producing.	Assemble, construct, create, design, develop, formulate, write
Synthesis	**Evaluating**: Making judgments based on criteria and standards through checking and critiquing.	Appraise, argue, defend, judge, select, support, value, evaluate
Analysis	**Analyzing**: Breaking material into constituent parts, determining how the parts relate to one another and to an overall structure or purpose through differentiating, organizing, and attributing.	Appraise, compare, contrast, criticize, differentiate, discriminate, distinguish, examine, experiment, question, test
Application	**Applying**: Carrying out or using a procedure through executing, or implementing.	Choose, demonstrate, dramatize, employ, illustrate, interpret, operate, schedule, sketch, solve, use, write

Comprehension	**Understanding**: Constructing meaning from oral, written, and graphic messages through interpreting, exemplifying, classifying, summarizing, inferring, comparing, and explaining.	Classify, describe, discuss, explain, identify, locate, recognize, report, select, translate, paraphrase
Knowledge	**Remembering**: Retrieving, recognizing, and recalling relevant knowledge from long-term memory.	Define, duplicate, list, memorize, recall, repeat, reproduce state

Source: Anderson and Krathwohl (2001), p.67-68.

The changes put in place by Anderson and Krathwohl (2001) included changes to terminology, the structure of the taxonomy, and its emphasis. Structurally, a new knowledge dimension was added, including factual, conceptual, procedural, and metacognitive forms of knowledge. Clarifying the rationale for this change, Krathwohl (2002) noted that learning objectives typically contain both a statement of instructional content (as a noun or noun phrase) as well as the cognitive processes to be undertaken in relation to that content (an action verb or verb phrase), and that the revised format allowed each "to form separate dimensions, the noun providing the basis for the Knowledge dimension and the verb forming the basis for the Cognitive Process dimension" (p. 213). Juxtaposing the six levels of the cognitive process dimension with the four levels in the knowledge dimension yields the following Taxonomy Table. An interactive version by Fisher (n.d.) may be viewed at http://oregonstate.edu/instruct/coursedev/models/id/taxonomy/#table.

Table 3.3: Taxonomy Table.

The Knowledge Dimension	The Cognitive Process Dimension					
	Remember	Understand	Apply	Analyze	Evaluate	Create
Factual Knowledge	List	Summarize	Classify	Order	Rank	Combine
Conceptual Knowledge	Describe	Interpret	Experiment	Explain	Assess	Plan
Procedural Knowledge	Tabulate	Predict	Calculate	Differentiate	Conclude	Compose
Metacognitive Knowledge	Appropriate Use	Execute	Construct	Achieve	Action	Actualize

Sources: Krathwohl (2002), Forehand (2005).

USING THE TAXONOMY TABLE IN PRACTICE

Given our focus on assessment in creative disciplines, Anderson and Krathwohl's (2001) explicit recognition of distinct forms of knowledge is an especially important development for assessing student professional competence, and we will cover that topic in greater depth in Chapter Four. Here, it is important to consider the usefulness to instructional goal-setting and assessment of having such a detailed multi-dimensional outline of cognitive process and knowledge dimensions. How does it help us align intention, instruction, student learning, and assessment? Prospectively, we can collaborate with other departmental colleagues and creative professionals as we develop curriculum and program-level learning intended learning outcomes, and utilize the Taxonomy Table as a reference guide to think through the relative complexity of professional tasks an artist in a given discipline must be able to undertake. At the course, unit, or even individual student level the Taxonomy Table can serve a similar planning function. If we have already written learning objectives for a module, course or even a whole program of study, we can use the Taxonomy Table as a tool to discern the extent to which forms of knowledge and cognitive processes of greater complexity are involved. Perhaps even more relevant, we can juxtapose our current learning objectives against the Taxonomy Table to see what could have been included but was not – in other words, we can use it to see where any gaps exist. Finally we can use the Taxonomy Table to classify not only our learning objectives, but also the instructional activities and assessments used (Krathwohl, 2002).

LEARNING DOMAINS FOR THE 21ST CENTURY

Acknowledging the importance of the earlier work of Benjamin Bloom and his colleagues, the National Research Council (NRC) published in 2012 an alternative conceptualization of taxonomies for learning that reflect 21st Century competencies and the need for deep learning across disciplines. *Education for Life and Work: Developing Transferable Knowledge and Skills in the 21st Century* was developed over a period of several years by the Committee on Defining Deeper Learning and 21st Century Skills (the Committee), headed up by James Pellegrino and Margaret Hilton. The Committee developed taxonomies in three domains of competence: Cognitive (memory and reasoning), Intrapersonal (self-management, or the capacity to manage one's behavior and emotions to achieve one's goals including learning goals), and Interpersonal (expressing ideas and interpreting and responding to others messages) (NRC, 2012, p.3).

While the taxonomies of educational objectives developed by Bloom and his colleagues were hierarchically organized, the Committee approached the creation of its taxonomies in a different manner, and viewed them as clusters of competencies with no innate hierarchy. Moreover, they purposefully used the term "competency" to indicate transferable knowledge and skills, including content knowledge within a discipline as well as the situational understanding of where, when, how, and why to use that knowledge to resolve questions and problems. It is that blend of domain knowledge and procedural knowledge that they called '21st century competencies,' a conceptualization that bears similarity to Anderson and Krathwohl's (2001) reframing of the cognitive domain discussed above. The Committee found that in practice the domains overlap, and that available evidence from the learning sciences pointed towards the conclusion that "deeper learning and complex problem solving involves the interplay of cognitive, intrapersonal, and interpersonal competencies" (NRC, 2012, p.8). The clusters of competencies identified by the Committee were articulated as follows:

- The Cognitive Domain includes three clusters of competencies: cognitive processes and strategies, knowledge, and creativity. These clusters include competencies, such as critical thinking, information literacy, reasoning and argumentation, and innovation.
- The Intrapersonal Domain includes three clusters of competencies: intellectual openness, work ethic and conscientiousness, and positive core self-evaluation. These clusters include competencies such as flexibility, initiative, appreciation for diversity, and metacognition (the ability to reflect on one's own learning and make adjustments accordingly – discussed at greater length below).
- The Interpersonal Domain includes two clusters of competencies: teamwork and collaboration and leadership. These clusters include competencies, such as communication, collaboration, responsibility, and conflict resolution (NRC, 2012, p.4).

Interpersonal Domain

Similar to the Committee on Defining Deeper Learning and 21st Century Skills of the NRC (2012), Vinson (2009) identified the Interpersonal Domain as relevant for higher education in the 21st Century, focused as it is on how people communicate and interact with others. The skills in this domain are acquired through exposure to role models, continued practice, and receiving ongoing coaching feedback, ideally in a face-to-face environment. Vinson (2009)

describes the Interpersonal Domain as a cluster of skills rather than a hierarchical ordering, including at least the following set:

- Seeking/giving information (asking for and offering information)
- Proposing (putting forward an idea)
- Building and supporting (helping another person's idea move forward)
- Shutting out/bringing in (excluding or involving another)
- Disagreeing (appropriately offering a difference of opinion)
- Summarizing (Restating in a compact form a discussion or collection of ideas)

Based on a large-scale review of the literature, Klein, DeRouin, and Salas (2006) developed an extensive taxonomy of interpersonal skills, grouped into two overall dimensions of communication and relationship-building. As with Vinson (2009) the Klein, DeRouin, and Salas (2006) taxonomy is an array of important skills, not arranged in a hierarchical order. See Table 3.4 below.

Table 3.4: Taxonomy of Interpersonal Skills

Interpersonal Skill Dimension	Interpersonal Skills Included
Communications Skills	Active ListeningOral CommunicationWritten CommunicationAssertive CommunicationNonverbal Communication
Relationship-Building Skills	Cooperation and CoordinationTrustIntercultural SensitivityService OrientationSelf-PresentationSocial InfluenceConflict Resolution and Negotiation

Source: Adapted from Klein, DeRouin, and Salas (2006).

For artistic education in the 21st Century, the cluster of skills within the interpersonal domain represent must-have competencies, especially for those aspiring professionals whose daily work will include team and group collaboration, communication with clients, building trust across diverse settings and groups – in short, most of those in creative disciplines!

Conative Domain

Conation is defined in the Oxford Dictionary (n.d.) as "The mental faculty of purpose, desire, or will to perform an action; volition." Regarding it as a neglected learning domain in higher education, Reeves (2006) espouses consideration of the conative domain as a vital companion to the cognitive, affective, and psychomotor domains described by Bloom and his colleagues (1956). Even though an individual has the cognitive capacity, affective values, and the motor skills to accomplish a task, having the will, drive, and volition to achieve at a high level is another question entirely, as Reeves (2006) explains. Atman refers to the conative domain as being concerned with striving behaviors – "the capacity for being purposeful, determined, and persistent" (1993, p.208). Huitt (1999) describes the conative domain as dealing with proactive, intentional behavior, a domain that is critical to self-directed behavior and self-regulation – both of which are highly relevant for the creative disciplines.

A research-based longitudinal perspective on the conative domain comes from Kathy Kolbe, who has over her 30 years of research developed conative theory, a system that posits four basic modes of action, or ways of interacting with the environment, with each individual having an innately preferred style (Huitt and Cain, 2005). According to Kolbe (2010), conative theory is defined by four basic, innate styles of preference for action: "The Fact Finder (FF) Action Mode is how one gathers and shares information, the Follow Through (FT) Action Mode is how one designs and arranges, the Quick Start (QS) Action Mode is how one deals with risk and uncertainty, and the Implementor (IM) Action Mode is how one handles space and tangible objects" (Kolbe, 2010, p.5). In terms of practical application, Gerdes and Stromwall (2008) offer a number of suggestions for how the use of conative style preferences could be used to facilitate student learning. They advocate the use of training programs for instructors to recognize conative style differences and to be able to facilitate student growth and development in alignment with conative style preferences. Student collaboration in teams and student peer mentoring could also be enhanced by shared knowledge of conative style preferences and how best to interact with others having different conative style modes.

In contrast to Kolbe's (2010) view of conative style preference as largely innate, Huitt and Cain (2005) offer a description of conation as a developmental process with multiple phases: directing (the purposeful direction of one's energies), energizing (overcoming initial inertia to move forward in a new direction) and persevering (continuing to move towards self-identified goals). See Table 3.5 below.

Table 3.5: Aspects of conation, volition, and self-regulation

Phases of Process		
Directing	**Energizing**	**Persevering**
1. Defining one's purpose 2. Identifying human needs 3. Aspirations, visions, and dreams of one's possible futures 4. Making choices and setting goals 5. Developing an action plan	1. Overcoming inertia 2. High self-esteem 3. Physical fitness, high physical energy 4. Focus attention 5. Positive self-talk 6. Ability to manage emotions (arouse and dampen) 7. Gets started, initiates task 8. Positive social interactions with family and friends	1. Engaging in daily self-renewal 2. Monitoring thoughts, emotions, and behavior 3. Self-evaluation using data collected in the monitoring process 4. Reflection on progress 5. Completing tasks

One of the benefits of Huitt and Cain's (2005) process description is to designate conation as a study of internal motivation, distinct from external motivation, and thus to serve as a guide to facilitate growth in advancing student conation. For those in creative disciplines, this ties in closely with the notion of self-regulation, whereby students increasingly take on personal responsibility for their own artistic motivation through directing energies, continually overcoming resistance to change and persisting towards their aspirations and goals.

Reeves (2006) points out that the higher education literature on teaching, learning, and assessment has not previously delved deeply into the conative domain. With the professional standards of execution and performance demanded in creative disciplines, perhaps this should not be surprising. It may be the case that the conative domain has been largely taken for granted in creative disciplines –simply because students without the volition and drive to succeed in the arts quickly fall by the wayside. Educational intentionality being at the core of our belief system in this book, overlooking such a core aspect of artistic process and maturity may have been the case in the past but our present consciousness of the domain leads us to the eventuality and necessity of understanding student conative style preferences for action, and how to facilitate student growth and

development in directing, energizing, and persevering towards their artistic and professional goals.

FROM LEARNING OBJECTIVES TO STUDENT LEARNING OUTCOMES

As instructors we have the responsibility to afford our students rigorous, thoughtful direction and specific expectations to guide them on the road to artistic excellence. A distinction exists between what competencies we intend students to develop – our stated learning objectives – and the actual results or student learning outcomes that we will accept as evidence of student learning. Having at hand the taxonomies of educational objectives discussed in this chapter enables us to articulate in a more specific and multi-faceted manner the cognitive, affective, psychomotor, intrapersonal, interpersonal, and conative expectations we hold for student learning in the creative disciplines, and to describe what action, product, or performance we are willing to accept as evidence of learning.

In practice, student learning outcomes are based on descriptive action verbs and rely on one or more taxonomies to help guide instructors to pitching assignments at the correct developmental level for the students, for an individual plan of study, for the goals of a module or course, and for the function of that course in the overall curriculum. Waller (2007) provides an extensive and useful list of such action verbs, organized by learning domain – cognitive, affective, and psychomotor – and within each domain by level. As Chase et al. (2014) observe, "In assessing learning in the creative and performing arts, one size definitely does not fit all. Different kinds of tasks call for different learning strategies, and different learning strategies call for different pedagogical approaches" (p. 33). To a greater extent than assessment in other fields, in creative disciplines we therefore recognize both uniform and unique student learning outcomes. *Uniform* assessment explores what students learn in common; while *Unique* assessment explores what each student learns that is qualitatively different from each other student (Ehrmann, 1998).

In an earlier time, it may have been adequate to define student learning outcomes quite simply and directly as being the really important things faculty think students should know, believe, value, be disposed towards, or be able to do by the time the students receive their degrees. Confronted by increased professional demands and changes in the nature of how our students will work in the 21st Century professional artistic context, in addition we are now called to consider interpersonal, intrapersonal, and conative dimensions of student preparation as well. In practice, rather than create reams of learning objectives, numerous assessments, and descending into paralysis by analysis, putting

together holistic tasks that combine several learning domains at once will not only provide the necessary evidence of student learning, but once we articulate our expectations for learning it will help students associate and cognitively structure the information so they can recall it more easily. Inquiry-based learning and problem-based learning tasks, often set in a collaborative team context, can facilitate holistic learning in the arts (Hoey, Chase and Ferguson, 2014; Lee et al, 2004).

Several student learning outcomes are perennial favorites in assessment plans of creative, design, and performing arts departments regardless of geographic location. For example, faculty in creative disciplines at colleges and universities usually have a strong interest in knowing:

- How well are students assimilating tools and techniques?
- How creative are the students?
- What is their level of preparation for professional practice? Is it adequate?
- To what extent are they demonstrating growth in the ability to engage in reflective critique and metacognitive development?

To enable readers to examine multiple instances of how a fairly ubiquitous student learning outcome may be assessed in different ways, we have cross-referenced the most commonly-occurring ones in the case studies within this volume.

DEVELOPING STUDENT REFLECTIVE AND METACOGNITIVE ABILITIES

The Committee on Defining Deeper Learning and 21st Century Skills of the NRC (2012) pointed out that "we now know that learning is enhanced by the intrapersonal skills used to reflect on one's learning and adjust learning strategies accordingly—a process called metacognition" (NRC, 2012, p.22). A significant part of becoming a professional artist is bound up with growing one's ability to be an acute, dispassionate observer of one's motives and performance or execution, and the fact that metacognition is incorporated within the intrapersonal learning domain identified by the NRC (2012) is entirely appropriate. Just as important as developing cognition, affect, and motor skills is developing the self-knowledge and awareness of what we don't know or don't know how to do, and having the ability to design a course of action that will enable us to acquire needed further abilities. This self-knowledge and awareness encompasses our generative ideation processes as well as our abilities to carry out and realize our ideas. John Flavell

(1976) is generally regarded as the originator of term 'metacognition' that encompasses such self-reflective ability and awareness. Flavell (1979, 1987) regarded metacognition as including both metacognitive knowledge (knowing what we need to do, and how to acquire needed knowledge) and metacognition regulation (becoming adept managers of our learning processes through self-monitoring, planning, and self-regulation).

As important as the development of metacognition is to artistic growth, the role of assessing student metacognitive knowledge and regulation is of equal significance. The British educator Leslie Cunliffe is a long proponent of the primacy of student metacognitive development in the arts. Cunliffe (2007) has taken the stand that assessment needs to be much further developed as a medium for students to gain reflective and self-awareness as artists: "The one function of assessment that has arguable been least catered for is its role in enabling students to learning how to regulate their own learning and creativity" (2007, p.2). Interest in assessing this vital part of artistic formation is broadly increasing, as are the quality of solutions proposed. For example, in the context of the design studio, Kulkarni and Klemmer (2012) outline an assessment process consisting of several elements: rubric-based self-assessment of work posted online and viewed by all students, self-assessment through weekly studio critique peer review, and faculty assessment of student design projects. Two highly creative elements of the assessment system were featured. First, students were incentivized at a maximum of 2.5% of the final term grade for self-assessments that came closest to staff grades. Second, students developed their own two-part rubrics for assessing their projects, including an implementation schedule and a weekly assessment of progress on that schedule. A major benefit Kulkarni and Klemmer (2012) point out was that using student-created rubrics allowed for a great deal of flexibility according to the nature of the design project, and thus made collaborative assessment more practical in large design classes. Using this system, they found that students' abilities to self-assess and improve their understanding of the characteristics of good design significantly improved over the term.

Like everything else in the arts, improvement in self-assessment and metacognition takes significant practice, specific feedback, and the provision of reflection opportunities. Bransford et al. (2000) stipulate that "People often need help in order to use relevant knowledge that they have acquired, and they usually need feedback and reflection so that they can try out and adapt their previously acquired skills and knowledge in new environments" (p.203). In alignment with Kulkarni and Klemmer (2012), Shreeve (2009) advises that opportunities for such practice can be afforded through self-commentaries submitted along with

assignments with critical feedback provided by the instructor, and that students can begin to practice in small groups "to develop their critical evaluation skills using each other's project work" (Shreeve, 2009, p. 18).

SUMMARY: PUTTING IT ALL TOGETHER

This chapter is intended as a guide to the format and taxonomies for describing what we expect our students to accomplish as part of their programs of study in the arts. We began the chapter with a guide to writing situationally-appropriate student learning objectives. Acknowledging the important role of 21st Century skills to professional success across creative disciplines, the chapter includes an expanded set of taxonomies for learning objectives that encompasses interpersonal, intrapersonal, and conative domains as well as the familiar cognitive, affective, and psychomotor learning domains. Table 3.6 below offers a high-level synthesis of the learning domains covered in this chapter. Readers may want to utilize this as a guide to thinking about what skill set may be encompassed within a specific domain and within each learning domain, what approaches or assessment tools may be most applicable.

Table 3.6: Overview of Learning Domain Taxonomies and Potential Instructional Uses in Creative Disciplines

Learning Domain	Dominant Ideas of the Domain	Potential Uses in Instruction in the Arts	Suggested Assessment Approaches and Tools
Cognitive	This domain deals with how people obtain, process, and utilize knowledge.	Broad applicability to intellectual learning tasks from remembering to creating.	Synthesis of technique, knowledge of form, purposeful statement of artistic intention in preparation, sketches, rehearsal, formative review, final product or performance as assessed by instructor, peers and juried review; Use of problem-based, inquiry-based, or case-based learning for group projects assessed using self, group and instructor feedback, videotaping

			of group interactions and analysis of evidence for model-based reasoning or other higher order cognitive outcomes.
Affective	This domain deals with emotions, values, feelings and attitudes, their organization, and individual commitment.	Growth in awareness, knowledge, internalization, organization and expression of the ethos of an artistic discipline, emotion and meaning within an artistic discipline	Grasp of ethos, emotion and meaning as exhibited in preparation, sketches, rehearsal, formative design review, final product or performance; ability to articulate developmental process in context of a critique; assessed using self, peer, instructor or jury or external expert panel feedback.
Psychomotor	This domain focuses on physical skills and coordination, executed to increasing degrees of accuracy, fluidity, rapidity, or strength.	Movement, coordination and fine motor skills are basic to fine and performing arts, and are usually addressed in the context of individual studio and master class instruction.	Development and weekly review of preparation and progress on individual student learning plans; studio critique and class performance; master class performance and critique; juried performance; external competition performance.
Intrapersonal	This domain deals with capacity for self-awareness and understanding, and the ability to self-regulate and engage in metacognitive learning strategies.	Facilitating growth in metacognitive knowledge (knowing what students need to do, and how to acquire needed knowledge) and metacognition regulation (becoming adept managers of learning processes through self-monitoring, planning, and self-regulation).	Assess student awareness practice and time allocation of study skills in discipline; use of e-portfolios and reflective essays that synthesize and summarize student progress across the works presented; feedback on specific behaviors and results of team projects and situations that approximate

			professional practice; ability of student to self-diagnose needs for further technical and professional development within artistic discipline.
Interpersonal	This domain deals with how people communicate and interact with one another.	Building student expertise in team-based collaboration, articulating artistic meaning, and interacting with professional clients.	Team, self and instructor assessment of project-based collaboration; analysis of videotaped performance of appropriate interpersonal skills; client feedback from design competitions, charrettes, and other situations that simulate the professional practice environment.
Conative	This domain is concerned with having the purpose, desire, and volition to perform at a high level.	Facilitate student growth and development in directing, energizing and persevering towards their artistic and professional goals.	Important aspect of professional preparation. Assess extent to which student has developed professional goals and an action plan for achievement; extent to which student overcomes obstacles and inertia in energizing behavior towards a change or new direction; extent to which student adopts self-monitoring, renewal and corrective behaviors and completes tasks.

Having offered this synthesis, we return to the notion expressed by Reeves (2006) at the beginning of this chapter, that the success of a learning environment is very much a product of alignment among critical aspects of teaching and learning. With an overview of constructing learning objectives and the expanded set of learning domains that are appropriate to professional preparation of students in creative disciplines, our hope is that readers will have a wider and more

appropriate array of choices from which to compare or create instructional practice and in turn benefit students in the arts.

REFERENCES

Anderson, L. W. (Ed.), Krathwohl, D. R. (Ed.), Airasian, P. W., Cruikshank, K. A., Mayer, R. E., Pintrich, P. R., Wittrock, M. C., Pintrich, P. R. 2001. A Taxonomy for Learning, Teaching, and Assessing: A Revision of Bloom's Taxonomy of Educational Objectives. *New York: Addison Wesley Longmann.*

Atman, K. 1987. The role of conation (striving) in the distance learning enterprise. *The American Journal of Distance Education, 1*(1), 14-28.

Atman, K.S. 1993. Goal accomplishment style and psychological type; Cultural variations. Psychological Type and Culture--East and West: a Multicultural Research Symposium, January 6-8, 1993, Honolulu, Hawaii, Proceedings, p. 221-227.

Bransford, J., Brown, A., and Cocking, R., (Eds.). 2000. *How People Learn: Brain, Mind, Experience and School.* Washington, DC: National Academies Press.

Bloom, B.S. and Krathwohl, D.R. 1956. Taxonomy of educational objectives: The classification of educational goals, by a committee of college and university examiners. Handbook 1: Cognitive domain. New York: Longmans.

Chase, D., Ferguson, J. and Hoey, J. 2014. *Assessment in Creative Disciplines: Quantifying and Qualifying the Aesthetic.* Champaign, IL: Common Ground Publishing LLC.

Cunliffe, L. 2007. Using Assessment in Knowledge-Rich Forms of Learning and Creativity to Nurture Self-Regulated Strategic Intelligence. Paper presented at Creativity or Conformity? Building Cultures of Creativity in Higher Education, University of Wales Institute and Higher Education Academy, Cardiff, Wales, January 8-10, 2007.

Fischer, D. n.d.. Instructional Design – The Taxonomy Table. Retrieved 12/17/2014 from
http://oregonstate.edu/instruct/coursedev/models/id/taxonomy/#table .

Flavell, J. H. 1976. Metacognitive aspects of problem solving. In L. B. Resnick (Ed.), *The nature of intelligence* (pp.231-236). Hillsdale, NJ: Erlbaum.

Flavell, J. H. 1979. Metacognition and Cognitive Monitoring: A New Area of Cognitive—Developmental Inquiry. *American Psychologist,* 34, (10), 906-911.

Flavell, J. H. 1987. Speculations about the nature and development of metacognition. In F. E. Weinert & R. H. Kluwe (Eds.), *Metacognition, Motivation and Understanding* (pp. 21-29). Hillside, New Jersey: Lawrence Erlbaum Associates.

Forehand, M. 2005. Bloom's taxonomy: Original and revised.. In M. Orey (Ed.), Emerging perspectives on learning, teaching, and technology. Retrieved 11/2/14 from http://epltt.coe.uga.edu/

Gerdes K. and Stromwall, L. 2008. Conation: a missing link in the strengths perspective. *Social Work,* 53, (3), 233-242.

Gronlund, N. 2002. *How to Write and Use Instructional Objectives.* Columbus, OH: Prentice-Hall.

Harrow, A.J. 1972. *A taxonomy of the psychomotor domain: A guide for developing behavioral objectives..* New York: David McKay Co.

Hoey, J., Chase, D. and Ferguson, J. 2014. Extending Inquiry-Based Education in Creative Disciplines through Assessment. In Blessinger, P. and Carfora, J. (Eds.), Inquiry-Based Learning for the Arts, Humanities, and Social Sciences: A Conceptual and Practical Resource for Educators. *Innovations in Higher Education Teaching and Learning,* Volume 2, 345-368. Bingley, UK: Emerald Group Publishing Ltd. doi:10.1108/S2055-364120140000002022.

Huitt, W. 1999. Conation as an important factor of mind. *Educational Psychology Interactive.* Valdosta, GA: Valdosta State University. Retrieved 11/2/14 from http://www.edpsycinteractive.org/topics/conation/conation.html

Huitt, W., & Cain, S. 2005. An overview of the conative domain. *Educational Psychology Interactive.* Valdosta, GA: Valdosta State University. Retrieved 11/2/14 from http://www.edpsycinteractive.org/brilstar/chapters/conative.pdf

Klein, C., DeRouin, R.E., and Salas, E. 2006. Uncovering workplace interpersonal skills: A review, framework, and research agenda. In G.P. Hodgkinson and J.K. Ford (Eds.), *International Review of Industrial and Organizational Psychology* (vol. 21, pp. 80-126). New York: Wiley and Sons.

Krathwohl, D. R., Bloom, B. S., & Masia, B. B. 1964. *Taxonomy of Educational Objectives: The classification of educational goals. Handbook II: Affective Domain.* New York: McKay.

Kolbe, K. 2010. *Protocol for the neuroscientific investigation of the conative faculty of the mind.* Phoenix, AZ: Center for Conative Abilities.

Kulkarni, C. and Klemmer, S. 2012. Learning design wisdom by augmenting physical studio critique with online self-assessment. Technical Report. Palo Alto, CA: Stanford University.

Lee, V. S., Greene, D. B., Odom, J., Schechter, E., & Slatta, R. W. 2004. What is inquiry-guided learning? In V. S. Lee (Ed.), *Teaching and learning through inquiry: A guidebook for institutions and instructors.* Sterling, VA: Stylus.

National Research Council. 2012. *Education for Life and Work: Developing Transferable Knowledge and Skills in the 21st Century.* Committee on Defining Deeper Learning and 21st Century Skills, J.W. Pellegrino and M.L. Hilton, Editors. Board on Testing and Assessment and Board on Science Education, Division of Behavioral and Social Sciences and Education. Washington, DC: The National Academies Press.

Oxford Dictionary. n.d. Oxford, UK: Oxford University Press. Retrieved 12/31/2014 from http://www.oxforddictionaries.com/us/definition/american_english/conation?searchDictCode=all.

Plutarch. 1927. On Listening to Lectures. *Moralia*, Volume 1. Translated by Babbitt, F. Loeb Classical Library No. 197. Boston: Harvard University Press p. 259.

Reeves, T. 2006. How do you know they are learning?: the importance of alignment in higher education. *Int. J. Learning Technology, 2, (4), 294-309.*

Shreeve, A. 2009. Assessment in Art and Design Handbook 5. London, UK: Creative Learning in Practice Centre for Excellence in Teaching and Learning University of the Arts, p. 18.

Simpson, E. 1966. The Classification of Educational Objectives, Psychomotor Domain. Urbana, IL: University of Illinois. Contract No. OE 5-85-104, U.S. Department of Health, Education, and Welfare, Office of Education. ERIC Document Reproduction Service #ED 010 3613.

Vinson, C. 2009. Learning domains and delivery of instruction. Retrieved

12/17/2014 from
http://chettourhorizonsforteaching.blogspot.com/2009/05/learning-domains-and-delivery-of.html.

Waller, K. 2007. Writing Instructional Objectives. National Accrediting Agency for Clinical Laboratory Sciences. Retrieved 12/17/2014 from www.naacls.org/docs/announcement/writing-objectives.pdf

CHAPTER 4

Principles of Good Practice for Assessment and Quality Assurance in Creative Disciplines: A Conceptual Model

A journey of a thousand miles must begin with a single step.
-Lao-tzu

Chapter four provides a set of principles and a model of those factors that taken together describe good practice in assessment and quality assurance within the creative disciplines. The chapter features a brief discussion of each aspect of what we might consider good practice.

With due deference to the philosophy articulated in *The Sound of Music* – that to start at the beginning is a very good place to start – when we think about assessment of student learning and quality assurance within the context of creative disciplines, the advice rendered to Alice by the Cheshire Cat in *Alice's Adventures in Wonderland* (Carroll, 1865) is also highly relevant – that if we don't know where we want to go, then it doesn't much matter which way we go and odds are good that we will never arrive. Key to good assessment practice is starting with well-considered ends in mind for an entire curriculum, and in effect designing a set of learning experiences such that those intentional educational ends are achieved. But sound assessment practice also depends on the ability to connect the dots – to be able to discern and understand the connections among student learning experiences, along with the precedents and consequents – and to be able to abstract from the individual student experience to a generalizable whole. The ability to connect the dots in such a manner is usually the product of only long and reflective teaching practice. Putting these two concepts together, we recognize the necessity for not only backwards but also forward design in a set of learning experiences or curriculum.

As educators, we want our students to become differentiated, skilled artists and to grow every day, and in order to do so, part of our task is also to develop purposive, through-designed learning experiences for our individual students that facilitate their development of requisite knowledge, skills, abilities, and dispositions to succeed in their chosen creative discipline. As part of that development process, another part of our task is to develop reasonable and usable

assessment plans that operate at the curriculum level and that provide sufficiently granular, valid, and reliable information for adapting courses, modules, and sequences within the curriculum to maximize learning effectiveness when prompted to do so by assessment evidence. Still another part of our task is to assess the learning outcomes of groups of students, at increasing levels of aggregation, to permit broader understanding of where our students are excelling and opportunities where revision of teaching and learning practice may be indicated. At a highly aggregated or the college level, part of our task is to determine, through assessment of student learning and alumni accomplishment, the extent to which we are meeting our stated missions and overarching student competencies, for example written and oral communication skills. Finally, a large measure of our task at all levels of aggregation/disaggregation is to interpret, collaboratively reflect upon, and make evidence-based changes in our curriculum design and teaching practice based upon the information on student learning outcomes we have gathered.

While assessment is a complex, multifaceted process, we can subdivide that complexity into recognizable elements. We are aware of the need to create robust student learning outcomes. We know that we have to define the context or background for each example, the specific methods in use, what the results have been so far, how the findings have been used to improve practice or induce other positive change, and what factors have most contributed to the success of an initiative. Assessment of student learning does not happen in isolation – it is a contact sport with multiple players involved. A clear understanding of the roles played by faculty, staff, graduate assistants, student peer evaluators, the students themselves, the professional community, and other relevant actors is another key to understanding why and how well a particular assessment initiative works.

In higher education we learn from each other, and spreading examples of "good practice" is a recognized way to broaden the acceptance, understanding, and use of innovative practices. In this context, it is important to acknowledge previous efforts in assessment practice that have paved the way. In particular, *Assessment in Practice* by Banta et al. (1996) was a milestone in that it provided numerous examples across disciplines and institutional levels. Numerous summaries of good general assessment practice exist, and have been summarized by Suskie (2006). The first and in many ways foremost set of general principles for student learning outcomes assessment was brought forward by the American Association of Higher Education (AAHE) in 1991 in the context of instructional program-level assessment, and retains much of its applicability to this day.

1. The assessment of student learning begins with educational values.
2. Assessment is most effective when it reflects an understanding of learning as multidimensional, integrated, and revealed in performance over time.
3. Assessment works best when the programs it seeks to improve have clear, explicitly stated purposes.
4. Assessment requires attention to outcomes but also and equally to the experiences that lead to those outcomes.
5. Assessment works best when it is ongoing, not episodic.
6. Assessment fosters wider improvement when representatives from across the educational community are involved.
7. Assessment makes a difference when it begins with issues of use and illuminates questions that people really care about.
8. Assessment is most likely to lead to improvement when it is part of a larger set of conditions that promote change.
9. Through assessment, educators meet responsibilities to students and to the public. (American Association for Higher Education, 1991)

Given the program-level context of the 1991 AAHE principles of good practice in assessment, how might we re-frame these principles with specific reference to creative disciplines in ways that work for the arts? Macdonald and Savin-Baden (2004) articulate a guide for assessment of Problem-Based Learning (PBL) that turns out to be a highly relevant framework for assessment in the creative disciplines as well. Starting from the insight that assessment must be congruent with a pre-professional or professional context similar to the context in which students will find themselves engaged as graduates, Macdonald and Savin-Baden recommend that:

- Assessment should ideally be based in a practice context in which students will find themselves in the future – whether real or simulated.
- [We should] Assess what the professional does in their practice, which is largely process-based professional activity, underpinned by appropriate knowledge, skills and attitudes.
- Assessment should reflect the learner's development from a novice to an expert practitioner and so should be developmental throughout the programme of studies.
- Students should begin to appreciate and experience the fact that in a professional capacity they will encounter clients, users, professional

bodies, peers, competitors, statutory authorities, etc. who will, in effect, be 'assessing' them.

- Students should also be able to engage in self-assessment, evaluation and reflection as the basis for future continuing professional development and self-directed learning.
- As lecturers, we need to ensure that there is alignment between our objectives and the students' anticipated learning outcomes, the learning and teaching methods adopted, and the assessment of learning – strategies, methods and criteria. (2004, p.7).

Encompassing the foci we articulated in Chapter One, the AAHE (1991) principles for assessment, and the experientially-focused assessment recommendation of Macdonald and Savin-Baden (2004), we can begin to outline a more generalized approach to quality assurance in the creative disciplines, based on the different context of creative disciplines from liberal arts, sciences, and technology. Yet an important caveat is in order. Artists are highly innovative, creative people. Any assessment model or system once proposed is bound to be expanded upon in a short space of time and in perhaps completely new directions. We hope and expect for that to be the case! We offer the following model as a starting point for further discussion in the arts community and elsewhere. A brief explanation of each of the elements in the model follows.

Figure 4.1: Principles of Good Practice in Quality Assurance for Creative Disciplines

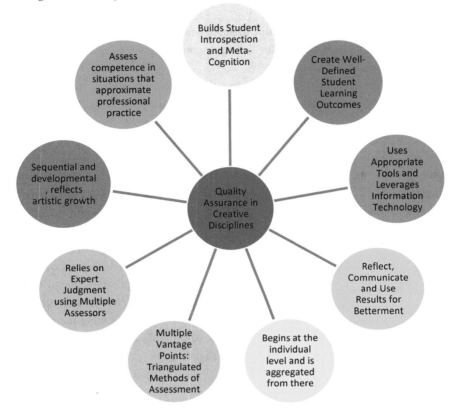

CREATING WELL-DEFINED STUDENT LEARNING OUTCOMES

We define student learning outcomes quite simply and directly as being the really important things faculty think students should know, believe, value, be disposed towards, or be able to do by the time the students receive their degrees. To a greater extent than assessment in other fields, in creative disciplines we recognize both uniform and unique student learning outcomes. *Uniform* assessment explores what students learn in common; while *Unique* assessment explores what each student learns that is qualitatively different from each other student (Ehrmann, 1998).

Several student learning outcomes are perennial favorites in assessment plans of creative, design, and performing arts departments across the country. For example, faculty in creative disciplines usually have a strong interest in knowing:

- How well are students assimilating tools and techniques?
- How creative are the students?
- What is their level of preparation for professional practice? Is it adequate?
- To what extent are they demonstrating growth in the ability to engage in reflective critique and metacognitive development?

To enable readers to examine multiple instances of how a fairly ubiquitous student learning outcome may be assessed in different ways, we have cross-referenced the most commonly-occurring ones in the case studies within this volume.

BEGINS AT THE INDIVIDUAL LEVEL AND IS AGGREGATED FROM THERE

We view as axiomatic that assessment in the arts must begin at the individual level, and can proceed to progressively more aggregated levels. Unique, idiosyncratic outcomes at the individual level such as creativity may not be especially amenable to assessment through group-level methods, but may respond well to assessment methods such as Teresa Amabile's (1982) well-established Consensual Assessment Technique that relies on multiple raters, each familiar with the domain in question. On the other hand, assessments where technical and foundational skills are the topic of interest will tend to be more amenable to rubric-based, group-level assessment from the outset. The task for faculty in studio courses then becomes one of creating at least two levels of assessment planning and implementation: one at the individual level, and one at the group (studio or course) level. Further, a group-level assessment plan at the curriculum or program level features student learning outcomes across the program or curriculum as well as assessment methods appropriate to group or aggregated level, typically using rubric-based assessment (for example, in assessing student e-portfolios).

It may also be the case that simultaneously assessing both individual and group learning is important. Assessing student collaboration on project within the studio context is highly relevant to design education, especially given the team-based nature of the workplace for many designers and architects. McPeek and Morthland (2011) explore the development and use of multiple tools to assess student project collaboration in the context of design studio courses. They describe the important roles played by peer assessment, public critique, instructor assessment, and self critique/reflective journaling within a triangulated

assessment schema that uses parallel and redundant assessments to achieve overall accuracy in the assessment process of each individual student's contribution.

At the individual level, we would expect an individual learning and assessment plan to feature both outcomes unique to the individual's goals and outcomes common across other students within the studio. An example for an individual student within a vocal studio will illustrate this point.

Table 4.1: Individual Studio Voice Assessment Plan

Technical	Neck tension; tongue tension; clearer, more forward vowel sounds; foster a brighter sound; bridge technical work to ease in upper register; develop more supple breath; divert governance of voice to the breath.
Language	Clearer, more forward feeling vowels related to technique; master expressive techniques; Develop immediacy in German; Develop fluency in French; reps in language
Performing	Develop wider range of emotion; Use improvisation to explore characters; Experiment with 'opposite' characterizations; ease of body language related to technique
Practice technique	Consistent lesson summaries; audit practice technique/Intro
Synthesis	Advanced development of holistic singing
Career Development	Summer Programs? Long term goals; Graduate school? Mapping

Source: Ebbers, 2014. Used by permission.

In this example, while the technical skills cited are standard to vocal technique, their application at the individual level is unique and requires informed judgment. Language skills, while also unique, are easily assessed in a more standardized format that can be aggregated to yield overall scores of language competence, reflecting a common program-level outcome of vocal performance studios of competence in articulating several languages. But without beginning student learning assessment at the individual level, assessment in the arts would miss where much of the value added in learning takes place.

RELIES ON EXPERT JUDGMENT USING MULTIPLE ASSESSORS

As a corollary to our axiom that assessment in the arts must begin at the individual level, we believe that professional, informed judgment is basic to arts

assessment, preferably involving multiple assessors with different vantage points, informed by shared understandings of expertise and expression as expressed in collectively-designed and negotiated instruments such as rubric, check-sheets, or other criteria-based methods. As noted by Amabile (1982) in her research on the Consensual Assessment Technique (CAT), a pillar of successful ratings of students' work in creative disciplines is that the raters are experts in their own right, and familiar with the particular arts domain in question. Contrary to commonly-expressed views of a lack of agreement among professional and expert raters, Amabile (1982) found in her over 30 years of research that quite high levels of inter-rater reliability were common in situations where CAT has been used for assessment. Another approach that leverages faculty expert judgment utilizes a standardized interview of faculty members to discover their consensus views on the elements of expertise in a discipline, and then uses those elements of expertise to develop successive competency levels of each element and rubrics to support their assessment. See Dirlam and Singeisen (2009) for an explanation of how this approach was applied in Architecture at the Savannah College of Art and Design.

PRINCIPLES OF LEARNER FEEDBACK AND COMMUNICATION

Constant, informed, and relevant learner feedback is basic to artistic formation, and it follows that principles of designing self-reflective and formative feedback should also be taken into account when designing assessments within creative disciplines. Nichol and Macfarlane-Dick (2006) have distilled the literature into a set of seven principles relevant to feedback practice. Regardless of the specific source, good learner feedback

1. helps clarify what good performance is (goals, criteria, expected standards);
2. facilitates the development of self-assessment (reflection) in learning;
3. delivers high quality information to students about their learning;
4. encourages teacher and peer dialogue around learning;
5. encourages positive motivational beliefs and self-esteem;
6. provides opportunities to close the gap between current and desired performance; [and]
7. provides information to teachers that can be used to help shape teaching. (2006, p.205.)

When evident in the case studies provided in this volume, we note the context and use of specific learner feedback mechanisms to positively affect student learning.

USE MULTIPLE VANTAGE POINTS: TRIANGULATED METHODS OF ASSESSMENT

Given that artistic expression is expressed in multiple facets, so too must a good arts assessment schema be triangulated and permit multiple vantage points on student learning. Triangulation, or the use of multiple methods to assess student learning outcomes of particular interest, is a commonly-followed strategy to seek convergence of assessment findings across multiple methods and thus establish the accuracy and trustworthiness of assessment evidence. Frequently, one or more direct, observational techniques are used in conjunction with an indirect method. For example, at Delaware College of Art and Design, the institutional assessment plan (2011, p.1-2) calls for a suite of direct assessment methods for student works: assessment through display and discussion via walkthroughs, graduation exhibitions, annual student exhibitions, and course-level assessment as varied direct assessment methods. Indirect assessment methods include end of year surveys and course surveys. Overall quality assurance methods include an annual desktop review that examines program accomplishments, assessment information, and program needs, as well as more in-depth academic program review on a five-year cycle.

REFLECT STUDENT ARTISTIC GROWTH THROUGH ASSESSMENT BOTH SEQUENTIAL AND DEVELOPMENTAL

As student artistic growth proceeds in waves and levels of understanding, so too should assessment of student learning in creative disciplines take place on multiple levels, continuously over the student life cycle, be experienced by the student, and be conducted in a sequential and developmental manner. Miller's (1990) framework for competency assessment – originally for assessment of healthcare providers – is instructive in this regard. Miller (1990) says that in competency-based assessment we progress from assessing the knowledge base, or what the student knows, to determining if the student knows how, can demonstrate how, and finally to whether the student does indeed accomplish tasks at a professional level and in the professional context. At the level of demonstrating competence through professional practice, not only would we expect to see requisite mastery, but also to see such mastery demonstrated subject to the pressures and contextual factors that accompany professional practice.

Figure 4.2: Framework for Professional Competence (adapted from Miller, 1990).

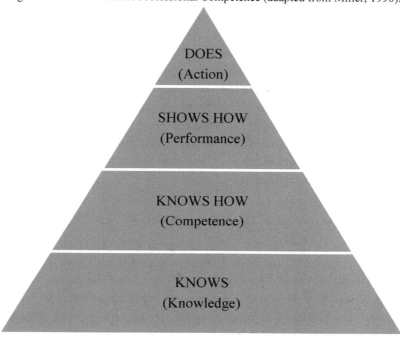

The assessment of professional competencies also needs to be seen as a continuum, beginning early in artistic training and extending past graduation into ongoing development as a practicing artist (Bashook, 2005). One implication is that the set of assessment methods we develop or choose need to be sufficiently robust to yield meaningful information at differing levels of artistic development.

ASSESS COMPETENCE IN SITUATIONS THAT APPROXIMATE PROFESSIONAL PRACTICE

Assessment of student performance in situations that closely approximate (or include) professional practice should be included in assessment of creative disciplines, usually towards the conclusion of a program of study. Hearkening back to Macdonald and Savin-Baden's (2004) advice, the importance cannot be overstated of allowing students to have opportunities to practice those very competencies they will be expected to demonstrate in professional life. It is difficult to imagine a musician, dancer, or actor graduating from a college or university without having had multiple opportunities (and requirements) to perform in public. Similarly, students in design disciplines need such externally-

focused opportunities and those in fine arts need the experience of public presentation of their art. An excellent example of bringing assessment to conditions approximating professional practice takes place in the School of Design, Architecture, Art, and Planning at the University of Cincinnati, where degree programs are built around a mandatory co-op program in which students alternate quarters of study and co-op beginning in the sophomore year. Assessment of student learning and performance is triangulated in these programs, and includes self-assessment by the student, assessment by the co-op supervisor, and by the supervising faculty member. Assessment results are used not only for individual student evaluation but are also fed back into the curriculum to ensure currency of the program (Cates et al., 2008).

ASSESSMENT METHODS IN CREATIVE DISCIPLINES

"Begin at the beginning," the King said, very gravely, "and go on till you come to the end: then stop." This advice in *Alice in Wonderland* may work well for some things (the writing of books, for example) but it does not for other things, as some things may seem to have no clear beginning or rather a continual beginning, and there may be no real end, but rather an ongoing or progressive cycle. Assessment may be this way with the results being fed into each new starting point.

In creative arts we have long traditions of continuous assessment. Those traditions, chiefly through master and apprentice or atelier models, have relied on close observation of a single student's work. Part of our task in assessment is to develop or recognize ways of assessing individual student learning that encourage student self-reflection and progress. We can accomplish this by developing the conscious organization of a student's body of work, for example through e-portfolios, and by requiring reflective statements or essays in which a student reflects on how s/he has grown as an artist (or as Alice said, "I can't go back to yesterday because I was a different person then.").

While ways of learning may be as infinite as grains of sand on a beach, the specific tools, techniques, and methods we use to assess student learning are generally recognizable as a group. One major intention of this volume is to explicate commonly-used and perhaps not so commonly used assessment methods, in hopes of providing readers with a broad array of assessment tools relevant to creative disciplines.

As pointed out in the first chapter, reaching good alignment among instructional objectives, intended student learning outcomes, and appropriate assessment methods is easier if we begin with a good sense of where we want students to arrive at in terms of the development of their art and technical skills

by the time they graduate. By defining the intended student learning outcomes and the opportunities students will have in a course or program to display their artistic competence, we effectively narrow the range of applicable methods to those that will be most appropriate in context. We can think of assessment methods for the arts in a taxonomy consisting of three major categories: Direct, Indirect, and Passive/Unobtrusive.

First are direct assessment methods, where assessment of a student performance, product, design, painting, or other artistic work is assessed either at the point of performance or via video recording. The work is performance, or artifact is observed first hand by faculty members, external reviewers, peers, or others and is assessed, typically by using rubrics, check sheets, or other criteria-based assessment tools. The student works being rated might be a performance, a work of visual art, a design, or photographic evidence. Less obviously, such artifacts could also include things like group or individual presentations; concept maps, grouping, diagram, flow charts; story board creation; an artist's statement; case-based individual essays, electronic or traditional portfolios; peer assessment; live oral (*viva voce*) examinations; observations and field notes; reflections, reflective journal (could be drawing, photographic, poetry), comparative analyses, reports, and examinations (Macdonald, 2005).

The second category consists of indirect assessment methods, where the learning, performance, or work of art is not directly assessment but is reported on. Reports might come from students themselves or from alumni. Employers, internship supervisors and other professionals supervising practica constitute another source of indirect assessment reports when they provide evaluation of student performance in an experiential learning situation where indirect reports about learning (from the students themselves) or about competencies acquired (from employers) are gained, usually through surveys or qualitative techniques such as focus groups, interviews, or journaling. In addition to surveys, focus groups, and internship evaluations, the student voice itself is an important source of indirect assessment, particularly where we want to understand the process of artistic development through which a student arrived at a particular work of art or design solution. Thus self-assessment and reflective (online) journals are both highly important.

The third category of assessment methods, Passive/Unobtrusive, consists of those assessments that are typically done passively, in the background, and are recorded and assembled for analysis. Online assessment is the most obvious example, since unobtrusive data collection techniques are typical to the online environment and form the basis of "big data" assessments, increasingly used in

online institutions to analyze the effectiveness of content, instruction, and learning. This form of assessment is most frequently found in online environments, where not only can data be collected, recorded, analyzed and use for reporting purposes, but such data can also form the basis of interactive, adaptive learning systems that respond to input from a student and assist with the development of student competence in a specific area.

Somewhat analogous to Ehrmann's (1998) distinction between uniform and unique learning outcomes cited above is the usage of instructional opportunities that are frequently combined with specific assessment methods. In music, for example, student performance is commonly assessed in end-of-term juries through the use of rating forms – either a checklist or a rubric. In the design arts, the crit or studio critique has a long history of usage, and a movement from only providing informal verbal feedback through desk crits to providing more formal feedback through written rubrics is evident. A broad overview of ubiquitous assessment methods is provided in *Assessment on Our Own Terms* (NASAD, 2009), in which the authors list a broad set of indicators/evidence/analysis as appropriate for common student achievement goals, or student learning outcomes, in creative disciplines. In the present volume, where commonly-used methods are featured in the case studies provided, they have been cross-referenced to other contextually similar situations.

USES APPROPRIATE TOOLS AND LEVERAGES INFORMATION TECHNOLOGY

Whereas the appropriate assessment tools may not have been available in the past, assessment practice has evolved over the past three decades to permit valid and reliable assessment of arts disciplines. As a corollary, good assessment in creative disciplines appropriately leverages information technology.

One of the most evident ways in which we can expand the scope of possibilities for teaching, learning, and assessment is through leveraging technologies, particularly as it applies to online learning. Prineas and Cini (2011) offer a comprehensive overview of how information technology may be used to improve the assessment of student learning in online courses: through the use of data analytics, a mastery learning approach characterized by asynchronous online interaction, and a designed approach to building learning experience, one that incorporates assessment of student learning as part of the course and curriculum development process. In this volume, we've highlighted the use of technologies to leverage assessment in the case studies provided.

COMMUNICATE, REFLECT, AND USE RESULTS FOR CONTINUOUS IMPROVEMENT

Assessment in creative disciplines takes root and flourishes in environments where an ethos of shared information, reflection and action based on evidence has developed. As artists and as teachers we are aware of the standards we hold for student excellence, yet until we share those standards and articulate them, reaching agreement on what exactly to assess and how to go about it remain elusive. Once we acknowledge a collective responsibility for student learning and develop the trust among our colleagues that permits information sharing in a non-threatening environment, we can begin to define outcomes, determine methods, and obtain tangible evidence of student competence in a meaningful way. Results obtained inform not only individual student progress, but are then aggregated, clearly communicated within the community, reflected upon, and used for meaningful adjustments to better facilitate student learning and success within the studio, curriculum, and the school.

SUMMARY

This chapter began by articulating key notions of assessment in creative disciplines: that we need a logical place to start, conceptual guides to mark the way, and the ability to connect the dots to see the larger picture, from assessment of individual students to more aggregated group-level assessment. To serve as an overview, we provided a conceptual model of quality assurance in creative disciplines. While this chapter touched on each area represented in that model, aspects of assessment especially important in creative disciplines have received special emphasis, such as individual-level assessment and metacognition. Our goal in this chapter has been to deliver an assessment schema worthy of the complexity and need for extreme quality in creative disciplines. Artists are passionate about quality and have always been so. Being an artist is soul-searingly difficult, and it's getting harder. But as Tom Hanks' character Jimmy Dugan proclaims in the classic film *A League of Their Own* (1992), "It's supposed to be hard. If it wasn't hard, everyone would do it. The hard...is what makes it great!" Our goal then is simply to help our colleagues and institutions doing what we do best: bringing about great transformation in our students' lives.

REFERENCES

A League of Their Own. Dir. Penny Marshall. Perfs. Geena Davis, Tom Hanks.

Columbia Pictures, 1992.

Amabile, T. M. The Social Psychology of Creativity: A Consensual Assessment Technique. *Journal of Personality and Social Psychology* 43, no. 5 (November 1982): 997–1013.

Baer, J. and McKool, S. 2009. Assessing Creativity Using the Consensual Assessment Technique. Chapter IV, Handbook of Research on Assessment Technologies, Methods, and Applications in Higher Education. http://users.rider.edu/~baer/BaerMcKool.pdf. DOI: 10.4018/978-1-60566-667-9.ch004

Banta, T., Lund, J., Black, K. and Oblander, F. 1996. *Assessment in Practice: Putting Principles to Work on College Campuses.* San Francisco: Jossey-Bass.

Bashook, P. G. 2005. Best practices for assessing competence and performance of the behavioral health workforce. *Administration and Policy in Mental Health, 32*, 563-592.

Carroll, L. 1865. *Alice's Adventures in Wonderland.* http://www.gutenberg.org/files/11/11-h/11-h.htm

Cates, C., Cedercreutz, K., Todd, A., Osborne, Z. and Von Eye, L. 2008. Managing Multiple Levels of Assessment. In Cates, C. and Cederkreutz, K. (Eds.) *Leveraging Cooperative Education to Guide Curricular Innovation: The Development of a Corporate Feedback System for Continuous Improvement.* Cincinnati, OH: Center for Cooperative Education Research and Innovation.

Dirlam, D. K. and Singeisen, S. R. 2009. Collaboratively Crafting a Unique Architecture Education through MODEL Assessment. In P. Crisman and M.

Gillem (Eds.) *The Value of Design* (pp. 445-455), Washington, DC: ACSA Publishing.

Delaware College of Art and Design, the institutional assessment plan (2011, p.1-2) Retrieved August 29, 2014 from http://www.dcad.edu/uploads/media/Accreditation/APPENDIX_AE_-DCAD_Educational_Assessment_Plan.pdf

Ehrmann, D. 1998. What Outcomes Assessment Misses. Invited Address, American Association for Higher Education Assessment Conference, June 14, 1998.

Kulkarni, C. and Klemmer, S. 2012. Learning design wisdom by augmenting

physical studio critique with online self-assessment. Technical Report. Palo Alto, CA: Stanford University.

Lao Tzu 6th Century B.C., *Tao Te Ching*. Trans. Feng, Gia-Fu and English, J. New York: Vintage Books, 1997. Chapter 64.

Miller, G. 1990. The Assessment of Clinical Skills/Competence/Performance. Invited Review. Academic Medicine, September Supplement. 69, (5), S63-S67.

Macdonald, R. and Savin-Baden, M., *A Briefing on Assessment in Problem-based Learning*. LSTN Generic Centre Assessment Series No. 13. 2004, p.7.

Macdonald, R., 2005. Assessment Strategies for Enquiry and Problem-based Learning, in Barrett, T, Labhrainn, I. M. and Fallon, H. (eds.). *Handbook of Enquiry and Problem-Based Learning: Irish Case Studies and International Perspectives*, Galway, CELT.

McPeek, K.T. and Morthland, L.M. 2011, July. Making the grade: Assessing group work in the design studio. Paper read at the 2011 International Conference, The Future of Education, Florence, Italy.

Nichol,. D and Macfarlane-Dick, D. 2006. Formative assessment and self-regulated learning: a model and seven principles of good feedback practice. *Studies in Higher Education*, 31:2, 199-218, DOI: 10.1080/03075070600572090.

Prineas, M., and Cini, M. 2011. *Assessing Learning in Online Education: The Role of Technology in Improving Student Outcomes*. National Institute for Learning Outcomes Assessment Occasional Paper #12. Champaign, IL: Author.

Suskie 2006. What is "Good" Assessment? A Variety of Perspectives. Retrieved August 29, 2014 fromhttp://www.clark.edu/tlc/outcome_assessment/documents/suskie1.pdf

Wait, M. and Hope, S. 2009. *Policy Brief: Assessment on Our Own Terms*. Reston, VA: National Association of Schools of Art and Design. Irma International.

Quality Assurance in Online Creative Programs

Today's designers work to make technology fit appropriately into our human-to-human interactions... You must perceive technology as a means toward a larger end, and that larger end is to help people achieve their goals and realize their hopes and dreams.

<div align="right">- Jon Kolko</div>

As the noted Interaction Designer Jon Kolko (2014) points out in the opening quote to this chapter, our task as designers and creative professionals is not to deny the advances and applicability of technology in facilitating human interaction, but rather to utilize it appropriately as a means to a larger end. In the case of teaching, learning, and assessment in creative disciplines, that larger end consists of thoroughly preparing future artists, designers, theoreticians, and performers in creative disciplines using all the tools available and having solid evidence that our graduates are ready for what lies ahead.

Chapter five takes up quality assurance in the rapidly expanding field of online learning as it is being applied to creative disciplines. Building on previous chapters, the chapter is concerned with the variety and suitability of arts programs now being offered in the online context, using guidelines and a model-based perspective for online education in determining what to assess in the online environment, opportunities for students to create works online, and how those works might be assessed within creative disciplines. In addition to resources for assessing student learning, the chapter concludes with an extensive set of guidelines for assessing the multiple facets important to online programs.

VARIETY AND SUITABILITY OF ARTS PROGRAMS ONLINE

Even with the advances to date in information technology, not every arts program is feasible in the online environment; the question of fit between technology and our human interactions (Kolko, 2014) still requires further development in many cases. Morgan (2003) cites the need for ongoing practice and individualized feedback as an issue in online education: "Competence in procedures and

techniques requires practice – the principal challenge for distance educators is to ensure students have the opportunity for sufficient practice with individualized feedback to guide progress" (p.8). Advising appropriate caution in maintaining the face-to-face interaction and ongoing practice so necessary for artistic development, Chase et al. (2014) nevertheless note the advancing trend in taking degree programs in creative disciplines online. They cite advances in information technology such as processor speed, ultra high resolution graphics, and exponentially increasing memory capacity that have made the move to online learning not only possible, practical and in some cases preferable, as well as the shift to a professional culture of online product creation in an increasing number of creative disciplines. A review of arts program offerings around the nation (Guide to Online Schools, http://www.guidetoonlineschools.com/school-list?pid=4000&lvl=0, Accessed 1/4/2015) reveals that both online and on-ground, traditional and nontraditional schools are increasingly offering programs online in creative disciplines. With some variation by institution, the creative programs generally being offered online as of this writing include the following:

- Advertising Design
- Animation
- Arts Administration
- Art Education
- Art History
- Computer Aided Design
- Creative Writing
- Fashion and Interior Design
- Film, Music and Audio
- Graphic Design/Multimedia
- Illustration
- Interior Design
- Photography
- Video and Television
- Video Game Design and Development
- Visual Communication
- Web Design and Interactive Media

The list of programs in creative disciplines currently being offered consists primarily of design, design-related, media, communication, writing, and academically-oriented arts programs. Most of these disciplines represent cases

where professional practice has already long since migrated into the digital age. Taking their cue from professional practice, accreditors such as the Council for Interior Design Accreditation (CIDA) now permit accreditation of online programs, and several institutions now offer Interior Design programs online. Similarly, since the National Architectural Accreditation Board (NAAB) now accredits qualified online programs, several schools have moved ahead to offer accredited online programs in Architecture. Where we do not yet see whole programs being offered online, for example in the performing arts, assessment practice has nonetheless also moved forward to leverage the collection of digital student artifacts, the organization of e-portfolios to showcase and tell the story of a student's artistic development, tagged video performance assessed by multiple raters using well-developed assessment rubrics, and the like. Kolko (2014) requires of us that we remain cognizant of trends and continue our quest to use technology in better outcomes for human interaction. Notably, an interesting fit exists among the evolving demands of the creative workplace, the expanded set of learning domains discussed in chapter two, and the kinds of student learning that are ubiquitous in the online environment.

TECHNOLOGY NECESSITATES CHANGE

A common observation in online learning is that moving from a ground-based to a blended or wholly online program modality necessitates changes in how we approach instruction, delivery of content, our roles as instructors, and even the expectations we hold for our learners. In Chapter three, we explored learning domains that may be used to plan or articulate learning objectives – from cognitive, affective and psychomotor to intrapersonal, interpersonal, and conative. We noted that possession of and fluency in 21^{st} century skills have become an incessant demand from the employers of our graduates – the basic discipline skills are assumed, but on top of that our graduates must exhibit the ability to collaborate, solve complex problems, work well in teams, communicate, and demonstrate highly developed metacognitive skills to remain at the forefront of practice. Interestingly, many of these same skills are most frequently noted as chief attributes of student learning in online programs. Serving as one possible conceptual framework for online learning and assessment, Swan's (2003) model of interactivity and learning online specifies several forms of interaction very much in line with 21^{st} Century skills – interaction with peers, with instructional content, and with the instructor. In this model, the role of the instructor is expanded to include supporting discourse among the learners, setting the climate for learning, and selecting appropriate instructional and resource content. Online

learning, in Swan's (2003) conceptual model, takes place through interactions with the content, other learners and the instructor.

Figure 5.1: Model of Interactivity and Learning Online

Source: Swan (2003)

ASSESSING STUDENT WORK IN CREATIVE DISCIPLINES IN THE ONLINE ENVIRONMENT

Online course and program delivery enables us to leverage information technology for the collection of information on student learning as never before, but at some point we have to ask how best to leverage technology to promote student learning in artistic disciplines, and what constitutes effective assessment and feedback in the online environment for the creative, performing, and design arts. Keeping in mind Swan's (2003) model above, what should we assess in the online environment? From that set of areas and generic skills within each area, what is appropriate to address in the set of creative disciplines that may be feasibly offered online? What tools might we use most appropriately? The Joint Information Systems Committee (JISC) (2010) offers perspective: "Effective assessment and feedback can be defined as practice that equips learners to study and perform to their best advantage in the complex disciplinary fields of their choice, and to progress with confidence and skill as lifelong learners, without adding to the assessment burden on academic staff." (p.8). This key observation

encapsulates our view, that taking creative disciplines online should enable faculty to leverage technology, substantially decreasing the burden of conducting and analyzing assessment information. In this vein, Palloff and Pratt (2009) offer relevant guidance in a set of principles for effective online assessment. Their rationale is clear: assessment practice must be aligned with intended student learning objectives, instructional strategies and assignments if it is to be effective and result in optimal learning environments for students. The principles are worth including in their entirety:

1. Design learner-centered assessments that include self-reflection.
2. Design and include grading rubrics for the assessment of contributions to the discussion and well as for assignments, projects and collaboration itself.
3. Include collaborative assessments through public posting of papers, along with comments from student to student.
4. Encourage students to develop skills in providing feedback by providing guidelines to good feedback and by modeling what is expected.
5. Use assessment techniques that fit the context and align with learning objectives.
6. Design assessments that are clear, easy to understand, and likely to work in the online environment.
7. Ask for and incorporate student input into how assessment should be conducted. (Palloff & Pratt, 2009, p. 30).

Similar to Palloff and Pratt (2009), Morgan and O'Reilly (1999) offer a set of key qualities for assessing online students:

- A clear rationale and consistent pedagogical approach
- Explicit values, aims, criteria, and standards
- Authentic and holistic tasks
- A facilitative degree of structure
- Sufficient and timely formative assessment
- Awareness of the learning context and perceptions

Morgan (2003) mentions a broad set of skills highly amenable to assessment in the online environment. Cross-referencing these skills with opportunities for demonstration of competence in creative disciplines, a high degree of commonalty is evident. Many of the same broad skills are not only important in

creative disciplines, but relevant methods and tools for assessment of those skills in the online environment are already in common use. Table 5.1 below presents a sample of the possibilities.

Table 5.1: Generic Skills to Assess Online and Assessment Opportunities Appropriate to the Arts

Generic Skills to Assess	Assessment Opportunities Appropriate to the Arts
Thinking critically and making judgments	Assessment of video-taped performances, Essays, reports, reflective journals, research projects, online simulations
Solving problems and developing plans	Multimedia or text-based scenarios, online simulations, videoconferencing, individual and group projects or reports
Performing procedures and demonstrating techniques	Assessment of video-taped performances, ePortfolios, video projects/YouTube, videoconferencing, verification by workplace mentor, site monitor, online simulations.
Managing and developing oneself	Journal, autobiography, artist's statement accompanying creative works, ePortfolio with reflective component, learning contract, short self-quizzes with instant feedback.
Accessing and managing information	Discipline-based research projects, database development, bibliography.
Demonstrating knowledge	Demonstrations and presentations online, research projects in the discipline, written exam with local proctors, reports, quick feedback through multiple choice, true/false matching, short answer tests.
Designing, creating, performing	Assessment of video-taped performances, demonstrations and presentations online, ePortfolios, projects using video or the Web, group projects.
Communicating	Assessment of video-taped performances, online threaded discussions, collaborative writing, debate, role play, demonstrations and presentations online (PowerPoint or other), report journal, essays.

Teamwork and collaborating	Problem-based or Inquiry-based learning through group projects, assessment of video-taped performances, case studies, online threaded discussions, collaborative artifact creation through SharePoint or other similar software, collaborative blogs, or conferencing discussions/debates.

Source: Adapted from Morgan (2003).

Chase et al. (2014) advocate taking a large-scale perspective when designing assessment across programs of study in the arts. They discuss using a variety of data sources, from information about students before they enter a program, basic facts from institutional records, longitudinal information gathered over their course of study, information at completion of the program, and then follow up to ascertain long-range outcomes. Taking a broad approach to quality assurance in online programs, as informed by Swan's (2003) model of an online learning community of inquiry noted above, Hoey and Manning (2005) advocate using a theory-based approach to assessment and evaluation of online courses and curricula, an approach that includes interactions of student with content, with the instructor, with each other, and with the technology environment are all considered important to forming a full picture of student learning.

To round out the resources for online assessment in creative disciplines presented in this chapter, many of the areas identified by Hoey and Manning (2005) and assessment tools they recommend have been updated and are included below – ranging from information collected about learner characteristics and their background all the way to assessing post-graduation outcomes.

Table 5.2: Learner Characteristics and Background to Assess in Online Programs

Areas to Assess	Assessment Tools to Use
• Create demographic learner profile (gender, ethnicity, etc.)	• Institutional Research data
• Motivation, educational goals	• Front-end pre-course or pre-program survey • Pre-program essay (example: Drexel University online MSIS program)
• Prior online course experience	• Screening tool (e.g., NVCC's self-test, "Is DE for me?" at http://eli.nvcc.edu/eliforme/eliforme2.asp)
• Perceptions/expectations about online learning	• Front-end pre-course or pre-program survey • Screening tool

• Native language/other languages	• Front-end pre-course or pre-program survey
• Technology skills/background	• Front-end pre-course or pre-program survey
• Learning style preferences	• Online learning style inventory, such as http://www.engr.ncsu.edu/learningstyles/ilsweb.html
• Track and relate to course/program success	• Longitudinal database with course/assignment performance and all profile elements included

Source: Adapted from Hoey and Manning (2005).

Table 5.3: Student Learning and Demonstration of Competencies Relative to Faculty Expectations in Online Programs

Areas to Assess	Instructional Activities	Assessment Tools to Use
Collective construction of knowledge	Student perception of learning through collaborative activities	• Online surveys, questionnaires
	Threaded discussion forums	• Frequency of postings • Rubrics for assessing progression of postings from amateur toward expert knowledge, keyed to faculty expectations for student learning • Analysis of textual data from discussion threads, chat spaces using coding schema, keyed to faculty expectations for student learning

	Group or collaborative creation of designs, outlines, documents, or other artifacts through SharePoint or other online versioning and editing software	• Frequency of contribution and number of edits contributed • Rubrics for team/collaborative projects that permit assessment of group process and quality of product produced • Rubrics for assessing progression of edits and additions from amateur toward expert knowledge, keyed to faculty expectations for student learning • Peer assessment instruments
	Online concept mapping (Trochim, 1989)	• Qualitative analysis of change in collectively constructed concept maps over duration of course.
	Blogs	• Frequency of postings • Rubrics for assessing how postings reflect growth of knowledge
Deep learning (critical thinking, reflective learning)	• Student e-portfolios (course-level; program-level) • Reflective journaling or writing	• Rubrics for portfolio analysis, keyed to faculty expectations for student learning • Content analysis of reflective works in e-portfolio • Content analysis of online journal entries • Inventories, diagnostic instruments
Course content mastery	• Student projects/works/presentations	• Rubrics for evaluating student projects/work/presentations, keyed to faculty expectations for student learning

	• Online quizzes, tests, practice quizzes, simulations • Online assignments • Online simulations, pop-up quizzes, to assess content grasp • Online competency-based testing • Self-assessments • Inventories, diagnostic instruments	• Checklists and rubrics for evaluating content mastery, keyed to faculty expectations for student learning
General skills (communication, writing, etc.)	• Online journal/notes • Online discussions, chats • File exchange: collaborative editing and versioning • Group projects • Blogs	• Rubrics for assessing quality of communication and writing in journal entries, postings, edits, etc.

Source: Adapted from Hoey and Manning (2005).

Table 5.4: Student Satisfaction Assessment in Online Programs

Areas to Assess	Assessment Tools to Use
Assess expectations, perceptions, and personal goals at beginning of course and program, and degree to which expectations were met at end of course or program.	• Pre/post course surveys
Assess satisfaction with all aspects of course and program, such as instructional methods, interaction and feedback, collaboration, course material, organization, technical support, accessibility, relevancy to learner goals.	• Course midterm survey, post-course survey • Course evaluation forms • End of program exit survey • End of program focus groups (might be online!) • Objective data: repeat enrollments, program retention

Source: Adapted from Hoey and Manning (2005).

Table 5.5: Faculty-Student Interaction and Feedback Assessment in Online Programs

Areas to Assess	Instructional Activities	Assessment Tools to Use
Interaction with instructor: Frequent formative feedback on progress facilitates learning and is often requested in the online environment	• Instructor feedback on questions posted via internal or external email • Instructor feedback on postings, dialogue (such as in Discussion forums, real-time chats collaborative online activities) • Instructor feedback on assignments • Instructor feedback on student e-portfolios	• Develop baseline expectations for feedback from pre-course survey • Assess satisfaction at end of course via post-course survey, course evaluation form
Student understanding of content delivery by instructor	• Ongoing spot checks of student understanding in real time	• Use online classroom assessment techniques during course (such as clearest point/muddiest point; see Angelo and Cross, 1993) • Use online pop-up response system for discussion groups

Source: Adapted from Hoey and Manning (2005).

Table 5.6: Student-Student Interaction Assessment in Online Programs

Areas to Assess	Instructional Activities	Assessment Tools to Use
Expectations for interaction with other learners		• Pre-course or pre-program survey • Post-course survey or course evaluation/end of program survey to assess degree to which expectations were met or have changed.
Perceptions of interaction with other learners		• Mid-course survey/focus group
Levels and quality of participation in collaborative learning experiences	Discussion forums, real-time chats	• Frequency of postings • Rubrics for assessing quality of postings
	File exchange, online editing and versioning	• Frequency of contribution and number of edits contributed • Rubric for assessing quality of edits and effort
	Internal e-mail	• Track record of internal emails using course management system
	Blogs	• Frequency of postings • Rubrics for assessing quality of postings
	Group work	• Rubrics for team projects • Peer assessment instruments

Source: Adapted from Hoey and Manning (2005).

Table 5.7: Assessing Interaction with Course Content in Online Programs

Areas to Assess	Assessment Tools to Use
Frequency and duration of engagement with course materials	• Server log files • Course management system
Quality of engagement with course materials	• Online quizzes • Rubrics for student work products • Student self-assessments

Source: Adapted from Hoey and Manning (2005).

Table 5.8: Interaction with Interface/Online Environment

Areas to Assess	Assessment Tools to Use
Experience using course management system, ePortfolio system, other online course/program resources	• Server log files • Tracking through course management system • Midterm, end of course surveys • Online discussion or chat thread • End of program exit surveys
Experience with technical support system	• Track calls to help desk and type of problems encountered; turn-around time; resolution • Midterm, end of course surveys

Source: Adapted from Hoey and Manning (2005).

Table 5.9: Comparative Performance, Progress, and Retention Assessment in Online Programs

Areas to Assess	Assessment Tools to Use
Assess performance of online students in relation to on-ground students in course performance	• Compare course and program GPAs • Use rubrics to do group-level assessment of key learning activities
Assess performance of online students in relation to on-campus students in • Retention/repeat enrollments • Progression • Graduation	• Institutional research data

Source: Adapted from Hoey and Manning (2005).

Table 5.10: Assessing Post-Graduation Outcomes Online

Areas to Assess	Assessment Tools to Use
Graduate and alumni satisfaction with program	• Exit surveys • Alumni surveys • Focus groups of alumni
Employer satisfaction with program graduates	• Employer surveys • Focus groups of employers
Placement of graduates, time to placement, relationship of position to degree	• Exit surveys • Alumni surveys
Starting salaries of graduates	
Further education aspirations, enrollment, or completion	

Source: Adapted from Hoey and Manning (2005).

SUMMARY

This chapter has offered a brief overview of the variety of programs currently being offered in creative disciplines. The chapter reviewed the variation in suitability for the online environment of programs in creative disciplines, noting that professional practice in a number of creative disciplines has already migrated to the digital environment and that disciplinary accreditors in at least two instances have explicitly acknowledged that reality. A conceptual model and set of guidelines for assessing student works online was presented; appropriate skills to assess and opportunities for assessment were provided. To serve as a resource for the broader notion of quality assurance in the online environment, the chapter also provided an extensive set of guidelines for evaluating multiple aspects of online programs in creative disciplines.

REFERENCES

Angelo, T. and Cross, K.P. 1993. *Classroom Assessment Techniques*, 2nd Ed. San Francisco: Wiley/Jossey-Bass.

Chase, D., Ferguson, J. and Hoey, J. 2014. *Assessment In Creative Disciplines: Quantifying And Qualifying The Aesthetic*. Champaign, IL: Common Ground Publishing, LLC.

Guide to Online Schools, http://www.guidetoonlineschools.com/school-list?pid=4000&lvl=0, Accessed 1/4/2015

Hoey, J. and Manning, T. 2005. Assessing Online/Hybrid Courses and Curricula: Concepts, Tools, and Frameworks. Workshop presented at Northern Illinois University, June 2005.

JISC. 2010. *Effective Assessment In A Digital Age: A Guide To Technology-Enhanced Assessment And Feedback*. Bristol, UK: Higher Education Funding Council for England.

Kolko, J. 2014. *Well Designed: How To Use Empathy To Create Products People Love*. Boston, MA: Harvard Business Review Press.

Morgan, C. 2003. Developing and assessing generic skills at a distance. *Staff and Educational Development International*, December 2003, 7-11. New Delhi, India: Aravali Books International.

Morgan, C. and O'Reilly, M. 1999. *Assessing Open and Distance Learners*. London: Kogan Page.

Northern Virginia Community College. n.d. "Is DE for me?" Accessed 1/4/2015 at http://eli.nvcc.edu/eliforme/eliforme2.asp.

Palloff, R. and Pratt, K. 2009. *Assessing the Online Learner: Resources and Strategies for Faculty*. San Francisco: Wiley/Jossey-Bass.

Swan, K. 2003. Learning effectiveness: what the research tells us. In J. Bourne & J. C. Moore (Eds.) *Elements of Quality Online Education, Practice and Direction*. Needham, MA: Sloan Center for Online Education, 13-45.

Trochim, W. 1989. Concept mapping: soft science or hard art? *Evaluation and Program Planning* 12, pp. 87 – 110.

Introduction

Section Two of this book explores the heart of the matter, the varied approaches brought by a number of our colleagues in the international higher education arts community to the task of assessing student learning, and to designing, implementing, and evaluating quality assurance systems for doing so. Within each discipline represented, we have sought to showcase promising and established good practice within both two-year and senior institutions. We present the case studies grouped by cognate or related to disciplines to facilitate comparisons as follows:

Chapter Six: Performing Arts

Chapter Seven: Fine Arts

Chapter Eight: Art Education, History, and Therapy

Chapter Nine: Film, Video, and Recoding Arts

Chapter Ten: Architecture, Landscape, and Interior Design

Chapter Eleven: Industrial/Product Design

Chapter Twelve: Fashion, Fibers, and Jewelry

Chapter Thirteen: Digital and Graphic Design

Now, before we venture into discipline-specific case studies, let's explore a few cross-disciplinary art and design case studies, the first is from the University of New South Wales School of Art and Design.

Maintaining Quality And Relevance In Cross-Disciplinary Art And Design
Online Education
UNSW Australia | Art & Design
Karin Watson
Simon McIntyre
Associate Professor Rick Bennett

SUBJECT MATTER OF THE CASE STUDY *COURSE[1]*

COFA0990 Cross Disciplinary Art and Design 1, the first core course for the fully online 'Masters of Cross Disciplinary Art and Design' Program at UNSW Art & Design, UNSW Australia.

Student Learning Outcomes

The Student Learning Outcomes (SLO) assessed were centered around helping new students in the program to understand the concept of cross-disciplinary art and design practices and how these creative approaches were used in contemporary practice. They also focused on how these principles could be applied to the student's own context and creative discipline.

Specifically, the Student Learning Outcomes, Graduate Attributes and relevant Australian Qualification Frameworks (AQF) for the course were:
Student Learning Outcomes:

- Understand the concept of cross-disciplinary art and design practice
- Possess an awareness of different cross-disciplinary creative approaches used in contemporary practice
- Identify connections and contrasts between different creative disciplinary knowledge and skills
- Reflect upon how principles of cross-disciplinary creative practice apply to their own existing practices, knowledge and professional ambitions
- Understand their own strengths and weaknesses in relation to communication and collaborative practice

UNSW Graduate Attributes[2]:

[1] Note: referred to as a 'unit' in some universities
[2] https://my.unsw.edu.au/student/atoz/GraduateAttributes.html

- Scholars who are understanding of their discipline in its interdisciplinary context
- Leaders who are collaborative team workers

Australian Qualifications Framework (AQF) [3]

- Level 9 Masters Degree[4] criteria, in particular:
 - Knowledge: graduates at this level will have advanced and integrated understanding of a complex body of knowledge in one of more disciplines or areas of practice
 - Application of knowledge: graduates at this level will apply knowledge and skills to demonstrate autonomy, expert judgment, adaptability and responsibility as a practitioner or learner

INTRODUCTION

Brief Background on the Institution/Program

COFA Online (COL) was established in 2003 as an academic unit responsible for the development and management of a wide range of fully online and blended undergraduate and postgraduate courses in art and design disciplines at the College of Fine Arts (COFA), a faculty at The University of New South Wales, Sydney. COL developed and disseminated online pedagogy and training and in 2007 expanded its offerings to include a fully online Master of Cross-Disciplinary Art and Design (MCDArtDes) program, with students and lecturers participating from around the world.

In 2014 the College of Fine Arts (COFA) was renamed UNSW Art & Design[5], and the COFA Online unit absorbed into the Learning and Teaching department of the faculty to better facilitate the increasing integration of online learning into the curriculum. It continues to assist in adapting existing face-to-face classes for blended learning and flipped classrooms models.

Through ongoing research, evaluation and refinement UNSW Art & Design has developed insights into the different pedagogical approaches required for online learning in creative practice and especially collaborative art and design

[3] http://www.aqf.edu.au/
[4] http://www.aqf.edu.au/aqf/in-detail/aqf-levels/
[5] https://www.artdesign.unsw.edu.au/

processes.[6] This approach was further consolidated in the recent postgraduate program renewal process to ensure closer alignment of Student Learning Outcomes with Graduate Attributes and the Australian Qualifications Framework (AQF).

DESCRIPTION OF THE OBJECTIVE

With the rapid increase in online communication technologies over the past decade, creative industries have continued to move towards globally networked and interdisciplinary modalities of practice.[7] This shift has required designers to increasingly master new skills in collaborative practice in order to effectively communicate and work in online environments with colleagues from different disciplines and locations around the world.[8]

It is important therefore that educational institutions reflect this new paradigm by incorporating group work, communication, adaptability and an understanding of other disciplines into their pedagogical approach and the SLO for their courses.

The MCDArtDes program addressed these issues by structuring its program to incorporate collaborative group projects within a set of core courses that drew from knowledge and skills learnt in a series of electives covering different creative disciplines. This case study discusses the first of the core courses and outlines the strategies adopted to achieve these learning outcomes.

[6] Watson, K., McIntyre, S., & McArthur, I. (2009). Trust and relationship building: critical skills for the future of design education in online contexts. Iridescent: Icograda Journal of Design Research, 1(1), 22-29.

[7] Watson, K., McIntyre, S., & McArthur, I. (2009). Trust and relationship building: critical skills for the future of design education in online contexts. Iridescent: Icograda Journal of Design Research, 1(1), 22-29.

[8] Mcarthur IW; Mcintyre SD; Watson K, 2007, 'Preparing Students for the Global Workplace `An Examination of Collaborative Online Learning Approaches'', in ConnecED 2007 International Conference on Design Education, Sydney, University of New South Wales, presented at ConnectED 2007 International Conference on Design Education, Sydney, 9 - 12 July 2007

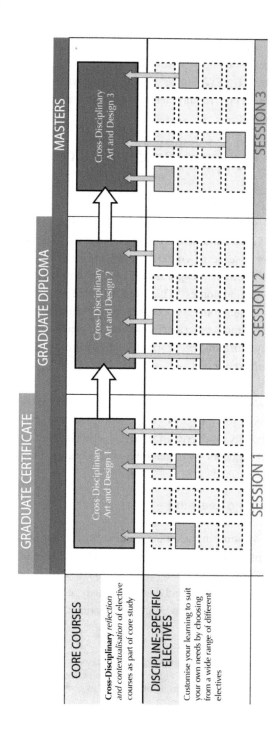

Of relevance also was a new legislative requirement in January 2012 that all postgraduate programs comply with the Australian Qualifications Framework (AFQ)[9] and as such UNSW embarked on a postgraduate coursework review process to ensure AFQ requirements were incorporated into its policies, procedures and templates[10].

CHALLENGES TO REACHING THE OBJECTIVE

New Context

Since COFA0990 Cross Disciplinary Art and Design 1 was the first of the sequential series of core units within the MCDArtDes program, it played a crucial role in establishing a sense of context for the entire program to follow. It also offered students definitions, explanations and examples of cross-disciplinary creative practice methodologies. This was valuable to the student because it helped build the foundations for deeper cross-disciplinary reflection of their multi-disciplinary learning experiences within the elective units, and opened the student to new ways of thinking, working and collaborating with people outside of their own field of experience[11].

Since this was a postgraduate course, most students came to the program with differing perspectives, skills and working methodologies that were specific to their undergraduate discipline. As such, there was no common set of themes, definitions, terminology and critical analysis criteria that could be used as a reference point, as students were learning and working in an interdisciplinary context.

Challenges of Online Learning

The flexibility of working in an online context with other students and teachers around the world provides opportunities for students to expand their knowledge and learn new skills within a wider global context. It also brings a new set of challenges that many students had not previously encountered. These include collaborating across different geographical locations and time zones; working

[9] The AQF is Australia's national quality assured framework of qualifications in the school, vocational education and training and higher education sectors. It was developed in 1995 and revised in 2011-13 and is approved by all Australian governments. http://www.aqf.edu.au/aqf/in-detail/faq/

[10] https://my.unsw.edu.au/student/Staff/MAPPS/PostgraduateReviewQuickGuide.pdf

[11] Excerpt Course Outline COFA0990 Cross Disciplinary Art and Design 1 (S1, 2014)

with fellow students from a different cultural or language background; and encountering different skills and methodologies associated with other creative disciplines.

Collaboration and Group Work

As with any group work, there were student concerns about the potential inequitable distribution of workloads and how their individual contributions would be graded. Many students first entering the course incorrectly perceived the teacher as being less able to facilitate group work since they were online and therefore considered 'remote'. Another misconception was that group work involved merely dividing up a group task into separate components that each student completed individually and then compiled together for submission, as opposed to a collaborative activity where all students worked together in solving a common problem or goal, which is reflective of collaboration in creative professions.

STRATEGIES & CREATIVE WAYS OF REACHING THE OBJECTIVE

Context

It became evident that in order to achieve the SLO and address the challenges previously highlighted, the course should include a set of projects that facilitated an authentic learning experience where students mirrored the collaborative and cross-disciplinary content and practice within their own learning processes. This would also include the practical issues of working across disciplines, times zones and within group contexts.

For Project 1, students would work individually on a case study of a cross-disciplinary project they had identified from practice. The task was to determine which disciplines were involved and why; to identify the skills, methodologies and work processes used; to highlight any challenges that the collaborators faced and, more importantly, to analyse how these were overcome.

After this, students moved onto the collaborative group component for Project 2. This required them to compare and contrast their collective case studies to determine any similarities and differences, with the purpose of establishing any common themes, challenges, and definitions, as well as any recurring methodologies and work practices. In so doing, the group members worked collaboratively to establish a set of criteria from the analysis they undertook, that

they could then use confidently to analyse other cross-disciplinary projects and practices. This was then submitted in a report or essay format.

The use of reflective formative and summative peer feedback from fellow students would also constitute a significant part of the feedback in the course. By sharing existing and newly acquired knowledge in this process, students had the chance to reflect upon and apply what they had learned in the course by actively reviewing and critiquing the work of other students[12].

Online Learning

A 'Student Policy' document was issued to students to outline program expectations when studying in a fully online environment, including what was expected from them in terms of satisfactory participation and attendance, the expected number and quality of contributions to discussion boards, tone when addressing peers and/or critiquing their work, participation in group projects, grading of work, procedures for disagreements, and so on. Similarly, a 'Teacher Policy' document was provided to ensure students understood what they could expect from their online teachers.

Group work and collaboration

One of the benefits of completing group work in an online environment is that all contributions, discussions and group dynamics are transparent and documented online, making it easier for the teacher to assess the quality of each team member's performance, as well as offer advice and guidelines on group dynamics as the project progresses. Students were instructed that all components of their group work were to take place in the course website so that it could be easily facilitated.

LESSONS LEARNED AND CHANGES MADE

Provision of a Scaffold for Project 1

Initially many students were unfamiliar with cross-disciplinary practice and found the first individual project difficult to grasp and analyse effectively. It was therefore decided to provide a scaffold of investigative questions that would guide the students through the process, and serve as a springboard for the comparisons required for Project 2.

[12] Excerpt Course Outline COFA0990 Cross Disciplinary Art and Design 1 (S1, 2014)

Introduction of the Wiki for Project 2

Initially students submitted the group component of the project in an essay format (word document, PDF, etc), however there were still some concerns about the equity of some student's contributions as regards frequency, timeliness, quality, and how the information could be used to build upon the collaborative process and continuing discussions around the project.

It was consequently decided that students should use a wiki for the group component as it provided the following advantages:

- Easy tracking of student contributions to the collaborative process for equity in grading
- Provides a reference point for teachers when assisting or providing guidance on the team's group work and collaboration skills
- Encourages authenticity in that students are familarising themselves with a collaborative online tool that might mirror contemporary practice or facilitate future collaborations with practitioners from other countries or geographical locations
- Better facilitates inclusion of diverse graphics, multi media and other creative elements into the art and design course.

Introduction of Self Reflection Portfolio for Project 3

A self-reflection portfolio was introduced as the third and final project for the course. This provided students with the opportunity to reflect on their own experiences, lessons learnt and challenges overcome to consolidate and build upon for subsequent courses and projects.

This reflective process made the project more personal, relevant and authentic for the students, and it was graded to add weight to the importance of the reflective process.

Factors That Contributed Most To The Success Of The Assessment

The course has consistently received a high level of student satisfaction.

Student Response to question: "Overall I was satisfied with the quality of this course"
CATEI Evaluations averages 2010 - 2014

Student Response to question: "The assessment methods and tasks in this course were appropriate given the course aims"
CATEI Evaluations averages 2010 - 2014

Undoubtedly the authentic learning process and alignment of student learning outcomes with assessments was the most significant factor that contributed to the success of the assessments. This was consistently supported in student feedback and comments to the CATEI[13] evaluation question of "what was the best feature of this course?"

[13] UNSW Course and Teaching Evaluation and Improvement evaluation

> *"... a clear and direct teaching method implementing precisely the knowledge field analysed (cross-disciplinary creative process management) through tasks." Student S2, 2011*

> *"...the tasks were the content in action." Student S2, 2011*

> *"The learning process being used as a demonstration of the information being delivered." Student S1, 2011*

Similarly, other students highlighted the effectiveness of building upon the skills learnt through their analysis of other cross-disciplinary projects, and the sequential course projects. The importance of self-reflection, and how it contributed to a greater understanding of the relevance of the content to their own practice was also acknowledged:

> *"...A very well structured course. The discussions were very enjoyable and I found the lectures interesting and relevant. I thought the assessment tasks were extremely well thought out, with each task building on the knowledge and experience gained from the previous task, and encouraged learning by doing, step by step. I also found the peer review tasks to be very constructive. I have gained a much clearer view of cross-disciplinary art and design, not only because I researched and discussed it, but because I engaged in it first hand, and I believe that the highly participatory nature of this course is its biggest merit. A massive learning curve and a very rewarding experience overall..." Student S1, 2012*

> *"...Deconstructing the nature of cross-disciplinary art/design projects and helping students to see how these methods can apply to their own work." Student S1, 2013*

> *"...The collaborative learning exercise was a great example of authentic learning. We were able to put into practise what we were learning about - or at least experiment with this style of project management/collaboration." Student S1, 2011*

> *"...This course was good for reflecting aspects of MYSELF in relation to the collaboration process and for highlighting areas about me, strengths*

and areas for review, that showed up just from being in different types of
company. I enjoyed all that too! :-) " Student s2, 2011

Many students also indicated that the best feature of the course was the
opportunity of working with other disciplines and people from around the world:

"...Being able to work with people from different parts of the
country/world." Student S2, 2011

"...stretching my brain to learn and feel comfortable with new online
technology (omnium & wiki) as well as concepts, new experience of
meeting and interacting with new people via online." Student S1, 2012

CONCLUSION AND SUMMARY

The dynamic field of cross-disciplinary creative practices is a rapidly changing
area, requiring constant re-evaluation of the course design. It was important that
any revisions were carefully aligned to the UNSW graduate attributes, and the
AQF ensured that the students were achieving outcomes that aligned to the larger
strategic aims of the program, the university, and the Australian higher education
sector. This was achieved over several semesters through reflection of the course
and assessment design from the perspective of student satisfaction surveys,
feedback from teachers, and observation of contemporary practice in industry.

SLO Ride: A Comparison of Outcome-Driven Assessments of Creative Work
Dr. Elizabeth Mix
Faculty Director of the Core Curriculum
Butler University

This case study compares and contrasts two assessments of student creative work
conducted at Butler University between Spring of 2012 and Spring of 2013. The
first was a program assessment of the Perspectives of the Creative Arts portion of
Butler's Core Curriculum; the second was an assessment of student progress by
Art+Design majors conducted by the Art Program. In both instances there were
challenges to overcome and strategies were developed to engage faculty in
continued refinement of teaching and assessment practices.

Butler University is located approximately five miles from downtown
Indianapolis and has an undergraduate student population of 4000. All students
are required to complete the Core Curriculum, which was redesigned in 2005 to
replace the traditional general education curriculum, driven by disciplinary

categories, with a new model driven by learning objectives. In this shift the Perspectives in the Creative Arts section of the core replaced static lecture-based "appreciation" offerings with more dynamic and engaging courses that required that students participate directly in a creative enterprise. The pilot assessments were developed in conjunction with the phased rollout of the new core and one of the first tasks was the conversion of learning outcomes to student learning objectives. Perspectives in the Creative Arts area of the core was assessed for the first time in May, 2012, and its assessment rotates with two other areas of the core curriculum (so it is assessed every third year).

Unlike Butler's core, which was a revision of a previous entity, the Art Program had been created only in 2009 and its Art+Design major, which boasts an innovative hybrid approach of fine art and design in every studio course, was made available to students in the Fall of 2011. Because assessment was well-established at Butler University by this time, especially in light of the new core curriculum, the Art Program developed measurable student learning outcomes in conjunction with its new course offerings and major. While these outcomes have been modified slightly as the program has continued to develop, the step of converting objectives to outcomes was not necessary. The Art Program began assessing its student learning outcomes in 2011; its seven learning outcomes are assessed over a three-year period. These differences are highlighted by a comparison of the original learning objectives of the core with the learning outcomes of the Art Program. The items bolded were the subject of assessment from May 2012-May 2013 that is treated in this case study.

Perspectives in the Creative Arts Learning Objectives:

1. To develop cognitive and affective appreciation for the process and products of artistic creation.
2. To participate actively in the creation of an artistic product.
3. To reflect on the nature and sources of aesthetic value.
4. To develop habits of participation in artistic and cultural events that will lead to lifelong engagement with in the creative arts.

Art Program Student Learning Outcomes:

1. Demonstrate an *understanding* of the basic principles of art + design, including visual vocabulary, and technical sensibility towards composition and materials.
2. Demonstrate innovative thinking, craft and sophistication in terms of aesthetic and technical *application* of materials and processes of art + design
3. Demonstrate an understanding of *connectivity* of a variety of art + design methods, materials, techniques and technologies.
4. Demonstrate an *understanding of the intellectual underpinning* of art + design in terms of history, process and theory.
5. Interpret, compare and critique their own and other's work in terms of materials, processes and concepts (demonstrating critical abilities with respect to innovation, craft and sophistication).
6. Demonstrate *professional growth* in critiques and portfolio development.
7. Demonstrate *personal growth* through community service and internships.

The differences between the contexts for the assessments, beyond the stated objectives/outcomes are significant. The Art+Design program courses are available open only to majors and minors, while the Perspectives in the Creative Arts courses are designed for non-majors. While in any given semester there are as many as twenty faculty teaching Perspectives in the Creative Arts each semester (there is therefore a large pool of faculty to conduct the assessment, and faculty need not assess their own students), there are just three faculty in the Art Program (making anonymity impossible). While the Art Program's assessment aims to demonstrate growth in artistic skills and professionalism in students over a sequence of courses ideally spread out over four years, Perspectives in the Creative Arts is a single course that may be taken by students at any time during their careers at Butler University and has as its goal exposure and experience with creativity, but not the expectation of growth over time.

These two areas in which creativity is assessed at Butler University had in common the challenge of assessing creative work and a particular challenge due to the various nature of student artifacts. A 25% random sampling of students in Perspectives of the Creative Arts yielded digital photographs of cardboard sculptures, collages and drawings, as well as audio files of students performing in ensembles and video of students performing monologues. Faculty conducting the

assessment found it impossible to compare these various forms of creative production in a meaningful way. Because of its small number of majors, the Art Program assessed the work of all their students over the course of a semester, but the hybrid nature of the program meant that students were consistently changing their media. In the Drawing and 2D design class, for instance, students worked with graphite at the beginning of the course and then worked digitally at the end of the course. When viewing early and late work together, it was difficult to see progress because of the change in medium.

While the assessments had one challenge in common, the process by which each assessment was conducted varied significantly. For the Core Curriculum, the process started with a year of preparation. Faculty ownership was ensured through faculty governance (a Core Curriculum Committee reporting to Faculty Senate as well as advisory committees lead by faculty given a formal position in charge of assessment and faculty development for the various areas of the core). Buy-in for the assessment was achieved through a series of faculty development events, but also through a series of individual conversations with faculty members who did not believe that assessment was accurate or useful. Strategies employed to sway these faculty ranged from leveraging a pending Higher Learning Commission (HLC) accreditation visit to means of fostering a sense of community among the faculty and helping them find ways that it could be directly useful to their teaching. Most faculty responded positively to language that contextualized assessment as something that was both necessary for accreditation and would ultimately benefit students.

At the start of the process in the core curriculum, Butler's Office of Institutional Research and Assessment (OIRA) generated a 25% random selection of students' names from each section of the course. Faculty were then notified of the students who were selected and submitted work samples to OIRA, where students' names were replaced by a tracking number to retain demographic data and are placed into a database accessible only internally. Four faculty (three who teach Perspectives in the Creative Arts regularly from different disciplinary areas—art, music and theatre—and one who does not teach in that area of the core curriculum) volunteered to develop rubrics (figures 1 and 2) and score artifacts using the rubric during a two-day event called "Assessfest." After norming a few items to the rubrics, faculty divided into pairs so that each artifact would be scored by two reviewers. Indirect data was collected using IDEA course evaluation forms required of all faculty—those teaching in the Perspectives in the Creative Arts area of the core curriculum are required to choose outcomes *Idea #6 Developing creative capacities (writing, inventing, designing, performing in art,*

music, drama, etc.) and *Idea #7 Gaining a broader understanding and appreciation of intellectual/cultural activity (music, science, literature, etc.).* These items were embedded in the rubrics in place of the learning objectives articulated with the creation of the new core for the pilot assessment, but the result was less than satisfactory, both because of poor fits between the IDEA items and the language of the original learning objectives and because the IDEA form is used to evaluate faculty performance (and so the use for a specifically program-level assessment was deemed compromised). The 2015 assessment is beginning with a rewriting of the course objectives into measurable learning outcomes, and, while faculty will continue use of IDEA forms for their annual performance evaluations, a separate instrument will be developed for the program assessment of the Perspectives of the Creative Arts area of the core curriculum.

The process used by the Art Program has in common with the above process only the use of a rubric to score student artifacts developed by faculty teaching in the program (figures 3 and 4) and a less-than-ideal match between the direct and indirect evidence. Because of the small number of students, no random sampling is conducted and assessment is conducted each semester. The assessment is conducted at a large end-of-semester exhibition in which each major and minor has individual display space. Faculty lead students in a group critique, during which each student introduced their work and then answered questions from both faculty and other students. Following the critique faculty scored their rubrics and students fill out a survey. The studio classes at Butler University use a college-designed evaluation, not the IDEA form, which was used to provide indirect evidence. As in the case of Perspectives in the Creative arts in the core curriculum, however, there was a poor fit between the data gathered in course survey and the direct evidence provided by student work.

The challenges faced by the faculty conducting the Art Program assessment had some similarities to those that were presented in the core assessment. Both groups of faculty looked at examples of rubrics, including the American Association of Colleges and Universities' (AAC&U) VALUE rubrics. The core faculty chose to develop a rubric that honored specific disciplinary differences, but this resulted in a rubric that reverted back to a system that the new core curriculum had hoped to change. The Art Program chose to closely adapt a rubric that was developed by Butler's Department of Dance; but ultimately this proved difficult. While the core assessment always used a database of student artifacts, the Art Program had tried using a database approach but abandoned that approach because of the lack of detail digital reproductions could provide. The end-of-semester exhibition provided an opportunity to view all original work in one

place, thus securing a sense of rootedness in time and place similar to the Assessfest approach used in the core curriculum.

Evaluating the artifacts themselves posed similar challenges, but the contextual differences between the core curriculum and the Art Program (non-majors versus majors, a desire to see participation versus growth, etc.) resulted in different solutions to this problem. Faculty scoring for the Perspectives in the Creative Arts area of the core decided that based on the original learning objective "To participate actively in the creation of an artistic product" it was not necessary to try to assess how "good" a particular artifact was, rather only that the student had created something. It was decided that in subsequent assessments the item would be a simple "yes or no" check based on review of course syllabi. This decision had the added bonus of being able to ensure that all courses had been converted from the old "lecture-style" course to the intended "hands-on" approach. Based on some artifacts submitted for the assessment of the "appreciation" item, and through conversation among the faculty during Assessfest, it was decided that a common assignment template could be developed to better allow comparison among disciplines (this would take the form of a paper analyzing a work in the medium introduced by the class). A pre- and post- common appreciation assignment was also discussed, an option in which faculty would show students a work from the medium introduced in their course on the first day of class and students would be asked to write a free-form response to it. The same work would be presented near the end of the course and the students again would be asked to write a free-form response. Faculty conducting the assessment hypothesized that the writing would be more sophisticated in the later sample. Either of these solutions were believed to yield not just better assessment data, but actual evidence of student growth that may well have been happening in classes, but the wide variance of types of evidence collected had obscured the ability to really demonstrate this.

The Art Program had always intended to measure growth, but had developed instruments that were incapable of capturing that information in a meaningful way and that could not be productively compared to indirect data provided by students. They addressed the challenges posed by both the rubric and the poor match of direct and indirect data through a solution developed and piloted in Spring 2013 (figures 4 and 5), one that consisted of a rubric and survey with shared language and that yielded a better comparison of data provided by faculty and students. They also initiated discussion about the very specific skills students should be developing across the curriculum, and how these must be sequenced in a way not just to demonstrate growth, but to ensure that growth is actually taking

place through careful curriculum design. The relatively new program with its even newer major was articulated very carefully in terms of the hybrid fine art/design elements on the course level, but the underlying skills students were developing had not been previously discussed.

What began as a general discussion of skills lead to the creation of an "ideal resume" that articulates the skills students graduating from the program should have. Once that was completed, faculty began backward mapping skills and software competencies to individual courses, an ongoing process. As a result of this assessment, both the direct and indirect components, faculty decided to change the curriculum to add a second and third level to courses in the curriculum where students develop these key skills, allowing them to increase their depth in a way that wasn't possible before due to the small number of faculty teaching in the program. Faculty in the Art Program believe that the identification of specific skills, and their careful sequencing though the curriculum, will allow student growth over time to be demonstrated clearly.

While the end-of-semester exhibition will continue to be the site of a group critique, the groundwork is being laid to move the assessment into electronic portfolios. Discussion among the faculty regarding the specific skills associated with portfolio development revealed that while students were being required to develop an electronic portfolio in their first year, and then again in their capstone course, faculty were not requiring that work be placed into the portfolio as students progressed incrementally through the program. Faculty agreed to start requiring that work be placed into the portfolio as part of every course offered, and to make that a graded requirement to ensure student compliance. This solution had the added benefit for the students of a fourth-year portfolio that was complete and just in need of transformation to a career-focused portfolio.

CONCLUSION AND SUMMARY

In the end, both assessments demonstrated the value of faculty conversation about teaching methods and student skill development. When brought together for the purpose of programmatic assessment that initially seemed to some faculty to be disconnected from the practice in the classroom, faculty were able to find creative collaborative solutions to the challenges they discovered. While this case study has focused most closely on the rubric development and assessment processes, the conversations that evolved during its implementation developed even more broadly to include issues shared across disciplines, from the causes of grade inflation and to how to inspire students' self-motivation in a flipped classroom. Ultimately the assessment of creative work is itself a creative process.

Butler University – Perspectives in the Creative Arts – Rubric for SLO #1 (Idea item #6): Develop Creative Capacities	Reviewer initials
	Paper #

Type of data (pre-post? Essay? Image? Video?)

Creative Capacities

	Not Applicable	No/little proficiency 1	Some proficiency 2	Proficiency 3	High Proficiency 4
1. **Visual Criteria** – (Art) Creative work demonstrates proficiency with: Compositional elements (balance, unity, scale/proportion, focal point) Formal elements (line, shape, value, color, space, texture) Craft/handling of materials (engaging delivery of content through materials) Understanding/Awareness of Process (performative dimension of creativity)					
2. **Performance Criteria** (Music) demonstrates Effective use of the physical instrument and/or vocal body to communicate Engaging delivery of intellectual and/or emotional content Demonstrates elements of effective musical performance (energy, dynamic, rhythm, tempo, vocal quality, visual effect) Understanding/Awareness of Process (performative dimension of creativity)					
3. **Performance Criteria** (Theatre/Dance) Demonstrates understanding of performer/audience relationship (space, interaction, intention) Utilizes effective elements of performance (energy, dynamics, vocal quality, physical presence, visual components, pace) Demonstrates understanding of context (historical, social, genre/style, artist, intention) Self-awareness of development and engagement through technique					

Figure 2: Revised short version rubrics used to score artifacts collected from courses in the Core Curriculum during Butler University's Assessfest, May 14-15, 2012

Art Program Fall 2012 Rubric for SLO#3 (*connectivity*): Demonstrate an understanding of *connectivity* of a variety of art + design methods, materials, techniques and technologies

Rubric	Below Average 1	Average 2	Above Average 3	Exceptional 4
Methods *collaboration *hybridity *assemblage	Demonstrates lack of knowledge of the use of both digital and traditional tools	Demonstrates knowledge of both digital and traditional tools but lacks a sense of integration of the two.	Demonstrates integration of digital and traditional tools.	Near professional level as possible for students
Materials (Traditional and non-Traditional)	Demonstrates lack of knowledge of the ability to work with a wide variety of sources.	Demonstrates knowledge of the ability to work with a limited variety of sources.	Demonstrates the ability to work with a wide variety of sources.	Near professional level as possible for students
Techniques (Digital vs. non-digital)	Demonstrates lack of understanding of layering images and ideas.	Demonstrates understanding of layering images and ideas but lacks complexity or seamless integration.	Demonstrates layering images and ideas with complexity and seamless integration.	Near professional level as possible for students
Technology	Demonstrates lack of knowledge of the conceptual connectivity of the disciplines of art and design.	Demonstrates some knowledge of the conceptual connectivity of the disciplines of art and design.	Demonstrates knowledge of the conceptual connectivity of the disciplines of art and design.	Near professional level as possible for students
Audiences	Demonstrates a lack of knowledge that artwork can be made for a wide variety of audiences, including- personal, artistic and commercial.	Demonstrates some knowledge that artwork can be made for a wide variety of audiences, including- personal, artistic and commercial.	Demonstrates knowledge that artwork can be made for a wide variety of audiences, including- personal, artistic and commercial.	Near professional level as possible for students
Interactivity	Demonstrates lack of understanding that artwork can be interactive and collaborative; that the input of the audience can be incorporated into the artwork.	Demonstrates limited understanding that artwork can be interactive and collaborative; that the input of the audience can be incorporated into the artwork.	Demonstrates a thorough understanding that artwork can be interactive and collaborative; that the input of the audience can be incorporated into the artwork.	Near professional level as possible for students

Figure 3. Rubric used by Art Program faculty to score student artifacts at the Fall exhibition ART NOW, December 2012.

Art Program Spring 2013
Performance Evaluation – (SLO #3) – Connectivity
Student: _____
Reviewer: _____
Demonstrate an understanding of *connectivity* of a variety of art + design methods, materials, techniques and technologies.

1 -Below Average 2-Average 4-Above Average 4-Exellent

1. Is able to demonstrate the ability to use both traditional and digital tools for artmaking. _____

2. Is able to work with a wide variety of sources- the observed world, photographic sources, typographic and commercial sources. _____

3. Is able to layer or juxtapose images and ideas. _____

4. Is able to demonstrate an understanding of the conceptual connectivity of the disciplines of art and design; that the definition of art can also include design approaches. _____

5. Is able to demonstrate an understanding that artwork can be made for a wide variety of audiences, including- personal, artistic and commercial audiences. _____

6. Is able to demonstrate an understanding that artwork can be interactive and collaborative; that the input of the audience can be incorporated into the artwork. _____

Overall Average _____

Figure 4. Revised rubric used by Art Program Faculty to score student artifacts at the Spring exhibition ART NOW, April 2013.

Art Program Spring 2013 Student Survey

Name: _____

Performance Evaluation – (SLO #3) – Connectivity (Indirect evidence)

Please rate your abilities in the following categories (using a scale of 1-4).

| 1-Below Average | 2-Average | 4-Above Average | 4-Exellent |

where:

1 = **below average** (I lack both knowledge and confidence in this area)

2 = **average** (I have knowledge in this area, but have a lack of confidence to deal with this area in a critique situation)

3 = **above average** (I have a lot of knowledge in this area and am somewhat confident in dealing with this area in a critique)

4 = **excellent** (I have a lot of knowledge in this area and I am completely confident in dealing with this area in a critique)

1. **I am able to demonstrate the ability to use both traditional and digital tools for art-making.** _____

2. **I am able to work with a wide variety of sources– the observed world, typographic, photographic and commercial sources.** _____

3. **I am to layer or juxtapose images and ideas.** _____

4. **I am able to demonstrate an understanding of the conceptual connectivity of the disciplines of art and design; that the definition of art can also include design approaches.** _____

5. **I am able to demonstrate an understanding that artwork can be made for a wide variety of audiences, including– personal, artistic and commercial audiences.** _____

6. **I am able to demonstrate an understanding that artwork can be interactive and collaborative; that the input of the audience can be incorporated into the artwork** _____

Figure 5. Student survey to collect indirect evidence developed to be directly comparable to the faculty rubric, implemented directly following critique sessions at the Spring exhibition ART NOW, April 2013.

Assessment x Design: Scaling Up by Thinking Small
Heather Lewis
Acting Chair, Art and Design Education
Pratt Institute

> The conversational strategy begins as an exercise in thinking small to
> take things to a human scale... Of course, there is no guarantee that
> starting a small conversation will lead to something larger. But the
> failure to take any step at all, no matter how small, comes with the
> ironclad guarantee that we will not be part of helping change happen.
> Parker J. Palmer (2010, 134)

This chapter describes the first stage of a campus-wide assessment effort,
Assessment x Design, driven by faculty initiative and research. It is still too early
to highlight lessons learned over time. However, the chapter suggests that by
articulating a theory of action and contextualizing the initiative within broader
historical and contemporary reform efforts, faculty can become part of a learning
community based on reflective practice.

HISTORICAL AND SOCIAL CONTEXT

Charles Pratt, whose humble background shaped his ideas about higher education,
established Pratt Institute in 1887 as a trade school, "[to] do something for young
people situated as I had been" (Morton, 1999). Pratt provided industrial training
to "make these ordinary workers intelligent, competent, and happy" by putting
"into the commonplaces of the shop and the workroom some of the inspiration of
culture" (Morton, 1999). In Pratt's editorial in the first *Pratt Monthly*, an art
instructor envisioned an education consistent with the Progressive ideals of the
era. According to the instructor, a Pratt education would "...awaken the power of
beauty, by education, in all minds, and the world will quickly become a
brotherhood...Each student...will become an individual reformer " (Ovington,
1901).

Pratt Institute's current mission continues to reflect some of these early
aspirations, guiding the Institute's preparation of undergraduate and graduate
students in the fields of art, design, architecture, information and library science,
and liberal arts and sciences. Similar to its 19th-century origins, Pratt continues to
"educate artists and creative professionals to be responsible contributors to
society" and to "instill in all graduates aesthetic judgment, professional
knowledge, collaborative skills, and technical expertise" (Pratt Mission, 2015).

While the thrust of Pratt's original mission continues to shape Pratt Institute's culture, the ways in which the Institute's faculty actualize the founder's goals shifted significantly over the course of the twentieth century. Today, new curricular reforms seek to preserve Pratt's founding mission while adapting to changes in the professional fields, as well as addressing national concerns about the weakening of the liberal arts mission in higher education.

Given Pratt's origins and emphasis on professional education, the Institute differs somewhat from traditional liberal arts institutions. But what Pratt shares with such institutions is a cautionary stance against the current trend to reduce professional preparation to a narrow concept of vocationalism. With inflammatory titles such as *The Last Professors: The Corporate University and the Fate of the Humanities* and *Liberal Arts at the Brink,* some scholars have suggested that neo-liberal values and vocationalism have weakened traditional liberal arts programs (Donoghue, 2008; Ferrall, 2011). Grubb and Lazerson argue that the civic, intellectual, and moral goals of a liberal education could become increasingly side-lined as market-driven segmentation in higher education and employer pressures on professional preparation threaten to diminish the value of the liberal art (2005). Pratt's historical commitment to professional preparation grounded in a strong, liberal arts foundation counters this trend. However, there is a need to better integrate the professional programs and liberal arts, not only to preserve liberal education but to promote better student outcomes.

CURRENT INSTITUTIONAL CONTEXT

As Pratt faculty and administrators prepare for two simultaneous accreditation visits this spring—from Middle States Commission on Higher Education (MSCHE) and the National Association of Schools of Art and Design (NASAD) —the pre-visit preparation work has identified Pratt's strengths and areas for improvement in teaching and learning as well as in assessment. To address MSCHE standards in the area of teaching and learning, faculty across the majors attempted to articulate some of the common assessment approaches embedded in their courses and programs.

Faculty working in a range of majors found that the nature of assessment in the arts is an ongoing process, but that this process is not always made explicit for students as well as external audiences. And it is also not clear how the embedded assessments currently in use lead to improvements in teaching and learning. There is a need to make current assessment practices more explicit and to use assessment outcomes to revise teaching strategies, course content, and program curricular frameworks. The most effective way to do this is to start at the course

assignment level with faculty who can assess student learning and make needed course changes in a timely and effective manner. Despite faculty involvement in the accreditation self-studies, the work is still at a distance from the classroom and studio, where faculty continue to work on aligning course and program-level assessment.

In addition to external accountability requirements, Pratt faculty are revising student learning outcomes in response to a reduction in the number of undergraduate credits; significant changes in the foundation, general education, and co-curricular freshman programs; and a new emphasis on inter-disciplinarity as an Institute-wide core value (Pratt Strategic Planning, 2013). Given the need to stimulate and sustain faculty engagement with both internal and external reforms as they are implemented over the next few years, a faculty team applied for and received a Faculty Innovation Fund award to support the *Assessment x Design* project. The project's goal is to build a culture of assessment at Pratt Institute that will simultaneously address external accountability requirements for program assessment and lead to more effective learning opportunities, both disciplinary and integrative, during the first year experience as well as across the majors and the liberal arts.

THEORY OF ACTION

The *Assessment x Design* project's theory of action draws from three related fields of knowledge in the area of organizational change. In the domain of cultural theory and psycho-sociological analysis, Armstrong and Rustin (2014) suggest that a top-down form of knowledge dominates many technical fields, but a more democratic form of knowledge can be "generated interactively in dialogue and through practical action, and its dissemination is more horizontal than vertical " (21). According to Long, a supportive culture enables members to take risks, learn independently, and remain curious (2014). The *Assessment x Design* project's theory of action builds on the concept of horizontal communication and learning with the understanding that for this approach to work, trust needs to be established in order to "develop a culture able to work through the anxieties and fears" inherent in the work of organizational members (Long, 48).

This theory of action posits that by examining assessment practices and making such practices public in a trusting environment, faculty will engage in what Parker Palmer (2012) calls "pedagogical risk-taking", and will be better able to help their colleagues do the same (40). Palmer's ideas about how collegial dialogue can help transform the academy are based on social movement theory and practice. Parker suggests that a core group of committed faculty can expand

into wider concentric circles of faculty and administrators who engage in potential transformative conversations leading to organizational change. Palmer argues there is no guarantee that an exercise that begins by thinking small will lead to change, but that "when people talk meaningfully with each other, the unpredictable can happen" (135). The theory of action therefore aims to develop a supportive and trusting culture that will generate dialogue and action within and across the Institute's academic departments.

A second component of the project's theory of action asserts that faculty action research, grounded in disciplinary approaches, can contribute to interdisciplinary learning through integrative assessments that span disciplines. As mentioned earlier, Pratt's commitment to inter-disciplinarity and a more holistic and integrative first year student experience provides the context for faculty to work across disciplines and departments. However, the *Assessment x Design* project started with faculty action research in the disciplines. Hutchings, a national assessment leader, argues that program assessment has focused on cross-cutting outcomes but that for faculty to become deeply engaged in assessment work, attention to disciplinary assessment is critical (2010). According to Hutchings, this disciplinary focus on assessment should be linked to the scholarship of teaching and learning which is grounded in the disciplines (2011).

Over the last two years, Pratt faculty have been involved in developing program outcomes, but are beginning to make stronger connections between course and program learning outcomes by articulating pedagogical practices, assignments and assessments in their disciplines. However, in the field of design, Mewburn argues that design teachers have not necessarily articulated what they do and why (2012). Mewburn sees an increasing need to provide adequate theories for contemporary pedagogical practice, to help teachers of design courses clearly articulate what they do and how they can capture learning as a process as well as a cognitive act (2012). Hutchings asserts that without disciplinary considerations, assessment is "departmental" but not necessarily "disciplinary… it is situated in the relevant administrative unit but may not entail significant deliberation about what it means to know the field deeply, why that deep knowledge matters, and how to ensure that all students in the program achieve its signature outcomes at high levels" (2011, 37).

The final component of the theory of action posits that action research methodology, based on inquiry into professional practice through systemic and reflective research, can promote classroom and program level improvement efforts. Hansen and Borden argue that action research can help facilitate the connection between "institutional research results and program improvement"

(2006, 49). The project's theory of action posits that the first wave of action research projects will generate expanding concentric circles of faculty researchers committed to building a culture of assessment.

ACTION-RESEARCH

Given the need for more extensive research on studio pedagogy in higher education, some faculty in the first round of the *Assessment x Design* action research focused on studio learning and assessment (Chase, et al., 2013). These action research projects explored how rubric criteria could help promote more effective student self-assessment. One of the participating faculty, Brian Brooks, who developed a self-assessment rubric for a first-year drawing course, explored how students could use the language embedded in the criteria to understand and transfer core concepts across assignments and function more autonomously with each subsequent assignment. Brooks found that after piloting the rubric for one semester, students developed a "vocabulary of reflection" which is "critical especially because drawing is visual and non-verbal" (2015, 1). He also noted that the rubric helped students assess their learning over time. This finding is reflected in Orr and Bloxham's study of studio assessment practices, which identified faculty assessment approaches "in practice", rather than as they are espoused (2012, 1). Orr and Bloxham found that the faculty in their study employed three conceptions of quality to support their assessment process, "the demonstration of significant learning over time, the demonstration of effective studentship, and the presentation of meaningful art/design work " (2012, 1). These findings share much in common with the action research findings from the *Assessment x Design* studio action research in drawing.

However, the use of rubrics in studio settings seems to be a relatively new phenomenon. A review of the literature in higher education suggests that faculty should proceed with caution. Scholars argue that students need to internalize assessment criteria and develop their capacity to identify criteria independently. However, use of rubrics for this purpose is not without its challenges (Sadler, 2010; Boud and Falchicov, 2007; Nordrum et al., 2013; Torrance, 2007). For example, Torrance cautions against the misuse of rubric criteria, asserting that "such assessment procedures and practices come to completely dominate the learning experience, and criteria compliance comes to replace learning" (2007, 292) Instead, Torrance argues, students should develop the capacity to "interrogate criteria, rather than accept them as a given" (292). Such scholarly concerns will guide the ongoing action research projects focused on self-assessment as the project expands beyond its initial small core of faculty.

Hopefully public discussion, among faculty and external assessment advisors, of the shared findings from the project's action research will generate discussion about how to scale up faculty participation in the *Assessment x Design* project. The challenge, as the project begins to expand, systematize and innovate in the assessment arena, will be to expand faculty engagement. Cain and Hutchings found that faculty engagement with assessment is no easy task because "faculty are at times mistrustful of the drivers of assessment, concerned about validity of measures, worried about how the data will be used and misused, and operating in situations that disincentivize engagement" (2015, 100). Such challenges are commonplace across the disciplines at Pratt Institute and yet, the faculty involved in the action research projects are prepared to take pedagogical risks in a learning context that enables them build their knowledge and curiosity about assessment. The next challenge will be to engage concentric circles of faculty, some of whom may still be somewhat alienated from the language of assessment.

SUMMARY AND CONCLUSION

The *Assessment x Design* project is expanding the concentric circles of engaged faculty from the small core group that initiated the project to a broader range of faculty, through dialogue about and re-design of disciplinary and cross-disciplinary assignments and assessments. Faculty will also explore integrative assignments across the liberal arts and sciences and professions through their work on assessment. Hutchings, et al. argue that "assessment (like teaching) is not a solo activity" and that "one of its virtues is to promote interaction among faculty across different disciplinary and program contexts as they focus together on students' progress toward learning goals they value in common. This is where bringing faculty together can pay significant dividends, resulting not only in better individual assignments but in more connected assignments, and more integrative *learning,* across the curriculum " (2014,12). Such faculty interaction will build on the action research projects as they begin to link assessment with integrative learning and uses e-portfolios as one of the tools to foster such an approach.

This chapter describes an assessment program that begins at a small scale, driven by the work of a small group of faculty at the studio and classroom level. The chapter argues that through horizontal dialogue and action research, timed with campus-wide assessment events such as accreditation self-studies and major curricular reforms, faculty can promote and sustain a culture of assessment.

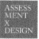

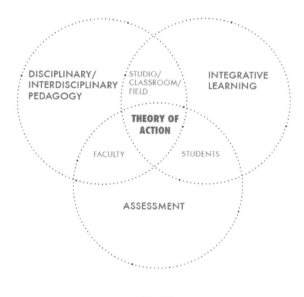

REFERENCES

Armstrong, David and Michael Rustin, M. 2014. "Introduction: Revisiting Paradigms." In *Social Defenses Against Anxiety: Explorations in a Paradigm,* edited by David Armstrong and Michael Rustin, 1-27. London, U.K.: Karnac.

Banta, Trudy W. and Associates. 2002. *Building a Scholarship of Assessment.* San Francisco, CA: Jossey-Bass.

Boud, David and Nancy Falchicov. 2007. "Aligning Assessment with Long-term Learning." *Assessment and Evaluation in Higher Education,* 34, no.1: 399-413.

Brooks, Brian. 2015. "Self-Assessment and Self-Regulation in the Drawing Studio." *Assessment X Design Action Research Project.*

Cain, Timothy R. 2014. *Assessment and Academic Freedom: In Concert, Not Conflict.* NILOA Occasional Paper #22. Urbana, IL: University of Illinois and Indiana University, National Institute for Learning Outcomes Assessment.

Cain, Timothy Reese and Pat Hutchings. 2015. "Faculty and Students: Assessment at the Intersection of Teaching and Learning." In *Using Evidence of Student Learning to Improve Higher Education,* edited by George Kuh, Stanley Ikenberry, Natasha Jankowski, Timothy Cain, Peter Ewell, Pat Hutchings, and Jillian Kinzie, 95-117. San Francisco, CA: Jossey-Bass.

Chase, David, Jill L. Ferguson, and J. Joseph Hoey IV. 2014. *Assessment in Creative Disciplines: Quantifying and Qualifying the Aesthetic.* Champaign, Illinois: Common Ground Publishing.

Donoghue, Frank. 2008. *The Last Professors: The Corporate University and the Fate of the Humanities.* New York: Fordham University Press.

Ferrrall, Victor Jr. 2011. *Liberal Arts at the Brink.* Cambridge: Harvard University Press.

Grubb, Norton W. and Marvin Lazerson. 2005. "Vocationalism in Higher Education: The Triumph of the Education Gospel". *The Journal of Higher Education,* 76, no. 1: 1-25.

Hansen, Michele J. and Victor M. H. Borden. 2006. "Using Action Research to Support Academic Program Improvement". *New Directions for Institutional Research,* 130: 47-62.

Hutchings, Pat, Natasha A. Jankowski and Peter T. Ewell. 2014. *Catalyzing Assignment Design Activity on Your Campus: Lessons from NILO's Assignment Library Initiative*. Urbana, IL: University of Illinois and Indiana University, National Institute for Learning Outcomes Assessment.

Hutchings, Pat. 2010. *Opening the Doors to Faculty Involvement in Assessment*. Urbana, IL: University of Illinois and Indiana University, National Institute for Learning Outcomes Assessment.

Hutchings, Pat. 2011. "From Departmental to Disciplinary Assessment: Deepening Faculty Engagement." *Change,* 43, no. 5: 36-43.

Long, Susan. 2014. "Beyond Identifying Social Defenses: 'Working Through' and Lessons from People Whispering." In *Social Defenses Against Anxiety: Explorations in a Paradigm*, edited by David Armstrong and Michael Rustin, 39-50. London, U.K.: Karnac.

Mewburn, Inger. 2012. "Lost in Translation: Reconsidering Reflective Practice and Design Studio Pedagogy." *Arts and Humanities in Higher Education*, 11, no. 4: 363-379.

Morton, Marcia. 1999. *Pratt and Its Gallery: The Arts and Crafts Years*. New York: Pratt Institute.

Nordrum, Lene, Katherine Evans, and Magnus Gustafsson. 2013. "Comparing student Experience of In-text Commentary and Rubric Articulated Feedback: Strategies for Formative Assessment." *Assessment and Evaluation in Higher Education* 38, no. 8: 919-940.

Orr, Susan and Sue Bloxham. 2012. "Making Judgments about Students Making Work: Lecturers' Assessment Practices in Art and Design." *Arts and Humanities in Higher Education,* 12, no. 2-3: 234-253.

Ovington, Mary White. 1901. "The Founder." *Pratt Institute Monthly* X, no.1: 10-22.

Palmer, Parker J. 2012. "Transformative Conversations on Campus." In *The Heart of Higher Education: A Call to Renewal*, edited by Parker J. Palmer and Arthur Zajonc, 125-151. San Francisco, CA.: Jossey-Bass.

Pratt Strategic Planning, 2013.

Sadler, Royce D. 2010. "Beyond Feedback: Developing Student Capability in Complex Appraisal." *Assessment and Evaluation in Higher Education* 35, no. 5: 535-550.

Torrance, Harry. 2007. "Assessment as Learning? How the Use of Explicit Learning Objectives, Assessment Criteria and Feedback in Post-secondary Education and Training Can Come to Dominate Learning." *Assessment in Education: Principles, Policies and Practice* 14, no.3: 281-294.

Case Studies in Performing Arts: Music, Theatre, Dance, Musical Theatre

Creating Together(Ness): Teaching MBA Students Through Theatre
Justin O'Brien – Management
Dr. Emma Brodzinski - Drama
Alex Turner – Drama
Royal Holloway, University of London

This case study explores the application of the "pedia of theatre" to facilitate an embodied learning process on the MBA programme. Drawing on the artistic encounter as a model of self-inquiry, the initial focus was on encouraging effective teamwork and communication. At the heart of the course were 'ensemble' exercises which engaged students in personal and shared exploration within a playful environment.

INTRODUCTION

The one-year postgraduate MBA (Master of Business Administration) programme has been developing for more than twenty years at Royal Holloway. The MBA is a generalist management programme that covers a wide range of essential business topics, *ab initio*, that helps broaden and deepen practical and theoretical knowledge. Datar et al. describe the MBA programme as providing T shaped skill sets; broadening cross functional expertise, overlaid on an existing narrower skills and experience base (2010). To enroll, candidates at Royal Holloway require a minimum of three year's work experience following their undergraduate studies and students are expected to bring experience from their industry, marketplace and role into the learning environment where an emphasis is placed on peer-to-peer learning. Teaching is intensive with more than six hundred contact hours including business visits, guest speakers, practical exercises and an international study visit.

Description of the Problem/objective, Including the Desired Learning Outcomes Students Should Demonstrate

Justin O'Brien, the current MBA director, sought to create a distinctive and impactful learning experience which drew on the wider expertise of Royal Holloway, which is renowned for its expertise in the arts. In particular he was looking to address the issue of effective teamwork. While students on the course were generally articulate and ambitious individuals, working collaboratively had proven to be a real challenge. O'Brien was looking to build on previous ad-hoc drama input during the first weeks of the course which had proved effective in accelerating self-awareness and serving to facilitate team building.

In introducing a more coherent arts-based module within the course, O'Brien identified the following learning objectives for the MBA students:

- Experience a peer learning environment that fosters a sense of democratic collegiality
- Develop management skills through creative activity
- Develop self awareness
- Encourage risk-taking
- Develop the ability to communicate verbally and non-verbally

Strategies for Reaching the Objective

The first challenge for this initiative was overcoming organisational barriers to cross-disciplinary learning and teaching initiatives. After establishing contact between the Management and Drama departments careful negotiation on both sides was necessary in order to explore what each department offered – both in terms of academic remit and practical application – and how these may be married in order to reach the identified learning outcomes. After a process of discussion it was decided that the general area of creativity would provide a productive starting point for an interdisciplinary module and a rich area of enquiry for the students.

Many business schools have started to think more systematically about creativity and are finding ways to enshrine it in their curriculum. In developing the module for Royal Holloway the collaborators looked to other programmes – such as the one at Grenoble Business School – that employ theatre in particular as a means to encourage creativity to flourish. The programme at Grenoble takes a blend of theatre training exercises and corporate theatre processes which stage scenarios in a manner which encourage reflective thinking in the spectators. The

learning objectives for the work at Royal Holloway suggested emphasis on process based activities which would foster self and group awareness.

In creating the module the team looked to interrogate what "creativity" might mean and how the constituent elements may be promoted. In reflecting upon the nature of creativity it seemed that the material falls into two very broad camps, which might be termed personal and organisational. The personal approach to creativity can be crudely characterised by a belief in the latent creativity of human beings and an understanding that increased creativity ultimately leads to personal change and/or improved well-being. This approach is exemplified in the work of psychologist Carl Rogers who says:

> The mainspring of creativity appears to be...[a hu]man's tendency to actualize [her/]himself, to become his potentialities...This tendency may become deeply under layer after layer of encrusted psychological defenses...[but it] awaits only the proper conditions be released and expressed (350).

Thus Rogers proposes that everyone is creative – although the material in this category may also propose the individual genius of the creative artist.

The other broad approach could be termed organizational. This perspective may be more focused on systemic change and institutional culture. DeGraff and Lawrence, the authors of *Creativity at Work,* argue:

> What allows a company to respond proactively to diverse pressures is *the development of creativity as a core competence*...The focus of creativity may be innovation in the traditional sense...but it may also be the development of new processes [and] new ways of communicating (2).

In reflecting on where this personal and institutional creativity may meet, the team took as their starting point for planning this course the notion of the ensemble, a significant development in the contemporary western theatre tradition. The history of the theatrical ensemble sees a reaction to the traditional star system. Companies such as the Meiningen Ensemble at the end of the 19th century were revolutionary in that they operated a system where actors may take the lead in one production and then a supporting role in another. The idea was to build a collective spirit where all contributions were valued and a sense of interconnectedness was valued. Stanislavski, the Russian director greatly influenced by The Meiningen Company, called this "inner ensemble" (quoted in

Radosavvljeviac, 3). This way of working demanded new processes and ways of communicating and placed an emphasis on training together as a group (rather than having the star turn up at the last minute to take the limelight). This, in turn, delivered a new type of aesthetic – so the Meiningen Ensemble was renowned for their perfectly nuanced crowd scenes. This commitment to the ensemble demanded particular discipline from the company in the way that they worked with their own creativity. Stanislavski taught his performers "there are no small parts, only small actors" (quoted in Whyman, 20), so, in the work at Royal Holloway we were looking to investigate the problems and possibilities of the creative ensemble – exploring both inter-personal and intra-personal elements through the inner as well as outer ensemble as a means to develop self-awareness and communication skills. From this starting point a programme that incorporated a number of drama-based activities was constructed that sought to develop the theme and meet learning objectives.

In seeking to promote a sense of ensemble, and an experience of democratic collegiality, the notion of safety was very important. A safe space in which to work was established through agreement of shared rules to the sessions. This took the form of a 'contract' made by the group in the first workshop. Students would collectively choose the colour of the A3 paper on which they would write the contract and the colour of the pen with which it would be written. When this was agreed, they could suggest commitments that they would like to be incorporated in the contract, which included logistical and social rules, such as:

- "We will arrive on time."
- "We will listen when other people are speaking."
- "Every contribution is valid."
- "There is no wrong answer."
- "We will switch our mobile phones off or to silent during the session."

When a rule was agreed by the group, this was written into the contract. This exercise established a set of rules particular to the cohort and enabled an agreed safe working environment.

The physical environment was also significant. An important aim for the project for the programme director was to take the students 'out of the box', and the space which housed the activity proved to be a very important element. In the programme's first year half of the sessions took place in Management Department seminar rooms. In *Through the Body – A Practical Guide to Physical Theatre*, performance scholar and teacher Dymphna Callery states: "You cannot

achieve good work in the midst of mess or piles of chairs. Always clear the space before working. And, if high-energy work is going on, ensure the environment is safe" (72). This is an obvious practical point but, although tables and chairs were moved to the side of the room to create an empty playing space, when students were invited to engage in physical activity, games and improvisations the team noticed a more constrained energy and lower level of concentration than in later workshops in Drama Department studio spaces. This may have been a result of students bringing pre-established notions of rules and behaviour of the seminar room, having had regular lectures and seminars in this space. The drama studio spaces were larger, allowing more room for movement and games, and they were initially unfamiliar to the participants; they were not part of the Management Department, and therefore had different subconscious permissions – students could behave in a way that they would not usually together in a business setting and it enabled a different energy in the workshop. It also allowed the team to put emphasis on this unfamiliar space as a 'liminal' and safe environment in which students could be mentally and physically creative.

Closely connected to this 'safe' space was the use of 'play'. The creative, collaborative and therapeutic benefits of playing games are widely agreed in our society and in the rehearsal room game-play is hugely beneficial to warm up, ensemble building and devising. Callery explains that play is an effective means to develop ensemble and references companies such as Theatre de Complicité, Theatre Workshop, and Peter Brook's troupe as practitioners whose emphasis on play has lead to exceptional quality in their performance work (94). Theatre practitioner Clive Barker describes the power of game-play in its ability to unlock a childlike inhibition-free approach in adults, identifying that "Children's games are a readily accessible, and seemingly acceptable, framework for releasing physical and emotional energy. Pressure is released, and the human being is to some extent made free, in a framework which is not susceptible to social criticism – provided the sessions are billed under some intellectually acceptable heading as 'Exploration of Theatre' of 'The Process of Acting'..." (64) – or in our case, 'Management and Creativity'.

Games were an integral 'warm up' activity in our sessions and very beneficial in early sessions, when we found, like Barker, that in "games session[s], the actors, participating unselfconsciously in a flow of activities, reveal themselves in action" (65). Barker explains:

> Every human being has, naturally, differing strengths and weaknesses and clear movement characteristics. In the playing of games one is able

to 'read' the class, to get what information one can about the people one is working with; what areas of physical work come easily to them, and where they need to develop (65).

Thus, like Barker, we were able to identify the ability of participants – collectively and individually – and vary our selection of and to approach subsequent games and exercises, as identified earlier. The release of energy and inhibition in games at the beginning of workshops brought the group together – developing their ensemble and teamwork skills – and generated energy for the session, as well as a relaxed and playful atmosphere essential to successful ensemble and devising work.

Another key objective was risk-taking, which was also explored through games and play. This was in part involved naturally through the process of MBA students experiencing practical exercises that were unfamiliar or new to them – especially students that had not encountered any devising and performance exercises in a theatre environment – which instinctively involved commitment and a degree of risk-taking for the individual. The nature of the exercises that the team set for participants involved risk-taking through different levels of participation – such as students exploring their physicality in group movement exercises; individually discussing personal responses to pieces of art and performance; or improvising during performances to create material spontaneously (which can involve a huge deal of personal risk). Being aware that this approach took students out of their comfort zone, they were encouraged to approach tasks free of inhibition, which a safe environment and relaxed game play were key in enabling, and this objective contributed to developing self-confidence and a supportive group environment. Lesavre, in his reflection on employing theatre within the MBA programme at Grenoble, identifies play as a way of establishing an "equal playing field" for management participants (245). "The novelty of these 'strange' games means that all participants are beginners, which makes the watching eyes of others less disturbing" (246). He notes that play can build trust and allow for the release of inhibition which, in turn, leads to greater self-confidence. This certainly seemed to be true at Royal Holloway as students reported that they felt the course brought them "closer together" and increased confidence.

A striking learning point for the team has been the difference between the two cohorts that have now passed through the programme. During workshops in the second year of the course, the team quickly discovered a noticeable difference in the approach and temperament of the students to that of the first year; requiring

a change in approach, exercises, and tasks, due to their collective backgrounds, skills, and temperament. This highlights the importance of using exercises tailored to, or chosen, with the specific group in mind; one set course template is not appropriate for all groups of MBA students and flexibility within the course structure is required. This brings with it challenges to the planning and delivery process, which is of course present in many drama workshops and programmes, in the need for the workshop leader to tailor exercises to skills or the interpretation by participants – during workshops as well as in planning. This flexibility in delivering a practical workshop is encouraged by Barker:

> In running games sessions I have never more than the first game in my mind, and this is always a release-of-energy game. From then on I improvise...Like all meetings, the games session runs on a pattern of demand and response. I make a suggestion or issue an invitation and the group responds by playing (each group tends to throw up its own specific character; if it doesn't, I don't have a group, just a collection of individuals, and the first task is to use games that will bring them into contact with each other) (67).

Responding to the group was central to the working methodology of the course as we looked to build ensemble. So, for example, we noted early on with the second cohort that emphasis in developing aural skills was required and so we looked to build in exercises which encouraged listening.

IMPACT

Questionnaires were issued to students in the second year of the programme. Feedback covered the following and were generally positive about the invitation to participate in an exploratory journey. Comments from the questionnaires indicated that the learning objectives had been met:

Experience a peer learning environment that fosters a sense of democratic collegiality:

Photo Credit: John Hunter

"The atmosphere of listening to each other and no judgement approach is very helpful to us"
"It bonded us together"

Develop management skills through creative activity:

Photo Credit: John Hunter

"I have to deal with clients every day and it helped me to have patience and pay more attention to listening"
"We have to work with different types of people – the workshops helped me to have a better understanding of people"
"It will help me in handling messy situations in a creative way"

Develop self awareness

Photo Credit: John Hunter

"I learnt a lot from the group and about myself"
"[The course] taught me to see things different [sic] and be confident"

Encourage risk-taking

Photo Credit: John Hunter

"I was a shy person but I was very happy in this class to behave freely"
"[The sessions] brought many people out of their comfort zone"
"I do not share personal feeling with others but this class helps me a lot"

Develop the ability to communicate verbally and non-verbally

Photo Credit: John Hunter

"I have better knowledge of how to interact with other team members"
"I've learnt the most important thing is to listen"

FACTORS WHICH CONTRIBUTED MOST TO THE SUCCESS OF THIS CASE

At the centre of this project was a commitment to finding a creative synthesis for interdisciplinary work. The faculty learnt about similarities and differences in approaches within the participating departments and sought to find productive points of interchange from which to begin. This work has prompted research that seeks to develop a theoretical framework for this area of enquiry as well as creative methods for facilitating students' learning. The programme won a University of London team teaching prize for its interdisciplinary, creative teaching methods and was featured in *The Guardian* for a 2013 feature on innovation in international MBA programmes.

In both years a final performance has been an important element of the module, providing a summative moment in the course. Although this was not formally assessed, the task brief encouraged students to draw on their learning from the course. Their achievements were recognised in the tutor and peer feedback following the presentations. In the coming year the team are looking to develop the module to feed in more directly to the core curriculum in leadership and management. This will provide new challenges as external factors will reduce the flexibility of the summative assessment process.

REFLECTIONS ON ASSESSMENT

Until this point the course has had no formal summative assessment. The final presentations were conceived as a cumulative moment in the process, created through drawing on material from the course and presented in the final session. The brief for this task was designed to give enough structure to hold the students' process while allowing them space to explore areas of interest. The presentations proved to be an important moment in the course, which students approached with great commitment. There was demonstration of learning both in the presentations themselves and also in the feedback sessions that followed as students critiqued their own work and the work of others.

In developing this work towards a formal assessment point we would look to strategies already employed within the drama department. When assessing practical presentations we mark according to: understanding and content; knowledge; inventiveness; performance skills; and group dynamics. An important element of practical assessment is an individual written process log, which should demonstrate good organisation, time management, engagement and research, and reflect critically on both process and performance. For MBA students we would

clearly moderate expectations in performance skills but, while these are moderated down, our expectations in terms of organisation and group dynamics would be enhanced.

We would also be aware, when working with the MBAs, of the need to prepare students for this form of assessment and marking criteria, which is likely to be unfamiliar to them. For this we would expand on our workshop practises, which offer feedback after each practical exercise and look to develop a formative point of assessment around a more developed workshop exercise which could allow the students to understand the process and gain an understanding of where they sit in terms of assessment.

At this point in the development of the course we have been happy to use self-assessment as an indicative tool. As Marienau notes in her study of adult learners:

> The findings indicated that self-assessment serves as a powerful instrument for experiential learning, strengthens commitment to competent performance in the workplace, enhances higher order skills for functioning in the workplace, and fosters self-agency and authority (1999: 135).

As the module looks to employ embodied learning to develop skills for the workplace, we believe that self-assessment is an important mode of assessment and would continue to embed it as the curriculum develops.

CONCLUSION AND SUMMARY

As part of its continuing development, the MBA programme at Royal Holloway looked to draw on expertise within a college that has proven strengths in the arts. The initial identification of learning outcomes that were deliverable through arts-based activity was fairly straight-forward but the real challenge was finding a common vocabulary that enabled students to engage fully and understand the activity as integral to their learning. The notion of creativity served as a common denominator and recognised both personal and group creativity as important to this cohort. The notion of ensemble proved to be a useful foundation for the intervention which provided a focus for the learning outcomes around peer-learning, self awareness, and communication.

REFERENCES

Barker, C. 2010. *Theatre Games*: *A New Approach to Drama Training*, London: Methuen.

Callery, D. 2001. *Through the Body*, London: Nick Herm.

Datar, S, D Garvin & P Cullen. 2010. *Rethinking the MBA: Business Education at the Crossroads*, Cambridge: Harvard University Press.

DeGraff, J & K Lawrence. 2002. *Creativity at Work: Developing the Right practices to Make Innovation Happen*, London: John Wiley.

Lesavre, L 'Are theatre and business links relevant? A conceptual paper and a Case study', *Journal of Management Development*, 31.3. (2012): 243-252.

Marienau, C. 1999. 'Self-Assessment at Work: Outcomes of Adult Learners' Reflections on Practice', *Adult Education Quarterly*, 9: 3: 135-146.

Radosavljevic, D (ed) .2013. *The Contemporary Ensemble: Interviews with Theatre-makers*, London: Routledge.

Rogers, C. 2004. *On Becoming a Person*, London: Constable.

Whyman, R. 2011. *The Stanislavky System of Acting: Legacy and Influence in Modern Performance*, Cambridge: Cambridge University Press.

Recruiting Students, Cultivating Learning Outcomes, And Implementing Assessment Procedures For A Redesigned Chamber Music Course At The University Of Arizona
Theodore Buchholz, D.M.A.
University of Arizona, School of Music

INTRODUCTION

The University of Arizona is a large state institution catering to 40,000 students with a music school embedded as a conservatory within the larger University setting. The School of Music is home to 500 undergraduate and graduate music majors.

The String Chamber Music Course at the University of Arizona currently instructs thirty string students. This is the highest enrollment for this class in the last five years as past semesters typically enrolled eight to ten students. The increased enrollment coincided with a redesign of the course aimed at defining learning objectives, grading criteria, and a vision for the course. The course is led by one faculty member and assisted by three other string faculty who provided weekly coaching to the student ensembles.

This new energy and mission for this course developed and included promises to students that their efforts would be rewarded with a curriculum that offered meaningful and engaging learning outcomes.

DESCRIPTION OF THE PROBLEM/OBJECTIVE

Developing a successful and effective chamber music course is no easy task. It is tempting to simply arrange students in ensembles, coach the ensembles each week, and then conclude the semester with a performance. In an effort to reinvigorate the chamber music program at the University of Arizona, the faculty decided a new approach must be embraced.

The inherent issues in such a course include recruiting and selecting appropriate student groups, focusing on learning outcomes, and establishing an assessment policy that is structured and reflective of student contribution and achievement.

Many students enter the course at disparate performance and maturity levels. Coordinating appropriate matches in ensembles is not simple, and like assembling groups for group projects, ensuring commitment from all members is an important goal. The members of a group will work very closely for five hours of work each week.

The majority of the learning in a chamber music course takes place during student-scheduled and student-led rehearsals, meaning an important learning outcome is developing student ability to effectively self-rehearse. It is a risky proposition to ask a group of eighteen-year-olds to effectively manage and communally share leadership with colleagues. The faculty determined that the first class meeting must focus on strategies for self-rehearsal, setting the tone for the semester.

Clear assessment in an arts curriculum can be a challenge especially in a national higher education culture that seems to promote grade inflation. Creating a new assessment procedure was one of the privileges of revamping this chamber music course. The goal was to develop a clear and student-interactive policy thatoffered the chance to evaluate their own progress and effort.

Challenges to Solving the Problem/Reaching the Objective Strategies/Creative Ways of Solving/Reaching the Objective

Recruiting – Group Placement

The first step toward an effective course was recruiting students. The challenge was that music majors are not required to take this course. However, based on the potential learning experience in this redesigned course, the string faculty hoped students would enroll whether or not the credits were needed to graduate.

The coordinator adopted an attitude of "positive pushiness:" heartily encouraging students to register for chamber music class by describing the rewarding experience developing ensemble skills, abilities to problem solve in rehearsal, and performance opportunities. The target students were any student with significant string playing experience. Being a music major was not a requirement. The faculty promoted the course at orchestra auditions, and flyers for the course were posted in the music building and around campus.

Managing disparate student levels required recruiting a larger pool of student participants so that the best ensemble placements could be made. Creating a larger, more diverse, and stronger body of student musicians raises the caliber of the course. Ultimately this makes recruiting more successful in future semesters.

Learning Outcomes

Chamber music provides a unique opportunity to develop students' skills. It is music making that comprehensively engages students. The study of chamber music is especially well-suited to developing individual responsibility, promoting student recognition, and creating student leaders. Small ensembles are also an ideal way to manage musical issues such as excellence in tone, rhythm, intonation, articulation, and dynamics. A challenge is that many students have little exposure to chamber playing or self-rehearsing.

The course syllabus listed five learning outcomes: knowledge of essential chamber repertoire, ability to effectively rehearse, improved ensemble skills, ability to negotiate performance anxiety, and leadership in music making. It seemed evident that developing the ability to self-rehearse would open the door to other learning outcomes.

Self-rehearsal allows for greater success in a music program. Stronger small ensembles mean a stronger school and a stronger music community. Enabling

students to manage their own rehearsals teaches leadership in music, which might be the most important thing a young musician can learn.

Each ensemble learns one entire piece from the standard chamber music literature each semester. The first step in approaching the piece is for each student to mark the musical score with important information. First, students mark adjectives that describe the music. Then they mark unison or similar rhythms, places to match bowings, large structural divisions, and the hierarchal layering of parts. This process allows each student to have a basic sense of how the component parts should be put together to create a unified work or art. Marking the score is an important step for a student to be able to lead a rehearsal.

Each student is assigned to individually lead a rehearsal and create a written rehearsal plan. The plan typically includes preliminary exercises to address upcoming issues, a list of sections to work on, and how to rehearse those sections. Then a final play through is often tape recorded and analyzed by the students. The document is turned in for credit. An example follows:

Figure 6.1: 	Rehearsal Plan

Rehearsal Plan
Musical and Technical Practice Aid

The word score serves as a way to unify the various elements of learning a challenging piece of music. This visual aid combines the phrase structure, musical content, technical demands, and most importantly the tools and resources that enable the musician to overcome the demands of work.

Directions:
1. Segment a work by finding the musical phrases. Write down the number of bars.
2. List adjectives to describe the music or write what the music is doing (cresc., dim, etc).
3. List what will be technical issues that will pose challenges.
4. Detail several practicing techniques that will enable the mastery of those technical challenges.

4 measures: forte, bold, resolute, declarative, crescendo through the 4th bar
Technical Issues: rhythm: subdivide 16ths, use metronome
	Tuning the extension in bar 1: extended exercises, slow practicing, play B major scales
	Shifting in bar 3: isolate and repeat
	Tuning the chords: individual note tuning (vertically or horizontally), sets of double stops,
		slow work 		in triple stops, practice the individual voices

4 measures: bolder, ff dynamic, resolute, declarative, this is a response to the first four bars
Technical Issues: rhythm: subdivide 16ths, use metronome
	Tuning the extension in bar 1: extended exercises
	Shifting in bar 3: isolate and repeat
	Tuning the chords: individual note tuning (vertically or horizontally), sets of double stops

4 measures: fz emphasis, 2nd bar stronger, bars 3 and 4 lead through to the next section
Technical Issues: 16ths clarity: practice without the bow
	Shifting between beat 1 and 2: isolate and repeat
	Rhythm of the dotted 8th tied to a 16th: use metronome, subdivide, building tempo on the metronome
	Practice this rhythm, bowing and articulation style with daily scales

4 measures: arrives strong on the first beat but then has a searching character
Technical Issues: Intonation: more or less a diminished harmony: practice slowly and use a tuner, piano, drone, etc.
	Sound quality on the fp: attention to bowing speed, weight, and vibrato usage
	Rhythm of triplets: subdivide on the whole note, use of metronome
	Practice this rhythm, bowing and 		articulation style with your daily scales

7 measures: arrives strong on the first beat but then turns into a highly excited search for an arrival in b minor
Technical Issues: Intonation: practice without the trills. Aim a little sharp for the upper note of the trill
	Then practice with a "ghost trill" (trilling on the d string but only playing the solid note on the A string
	Trill speed: practice scales with trills, practice Cossmann's finger trill exercises
	Shifting: practice "one-finger" chromatic scales, isolate and repeat the shift to the high D

4 measures: an arrival in B minor, energetic character, can be broken down further into two two-bar units
Technical Issues: rhythm: subdivide 16ths, use metronome
 Tuning the hand positions: practice the "octave frame", slow practice, use of different rhythms
 Shifting from beat 3 to 4: isolate and repeat the B to B shift, practice shifting to an octave frame
 Articulation and bow stroke: practice this bowing style and rhythm daily with scales

6 measures: an energetic character, can be broken down further into three two-bar units, swells in the dynamics
Technical Issues: spiccato bow strokes
 Shifting in bar 2: G to F: isolate and repeat the shift, practice shifting to an octave frame
 Create exercises that circle around these positions, use different rhythms
 Articulation and bow stroke: practice this bowing style and rhythm daily with scales

4 measures: an agitated character, fz and accent articulations, melodic fragments contained with a perfect fourth, crescendos over 4 bars
Technical Issues:
 Intonation: the hand frame position: practice one octave scales in thumb positions, delayed continuity
 Shifting from B to A#: isolate and repeat the shift, use of rhythms
 Create exercises that circle around these positions, use different rhythms
 Bow: bow speed, weight, and vibrato for the accents and fz, adding more sound as this section intensifies

4 measures: an agitated character, fz and accent articulations, diminuendo and crescendo
Technical Issues:
 Intonation: the hand frame: half step and whole step hand position
 Practice only the odd numbered notes for the basic framework
 Practice with separate bowings slowly, use of different rhythms
 Repetitively practicing the shift from the 3rd to the 4th bar (C# to F#)
 Delayed continuity: groups of 3 notes, then 5 notes, then 9 notes, then one bar at a time
 Release left hand tension: relax thumb, be aware of an extraneous motions
 Create exercises that circle around these positions, use different rhythms
 Tempo building using the metronome from **40 = EIGHTH** note to tempo (quarter = 116+)
 Bow: bow speed, weight, and vibrato for the sound as this section intensifies while keeping a clear sound

8 measures: an arrival in B minor, appassionato, declarative rhythms, swooping character to the high G then relaxing down an octave
Technical Issues:
 Intonation: the hand frame position: practice one octave scales in thumb positions, delayed continuity
 Isolate and repeat the many shifts in this passage, use of rhythms, separate bowings, delayed continuity
 Create exercises that circle around these positions, use different rhythms
 Bow: bow speed, weight, and vibrato for the accents and fz, adding more sound as this section intensifies

 Then you are ready to build metronome tempo from 1/3 tempo to just above tempo ridding any extra or tense motion. Focus carefully to intonation, rhythm, sound quality, and phrasing.

The rehearsal leading assignment seeks to build leadership and strategizing abilities. This is often harder for shy students, but ultimately helps them

participate equally. Once each member has had a turn to lead a rehearsal, his or her ability to collaborate in leadership has grown.

Problem solving rehearsal strategies were discussed early in the semester. The following table was distributed for students to use as a touchstone in creating their own innovative solutions to ensemble problems.

Table 6.1: Rehearsal Techniques for Addressing Common Issues

DIFFICULTY	SOLUTION
Sound Quality	"Kreisler highway:" analogy to driving: speed, weight, bow placement Assign orchestration to the different phrases
Matching Bow Strokes	"Telephone" game: each person plays 1 note as the line is passed around Half of the group plays, the other half observes Visualized bow strokes: shapes that describe the sound Add one player at a time Half of the group plays, the other half observes Play softly to listen carefully
Bow Direction	Stop after each measure to check direction Airbow: play the piece with the bow in the air Reverse the bowing
Intonation	"Telephone" game: each person plays 1 bar as the line is passed around Half of the group plays, the other half observes Note by note Have half the group hold a drone note Stop and hold the note on strong beats or difficult notes Use different rhythms Play softly to listen carefully Sing the notes Additive practice technique: play only the first note, then two notes, then three, etc. adding one note each time Pitch telephone game
Difficult/Fast Passages	Additive practice technique: play only the first note, then two notes, then three, etc. adding one note each time Use different rhythms or different bowings Delayed continuity: use pauses between groups of notes Metronome building Pluck with the same finger as the left hand
Shifting	One finger scales Stop and hold the note after the shift

Ensemble/ Tempo	Play pizzicato "Telephone" game: each person plays 1 bar as the line is passed around Half of the group plays, the other half observes Add one player at a time, until are all playing Human metronome: one person plays a continuous subdivision Have each person face out, so no one can see any other person, and is forced to rely on aural rather than visual cues Play softly to listen carefully
Matching Vibrato	"Telephone" game: each person plays 1 note as the line is passed around Half of the group plays, the other half observes Close eyes and listen Remove the vibrato, and then put it back in one person at a time Play softly to listen carefully
Phrasing	"Telephone" game: each person plays 1 bar, as the line is passed around Half of the group plays, the other half observes Tension and release in music – always search for better ways to build tension and to release it in the big and little picture Role play as a great expressive virtuoso Bowing shapes: visualize the shape the bow is making Reverse the bowing

An important component of self-rehearsal is for each student to plan how to make improvements for themselves and the group. The course encouraged students to constantly develop critical thinking. One useful tool was the consistent application of the rubric shown in Figure 6.2. This rubric asks each member and the collective group to weigh how their own performance can be related to the group, and what steps the individual and ensemble might take to improve their next performance.

Figure 6.2: Student Self-Improvement Rubric

	What I did	**What I could do**
What we did		
What we could do		

Assessment

Each coaching, master class, and performance was assessed for preparation, punctuality/attendance, and performance. The entire group submitted a mutually agreed upon grade worth 20% of the final grade. The faculty coach's assessment was worth 30% of the final grade. The written components of the course represented 10% of the grade, as did each of the two master class performances. The final performance was worth 20% of the grade. The course also awarded extra credit for projects such as additional performances at K-12 schools or other community venues. See Table 6.3 below.

Table 6.3: Assessment Percentages

Written rehearsal plan	10%
Master class performance 1	10%
Master class performance 2	10%
Faculty coach grade	30%
Agreed upon group grade	20%
Final performance	20%
Possible extra credit	up to 5%

String Chamber Ensemble

Course Information

Course Prefix/Number: **201/501 MUS LAB**
Course Title: **Coached Ensemble**
Semester: **Fall 2014** Class Days/Times: **Tuesdays 2:00 – 3:50**
Site/Room: **114 and TBD** Rehearsal and Coaching times: **TBD**
Credit Hours: **1** Pre-requisites: **Audition**

Instructor Information
Name: **Dr. Theodore Buchholz**
Phone/Voice Mail: **(520) 621-7012**
E-mail: **buchholz@email.arizona.edu**
Availability: **Office hours - Room 217: Weds. 2:00-4:00, Thurs. 1:00-
2:00 and by appointment**

Course Materials
Students supply their own instruments and accessories (tuners and metronomes). Chamber music parts and scores can be checked out from the Fine Arts Library. It is the student's responsibility to maintain and return sheet music. Students should find access to recordings of the works performed through the library. Other assignments and readings will be distributed in class or on Desire to Learn (D2L).

Course Description
The vitality of performing ensembles is essential to the mission of the music department, and also enriches the school and greater community. This course prepares students for performance of exceptional and diverse chamber repertoire. The study of this repertoire will build strength of ensembles through a progressive sequence, promote artistic excellence, and create a fulfilling performance experience for ensembles and musicians. The course will include weekly rehearsals, coachings, fortnightly master classes, and special performances. This course is designed for music performance majors, music education majors, and non-majors.

Course Objectives
Upon completion of the course, the student will have developed:

- Knowledge of essential chamber and ensemble repertoire
- Ability to effectively rehearse
- Improved ensemble skills including rhythm, intonation, tone, phrasing, articulation, and musicianship

- Ability to negotiate performance anxiety
- Leadership in music making

Course Outline, Content, and Requirements
Students enrolled in the course will:

- Select appropriate repertoire with the assistance of your coach and Dr. Buchholz
- Establish and adhere to a consistent rehearsal time every week
- Attend one coaching each week
- Attend the master classes that meet every two weeks. See the schedule below.
- Perform in select Tuesday master classes as determined by your coach and Dr. Buchholz. Bring extra copies of the score to the class.
- Prepare a complete chamber work to performance level.

For an ensemble to function at its optimal level and maximize each student's experience, regular daily practice outside of rehearsal is required. Part assignments are made on a semester basis.

Course Schedule
Tuesday 2:00 – 3:50 Master Classes

8-26-14	Course overview What makes for an excellent ensemble? Rehearsal techniques
9-2-14	No class
9-9-14	Ensembles perform (Theodore Buchholz leads this master class) Intonation Discussion (co-led by Graduate Quartet)
9-16-14	No class
9-23-14	Ensembles perform (Theodore Buchholz leads this master class) Extra credit project discussion
9-30-14	No class
10-7-14	Ensembles perform (Philip Alejo leads this master class) Discuss favorite chamber music repertoire
10-14-14	No class
10-21-14	Ensembles perform (GTA Quartet leads this master class) Speaking to audiences and Eric Booth article
10-28-14	No class
11-4-14	Ensembles perform (Hong-Mei Xiao leads this master class)
11-11-14	No class (Veterans Day)
11-12-14	Note: this is a **WENDESDAY at 7:00 PM**: Margaret Hiller Master Class
11-18-14	Ensembles perform (Lauren Roth leads this master class)
11-25-14	No class

12-2-14	Performances (or possible showcase performance, venue TBD)
	Course evaluations
	Discuss potential repertoire, plans, concepts for next semester

Grading

This course is taught by a very demanding teacher. Grading is based on real-world expectations of what is needed to succeed in music. The ensemble course is a class-participation, performance-oriented course. It is expected that each member will attend all rehearsals and performances and to master his/her individual parts through focused individual practice. Each member must be committed to the group to ensure the highest artistic level. Lateness and absence are detrimental to the ensemble, and thus detrimental to your grade. Therefore, grading will be assessed based on your participation and progress in the ensemble. An extra credit project is offered.

Written rehearsal plan	10%
Master class performance 1	10%
Master class performance 2	10%
Faculty coach grade	30%
Agreed upon group grade	20%
Final performance	20%
Possible extra credit	up to 5%

Grading scale: 90-100 = A; 80-89 = B; 70-79 = C; 60-69 = D, below 60 = F
Extra credit project Up to 5 points added to the final grade

Extra Credit Projects

These extra credit projects can be a path towards leadership in music performance and education, which might be the most important thing you can learn in this course.

Performance Opportunities

Ensembles are encouraged to take every possible performance opportunity including master classes, additional end-of-semester recitals, a nursing home recital, an alternative venue performance, and any other performances throughout the semester. There may be occasional guest master classes. Students are advised to regularly perform in any venue including community centers, public schools, and churches.

Clinic/performance at public school

Visit local public schools and either offer an educational concert, musical discussion, or performance. This is an opportunity to perform a piece you have been working on and to reach out to an audience about the value of classical music. If you choose this project, I will arrange the visit and will be there to supervise.

Attendance

Attendance and class participation are an important component of the course grade. Therefore, students must attend all meetings. Unexcused absences will result in a lower course grade. Note the following policies:

- Absences due to documented medical or family emergencies will be excused
- Absences due to required college-sponsored events will be excused
- Absences for religious observances or holidays will be excused
- Any other absences will be unexcused
- Notify the instructor of an absence as soon as possible
- Being late twice will result in one unexcused absence
- Attendance is taken promptly at the starting time

Caveats

The instructor will make every attempt to follow the above procedures and schedules, but they may be changed in the event of extenuating circumstances.

Classroom Behavior

- Turn cell phones to silent during coachings, master classes, and performances
- The Arizona Board of Regents' Student Code of Conduct, ABOR Policy 5-308, prohibits threats of physical harm to any member of the University community, including to one's self. See: http://policy.web.arizona.edu/threatening-behavior-students

Special Needs and Accommodations Statement

Students who need special accommodation or services should contact the Disability Resources Center, 1224 East Lowell Street, Tucson, AZ 85721, (520) 621-3268, FAX (520) 621-9423, email: uadrc@email.arizona.edu, http://drc.arizona.edu/. You must register and request that the Center or DRC

send me official notification of your accommodations needs as soon as possible. Please plan to meet with me by appointment or during office hours to discuss accommodations and how my course requirements and activities may impact your ability to fully participate. The need for accommodations must be documented by the appropriate office.

Student Code of Academic Integrity

Students are encouraged to share intellectual views and discuss freely the principles and applications of course materials. However, graded work/exercises must be the product of independent effort unless otherwise instructed. Students are expected to adhere to the UA Code of Academic Integrity as described in the UA General Catalog. See:
http://deanofstudents.arizona.edu/codeofacademicintegrity/.

Acknowledgment and Receipt of Syllabus: Please fill in and return the following acknowledgment by the second class meeting:
Name _____
Phone #_____
E-mail Address_____
____I have received my course syllabus (including course objectives, policies, requirements and schedule) and have read and understood all the enclosed materials.
Regarding contacting the student:
____I have no objection to receiving an occasional call from the instructor at the number given with my registration materials.
____I prefer that the instructor not call or contact me by phone anytime during the semester.

Regarding waiver of the performer to allow recordings of performances to be broadcast on public media and/or online:
____I have no objection to allowing recordings of performances to be broadcast on public media and/or online.
____I prefer to not allow recordings of performances to be broadcast on public media and/or online.

_____ _____
Signature Date

Student participation within the coaching or master class was evaluated based on punctuality/attendance, preparation, and performance. Figure 6.3 depicts the TRIAD Rubric (Tone, Rhythm, Intonation, Articulation, Dynamics) that was used to guide the faculty on assessing preparation and performance.

Table 6.4: "TRIAD" Performance Assessment Rubric

	Minimum 70%	Average 80%	Highest Level 90%
Tone	Acceptable sound quality reflecting acceptable technique and musicianship	Fine tone quality with few errors in tone production	Superb tone quality reflecting excellent technique and musicianship
Rhythm	Some inaccuracies but the performer is able to realign after a mistake	Mostly accurate rhythms: some complex rhythms not entirely accurate	Superb rhythm reflecting excellent technique and musicianship
Intonation	Some mistakes in intonation but the performer is able to regain proper pitch	Mostly accurate intonation: occasional brief mistakes in pitch	Superb intonation reflecting excellent technique and aural ability
Articulation	Articulation choices are present and in the correct style	Articulation reflects various characters in the music	Articulation choices project artistic decisions
Dynamics/musicality	Dynamics and musicality are evident yet lack refinement	Dynamics and musicality are organized and projected	Dynamics and musicality are artistic and compelling

Accomplishments

Based on enrollment, student feedback in course evaluations, and the success of student performances, this course accomplished important goals.

Thirty students joined the course, and all were music majors. This healthy enrollment tripled the numbers from previous semesters. Student course evaluations reflected an 89% positive rating of the learning experience. The course culminated with successful student performances. Each of the nine ensembles performed their prepared repertoire for public audiences. Students coordinated two concerts including advertising, promoting, running the events, posting the concert videos online, and achieved a high caliber of performance success.

Factors That Contributed Most to the Success of the Assessment

A significant factor that contributed to the success of this course was each student's sense of ownership over the course content. The course was designed to promote student ability to self-navigate many aspects of music from rehearsal to the entrepreneurial skills required to organize a concert. The course also offered students the opportunity to self-assess their own work as 20% of their final grade.

The end of semester performances would not have been so successful if students had not been able to effectively self-rehearse. The instructor initially was concerned that a written assignment in a performance course would not be received well. After the course ended many students mentioned how much they had enjoyed creating the written rehearsal plan.

Group work can be a challenging situation due to the nature of personal interactions. Students appreciated the chance to assess a portion of their grade. One of the groups that initially struggled ultimately succeeded with a positive performance and rehearsal experience. When that ensemble was asked to self-assess themselves with a letter grade they decided on a realistic 'B'. The faculty appreciated all the ensembles abilities to honestly evaluate their work.

CONCLUSION AND SUMMARY

The vitality of performing ensembles is essential to the mission of a music department and enriches a school. Further, building a stronger chamber music course enriches the community through public performances, and provides tools and experiences for the students to become leaders as performers, educators, or arts administrators in the real music world.

A goal of this course was to prepare students for the performance of exceptional chamber repertoire and to apply that learning experience when shaping their music careers. The performances and extra credit assignments offered students outreach to the community with meaningful classical music

experiences. As this course continues in future semesters, a goal will be to delve deeper: find new ways to teach music leadership in the twenty-first century through chamber music.

Most students indicate they will take this course in future semesters. Faculty will continue to develop and adapt strategies as goals and new learning outcomes continue to evolve.

Strong Institutional-Assessment Culture Encourages Faculty
to Create Meaningful Discipline-centered Assessments
Chris Gray and Robin Berkley
Illinois Central College

Subject Matter of the Case Study: Course level goals.

This case study explores how an assessment framework led to an Acting Scene Rubric used for beginning and advanced acting courses. Given that the acting courses in a community college are not required curricula leading to a specific theatre degree, no program goals exist. Therefore the level of assessment comes from course level goals.

INTRODUCTION

This case study explores how one institution built a culture of assessment providing the necessary training, support, and resources that encourage faculty members to apply assessment principles in their own disciplines. While the institution has well-defined practices for assessing general education and programs, there are few guides for arts-programs, especially in the community colleges to create meaningful assessments. Given that the acting courses in a community college are not required curricula leading to a specific theatre degree, no program goals exist. Therefore the level of assessment for arts in the community college often comes from course goals. This case study traces how theatre faculty, supported and encouraged by an institutional culture of assessment, created rubrics to be used in acting courses.

BRIEF BACKGROUND ON THE INSTITUTION/PROGRAM

Illinois Central College (ICC) is a comprehensive community college serving the Peoria, Illinois area. ICC offers transfer degrees and applied science degrees and certificates. Students interested in pursuing theatre enroll in an Associate of Arts degree. The Associate of Art degree is a 60 credit hour degree, which contains a

general education core of 37 credit hours; the remaining 23 credit hours are electives. Theatre students use elective hours to take courses in acting, directing, and technical theatre. While the program considers these students theatre-majors they are technically enrolled in the broad degree with no specific requirements. In other words, there is not a specific theatre degree and students are only encouraged to take the theatre course sequences if they plan to major in theatre.

ICC's assessment journey began in 1992 as a result of a self-study visit from its regional accreditor, the Higher Learning Commission (HLC) of the North Central Association. ICC began preparing bi-annual Institutional Outcomes Reports until 1996 when the regional accrediting body shifted their focus to student academic outcomes assessment. The college responded by forming an Assessment Committee to collect classroom assessment activities and used an AQIP (regional accrediting continuous improvement model) to assess general education goals across the curricula. In 2010 the college shifted its assessment focus as a result of guidance from the regional accrediting body, and under new leadership created a comprehensive process where course goals are assessed each semester, programs are assessed annually, and general education goals are assessed on a three-year cycle. The Assessment Committee has also used departmental assessment advocates, created an annual assessment fair, and created an assessment academy to support and encourage faculty to use assessment as a means to improve learning. The assessment culture at ICC has certainly changed and assessment is now a driving force on the campus.

ICC's theatre program serves 30-40 students annually offering coursework and four productions. Students take coursework in acting, directing, technical theatre, costume, and make-up, and they are expected to be actively involved in the productions through practicum (see Table 6.5). The production value is high for the program as the college supports the program with robust budgets, space, and staffing. In addition to two full-time faculty members and four adjunct faculty members, the college employs a technical director, scene-shop foreperson, costume shop supervisor, front-of-house staff, and student technicians to mount the four productions.

Table 6.5: Required Program Courses

Course	Name	Credit Hours
THTRE 113	INTRODUCTION TO TECHNICAL THEATRE	3
THTRE 114	FUNDAMENTALS OF THEATRICAL DESIGN	3
THTRE 115	STAGE MAKE-UP	2
THTRE 118	THEATRE PRACTICUM	1
THTRE 119	THEATRE PRACTICUM	1

THTRE 122	ACTING I	3
THTRE 123	DIRECTING I	3
THTRE 210	INTRODUCTION TO COSTUMING	3
THTRE 218	THEATRE PRACTICUM	1
THTRE 219	THEATRE PRACTICUM	1
THTRE 222	ACTING II	3
THTRE 223	DIRECTING II	3

See specific requirements for Associate in Arts Degree

Description of the Problem/Objective:

The college's assessment processes and reporting are focused on general education goals and programs (with theatre not being an official program but instead a suggested course of study within a broader transfer degree). The college-wide emphasis for faculty teaching in the Liberal Arts and Sciences is primarily general education, but the faculty value their own disciplines and see their roles as both offering general education for all students *and* preparing future majors in their discipline for successful transfer. Given a robust assessment culture with training and support at ICC and the lack of a specific theatre degree with a unique mission and student learning outcomes, ICC theatre faculty are challenged to create assessments that are meaningful to their discipline, courses, and students. Specifically Robin Berkley, Professor of Theatre, sought to create meaningful assessments for her acting coursework.

CHALLENGES TO SOLVING THE PROBLEM/REACHING THE OBJECTIVE

The challenge to creating meaningful assessments for an acting sequence were threefold. First, the theatre faculty expressed concern that formalizing assessments would minimize the formative and verbal processes currently used to critique students' growth in acting and serve to minimize and standardize the complex process of acting. Second, the lack of empirical data on assessment in acting and the resistance of the theatre discipline to accept and adopt assessment practices led ICC faculty to believe theatre was ineffable. Finally, there were no formal program goals.

STRATEGIES/CREATIVE WAYS OF SOLVING/REACHING THE OBJECTIVE

The institutional-assessment culture and assessment initiatives had created an environment where faculty felt encouraged and compelled to utilize assessment

techniques in their classes and programs. In order to create a meaningful assessment for the acting sequence it was necessary to address each of the three obstacles, which included faculty resistance, a lack of discipline-specific examples, and a lack of formalized theatre-program goals.

The first and largest obstacle was the theatre faculty's resistance to assessment as it was presented to the faculty. ICC's assessment practices evolved over the last twenty years and many of the early expectations that came from the Assessment Committee were later abandoned. The change of course and rotating requirements left faculty skeptical and in compliance mode. Examples of the changing expectations that were later abandoned included requiring each course to assess a general education goal and connecting each course goal to a general education goal. Further almost all early Assessment Committee expectations involved marking a checkbox or filling in a box with an emphasis on completion. These changes led the theatre faculty to be skeptical that any assessment initiative would last or be meaningful to student learning.

However, ICC refocused assessment efforts beginning around 2010 to create assessment activities that were research-based and data-driven, grounded in best practices, and were designed with faculty input. The latest assessment plan for ICC includes:

- a minimum of one course goal being assessed each time the course if offered,
- assessment advocates in each academic department to serve as resources, mentors, or liaisons,
- general education assessment occurring at the institutional level,
- professional development for faculty to learn about, apply, and lead assessment activities, and
- usage of assessment results to budget, plan, and revise curricula.

Specific to course level assessment, a new form was created that asked faculty to assess one course goal each time the course was offered by identifying the instrument/tool/assignment, the outcome and an evaluation of the results, possible changes to improve the outcome, and recommendations for planning based off the assessment. The institution then committed to this form by using the recommendations for budgeting and planning. For instance, a number of oral communication course level assessments identified the need for students to be able to see themselves delivering addresses. Based off this feedback the institution purchased flipcams for use by communication instructors and worked

with tutoring to ensure tutors with oral communication expertise and technical knowledge were available for students to practice and record themselves. Faculty reported increased public address scores as a result of these changes.

Additionally course-level goal results are available to all ICC employees, and academic administrators encourage faculty in the same discipline to view other assessments and begin dialogue. Essentially, the new assessment efforts changed the culture of assessment and provided tools and support for theatre faculty to become more receptive to assessment. Theatre faculty began using the new form, which provided them the opportunity to assess activities they found meaningful and to contextualize the results within their classes and programs. Figure 6.5 is an example of the course-level assessment used for both the beginning and advanced acting courses.

Figure 6.5. Course-level assessment

Course-Level Goals for **THTRE 122**

Class Number: 1352 Mode: Traditional Mtg Goal/Comp: 19/18 Semester: Fall 2013

Measures of Student Learning (Direct or Indirect)	Outcome (Result) Number Meeting Goal/Number Completing Task	Possible Explanation (If Results Disappointing)	Proposed Changes (If Any) To Improve Outcome	Recommendation For Planning and Budgeting (If Any) To Improve Outcome

Course-Level Goal for Student Learning:
Goal 1 - Identify and utilize the criteria necessary to determine excellence in acting

Critique of actors/acting in a live play	16/18 = 88.89%	Acceptable Those who did it did well	None recently revamped assignment will see how the works for several semesters	

Figure 6.6. Course Level Goals for THTRE 222

Course-Level Goals for THTRE 222

Class Number: 1947 Mode: Traditional Mtg Goal/Comp: 13/13 Semester: Spring 2014

Measures of Student Learning (Direct or Indirect)	Outcome (Result) Number Meeting Goal/Number Completing Task	Possible Explanation (If Result is Disappointing)	Proposed Changes (If Any) To Improve Outcome	Recommendation For Planning and Budgeting (If Any) To Improve Outcome
Course-Level Goal for Student Learning: Demonstrate knowledge of acting theory and character development through scene work				
Choose script and scene from scripted read and create self guided scene analysis and perform scene	11/13 = 84.62%	Acceptable. It was good. I was very surprised that they came back with as much in the analysis as they did. I thought there would be lots of holes and they held onto the material quite well.	Give them a bit more time to choose play and read. I had to extend that time by a class period. I was really pushing.	None

The first example (THTRE122) is broad and simply shows that most students were able to identify and utilize criteria necessary to determine excellence in acting by critiquing actors/acting in a live play. The second example (THTRE222) is more specific and shows that most student demonstrated knowledge of acting theory and character development through scene work by choosing a script and scene and creating a self-guided scene analysis and performance. The explanation of the results in this example show the instructor was surprised with the analysis and recognized the need to allot for more time next time the exercise is completed.

Theatre faculty overcame their resistance to assessment due to the institutional-assessment culture and the levels and layers of support the institution provided to faculty.

The second obstacle involved a lack of discipline-specific examples for assessment. To address this challenge, the lead acting faculty collaborated with the departmental assessment advocate, who also happened to be a former theatre instructor and dean, and began a year-long dialogue about the value, need, and concerns about assessment in theatre arts. The faculty often questioned how ICC's assessment initiatives and training applied to theatre.

ICC's assessment committee provided a great deal of training on writing goals and creating rubrics. The examples used to train faculty were usually very straight-forward and tended to come from convergent problems. These examples were helpful when addressing the simple tasks involved in acting, such as line memorization, projection, and blocking, but were not as useful to the higher-level choices actors needed to make such as characterization, inflection, and appropriateness of gesture to character goal. In fact, the faculty expressed concern that assessment was dumbing down the process and forcing them to teach to a box. The team began to spend a great deal of time talking about the unique tenets of acting. This discussion addressed:

- the divergent rehearsal process that relied on the student skill and experience level,
- the continual formative feedback given to students during the acting process, and
- the realizations that much of the traditional assessment was largely based on the expert faculty member's judgment and were influenced by the student's growth.

These complex and unique qualities of theatre led the theatre faculty to realize the training on goals and rubrics did not prepare the faculty to create an assessment instrument that valued divergence, individual growth, and expert judgment. Instead, the faculty took on the challenge of creating a new instrument that would follow good assessment and acting principles.

In the effort to begin to create the assessment instrument that would value the unique qualities of acting and follow good assessment principles, ICC tackled the last obstacle, which was a lack of program goals. Since the acting classes were electives in a general education associate degree, no program goals existed. However, the course goals for the beginning and advanced acting courses (Table 6.6) identify the necessary skills, knowledge, and attitudes.

Table 6.6: Course goals for acting courses

Course level goals for the beginning acting course are:
1. Demonstrate a working vocabulary of acting terms.
2. Develop performance skills using improvisation, exercises, and monologues.
3. Identify and utilize the criteria necessary to determine excellence in acting.
4. Begin to discover how to use acting tools toward development of personal process of acting.
5. Demonstrate acting theory through classroom exercises and scene work.

Course level goals for the advanced course are:
1. Acquire new and mature previously learned techniques to the art and craft of acting.
2. Discover the importance of the script and its interpretative use.
3. Demonstrate knowledge of acting theory and character development through scene work.

From the course goals the theatre faculty identified scene selection, analysis, characterization, collaboration, and physicalization as the core components of an acting process. Using available resources from peers, theatre associations, and ICC assessment resources, the theatre faculty designed a rubric that rates the overall component holistically but provides operational definitions of specific traits within the component. Each core component was then described in a narrative format and finally standards for each component were expressed at the excellent good and fair level.

Table 6.7 shows a portion of the rubric focusing on one of the five core components, Physicalization. The column to the far left describes the ideal traits of that component and then the excellent, good, and fair columns describe traits as they may be performed at each level. Deciding at what level to operationalize

the goals was a challenge. Table 6.7 shows components described by traits, but it would be possible to have each trait be a stand-alone scorable item. However, the faculty chose to group the traits into components as not all traits would be required in each scene.

Table 6.7. Physicalization Section of Acting Rubric

	Excellent	Good	Fair
Actors physically embody character. They use external expression to display character intent. Performance is polished in use of gesture, movement, facial expression, and posture. Characters are controlled, precise and believable.	• Actors **almost always** physically embody character. • Actors **almost always** use external expression. • Actors are **almost always** polished. • Characters **almost always** controlled.	• Actors **sometimes** physically embody character. • Actors **sometimes** use external expression. • Actors are **sometimes** polished. • Characters **sometimes** controlled.	• Actors **seldom** physically embody character. • Actors **seldom** use external expression. • Actors are **seldom** polished. • Characters **seldom** controlled.

The rubric containing all five components filled an entire letter sized piece of paper. The faculty shared the rubric with colleagues for feedback and added a poor column as a result. The faculty then shared the rubric with students when introducing the next scene and asked the students to use the rubric as a guide as they developed their scenework and used the rubric to score the scenes.

Lessons Learned /Changes Made/ Accomplishments

The rubric experiment was not wholly successful. The faculty member felt stifled by the box checking and lack of space to provide qualitative feedback and the student felt overwhelmed by the amount of expectations and information. However, the creation of the rubric and the assessment-based conversations that occurred during the creation led to meaningful discoveries about assessment in

theatre. First, the process allowed the faculty to articulate what the expectations were in a manner that normally evolved in the formative assessment process during rehearsals, performance, and critique. Additionally, the rubric served to inform students prior to the process what the goals and expectations were. Finally, the faculty member realized she needed to create a more concise rubric/scoring guide that articulated and operationalized the necessary concepts and skills that could be shared liberally and be used collaboratively among the students and faculty in the formative process. The revised rubric/scoring guide became a vision by which the formative and verbal rehearsal processes could aspire to reach.

Figure 6.7. Selection of Revised Rubric/Scoring Guide

Vocal (40 pts)			
Volume/diction, rhythm/tempo/intensity			
Exceptional in all areas	Good, needs to be fine tuned	Fair, needs focused work	Poor, didn't address
40	30	20	10
Movement (20 pts)			
Blocking, supporting scene and goal			
20	15	10	5
Movement (20 pts)			
Personal business fits character, physical characterization appropriate			
20	15	10	5

Figure 6.7 shows a portion of the revised rubric/scoring guide. The significant changes were narrowing the scope of the components and traits to allow the faculty to select specific components to work on for any given scene and providing more space for qualitative feedback. Additionally the format changed from a detailed grid to a general guide listing the component, simplified descriptions of the traits, and then using four-tiered scoring approach from exceptional to poor. Finally, student input could be gathered through the rehearsal process and the rubric/scoring guide could be adjusted as needed to reflect the needs of the particular scene.

The rubric/scoring guide is now commonly used in the acting courses but is often altered to reflect specific components or traits the faculty choose to focus on

during a particular scene. The rubric is provided to students as they are introduced to a scene, and they are encouraged to use the rubric as a guide for their own process and to provide feedback to their peers. The rubric improves communication of expectations to students. However, the faculty still voice concern that the rubric oversimplifies the acting process, and if not used properly, can encourage faculty to simply provide a score instead of the rich qualitative feedback that is at the core of theatre pedagogy.

The success story here is not necessarily the product, as it continues to be improved, but is instead how arts faculty can create meaningful assessments when they are afforded the support, training, resources, and time to discover how assessment principles can be applied to the arts.

CONCLUSION AND SUMMARY

Assessment in the arts is difficult as the arts are divergent fields that resist standardization. However, arts faculty recognize the importance of assessment as a tool to measure and improve student learning. This is a story of a theatre professor who was willing to journey down the assessment pathway and was met with institutional support that provided resources and training and was given the support to contextualize assessment within the unique qualities of the theatre discipline.

Case Studies in Fine Art: Photography, Illustration, Sculpture, Painting, and Printmaking

A Data Installation: Repurposing Portfolios for Use in Program Assessment
Brianna Moore-Trieu, Ph.D
California College of the Arts

Subject Matter of the Case Study: Developing Useful Data Tools for Faculty and Chairs to use in external review, assessment of student learning, and annual program planning.

Brief Background on the institution/program: California College of the Arts is an Arts and Design College with a split campus in San Francisco and Oakland, California. There are 22 undergraduate majors in fine arts, design, writing, and architecture disciplines and 13 graduate programs.

A PURPOSE FOR RE-PURPOSING

Engaging faculty and administrators in the assessment process can be difficult for colleges. Assessment is easily conflated with standardized testing and thus may create resistance to its implementation. At CCA, assessment is widely conducted; however, faculty buy-in to the systematic documentation and consistent use of assessment data in decision-making has proven challenging. This case study focuses on engaging Art and Design faculty through the development of a data portfolio, which promotes standardization of assessment results, but imbeds the familiar principles of portfolio assessment, such as providing a multidimensional view of student learning. An outline of the process to develop such a program data portfolio is discussed along with a pilot of its use in the Photography program's external review.

Using a data portfolio as a structure to collect and display data for assessment is an attractive choice for an arts and design college for a couple of reasons. Firstly, portfolios have historically been used by arts and design school faculty to assess student learning because of their capacity to display the multifaceted artistic skills of students. It follows that portfolios would also be an effective tool to collect and display the multifaceted sets of information that represents student learning within a program.

Another attractive quality of portfolios is active participation of the user in the evaluation process (Banta, 2002). Portfolios provide a mechanism in which users can self-reflect on the learning process (Driscoll & Wood, 2007) and become active curators in collecting evidence of student learning. Because active involvement by faculty is important in any form of institutional change (Diamond, 2002), a tool that lends itself to active participation, like a portfolio, has a greater likelihood of engaging faculty in the use of assessment data in decision making and making progress towards institutionalized assessment.

To ensure that program data portfolio is a useful tool for assessment in the institution, the following may also be necessary:

1) Clear statement of purpose for using the data portfolio as an assessment tool
2) Collaborative effort between faculty and administrators to determine which information to include in the portfolios
3) Well-organized multidimensional evidence for review, including:
 A. Student work and assessment materials
 B. Standardized statistics, which allow for comparisons over time and with other programs
4) Facilitated reflection on portfolio information with program faculty
5) Incorporation of the portfolio in internal, external, or inter-departmental reviews

Enactment of these items may occur over three phases. The first phase focuses on developing and creating awareness of the program data portfolio (Items 1 – 3). In this phase, collaboration from both faculty and administrators is invited. The second phase focuses on distribution and implementation of the program data portfolio (Items 4-5), during which a pilot of the program data portfolio may be distributed to selected pilot programs. In this phase the program data portfolios may also be linked to the digital archives of student assessment materials; at CCA this was done through a system called Vault. Facilitated reflection of faculty on their programs using the information in the data portfolio may occur in the second phase. The third phase makes use of the data portfolios in decision making, a common procedure in all programs. The third phase will be accomplished if phases one and two are successful and faculty share the value of using these tools for decision making with other faculty.

Phase 1: Developing and Creating Awareness of the Program Data Portfolios
In order to ensure effective use of the data portfolio, a clearly defined purpose for using the portfolio assessment needs to be established. Enlisting leadership to define that purpose is essential. In this case, The Provost (Melanie Corn), Director of Assessment (Dominick Tracy), Chair of Textiles and Fine Arts Assessment Coordinator (Deborah Valoma), and four other faculty chairs were asked what purposes they thought the data portfolio could serve to determine what the foreseeable uses might be. During the discussion, two sets emerged, one for program faculty and one for administrators. The following were established as tentative uses of the data portfolio:

For program faculty (faculty and chairs):

- In internal program review, data portfolios can be used in conjunction with other information to make decisions about changing curriculum, focusing resources, and making internal requests to the provost. Data portfolios should highlight areas of strength or in need of development, support requests for additional resources, and be useful for identifying partnerships between programs
- Annual strategic program planning
- For external reviewers to understand program inputs, outcomes, and student learning
- Accreditor visits (e.g., WASC and NASAD)

For administrators (Provost and Associate Provost):

- Data portfolios can be used by the Provost to better understand career development necessary for faculty and to make decisions about faculty hires
- To better understand trends across programs, resources needed, and internal requests being made
- For making budgetary decisions (extent to be determined)

With these purposes in mind, there may be a multitude of measures of student learning and success upon which programs can reflect. The Institutional Research Office can help by distilling all possible data into a finite set of options. The following data points are options that were presented to CCA faculty as choices to include in the program data portfolio:

1) Program mission statement
2) Program learning outcomes
3) Digital archives of student work
4) Assessment materials (i.e., Junior Reviews, rubrics)
5) Program facts (e.g., enrollment statistics, retention rates, graduation rates, and post-graduation salaries)
6) Demographics of populations served (e.g., % first generation, % female, % international)
7) Adjacencies with other programs (e.g., majors of students taking courses in the program, previous major of students switching into the program, new majors of students switching to another program)
8) Student responses on the National Survey on Student Engagement (NSSE) and Strategic National Arts Alumni Project (SNAAP) surveys
9) Faculty, alumni, and student accomplishments

Developing a portfolio template with the majority of information pre-populated eases the burden of programs in collecting this breadth of information from across departments within the college, while giving them the opportunity to actively participate in the curation. While much of the information in the data portfolios can be pre-populated by the Institutional Research Office, some aspects may be left to the chair and faculty of the program to contribute, such as the curating of student work, rubrics, and assessments for learning outcomes. In addition to these, chairs are asked to document student, faculty, and alumni accomplishments at CCA.

Selected data options were incorporated into a draft program data portfolio and the resultant data portfolio for one of the pilot programs, Photography, is shown in the following pages.

The first page of the data portfolio includes basic program information along with the program's mission statement (see Figure 7.1).

Figure 7.1.

CALIFORNIA COLLEGE OF THE ARTS CCा

Photography 2013

PROGRAM DATA PORTFOLIO

| FOUNDING YEAR | 1936 | DEGREES GRANTED | BFA | DEPT. CHAIR | TAMMY RAE CARLAND | TOTAL FACULTY | 10 | TOTAL MAJORS | 54 |

CCA's Photography program is committed to a broad-based curricular approach that engages students in the most contemporary practices of the medium as well as the traditions and historical structures from which these practices evolve. The curriculum provides students with the technical foundation in both analog and digital imaging, as well as the critical skills and theoretical insights necessary to pursue their creative visions. Students in the program develop the capacity for continual self-evaluation and independently sustained creative and professional activity.

Figure 7.1 also displays program learning outcomes along with the percentage of students in the program meeting, exceeding, or significantly exceeding expectations on these outcomes.

Figure 7.2 shows how assessment of student learning can be linked to the program data portfolios. For example, the template allows links to the curriculum matrix (a matrix of each program learning outcome mapped to courses in which they are being taught), college wide learning outcomes, the rubrics used to assess program learning outcomes, and links to sample student work representing program learning outcomes.

Figure 7.2.

PROGRAM LEARNING OUTCOMES

Students who complete this program will be able to:

• Develop a Visually Coherent Body of Work- Students formulate a visual project that visually and verbally communicates in its formal and conceptual principles.
 40% Meeting, 35% Exceeding 10% Significantly Exceeding
• Develop a Personal Vision- Develop the capacity to both individualize and situate one's
practice in relationship to historical and contemporary artists and art dialogues.
 60% Meeting, 25% Exceeding 5% Significantly Exceeding
• Read critically and express one's own ideas in the form of expository writing, research analysis and artist statements.
 45% Meeting, 30%Exceeding 5% Significantly Exceeding
• Practice professionally within an art/photography practice beyond college-level study through exposure to
various career models and an understanding of professional ethics and leadership
 40% Meeting, 30% Exceeding 15% Significantly Exceeding

CURRICULUM MATRIX COLLEGE WIDE
 OUTCOMES REPRESENTED

OUR STUDENT WORK

VISUAL COMMUNICATION WRITTEN COMMUNICATION
 0 1 2 3 4 0 1 2 3 4

Note: Percentages of students meeting or exceeding learning outcomes in this example are fictitious and only used as an example. Numbers do not reflect actual program performance on these or other measures. Design layout by Meghan Ryan and Sarah Kim.

Figure 7.3 shows how samples of student work can be linked to the data portfolio to better understand program learning outcomes. Visual Communication is one of Photography's program learning outcome assessed using the junior review. A rubric from 0 to 4 is used to assess how well students are meeting this program learning outcome. Using Vault and the Data portfolios, faculty can select a value on the rubric which links to student work that represents that score. The Photography student received a "3" on the Visual Communication rubric for this particular piece, an example of the student work that can be referenced in the data portfolio.

Figure 7.3.

OUR STUDENT WORK

VISUAL COMMUNICATION
 0 1 2 3 4

Visual Communication: **3** - Students develop their ideas and express themselves visually in a conceptual and formal way that exceeds expectations. Students demonstrate conceptual principles in a variety of formats/media.

Following the assessment data, the portfolio presents additional data points about the program, such as number of majors and percentage of majors who are freshman, sophomores, juniors, or seniors. These can all be useful measures for course planning and better understanding program needs. Figure 7.4 shows demographics of students in the program such as race/ethnicity. The overall diversity of the college (CCA) is presented as a reference point for the program data.

Figure 7.4.

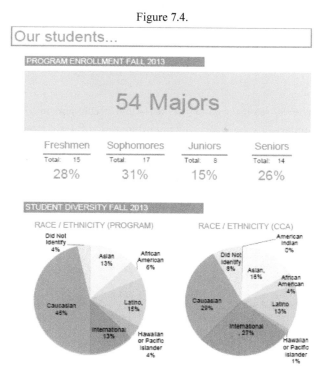

Figure 7.5 shows how the program data portfolios can be used to show adjacencies between programs. The Venn diagram shows students enrolled in courses taught by the Photography program in Fall 2013. The majority of students taking Photography courses are Photography majors, but students from Graphic Design and Illustration programs are also enrolled. Greater awareness of adjacencies between programs can lead to further collaboration in curriculum and resource planning.

Figure 7.5.

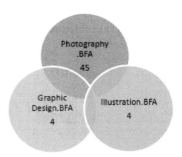

Figure 7.6 shows retention data of first-time freshmen in the Photography program. Comparisons between the retention rate of Photography students is benchmarked to the rest of the college (CCA) and to the average retention rate of Association of Independent Colleges of Art and Design (AICAD) peer schools. Similar comparisons are also made when displaying graduation rates and acceptance rates in the data portfolio.

Figure 7.6.

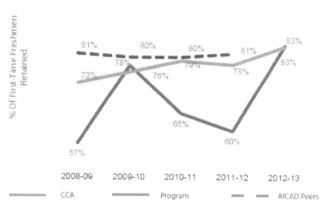

Retention and persistence

STUDENT PERSISTENCE AND COMPLETIONS

INTENDED MAJOR FIRST YEAR RETENTION RATE

AICAD Peers: Reflects average of Maryland Institute College of Art (MICA), School of the Art Institute of Chicago (SAIC), School of Visual Arts (SVA), Pratt Institute (Pratt), Parsons New School for Design (Parsons), Art Center for Design

Figures 7.7 and 7.8 illustrate data on what alumni and current students say about their experience in the program. Figure 7.7 shows responses from students who graduated from the Photography program. These data are from the Strategic National Arts Association Project Survey (SNAAP). Alumni responded to how satisfied they were with educational experiences and opportunities in the program. Comparison of alumni responses from the program are benchmarked with responses from other students graduating from CCA. Figure 7.8 displays current student responses from the National Survey of Student Engagement (NSSE). Students give feedback on the types of coursework they are asked to do. Responses from both SNAAP and NSSE can be used to better understand strengths and areas of improvement in curriculum planning for the program.

Figure 7.7.

Student Experiences

ALUMNI EXPERIENCES

Total Respondents
16

RECENT ALUMNI REPORTING THEIR LEVEL OF
SATISFACTION AS VERY SATISFIED OR SATISFIED
WITH THESE ASPECTS OF THEIR TIME AT CCA:

	Somewhat Satisfied		Very Satisfied	
	Program	CCA	Program	CCA
Opportunities to perform, exhibit, or present your work:	43%	43%	50%	41%
Opportunities to work in different artistic disciplines from your own:	29%	38%	43%	43%
Opportunities to take non-arts classes:	7%	35%	43%	32%
Instructors in classrooms, labs, and studios:	36%	35%	50%	53%
Academic advising:	21%	31%	29%	23%
Advising about career or further education:	21%	26%	14%	8%
Opportunities for degree-related internships or work:	29%	20%	29%	13%
Opportunities to network with alumni or others:	43%	28%	21%	17%
Sense of belonging and attachment:	57%	35%	29%	37%
Freedom and encouragement to take risks:	36%	30%	29%	51%

Source: SNAAP Survey administered Spring 2012

Figure 7.8.

CURRENT STUDENT EXPERIENCE

Total Respondents
10

DURING THE SCHOOL YEAR, HOW MUCH OF
YOUR COURSEWORK EMPHASIZED:

	Somewhat Satisfied		Very Satisfied	
	Program	CCA	Program	CCA
Memorizing facts, ideas, and methods:	36%	37%	0%	7%
Analyzing an idea, or examining a particular case in depth:	20%	37%	30%	37%
Synthesizing or organizing ideas into information to form new or more complex interpretations:	18%	20%	36%	41%
Making Judgements about the value of information and examining how others gathered and interpreted data:	18%	21%	36%	32%
Applying theories to practical problems or in new situations:	18%	27%	9%	25%

Source: NSSE Survey administered Spring 2014

A more in depth summary of the development phase of the process can be found in Appendix B. An inventory of all data points used in the program data portfolio can be found in Appendix C.

Phase 2: Distribution and Implementation of the Program Data Portfolio
The second phase of the project focuses on distribution and implementation. In this phase, the data portfolio was distributed with program specific results to four pilot programs: Graphic Design, Fashion Design, Glass, and Photography, the last of which underwent an external review using the program data portfolio. Feedback interviews on the usability, relevancy, and interpretability of data were done with each program chair 2-4 weeks after distribution, and adjustments were made as needed to the data portfolio template. A follow-up interview with the Photography Chair (Tammy Rae Carland) and Associate Director of Fine Arts (Julie Caffey) was conducted post external review to understand how the data portfolio was used in conversations about student learning and program outcomes. The following is an excerpt from the post external review interview with the Photography Chair, who later became Director of Fine Arts, and the Associate Director of Fine Arts:

1) How did the external review go? What was using the program data portfolio in external review like?

"...such a huge part of review when you go through a WASC or external visit is [locating all the information you need], if you have all this information in hand, you don't have to go to administrators or anyone else to get it. [The data portfolio], it's a really empowering tool."

"We didn't have to give these reviewers huge binders of information and they can still use this information after they leave to write their reports."

2) Did either the external review or the use of the data portfolio result in an increased focus on assessment?

"Very much; it's raised everyone's awareness, along with other efforts [by Director of Assessment (Dominick Tracy), Assessment Leadership Team Co-Chair (Deborah Valoma), and Director of Libraries (AnneMarie Haar)]. It provides people tools to make assessment doable."

3) What program decisions were informed when reviewing the data portfolio?

 "The alumni survey data [SNAAP] provide clear support for curricular changes. Having an objective voice [through data] is a really effective and needed component of assessment. Also, hiring decisions made as part of this program assessment."

4) How do you foresee using the data portfolio in the future? Particularly, its intersection with assessment of student learning?

 "Internally it has the clearest use, for faculty hiring plans; a lot of the arguments are usually narrative. This tells a clear picture about gaps in ranked faculty, teaching, or skill gaps based on the retirement of teachers. Also knowing about strong adjacencies between different programs – and figuring ways to build those out. It will be useful for smaller programs to know how many students are accessing majors and where there is overlap between program [and greater faculty collaboration]."

5) What were some challenges in using the data portfolio?

 "Some of the snapshots, the challenge in looking at one year of data, some faculty felt didn't show broad enough scope or told a story that they wanted to tell. It's a cultural shift looking at things statistically versus the way they used to look at them."

6) What were the challenges in looking at student learning assessment?

 "The build out [of the archiving system, Vault]; we want to be able to look at individual student's progress over time....Getting all the programs to [document each level of assessment] is challenging. They will need technical support. We don't yet have this built into the curriculums for all other programs, but...this will be an area of focus."

Phase 3: Institutionalization of the Program Data Portfolio

Based on the post external review interview process, there is evidence that the program data portfolio has had some early success and might have a chance at

becoming an institutionalized part of decision making at the college. Factors that contributed to the success were:

1) Early involvement of faculty and administration in developing the program data portfolio
2) Clearly outlined purposes for the use of the data portfolio
3) Using feedback from faculty to make adjustments to the portfolio
4) Creating an aesthetically pleasing portfolio
5) Reducing the burden of data collection for faculty
6) Empowering chairs to reflect on the data
7) Identifying thoughtful program leaders with which to pilot the program data portfolio

This case study represents the beginning of institutionalizing assessment at CCA through the use of an assessment tool we call the program data portfolio. Other assessment efforts are also underway at the college, which include increasing awareness of college-wide learning outcomes, enhanced alignment between program learning outcomes and program assessments, documenting results of assessments in digital archive systems, and facilitating a shared understanding about the goals of assessment. We hope the combination of the program data portfolio with these efforts results in a synergistic effect for assessment.

Special Note: The author of this case study would like to thank Lisa Jonas for her editorial assistance.

REFERENCES

Banta & Associates. 2002. *Building a Scholarship of Assessment*. San Francisco, CA: Jossey Bass. 201-223.

Crocker L. & Algina, J. 1986. *Introduction to Classical and Modern Test Theory*. Belmont, CA: Wadsworth Group.

Davies, Anne & Le Mahieu, Paul. 2003. Assessment for Learning: Reconsidering Portfolios and Research Evidence. In M. Segers, F. Dochy, & E. Cascallar (Eds*.), Innovation and Change in Professional Education: Optimising New Modes of Assessment: In Search of Qualities and Standard*. Dordrecht: Kluwer Academic Publishers. 141-169.

Diamond, Gardiner, & Wheeler. 2002. Requisites for Sustainable Institutional Change. In Diamond, *Field Guide to Academic Leadership*. San Francisco, CA: Jossey Bass.

Driscoll. A. & Wood, S. 2007. *Developing Outcomes-based Assessment for Learner-centered Education*, (1st. ed.). Sterling, VA: Stylus Publishing, LLC.

Gillespie, C., K. Ford, R. Gillespie, & A. Leavell. 1996. Portfolio Assessment: Some Questions, Some Answers, Some Recommendations. *Journal of Adolescent & Adult Literacy*. 39, 480 – 91

Karlowicz, K.A. 2000. The Value Of Student Portfolios To Evaluate Undergraduate Nursing Programs. *Nurse Educator*, 25(2), 82-87.

Shaklee, B. D., Barbour, N. E., Ambrose, R., & Hansford, S. J. 1997. *Designing and Using* Portfolios. Boston: Allyn and Bacon.

Western Association of Schools and Colleges: Senior College and University Commission. 2013. *Handbook of Accreditation – 2013*. Available at http://www.wascsenior.org/resources/handbook-accreditation-2013/part-i-2013-handbook-and-wasc-accreditation

APPENDIX A
All Chairs Meeting Agenda: Program Data Portfolio

- Purposes of the Data Portfolios:
 To provide program-specific data to each program for:
 1) Internal Program Review
 2) External Program Review
 3) WASC and NASAD visits
 4) Annual strategic program planning
 5) Other purposes?
- Goals of this Meeting:
 - Introduce sample data which can be broken out by programs
 - Learn more about how chairs would use this data
 - Figure out additional data points of interest
 - Review draft template for feedback on layout
- Presentation of Draft Program Data Portfolio Template
- Discussion: Exercise Using Sample Data Portfolio Template
 1) What decisions could you make about your program using this information?
 2) Would you share this information with the faculty from your programs?
 3) What are your concerns about using this data?
 4) How else could you see this data being used?
 5) Are there pieces of information you would want present in the internal reviews but not in the external reviews?
 6) What other data points would you want to have about your program?
 7) What other comparative data would be useful for your program to have?

APPENDIX B

Project Phase	Duration
Phase 1: Creating Awareness and Developing a Program Data Portfolio	
Inventory Available Data: Compile list of possible data options for program data portfolio	1-3 months
Review and Define Purpose: Review possible data to include in portfolios with upper-level academic affairs and faculty leaders, incorporate feedback, clearly define purpose(s) of program portfolio data	1-2 hr meeting
Coordinate and Collaborate Effort: Identify pilot programs and faculty leadership to help develop program-level portfolio template (ask provost or associate provost for list of candidates)	10-15 min meeting
Meet with Archivist: Such as the Librarian, learn about how student work is digitally archived and opportunities available for assessment collection	1 hr initial meeting (set up regular check-ins)
Create a Prototype: Populate data portfolio template with preliminary data	1-3 months
Create Awareness: Share data portfolio prototype with a curriculum committee or at an all chairs meeting; invite alternatives and new ideas for program data portfolio	45 minutes
Collaborate More: Share draft portfolio template with other stakeholders of interest at the college; invite feedback	2 weeks
Enhance User Experience: Work with a design team/graphic design/work-study student to enhance user experience with the portfolio template	1 month
Phase 2: Distribute and Implement a Program Data Portfolio	
Make a Special Delivery: Distribute program-level portfolio to pilot program(s); express importance of being selected for the pilot	3-5 emails
Evaluate the Product: Administer a survey or face-to-face interviews with pilot program chairs on user experience with the report; also take this opportunity to address concerns and any issues with understanding the data	2 weeks
Iterate: Determine what changes need to be incorporated for next year based on initial feedback	3 weeks
Close the Loop: Interview program chairs after undergoing their external reviews, program review, or annual strategic planning meeting to see how data was used in decision making; incorporate needed adjustments into next year's report	2-4 weeks

APPENDIX C

Examples of Data to Include in Program Data Portfolios
Founding Year of Program
Degrees Granted
Department Chair Name
Total # of Majors Enrolled
Total # of Faculty (Fall 2013)
Program Mission
Program Learning Outcomes
Curriculum Maps for Program
College Wide Outcomes Alignment with PLOs
Links to Rubrics for Program Learning Outcomes
Links to Archived Student Work
and % by Class (Freshman, Sophomore, etc.) in Program
Student Diversity:
 % by Race/Ethnicity in Program
 % by Race/Ethnicity in Entire College
 # of International Students
 Countries Represented
 % of English Language Learners in Program
 % of English Language Learners in Entire College
 % of 1st Generation Students in Program
 % of 1st Generation Students in Entire College
 % Female in Program
 % Female in Entire College
 % Male in Program
 % Male in Entire College
 # of Students by State of Origin for Program
Adjacencies - The Majors of Student Enrolled in 'Program' Courses
Top Majors of Students Enrolled in Program Courses (Venn Diagram)
Major Switches to Another Program from Program
Major Switched from Another Program to Program
Course Capacity
First Year Student GPA (Classes) in Writing, Critical Studies, and Courses in the
Major
First Year Retention for Program
First Year Retention in Entire College
First Year Retention AICAD (Other Art Design Colleges)
Transfer Retention for Program
Transfer Retention in Entire College
Persistence of Declared Majors Program (3rd Year Persistence)
Persistence of Declared Majors College (3rd Year Persistence)
Persistence of Declared Majors Program (4th Year Persistence)
Persistence of Declared Majors College (4th Year Persistence)
Transfer Persistence of Declared Majors Program (3rd Year Persistence)
Transfer Persistence of Declared Majors College (3rd Year Persistence)

Transfer Persistence of Declared Majors Program (4th Year Persistence)
Transfer Persistence of Declared Majors College (4th Year Persistence)
4 Year Graduation Rate (Program)
4 Year Graduation Rate (College)
6 Year Graduation Rate (Program)
6 Year Graduation Rate (College)
Median Salaries of Program Graduates (Year 1)
of Students Found Year 1 (Program)
Median Salaries of College Graduates (Year 1)
of Students Found Year 1 (College)
Median Salaries of Program Graduates (Year 2)
of Students Found Year 2 (Program)
Median Salaries of College Graduates (Year 2)
of Students Found Year 2 (College)
Median Salaries of Program Graduates (Year 5)
of Students Found Year 5 (Program)
Median Salaries of College Graduates (Year 5)
of Students Found Year 5 (College)
Applicants (Program)
Applicants (College)
Admitted (Program)
Admitted (College)
Enrolled (Program)
Enrolled (College)
% Accepted (Program)
% Accepted (College)
% Accepted (AICAD)
% Yield (Program)
% Yield (College)
% Yield (AICAD)
Top 5 Program Competitors from National Student Clearinghouse Data
% Freshman, %Second Degree, and % Transfer (Program)
% Freshman, %Second Degree, and % Transfer (College)
Average High School GPA, First Time Freshman (Program)
Average High School GPA, First Time Freshman (College)
% of Students with Portfolio of 3 or 4, First Time Freshman (Program)
% of Students with Portfolio of 3 or 4, First Time Freshman (College)
Average College GPA, Transfers (Program)
Average College GPA, Transfers (College)
% of Students with Portfolio of 3 or 4, Transfers (Program)
% of Students with Portfolio of 3 or 4, Transfers (College)
% Accepted Fall 2009-2013
% Accepted Fall 2009-2013
Total Faculty (Fall 2013) Program
Total Faculty (Fall 2013) College
Total Ranked Faculty (Fall 2013) Program
Total Unranked Faculty (Fall 2013) Program

% of Faculty with Terminal Degrees
% of Full Time Faculty (Fall 2013) Program
% of Full Time Faculty (Fall 2013) College
% of Part Time Faculty (Fall 2013) Program
% of Full Time Faculty (Fall 2013) College
of Faculty Lines
Average Length of Hire of Faculty in Program
Total Number of Teaching Lines taught by Faculty in Program
Faculty Diversity:
% by Race/Ethnicity in Program
% by Race/Ethnicity in Entire College
% by Gender in Program
% by Gender in Entire College
SNAAP Survey "How recent alumni rated their overall experience" Program
SNAAP Survey "How recent alumni rated their overall experience" College
Number of Respondents SNAAP Survey "How recent alumni rated their overall experience" (Program Respondents)
SNAAP Survey "Recent alumni who would attend if they could start again " Program
SNAAP Survey "Recent alumni who would attend if they could start again" College
Number of Respondents SNAAP Survey "Recent alumni who would attend if they could start again" (Program Respondents)
SNAAP Survey "Recent alumni reporting their as very satisfied with these aspects of their time in Entire College"
SNAAP Survey "Recent alumni reporting their as very satisfied with these aspects of their time in Entire College" College
Number of Respondents SNAAP Survey "Recent alumni reporting their as very satisfied with these aspects of their time in Entire College" (Program Respondents)

Developing a Rubric to Assess Student Work in Studio Art Degree Programs
Jennifer Rissler, Associate Dean
San Francisco Art Institute

INTRODUCTION

Encompassing some of the most significant art movements of the last century, the San Francisco Art Institute (SFAI) has historically embodied a spirit of experimentation, risk-taking, and innovation. Since 1871, SFAI has attracted individuals who push beyond boundaries to discover uncharted artistic terrain. With an ever-expanding roster of esteemed faculty and alumni, robust exhibitions and public programs, and a mission dedicated to the intrinsic value of art, SFAI is poised to expand upon the West Coast legacy of radical innovation that grounds SFAI's philosophy for another century. A small art college with global reach,

SFAI fosters a highly conceptual, interdisciplinary fine arts curriculum, offering BFA and MFA degrees in studio art, as well as BA and MA degrees in the History and Theory of Contemporary Art (HTCA) and Exhibition and Museum Studies (EMS).

Description of the Problem/objective

Since its inception in 1871, SFAI has been student-learning focused, with the student and his or her achievements at the core of assessment. The curricular structure emphasizes the critique, a long-established teaching and learning model employed at SFAI. Dialogic by design, this teaching and learning methodology engages faculty members and students in meaningful, immediate, and direct course-level evaluation. Yet over the years, SFAI, like many art schools, has failed to quantify and qualify this assessment into a more aggregate form, such as adequately reporting the results of student learning at the program or institutional levels. Robust assessment efforts at SFAI, therefore, began with interrogating how a single subject art college can utilize components of program assessment effectively within the visual arts disciplines, which in general are perceived as unquantifiable.

The author, along with faculty leadership, initiated robust student learning outcome assessment with the development of BFA Program Learning Outcomes, choosing to focus on our largest cohort, the approximately 450 BFA degree-seeking students. At the 2011 conference of the Association of Independent Colleges of Art and Design (AICAD), I gave a presentation to illustrate how SFAI used departmental, discipline-specific assessment to move effectively toward program-level assessment with the development of a BFA rubric, shaped by SFAI's interdisciplinary curricular nature. I have subsequently presented this case study at the College Art Association in 2012, and several peer institutions have inquired about using it to develop similar program assessment initiatives at fine art institutions. This case study provides a narrative of my approach to developing and embedding the BFA rubric specifically in the capstone Senior Review Seminars.

Challenges to Solving the Problem/reaching the Objective and Strategies/creative Ways of Solving/reaching the Objective

The most immediate challenge confronted in developing the BFA rubric was assuaging faculty concerns that assessment is, ostensibly, a critique of their teaching and an unnecessary burden placed on faculty. SFAI is not alone in this

respect, as similar conversations no doubt occur at many higher education institutions since the introduction of formal assessment rubrics and more prescriptive accreditation regulations. However, within the visual arts, the argument levied by faculty members, the majority of whom are practicing artists, is that the very practice of critique is an effective pedagogical assessment metric and one uniquely tailored to fine art academies. In this respect, I would argue, aren't fine art academies better at offering on-going, immediate, iterative assessment through the critique process?

To shift this dialogue onto student learning more directly, significant conversations within the Program Assessment Committee, a standing committee of SFAI's Faculty Senate, focused on generating consensus that the critique is a practice understood and used by each studio discipline. Although different vocabularies specific to medium no doubt occur within critiques, there are common proficiencies within each of the seven studio majors in SFAI's BFA program (Art and Technology, Film, New Genres, Painting, Photography, Printmaking, Ceramic Sculpture/Sculpture). Once this was established, faculty support toward the creation of a universal BFA rubric was solidified.

Initially, and in keeping with the interdisciplinary nature of SFAI's BFA curriculum, this objective was reached by auditing discipline-specific competencies to see where competencies overlapped. Not surprisingly, three main proficiencies emerged across the disciplines where assessment of student work was already occurring on the course level: theoretical, historical, and conceptual platforms. (See documents from PowerPoint to illustrate this process – several primary source materials, including my documents, are included at the end of this case study.) In hindsight, I realize that this exercise was extremely important in that it fostered trust among and between faculty and me, and also demonstrated to faculty that their assessment on the course level could effectively be used to shape BFA Program Learning Outcomes:

1. Demonstrates high level of skills in visualization and art making by fully engaging in the use of a medium's traditional and digital technologies to create significant work–as taught and assessed in individual studio courses through assignments, projects and critiques.

2. Demonstrates a conceptual ability by understanding the work's intellectual/disciplinary foundations–as taught and assessed in liberal arts and studio courses through readings, written assignments, presentations and critique.

3. Demonstrates a capacity for self-reflection in a theoretical context through historical analysis, critical thinking, and writing– as taught and assessed in liberal arts and studio courses through readings, written assignments, and critique.

4. Demonstrates a thorough understanding of a discipline (major) by studying the work of artists who have made exemplary aesthetic and worldly contributions, as taught and assessed in HTCA and studio courses through written assignments, class presentations/discussions and critique.

5. Demonstrates a relationship to other media by combining an emphasis in a studio discipline with explorations in multidisciplinary areas of practice– as taught and assessed in individual studio and HTCA courses through assignments and projects.

6. Situates artistic and scholarly work within a rigorous field of cultural and historical discourses in order to navigate the socio-cultural and aesthetic shifts in artistic practice–assessed and in liberal arts and HTCA courses through written assignments, projects, class presentations/discussions, and critique.

Finalized in Fall 2013, BFA Program Learning Outcomes shaped the subsequent development of a BFA rubric, which measures student work along five lines of inquiry, including technical and conceptual facilities, historical and theoretical contexts, research acumen and interdisciplinary engagement. With a nod toward nomenclature associated with developmental stages of artistic practice, proficiency levels include "emerging," "moderately established," "established," "moderately mature," and "mature." Numerical proficiencies are also associated with each level, 1-5 respectively, in order to generate quantifiable evidence that will assist SFAI in enhancing curricular offerings to better support student learning. (See Master BFA rubric after the PowerPoint slides.)

The BFA rubric has been used formally since Spring 2014 to assess work of all graduating BFA students through the capstone course, Senior Review Seminar. The proficiencies included in the BFA rubric measure how successfully students investigate their own body of work, develop their abilities to propose and defend statements about their work, and build their abilities to articulate their observations of their own and others' art. These skills are applied in presenting and defending their work to a final review committee within the seminar. Standardized signature assignments in all sections of the course include: development of self-generated goals for the semester; authoring effective artist

statements and resumes; completion of an electronic portfolio containing artwork, CV, and artist statement; a final review panel presentation; and an evaluation of progress by comparing artwork from admission portfolios to SFAI with current seminar results.

BFA Program Learning Outcomes are also used to assess readiness for advanced level studio coursework. It is often challenging to enforce 100-level course prerequisites for studio courses because of uneven waiver standards and lack of consistent evaluation processes for waiving 100-level prerequisites. In Fall 2013 a formal waiver procedure was instituted. Proficiencies from the BFA rubric were used as the foundation for measuring student qualifications for a waiver in the following categories: technical, conceptual, historical, theoretical, and research/engagement. Evidence of a readiness to complete 200-level coursework must now meet a proficiency benchmark of 'Moderately Established' competencies for all assessment categories.

Lessons Learned /Changes Made / Accomplishments

A further enhancement to Senior Review Seminar includes a concomitant course requirement for students to enroll in a 0 unit BFA Exhibition class. This requirement applies to students who entered SFAI in Fall 2013 and will affect all students by Spring 2018. The requirement also includes a modest fee for the production of an exhibition catalog. This new requirement ensures student participation in the BFA exhibition, which historically was voluntary. A BFA exhibition and catalog will allow students to take signature assignments from their Senior Review Seminar (including an artist statement and fully developed body of work) into the realm of professional exhibition practice. Graduating students will learn the intricacies and necessities of promotion and documentation, working collaboratively on the BFA exhibition. Quantifiable results from the BFA rubric, used to assess final work in the Senior Review Seminar, will assist students in determining which piece or pieces from their finished body of work are the strongest for public exhibition.

Due to the highly idiosyncratic and interdisciplinary manner in which BFA students explore the undergraduate curriculum, robust BFA assessment has the potential to highlight future curricular modifications. One such revision may include a Junior Review, as another point at which to assess student work through the BFA rubric. Beginning in Spring 2015, the BFA rubric also will be used in Contemporary Practices, the foundation course required for entering first-time freshmen. Using the BFA rubric at these critical curricular junctures will assist SFAI in closing a significant loop, embedding assessment of student development

throughout their trajectories, in an iterative manner, and one that mimics artistic practice.

Conclusion/Summary

Critique of assessment by faculty that derailed initial efforts to realize a BFA rubric ultimately contributed to the success of this particular case. Dialectical discourse in particular, between faculty members themselves and also between faculty and myself, led to a shared understanding of the difference between critique and assessment. Perhaps fine art faculty, as natural agents of dialogue and critique, foster a process germane to art practice that also, in retrospect, is equally germane to assessment in the visual arts. In this case, appropriating the language of critique into assessment practice was crucial to its success. This idea, which is fundamentally simplistic, was generated by the faculty as a means to extend their practice and universally accepted teaching methodology – the critique – into assessment.

Returning to their early concerns that assessment is a measure of their teaching capabilities, I would argue that this is indeed true. For in recalling their admonition that formal assessment isn't necessary because fine art academies are better at offering on-going, immediate, iterative assessment through the critique process, I would suggest that this is true precisely *because* of their unique abilities as practitioners to teach *vis a vis* critique. Adopting this strategy into assessment reinforces what they do well, and removes the emphasis away from teaching and places it squarely on a learning process that fosters the development of SFAI students as *artists*.

In conclusion, it is worth recalling an important treatise on teaching in the fine arts, taken from the Spring Semester, 1952, prospectus from the Black Mountain College, a little known but seminal document that directly informed my work in stewarding SFAI's assessment efforts. Although the document is unsigned, it is believed the author is Charles Olson, poet and rector of the Black Mountain College. Several of its tenets, and indeed its very ethos, are reflected in SFAI's assessment initiatives.

"Black Mountain College is heretical because it has practiced from its founding (1933) two of the simplest & oldest principles on which higher learning – when it has been higher – has rested.

I. that **the student**, rather than the curriculum, is **the proper** center of a general education, because it is he and she that a college exists for

II. that a faculty fit to face up the student as the center have to be measured by **what they do with what they know**, that it is their dimension as teachers as much as their mastery of their discipline that makes them instruments capable of dealing with what excuses their profession in the first place, their ability to instruct the student underhand.

Several things follow these two base principles, so far as the instruction of Black Mountain College goes. One characteristic, from the beginning, has been the recognition that ideas are only such as they exist in things and in actions. Another worth emphasizing (it is still generally overlooked in those colleges where classification into fields, because of curriculum emphasis, remains the law) is that Black Mountain College carefully recognizes that, at this point in man's necessities, it is not things in themselves but **what happens between things** where the life of them is to be sought."

Assessment and the Visual Arts: A Case Study from SFAI

Susan Martin, Assistant Dean for Academic Success
Jennifer Rissler, Associate Dean of Academic Administration

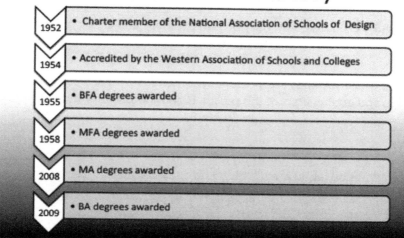

sfai
san francisco. art. institute.
since 1871.

Accreditation History

1952	• Charter member of the National Association of Schools of Design
1954	• Accredited by the Western Association of Schools and Colleges
1955	• BFA degrees awarded
1958	• MFA degrees awarded
2008	• MA degrees awarded
2009	• BA degrees awarded

sfai
san francisco. art. institute.
since 1871.

Accreditation and Assessment

- Following this 10 year period, WASC has determined that institutions are still heavily focused on the **structures** and **processes** of assessment

- But little progress has been made on **evaluating** or **benchmarking** learning results

sfai
son froncisco. ort. institute.
since 1871.

Accreditation and Assessment

NASAD's executive summary on Achievement and Quality:
Higher Education in the Arts (2007):

" The arts disciplines are virtually synonymous with achievement
and quality. Part of the reason is continuous, rigorous
evaluation."

"The most effective education and evaluation systems in the arts
in higher education are developed from an artistic rather than a
technical perspective."

sfai
son froncisco. ort. institute.
since 1871.

The question we must answer:

*How can we utilize components of program
assessment effectively within the visual arts
disciplines, which are generally perceived as
unquantifiable?*

sfai
san francisco. art. institute.
since 1871.

Course name _____ Student name _____

Date _____ Faculty name _____

UNDERGRADUATE STUDENT ASSESSMENT FORM

GENERAL	Excellent	Good	Average	Poor	n/a
Attendance					
Participation					
Preparedness					
Thoughtful & professional presentation					
Establishment & articulation of artistic goals					
Responsiveness to commentary					
Ability to generate dialogue					

Comments:

ARTWORK	Excellent	Good	Average	Poor	n/a
Quality of execution					
Completed work (when appropriate)					
Quantity of work					
Acceptable technical/formal facility					
Demonstrated growth in work					
The visual supports the verbal					

Comments:

IDEAS/CONCEPTS	Excellent	Good	Average	Poor	n/a
Quality of idea					
Clear articulation of viewpoint					
Pursues recommended research					
Displays breadth of knowledge in one's field					
Knowledge of critical discourses in one's field					
Demonstrates knowledge of historical context of one's work					
The verbal supports the visual					

Comments:

The Process

2008-2009		
Developed Departmental Learning Outcomes (DLOs) Embedded Course Learning Outcomes (CLOs) in syllabi, aligned with DLOs	**2009-2010** Received formal training from WASC on program assessment Invited assessment specialist Dr. Amy Driscoll to faculty senate	**2011** A BFA assessment rubric was piloted

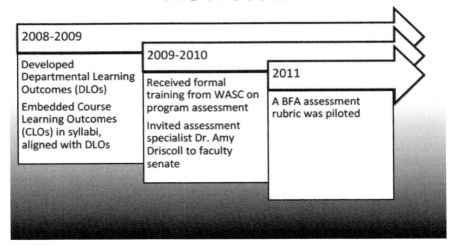

sfai
san francisco. art. institute.
since 1871.

Student #1—Profile

- Transferred to SFAI from Skidmore College
- Transferred 9 units of Major Studio credit
- Transferred 12 units of Elective Studio credit
- Attended SFAI for 5 semesters
- Photography Major
- Cumulative GPA: 3.927
- Dean's list and Honor's Studio recipient

sfai
san francisco. art. institute.
since 1871.

Student #1—Applicant Work

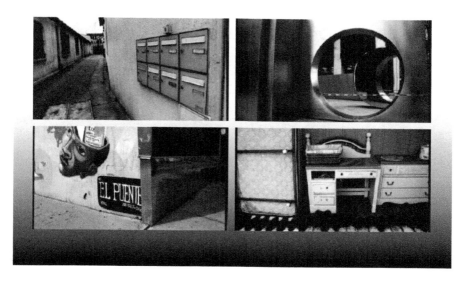

sfai
san francisco. art. institute.
since 1871.

STUDENT #1
ADMISSION ESSAY

NOTE: Please use the space below for your essay.

The photographs in my portfolio reflect my experience of being abroad for my junior year of college in Paris, France. There are also photographs of New York, Montana, and Denmark, which I visited during that year. Although I have been moving around since my parents were divorced in 2000, I was not entirely prepared to cross the Atlantic and came down with a bad case of homesickness. Making art helped me cope with my bewildering feelings by allowing me to explore a new city through an indifferent lens. It has been difficult to attach emotionally to the places I have inhabited, and I think this is evident in my work. These places are not my home and they never could have been.

+ Making art nourishes me. With photography, I learn about myself and my emotions through my relationship with the subject in an ever changing environment. When I take a picture, I ultimately want the final print to convey not only my feelings about that particular time and place, but also the effect of losing a home to constant relocation. My home is very important to my sense of self and identity. Art helps me to explore my relationship with my shifting landscapes and to find closure and healing in the process.

+ My feelings towards my surroundings direct my approach to framing a photograph. The process is spontaneous, impulsive, and intuitive. Often I set out on "photo walks" and let my eyes guide me from one interesting point to another. Dynamic and sometimes disorienting angles play an important role in determining a composition, particularly in an urban setting.

+I enjoy working with film because it brings my thoughts into my hands. In the serene environment of the darkroom I can easily reflect on the artistic process and how it has effected me. When examining my contact sheets, it is difficult for me to select the "best" images. The personal investment can make it difficult to disregard even my worst shots. In time however, I ultimately choose images, among the well-composed, that have the strongest emotional connection and that would best communicate those emotions to an audience.

sfai
san francisco. art. institute.
since 1871.

Student #1—Graduating Work

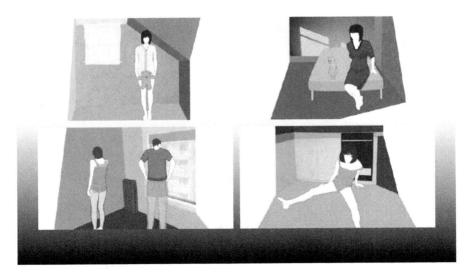

sfai
san francisco. art. institute.
since 1871.

Student #1 – Results

- Composite Score: 3.3
- Technical: 3
- Conceptual: 3
- Theoretical: 4
- Historical: 3
- Research Engagement 1: 3
- Research Engagement 2: N/A
- Research Engagement 3: 3

sfai
san francisco. art. institute.
since 1871.

Quantitative Analysis of BFA Rubric - Spring Show 2011
10/11/2011

	Student #1	Student #2	Student #3	Student #4	Student #5	Student #6	Student #7	Student #8	Student #9		correlation coefficient
technical		1	5	1	1	3	5	5	3		
conceptual	4	1	4	1	1	3	3	5	3		
historical	3	1	5	1	1	2	5	4	3		
theoretical	4	1	4	3	1	2	3	4	1		
research/engagement1	3	1	5	1	1	2	5	5	3		
research/engagement2			3	3	1	1	3		3		
research/engagement3	3	2	5	2	1	3	5	5	4		
review composite	3.3	1.4	4.7	1.4	1	2.4	4.4	4.5	3.1		
student major	PH	NG	PR	DT	SC	PA	FM	PA	PH		
admit status	transfer	freshman	n/a	freshman	transfer	transfer	transfer	transfer	freshman	transfer	correlation coefficient
portfolio score	n/a	n/a	3	4	3	2	n/a	n/a	3		-0.24
sfai gpa	3.9	3.8	3.6	3.8	3.8	3.6	3.7	3.4	3.6		-0.58
lib arts gpa	3.7	3.7	3.4	3.9	3.7	3.4	3.5	2.9	3.5		-0.69
art his gpa	3.8	3.4	3.6	4	3.9	3.7	3.5	3.7	3.4		-0.36
composite in gpa	3.7	3.6	3.5	3.9	3.8	3.5	3.5	3.2	3.4		-0.71
major stu gpa	3.9	3.9	3.5	3.8	3.9	3.9	3.8	3.6	3.7		-0.72
elec stu gpa	3.9	4	3.8	3.6	3.8	3.4	3.9	3.4	3.5		-0.11
composite stu gpa	3.9	3.9	3.7	3.7	3.9	3.7	3.8	3.5	3.6		-0.48
stu 100	6	9	11	2	6	1	8	7	14		0.41
stu 200	8	10	7	9	4	5	8	7	6		0.04
stu 300	3	5	6	1	5	5	6	10	3		0.55
total stu (24 max)	17	24	24	12	15	11	22	24	23		0.58
years to grad	4	4	4	4	3.5	4	4	4	3.5		0.34
sfai terms	5	8	8	4	4	4	7	8	6		0.61
tran terms	3	0	0	4	4	4	4	1	1.5		-0.56
tutorials	0	1	2	0	2	3	3	0	0		0.19
tut + dir stu	0	2	3	0	2	3	4	3	1		0.48
tut + dir stu + hons	1	3	4	1	3	3	5	4	2		0.53
tut + dir stu + hons + sen	1	4	4	1	3	4	5	4	2		0.38
true advanced courses	2	1	1	0	0	2	0	0	0		-0.26
CLO rating	3.04				3.00						1.00
CLO rating - studio	3.09				3.05						1.00
300 classes	in-393	ng-398	pr-398	in-391	ce-302	po-380	fm-380	po-380	in-396		
	ph-303	ng-310	pr-303		sc-380	pa-380	fm-380	fm-380	ph-391		
	ph-304	in-390	pa-380		sc-310	pa-380	dt-380	po-380	ph-398		
		in-391	in-391		sc-380	in-390	in-391	in-396			
		ng-380	pa-380		in-391	in-396	in-396	in-391			
			in-398				in-396	in-393			
							fm-398	in-391			
								in-393			
								in-393			
								in-393			

Correlation Ranks
0.61 terms spent at SFAI
0.58 total studio classes
0.55 total 300-level studio classes
0.53 total tutorials + directed studies + honors studio
0.48 total tutorials + directed studies
0.41 total 100-level studio courses
0.39 total tutorials
0.38 total tutorials + directed studies + honors studio + senior seminars

CHAPTER 8

Case Studies in Art Education, Art and Music History, and Art Therapy

**Equipping Prospective and Practicing Teachers with Relevant Tools for
Today**
Jan MacLean, Faculty of Education
Art Education
Simon Fraser University

INTRODUCTION

Founded in 1965, Simon Fraser University is one of Canada's leading
comprehensive universities with approximately 30,000 students spread over three
campuses. The Faculty of Education at SFU is dedicated to offering innovative
and meaningful approaches to teaching and learning, and like most university
faculties we are continually researching ways that assessment can be an integral
and meaningful part of this process.

DESCRIPTION OF THE PROBLEM/OBJECTIVE

A primary aim of the Education Faculty is to equip prospective and practicing
teachers with creative and relevant tools to meet the ever-changing demands of
today's classrooms. In the last decade, the explosive development of digital
technology in our culture and classrooms has presented unique challenges and
opportunities for all educators, but especially educators of the arts. Increased
expectations have been placed on art educators to teach digital media skills and
explore contemporary issues surrounding the use of technology in our culture.
The demand for increased digital media in art courses leaves many educators with
the need to re-examine and re-think the aims and purposes of art education and
new conceptions of aesthetics.

Additionally, students' ease and fluency with new media has resulted in many
art educators feeling under-prepared to design and implement curriculum that is
motivating and engaging to students who are immersed and confident in this area.
Consequently, many educators are finding that there is a growing gap between the
curriculum that students wish to explore, and the kind of curriculum teachers are

able to offer. Numerous educators have expressed the desire to increase their skill and knowledge base in this area in order to meet their students' sophisticated level of competency and interest.

In response to these needs we developed a fourth year level undergraduate course titled, "Urban Arts in the Contemporary Classroom". Objectives of the course are to:

a) Examine how new and emerging technology is impacting the field of art education.

b) Prepare and equip art educators to meet the increasing demand to include and teach curriculum integrating traditional, current and emerging technologies.
 Introduce a range of methods and approaches for meaningful incorporation of emerging tools and technology in keeping with the Prescribed Leaning Outcomes of the BC Fine and Performing arts curriculum.

c) Refine and increase digital literacy skills in order to design and implement learning environments that are motivating and engaging to students who are immersed and confident in utilizing new media.

d) Explore the connection between art, technology and ecology. And most importantly, to develop strategies for assessment and evaluation of curriculum that incorporates new media, and allows students to experiment in a manner that *encourages*, rather than *discourages* experimentation and risk taking.

The course was offered for the first time in the spring of 2014. As a prime objective of the course was to provide opportunities for students to investigate innovative approaches to integrating new media and concepts, it was vital to foster an environment that would support risk taking and open ended learning. An additional objective was to balance the need to offer activities and assignments that would foster expertise and skills in digital media and the arts, while providing students opportunities to pursue and develop their unique sense of aesthetic and personal meaning making.

CHALLENGES TO SOLVING THE PROBLEM/REACHING THE OBJECTIVE

One of the major challenges I faced designing and teaching the course was how to assess work that places high value on risk taking and open ended process. And as

I felt it was important to nurture aesthetic development, I did not want to suppress individual aesthetic choices. In other words "how to assess the ineffable?"

An additional challenge in terms of assessment was the composition of students taking the course. Approximately one half of the class was education students, with a small number of practicing teachers taking the course as part of a Graduate diploma. The course was also available as a Breadth requirement for students outside of the field of education and these students were generally from the fields of business, economics and science. It is worth noting that about a quarter of the education students were International students. Even though the course was designed to support teachers in the arts, most of the students were non-artists, which meant there was a clear range of pre-existing skills in the area of arts and technology. Consequently, taking an arts and technology focused course was a fairly "risky venture" for almost all of the students

STRATEGIES/CREATIVE WAYS OF SOLVING/REACHING THE OBJECTIVE

I found the most effective way of meeting these challenges was to design assignments that focused on process, experimentation, and reflection. Therefore the two major assignments for the course were an electronic portfolio comprised of reflections on in-class activities and a digital collage. The following are descriptions of the assignments as they appeared in the syllabus:

> Adopt a (Binary) Tree" Digital Collage: For this project you are asked to observe, record, document and respond to a part of nature that you encounter on a regular basis as part of your everyday life (for example specific tree/trees, bushes, area near creek, and so on). A key concept of this project is to encourage a deeper awareness and connection to nature through multiple technologies. Photography, video, drawing should be used in the documentation process and you are encouraged to respond through a variety of forms (writing, poetry, drawing, painting, music, dance, sculpture, etc.).

> Your observations and responses will culminate in a digital collage to be presented in class. You are free to add music and text to your collage but all images must be photographed or created by you (images cannot be downloaded from the Internet).

Collages will be presented in class on final week. Digital process log and Reflection to be emailed before final class.

You will also be required to write a (minimum) three page reflection on your experience with discussion on how a project such as this might be used to teach existing curriculum, cross curricular areas and/or develop new directions in curriculum development.

Reflection of In-class activities: You are expected to keep a weekly reflective journal as a way to respond to in-class activities, discussions, journal prompts and any other questions/ideas that emerge for you. In your journal please consider how you would extend, modify or adapt class activities, ideas etc. to use in an educational setting. As much as possible, please be specific about the age group and setting (for example, working with street youth in an urban environment). In your journal include images of artwork produced in class, extensions of art explored in class, and related outside resources (eg. link to Ted talk on subject discussed in class) etc. Weekly response to in-class activities and journal prompts should be a minimum of 250 words.

I am looking for the quality of your ideas, your effort and clarity of expression. By expressing your own thoughts clearly you will reveal the effort you have put into grappling with the ideas and questions posed.

A number of strategies were utilized to effectively address the objectives. For the "Adopt a Binary Tree" assignment, evidence of process was weighted much more heavily than the final product. See Table 8.1 below.

Table 8.1: Reflection Rubric

C Range	B range	A range
Reflection is basic, with minimal critical analysis, original thought and connection to personal experience and educational practice	Reflection is good, with some level of critical analysis and original thought and connection to educational practice	Reflection is excellent, with key points fully identified with a high level of critical analysis, original thought and connection to personal experience and educational practice

The stated criteria made it clear that students would not be graded solely on their final product, but rather their process and engagement with the project. To this

end, students were required to keep a "digital process log" and instructed to "record dates, ongoing notes, reflections, and questions" as they worked on the project. As well, process logs were submitted for both midterm and final assessment. I also had many informal 'one on one' check in meetings with students throughout the semester. And it was emphasized that in order to receive a high mark the student had to start the process early on in the semester.

Additional approaches included midterm assessment of journal reflections as well checking in one-on-one with students, and viewing images they had so far. This provided students with a chance to ask questions and check that they were on the right track. Students were also welcome to email projects along the way for my feedback. Overall, the strategy of continually 'checking in' helped to reduce student anxiety and allowed students to be more comfortable with process-based learning.

The other significant challenge concerned how to access student work in a way that takes into account variable starting points. Because of the range of experience and proficiency in the arts, it was important to offer activities that had a variety of entry points and could be developed and built upon regardless of the individual's skill set. Acceptance of students highly individualized starting points was vital, therefore a "low floor, high ceiling", approach to teaching the weekly art activities was key. The activities themselves allowed for an array of interpretations and the criteria took into account a wide range of pre-existing skills and expertise.

One solution I developed for supporting different starting points was to design the class so that each week specific art making skills, approaches and knowledge were imparted both in the lecture and studio component of the class. The classes were four hours in length and at least two hours were spent in hands on arts activities. Consequently, a substantial amount of time was spent investigating approaches and methods to art making. As much as possible, in-class activities were designed to demonstrate course expectations. Therefore, as students were being asked to "adopt an area of nature" for their digital collages, working outside was modeled from the first class in early January. After a presentation on the elements and principles of design, students went outside with viewfinders, smart phones and drawing tools to draw and capture images in nature that exemplified one of the elements or principles of design. The viewfinders were used intentionally to slow down the process, so that the activity also emphasized observation and contemplation.

Another example of a "hands on activity" the class participated in was collecting found objects from nature to make drawing tools. These tools were

then used to make large collaborative drawings. As well, students designed wearable art based on images they had taken of their "adopted area of nature". Students also collaborated to design soundscapes linked to images of their area of nature.

Throughout the course, students were also exposed to more traditional ways of art making such as painting, printmaking and collage. Additionally, workshops in using animation and iMovie apps were provided to help students build their expertise in digital media. I found that all of the aforementioned methodologies and approaches contributed to the overall success and effectiveness of the class.

LESSONS LEARNED /CHANGES MADE/ ACCOMPLISHMENTS

Essential to teaching open-ended assignments to a diverse group of learners is to design criteria that is suggestive rather than prescriptive, and yet is clear enough for concrete learners to grasp. In order for this kind of approach to be effective, a certain amount of trust is needed. I found that one of the most significant ways to create a trusting environment was to set up a structure of 'ongoing assessment' with students. This assessment was both formal and informal. Students were required to email their portfolios for written midterm assessment, but a great deal of the assessment was in the form of an informal conversation where students were able to show me part of their assignment, ask questions and be given responses to help clarify and guide the process. I let students know ahead of time to make sure they brought 'evidence of their process" to specific classes. By developing a series of "check in points" a few important aspects of assessment are addressed. The foremost was to be able to assess if the student is actually engaged with the process. Additionally, I found it was important to provide clear written criteria and hold discussions with the class in order to address any questions or concerns they might have.

A further consideration for more open ended, exploratory learning is the element of time. As there are multiple answers and a wide range of outcomes, there needs to be enough time so that students can use their own aesthetic judgment on what will be included in their final product. Along with discerning what images to respond to, time is needed to respond to images through art making. The very nature of engaging in process based art making and reflecting upon that process, requires a high degree of engagement and commitment.

Along with my feedback, there was some informal peer review of projects. I found students were very open and honest with one another, and offered each other valuable support and direction. One of the factors that contributed to constructive peer feedback was the emphasis placed on collaborative learning

modeled in the class activities. The next time I teach the course, I will offer more opportunities for peer feedback and review. As well, there was some self-evaluation, but this is another area I would involve students in more in the future.

FACTORS THAT CONTRIBUTED MOST TO THE SUCCESS OF YOUR ASSESSMENT?

One of the major factors that contributed to the success of the assessment was that the criteria made it clear that students would be rewarded in terms of marks for experimentation. This factor contributed the most greatly to student's willingness to experiment. Giving students formal and informal feedback early on and consistently throughout the course were also important factors. Developing and building a range of skills such as, building drawing tools, tutorials on animation and using iMovie, designing and making wearable art, also contributed significantly to the positive outcomes students experienced. Additionally, allowing for a wide range of interpretations was fundamental.

As well, because "evidence of process" and "reflection on in-class activities" were the major criteria used for assessment, students were able to immerse themselves in the experience and were more willing to take risks and make mistakes. Because mistakes were recognized as an important part of the process and reflected in their marks, students took more chances. As a result, their final products were very creative and unique. Another positive outcome of assessing in this manner was students shared their expertise and ideas more freely because they did not feel they were competing. Students also shared their process and progress with each other, so that they received constructive peer feedback in pairs and small group settings. Sharing of the final projects had a celebratory feel, as students brought food to share and after each collage was presented students would offer positive feedback and constructive criticism. And not to be underestimated in terms of what contributed to the success was the faculty and university support of new initiatives and innovative approaches in all aspects of teaching and learning.

CONCLUSION AND SUMMARY

Education in and through the arts lends itself well to pedagogical development that emphasizes both personal meaning making and reflection on how to best implement engaging and meaningful learning practices. I believe that evaluation and assessment are an important part of that process and that rather than teach

what we know can be easily assessed, it is more important to find ways to assess what is more elusive, ambiguous, and open to multiple interpretations.

As an educator of future and practicing teachers I am aware that I am not only teaching course content, but also role modeling how "open ended process based learning" might be taught. This is particularly important in the Faculty of Education as almost all of our students wonder how art that allows for freedom of choice and interpretation can be assessed. Therefore, I feel a responsibility to not only offer assignments that students will find meaningful and engaging, but also role model how assessment and evaluation can be a positive and constructive element of developing aesthetic awareness and artistic skills.

My hope is that by modeling this way of assessment, students will be less wary of assessment and evaluation in the arts and feel more confident in offering assignments that encourage risk taking and experimentation. Consequently, it is vital to role model assessment that encourages, rather than hinders curiosity and exploration. This can only be done in an environment where mistakes are encouraged and to a certain extent celebrated. It is not easy to "assess the ineffable" but if we want our students to grow in ways that cannot be prescribed, it is a challenge worth taking.

Building Assessment from Scratch: Moving from Intuitive to Systematic Assessment Models
Emily Laurance and Kevin McLaughlin
Department of Music History and Literature
San Francisco Conservatory of Music

Subject Matter of the Case Study
Revision and Assessment of the undergraduate Music History sequence and graduate research seminars

INTRODUCTION

Emily Laurance currently serves as chair of the Music History department at the San Francisco Conservatory of Music. Kevin McLaughlin serves as Music History faculty along with being Library Director and Trumpet faculty. In the last ten years we have collectively had to invent assessment procedures within our department almost entirely from scratch, since when we began the department was virtually without autonomy or infrastructure. In 2003 there were no full-time dedicated positions in the department; as a result, the department's status was low and it suffered from a general malaise. In fact, at the time all music history instruction was in the hands of adjunct instructors and faculty in other departments. Since there were no full-time music history professors, there was also no chair and consequently no leadership in the assessment and revision of departmental curriculum.

Assessment procedures at SFCM generally were confined to individual departments; thus, assessment across the institution was uneven at best. Assessment was driven primarily by a sense of traditional musical curriculum and pragmatism. While this occasionally led to positive results, in some departments it also resulted in inertia. Systems and procedures were created as needed, and were not necessarily guided by larger conversations across the institution, let alone those of outside professional educators or with reference to the latest research on student learning. Two fundamental stimuli drove the assessment process: accreditation demands and intuition about effectiveness of student learning. Each episode of assessment and curriculum revision took place organically, and was often the result of larger conversations and consensus building.

The Music History department at SFCM saw substantial changes with the arrival of a new Conservatory dean in the fall of 2003. The dean's own academic background in music history bolstered the impetus to strengthen the music history curriculum. The dean's first step was to hire a departmental chairperson in fall 2004, and to charge him with a thorough revision of the music history curriculum. What follows details some of the more substantial changes at both the baccalaureate and the master's level in the past ten years.

CURRICULUM ASSESSMENT CHALLENGE I: THE UNDERGRADUATE MUSIC HISTORY SEQUENCE

The new Music History chair determined, through preliminary discussion with the dean, other faculty and through student feedback, that the level of student learning in the undergraduate history sequence inadequately reflected the needs of the students and the goals of the institution. These foundational courses were the responsibility of an adjunct instructor with negligible presence on campus and little investment in the institution's undergraduate curriculum. The chair believed this a fundamental structural problem; therefore, he and the dean created an additional full-time line, hiring Emily Laurance in that role in fall 2006.

STRATEGIES FOR REACHING OUR OBJECTIVES

With two-full time faculty in place, the Music History department initiated a more systematic assessment of its offerings, beginning at the undergraduate level. The chair assembled a committee consisting of the two full-time Music History professors, the chair of Music Theory, undergraduate and graduate students, the dean, and the library director.

Some of the major considerations for the revision were the following: 1) we inherited a two-semester undergraduate music history survey, but it was clearly insufficient to cover the 1200 years of material required in the undergraduate survey; 2) there was not enough emphasis placed on score reading and analysis of historical musical works; 3) students' writing skills were inadequate for the production of the assigned term papers; and 4) we wished to align ourselves more with the requirements of peer institutions and the expectations of the National Association of Schools of Music (NASM), the accreditation body for schools of music in the United States. Although we did not refer to them as such, these considerations formed a core of student learning outcomes that guided us through the crafting of the new curriculum.

There was a general consensus that undergraduate student learning of Western music history was not taking place at a level commensurate with our own graduate placement exam. The committee's discussions named several reasons for this. The most obvious was the compression of the material into a two-semester sequence. A survey of practices of peer institutions revealed that our two semesters were comparatively condensed, and that sequences of three or even four semesters were more typical in the field. The committee thus expanded the undergraduate music history introductory sequence from two semesters to three, and instituted a requirement of at least one upper-level music history course in addition to the survey, which students were to select from a variety of topics.

A more detailed analysis of desired student outcomes also led to a revision of instructional method within the music history sequence. The earlier, two-semester model relied heavily on assignments from a history text that emphasized a chronicle of detailed historical facts. Stylistic information and score engagement were present, but accessible mainly within a received overarching narrative. We wished students to engage more confidently with the assigned scores and recorded performances in a less mediated fashion. We also wished them to extrapolate stylistically relevant observations about unfamiliar repertoire from their knowledge of assigned works in the course.

Our desire to have students engage directly with musical examples led to the revision of individual lesson plans. Rather than read extensive descriptions of stylistic traits for memorization, students identified these traits themselves, during class discussion and in homework assignments. Similarly, instead of assigning long readings from a traditional historical text and requiring students to reproduce the received narrative on an exam, we assigned selected source readings to encourage students to construct their own narrative, in collaboration with the instructor and each other, from examples of direct historical evidence.

The old two-semester sequence also included assigned essays as a culmination of each semester's work. Student work in these assignments, however, mainly recounted a string of facts from the text and did not engage in analytical discussion of musical styles or genres. Since the class did not focus on the large-scale composition of original essays, these longer assignments were abandoned in favor of shorter written assignments that provided clear instruction concerning paragraph organization and the effective use of evidence, whether from primary readings, secondary readings, or directly observed features of the score.

This initial stage of curriculum revision was done primarily from an intuitive, rule-of-thumb understanding of assessment based on the collective establishment of a few broad principles. However, once the initial revised model was in place, a more systematic method of assessment emerged over time. This has resulted in incremental but meaningful changes implemented through a more continuous cycle of assessment and revision over the past eight years. Although the following passages describe the emergence of assessment procedures in all three semesters of the music history sequence, we will primarily discuss the assessment and continuous revision of the first semester of the sequence, which was the subject of the most reformulation, and may in many respects be thought of as representative.

SUBSEQUENT CHANGES TO ASSESSMENT PROCEDURES AND CURRICULUM

Although the music history sequence expanded from two semesters to three, two factors continued to test the limits of content in the first semester. First, only fifty years of content was removed from the first semester: while the instructor was formerly responsible for music history from 800-1750, in the revised model s/he was still required to cover material through the year 1700. Furthermore, while the number of semesters had expanded, the number of contact hours had not. Each semester had been reduced from three contact hours a week to two. This reality dictated that the first semester had to be re-envisioned with a narrower selection of representative works, particularly given our stated objective of deeper student involvement with musical scores. The comparative breadth of this semester's coverage led to the reorganization of the course into three, rather than two units. The students thus had more frequent quizzes and exams, but on a more manageable amount of material.

Two other changes, however, were probably more significant in the long run. First of all, I, as department chair, drafted a comprehensive set of student learning

outcomes for the sequence, including some specific to each semester's material. This simple step instituted a much more self-conscious monitoring of lesson plans, assignments, and materials from that point forward. Second, because of the time pressures on the first semester of the sequence, I instituted additional weekly recitation sections, run by a graduate assistant, to review and reinforce material covered in the regularly scheduled class meetings. This structural change meant that the graduate assistant became a true teaching assistant, and as a result became part of a de facto assessment team. The teaching assistant not only had a more extensive understanding of the course elements, s/he also had a better understanding of the undergraduate student experience in the course. When the teaching assistant graded the course's weekly assignments s/he also had a far richer understanding of how those assignments related to lectures, discussions, assignments and stated course SLOs. In addition to individual student feedback it was natural for the assistant to provide global observations about overall student performance and the clarity and effectiveness of the original assignments. Once this procedure was established the assignments were then measured against and mapped onto the course SLOs. With each yearly iteration of the course, the alignment between assignments and outcomes is evaluated and revised. We also now routinely map SLOs to lesson plans for all classes and recitations, all with the goal of creating a better designed and better integrated course.

In recent years we have begun collecting longer-range data to determine what effect, if any, these curricular changes have had. In cases where our undergraduates continue in the Conservatory's master's program we track their music history placement exam results. However, for a number of reasons these statistics are not very meaningful. First, the sample in a given year is very small. From a total population of about 200 incoming master's students, our undergraduates represent only six to fourteen students in a given year. Moreover, the students who go on to our master's program are sometimes our strongest students but also sometimes our weakest. And finally, there is often a large percentage of non-native speakers within this small population, so it is difficult to consider this sample truly representative.

Success and failure rates from individual courses within the undergraduate sequence constitute more meaningful data. In the earliest versions of the three-semester music history sequence, the failure rate for the first semester was very high (the students who were failing often had extremely low overall percentages, suggesting that there may have been among them a high degree of disengagement). Since 2009 the overall average student grade percentage has steadily increased. In fall 2012, for example, the average letter grade for the first

semester of the sequence was C, but the average percentage was lower because of the very low scores of the failing students (66%). By fall 2013 this rate had improved to 70% and in fall 2014 the average grade percentage was 75%.

CURRICULUM ASSESSMENT CHALLENGE II: GRADUATE RESEARCH SEMINARS

Following the initial stages of revision to the undergraduate curriculum the two full-time Music History faculty (the chair and myself) began a similar evaluation of the master's Music History curriculum. In fall 2007 a new committee assembled for this purpose, one that included several current graduate students. Upon matriculation, master's level students are required to take a music history placement exam. Up until 2008 this exam covered factual material drawn from a prominent Western music history textbook and included information from 800 AD to the present. If a student did not pass the placement exam he or she was required to take a one-semester intensive survey. This was judged to be a remedial course, and so received no credit.

STRATEGIES FOR REACHING OUR OBJECTIVES

As was the case with the undergraduate curriculum, there were several issues identified by the relevant committee. First, the one-semester remedial survey was generally thought ineffective. The assumption behind the course was that master's level students had taken a music history survey at their undergraduate institution, so failure in the placement exam indicated solely a need for "review." However, a substantial number of arriving master's students had had no music history survey at all: either they had done a bachelor's degree in another field or they had received a degree in a country where Western music history instruction was not part of the curriculum. These students needed more than a one-semester review. What is more, placement into the review course meant that master's student would have to complete six music history courses in four semesters; with the other requirements of the master's degree, this created quite a burden for these students.

To mitigate these problems the graduate curriculum committee decided to eliminate testing incoming students on Western music history before 1700, mainly because most Conservatory students seldom perform repertoire prior to that year. The remaining material—repertoire from the 18^{th} through the 21^{st} centuries—was spread out into two semester-long graduate-level review courses. These review courses, however, now count toward a student's overall Music

History requirements. Students who place out of the review courses are afforded more choice of music history classes in their respective programs, though the total number of required classes remains the same as their peers'. These changes went into effect in fall 2008.

There was, however, a larger problem with regard to the master's curriculum other than the remedial review course. The master's curriculum then in place was very general: each student was required to take five courses with the generic title "seminars." These courses were highly varied in their subject matter and in their methods. Moreover, they had been taught by any faculty member who had expressed an interest in doing so, including members of the theory, composition, and performance faculty. Some of the courses emphasized historical context while others were strictly analytical in approach. This resulted in a wide variation of expectations from the students. Some courses required no outside work while others required extensive research and writing. While the majority had syllabi these courses were not closely overseen. Frequently students finished their degree without having to do any substantial research or written work on music at the graduate level.

The dean and the chair of Music History met and discussed instituting a class of courses that they christened "proseminars"; these were to be courses specifically devoted to teaching graduate research and writing skills in music, and would be required of all master's students. The dean in particular wished proseminars to constitute a common experience for all master's students to communicate the importance the Conservatory placed on these skills. Both the dean and the department chair felt it important that these courses be taught by full-time academic faculty, so the chair formed a working group of the two full-time Music History faculty members and the library director. The three of us identified the skills we wished the students to acquire and use in these courses. We agreed on three basic principles: first, our students needed to acquire a better grasp on how to find relevant and high quality information; second, our students needed to evaluate the information they found with a higher degree of critical acumen; and finally, our students needed to learn how to write at a graduate level, including developing a thesis and organizing evidence to form a coherent and persuasive argument.

What we were proposing, in essence, was a version of what is usually called a "bibliography" or "research methods" course—a standard part of the master's curriculum in many music programs. What we wished to avoid, however, was the deadly reputation that such courses often acquire. Since these courses are taught irrespective of course content, they can often seem highly abstracted from the

applied studies of the conservatory student. Furthermore, the chair felt strongly that since students came to the Conservatory rightly expecting to learn about particular repertory, composers, and genres, they deserved coursework that supplied real information about the music they performed. We thus decided that proseminars would use specific course content to teach the skills that we wished to emphasize. Consequently, we further determined that there would always be a choice of topics available to each student. We were limited by the small number of full-time faculty members qualified to teach a graduate research course, but we were able to schedule three options per semester.

Because of the desire of the dean and others for a common academic experience, we decided to require all students to take proseminars and not to provide any mechanism to place out of them. The reasoning was straightforward: anyone can profitably work on their writing, and, furthermore, writing a paper is in and of itself valuable assessment of student learning in any given course content.

The same principle of providing a common experience led us to schedule all proseminars concurrently, and each week to have a plenary meeting of all proseminars, team-taught by the three instructors, followed by breakout meetings of the individual courses. From the very beginning this decision proved problematic: because the plenary presentations were large, it was easiest to treat them as formal lectures, and the students were obliged to assume a passive attitude for the bulk of that time. This was exacerbated by the general nature of the plenary presentations: since we were speaking to three different classes with three different content areas (for example, operetta, symphonic poem, and Haydn) we could only speak in very broad terms about the research process. It became clear early on that this method reverted to the older "research methods class" model, disengaging students from applied research. It delayed the students' work on their own projects, and was ineffective at addressing particular problems that they encountered in their work.

Our desire to provide a common experience also yielded successes. Although our syllabi varied because of our divergent course subjects, we faculty felt it important to synchronize the course structure of all three proseminars. We therefore had common general topics from week to week and common assessments scheduled at specific intervals. For example, we all assigned an annotated bibliography that went through a preliminary draft. We all assigned a midterm, a paper proposal, and a preliminary draft of the final research paper at corresponding points of the semester. Finally, we all scheduled two weeks of individual tutorials in the latter part of our classes to discuss revision of

individual student work. This last feature of the proseminars proved to be particularly successful. It was immediately evident from student evaluations and other direct feedback that the students appreciated the individual attention; moreover, they felt that this was the single most important factor in helping them produce higher quality work.

During this inaugural year, proseminar instructors met weekly to plan the plenaries together. As a practical matter this meant that there was a great deal of discussion about the successes and challenges of the proseminars overall. We all observed the problems associated with the plenaries and worked on ironing them out. However, our high level of self-consciousness about this new class of courses contributed to resistance from the students themselves – another big challenge of the newly instituted proseminars. Many students felt that proseminars (particularly the plenaries) were robbing them of valuable practice time and were irrelevant to their main purpose at the Conservatory: performance. Moreover, many students resented the required nature of the courses since they "already knew how to write a paper." Some of these objections, we believed, would recede when the proseminars became a more customary part of the curriculum. More problematically, there was also some resistance from faculty members teaching proseminars. Many professors felt that it was too much to ask to include the course content of a graduate seminar in a course with so much time devoted to teaching research and writing skills, and that ultimately they were teaching neither to their satisfaction.

In light of the general dissatisfaction with the weekly plenaries, the proseminar faculty decided to reduce their number. We did not want to eliminate them altogether, because we still were attached to the idea that these meetings would help provide a common experience. We also liked how the team teaching of the plenaries gave the students three different perspectives on the research process. However, the abstract and passive nature of the format remained. By the end of the first year, it was clear that the plenaries were not working the way we had envisioned. We reduced their number yet again in fall 2010.

In the middle of the 2010-2011 academic year the chair took stock of the proseminar experiment. Combining faculty discussion with student feedback he questioned their overall effectiveness. Besides the problems with the plenaries, he identified several other problems:

1. Scheduling all three classes at the same time caused problems for classroom schedules and student schedules.
2. Offering only three topics per semester restricted student choice.

3. The focus of the courses wavered between research/writing and course content; there didn't seem to be enough time for either.

The tension between a content- and a skills-based curriculum was also a problem with student assessments over the semester. Many of the assignments evaluated students on the basis of general course content, and often seemed to have no immediate relevance to their individual research projects. In the second half of the semester, when students were asked to concentrate on their papers, the inclusion of additional course content seemed like a pile-on of busywork.

That spring the chair proposed to the academic affairs committee that the curriculum be changed: that master's students only be required to take one music history course (from the required set of five) with a compulsory term paper; that there be four or five such courses offered in any given semester; and that such courses be limited to fifteen students. Gone was any attempt to schedule such courses concurrently or to define course structure beyond the presence of a research paper; gone, too, was the ambition of providing a common experience. But everyone agreed that the individual writing tutorials were effective. Those we assumed would remain.

In fall 2012 the departmental chair retired and I, Emily Laurance, became chair. By that time we had been offering four, rather than three, proseminars each semester and, as a result, we were compelled to expand our roster of proseminar instructors. Many of those we recruited were highly qualified, but were part-time faculty and could not afford to be on campus more than a few hours per week. Our use of part time faculty as well as our generally reduced ambitions for the proseminars meant that there was less effort put into creating a common structure for all proseminars. We were unable to continue our weekly meetings in which we compared notes and shared assignments and classroom activities. The inevitable result was that the student experience in one proseminar began to differ more noticeably from that in another. The proseminars of the three full-time instructors (the two full time Music History faculty members and the library director) continued to show some commonality, but those of the part-time faculty deemphasized the writing process and minimized the individual tutorials due to time constraints.

To counteract this, I created and shared a document, with the particular aim of helping part-time faculty design their proseminars in line with our overall aims. In it I included a set of general student learning outcomes I had drafted for my own proseminars that addressed research and writing skills. I also created a week-by-week template that sought to integrate the course topic content with the

instruction of research and writing skills. I did this by limiting the general course content to assigned readings that provided students with a framework from which to build their own projects, and by requiring students to use regular written assignments to define and hone their own research area and thesis. This meant that each written assignment was a stepping-stone, leading students to generate prose that could ultimately be incorporated into their final research paper. This approach has helped to solve the perceived problem of time limitations in the course and, more importantly, has kept the focus of the courses squarely on original student projects. As a result, students are less likely to feel that the day-to-day work of the proseminars is irrelevant to their own interests and aims.

SUBSEQUENT CHANGES TO ASSESSMENT PROCEDURES AND CURRICULUM

There are at least two major challenges with the proseminars that remain. The first is the continued challenge of aligning the courses of the part-time faculty with those of the full-time faculty. To accomplish this, I am reinstating the regular meetings of all proseminar faculty this spring. Our part-time proseminar instructors are highly dedicated and are willing to commit to the additional time. Starting from the template that I distributed in fall 2012, I plan on leading discussions about the range of experiences in the proseminar, and ultimately to generate a revised version of the proseminar model, generally adaptable to a range of course content areas. With these meetings in place, we can use them to formalize proseminar assessment procedures. Our next task will be to align the proseminar student learning outcomes with the scaffolded assignments represented on our common template. Since evaluation of student progress in these courses leans heavily towards the writing and revision process, we will then draft rubrics that help us to standardize our writing expectations.

The other major challenge concerns our substantial non-native speaker population. The Conservatory has historically set a low bar for English language facility at admissions, and this has rendered the academic challenges of the proseminars almost entirely unmanageable for a number of our master's students. This is being addressed on multiple fronts: first, Admissions is gradually raising their required TOEFL score for master's students. Second, we have this year introduced a new course for students placed into the English as a Second Language curriculum that we are requiring them to take prior to enrolling in a proseminar. This course, Graduate Studies for International Students, is team taught by a Music History faculty member and by an ESL faculty member. The curriculum imitates many of the proseminars' scaffolded reading, research, and

writing assignments, but at a slower pace, with more explicit instruction on note taking, annotation, and other study skills, with more time built in for revision of written work, and without the requirement of a final research paper. We are hoping that this course will enable our novice English speakers to ready themselves to participate in the proseminars more confidently.

Over the last ten years we have built upon our assessment procedures while introducing major new curricular components, although it has often felt like tracking a moving target. Of necessity, we have felt our way as we went. Faculty conversation, student feedback, and trial and error were all crucial to reaching greater effectiveness and stability in the curriculum. Although these are rudimentary assessment procedures, without these basic tools we would not have had the confidence to build on our successful approaches and to jettison less successful ones. With the establishment of new curriculum structures, a mechanism for varied feedback, and nuanced assessment procedures in place, we have seen a culture of continual improvement finally take root.

Assessment in History of Theatre I, Department of Humanities at the Palm Bay Campus; Department of Performing and Visual Arts at the Cocoa Campus
Janet E. Rubin, Ph.D.
Eastern Florida State College

Brief background on the institution/program

Eastern Florida State College (EFSC) transitioned from its genesis as Brevard Community College in 2013. The name change was motivated, in part, when the institution began offering a limited number of four-year degrees. It has not, however, ceased to offer associates degrees and work force certifications. In addition, the college has a relationship with Brevard County Public Schools and qualifying high school students can dual enroll at EFSC.

To better understand the institution and how it approached the assessment process, it is necessary to understand several things. First, EFSC has four physical campuses in Brevard County, Florida and it also offers online classes. As a four-year institution, the college took a more vigorous approach to assessment. Regional accreditation also was a driving force, prompting a need to show constant improvement. Certain courses were selected for assessment each year, and History of the Theatre I was designated for assessment in the Spring 2014 semester. While the full-time faculty bore primary responsibility for assessing these classes, in certain cases adjuncts were tapped to assess their sections. Full-time faculty scored the work of their students as well as the work of students of

adjuncts teaching the same course. These assessments did not impact the student's grade in the course. In all, more than 160 sections across 38 courses in the AA program were chosen for assessment. As for our course, History of the Theatre I satisfies a student's General Education requirement. It also is a Gordon Rule class, which means that college-level writing is expected.

DESCRIPTION OF THE PROBLEM/OBJECTIVE

Eastern Florida State College's Academic Affairs Council's Assessment Committee was charged with implementing an evaluation assessment framework for learning outcomes for the institution. The assessment discussed in this case study was implemented as a part of the AA Assessment Initiative. The assessment was to determine how well students have mastered the college's Core Abilities, the program learning outcomes for the AA degree. Faculty was instructed to identify an assignment for assessment and submit papers/projects from the entire class. Students' names were to be on the papers/projects, although they would later be removed. The Chair of the Assessment Committee received the documents. Faculty was assured that data would be coded by degree/program/certificate and that none of the information would be used to evaluate instructors.

In order to meet the objectives of the assessment, the full-time faculty member in Theatre, whose program is housed on the Cocoa campus, selected the core ability and identified an assignment to assess it. The part-time faculty member, teaching the course on the Palm Bay campus, had to use the same assignment and assessment procedure. A template was designed to assess the History of the Theatre I assignment, see Table 8.2 below.

Table 8.2: History of Theatre Assessment Rubric

	Novices (1)	Apprentices (2)	Practitioners (3)	Professionals (4)	Exemplars (5)
Criterion #1: Design research objective. "I'm going to figure out how to make a bunraku puppet."	Research objective is vague or inappropriate. "I'm going to research Japanese anime."	Research objective requires more specific focus. "I'm going to research all of Japanese theatre."	Research objective appropriate to the assignment. "I'm going to research Bunraku."	Research objective is concise, focused and appropriate to the assignment. "I'm going to research puppet design in Bunraku."	Research objective is concise, focused, appropriate to the assignment and also reflects a unique or original approach. "I'm going to research puppet design in Bunraku through making a puppet, talking to an expert, traveling to Japan..."
Criteria #2: Choice of Sources. *Note emphasis on primary sources.*	Chooses irrelevant and/or unreliable sources unsuited to academic research. (i.e. Wikipedia)	Chooses adequate information, including primary sources where appropriate. (Reliable but everyday websites)	Chooses reliable information, including primary sources where appropriate. (Databases and Google searches)	Chooses scholarly information, including primary sources where appropriate. (Databases)	Chooses scholarly, discipline-specific information, including primary sources where appropriate. (Database info is more specific)
Criterion #3: Evaluate information and sources critically.	Inadequate evaluation of information and ideas. (Faulty, big holes, vague)	Adequate evaluation of information and ideas. (Some analysis, lots of reporting facts)	Effective evaluation of information and ideas. (Putting pieces together, making comparisons)	Above average evaluation of information and ideas. (Putting pieces together, drawing comparisons, drawing conclusions)	Sophisticated evaluation of information and ideas. (Putting pieces together, making comparisons, drawing unique conclusions or making unexpected brain leaps)
Criterion #4: Integrate Information	Integration of information is lacking and does not support the planned objective. (final product is a mess)	Partially integrates information into a coherent final product to accomplish the planned objective. (posters is lacking in information)	Adequately integrates information into a coherent final product to accomplish the planned objective. (poster covers the basics but no more)	Effectively integrates information into a coherent final product to accomplish the planned objective. (poster thoroughly covers the topic, is well-organized and easy to read)	Effectively integrates information into an original, persuasive final product to accomplish the planned objective. (posters is fabulous - covers the material, is easy to read and well-organized, also adds insights and originality)
Criterion #5: Use information ethically and legally	Lacks knowledge of laws, regulations, and institutional policies regarding access to and use of information resources and shows evidence of willful plagiarism.	Lacks knowledge of laws, regulations, and institutional policies regarding access to and use of information resources and commits unintentional plagiarism.	Follows laws, regulations, and institutional policies regarding access to and use of information resources and demonstrates an understanding of plagiarism. Attempts to cite sources correctly.	Follows laws, regulations, and institutional policies regarding access to and use of information resources and demonstrates an understanding of plagiarism. Citations are cited correctly for the most part.	Follows laws, regulations, and institutional policies regarding access to and use of information resources and demonstrates an understanding of plagiarism. Citations are consistently in the correct format.

Source: Henry, Jeanine. "Analytic Rubric Template for History of Theatre (Process Information)." Eastern Florida State College, 2014.

CHALLENGES TO SOLVING THE PROBLEM/OBJECTIVE

Several challenges marked the assessment of History of the Theatre I. This author is the part-time faculty member who teaches the course on the Palm Bay campus. Although she retired from another university as Professor of Theatre with more than thirty years of experience before teaching at EFSC, it had been many years since she had taught this course and it was the first time teaching it for her current institution. While good faith efforts were made to keep adjuncts informed about the assessment process, the full-time faculty member attended relevant meetings and had a better grasp of the process as a whole. A second challenge had to do with timing. Our assessed assignment was a short research project with three components: (1) a reflection paper; (2) a creative project; and (3) the presentation of the project. The following is the syllabus description.

Short Research Project: Students will research a theatre history topic of their choice and produce a visual and written product reflecting the overall subject studied. Project options include role play, creating a 3-D object, creating a collage, etc. Students must also write a short reflection paper on this project. Projects will include research, references will be properly cited, and a bibliography will be included. There are three elements to this project: presentation, creative product, and reflection paper. **Students must complete all three elements to receive a grade for the project**. Guidelines will be on ANGEL. See syllabus for deadline.

In addition to the syllabus description, the students had available to them the assignment's guidelines which follow. These were posted online at the beginning of the semester so that students could access them at any time.

GUIDELINES FOR RESEARCH PROJECT

The goal of this research project is to enable you to learn more about a topic in theatre history that interests you and to present this knowledge in a creative way. Each student will explore any general topic relating to theatre history *within our time frame* (Ancient Greeks to 1915). Make sure the topic is not too broad or too narrow in focus. Make sure the topic clearly relates to theatre history. There are three elements to this project: 1) the creative product; 2) the reflection paper that includes your references; 3) short (5 minute) presentation of your project to the class. ALL THREE ELEMENTS MUST BE COMPLETED TO RECEIVE A PASSING GRADE FOR THE PROJECT.

After thorough research of <u>at least three sources</u>, the student will produce a visual and/or written product reflecting the overall subject studied. Several

options students may consider are included below, but *this list is by no means all-inclusive.* If you have another idea for a project that's not listed, consult the instructor for approval. Keep in mind that the student's final product must include a **written reflection** paper that is 3-5 pages long.

CREATIVE PROJECT

Following are some ideas you may consider in planning your project:

Acting/Role Playing: Select an individual who has made a significant contribution to theatre history within our time frame. Perform a short one-person play that explores this person's life. You may also create a performance event that reflects a time in history, the performance of a play, etc. For example, you might perform monologues from Shakespeare's plays, or the one- person version of *Tartuffe.*

Design/Technical Theatre: Create a model of the Globe Theatre, or make a model of Torelli's chariot and pole system of scene shifting.

Costume Design: Design costumes for a play. What might the original actors have worn? What adjustments do you have to make for contemporary actors? Demonstrate your designs through renderings or through creating the costume itself. Do not simply say that you are doing a modem version of the play and render contemporary clothing. Your design must draw upon the influence of the original production and time period.

Masks: Create masks from various time periods. Can you determine if Greek masks were used to amplify sound? What do you learn about commedia dell arte from creating its masks?

Puppetry: Create a puppet show that reflects a topic in theatre history.

Puppets: Make puppets that are historically accurate for a particular time period. You might, for example, make puppets for *commedia dell 'arte* characters.

PowerPoint Presentation: Create a presentation with the aid of visual technology. **Video:** Create your own video. Bring a play from theatre history to life or create your own documentary.

Collage: A collage is a collection of select pictures put together in a unique way. Focus on your general topic, and create a unique product that reflects what you've learned about it. For example, perhaps you'd like to focus on theatre during the era of Louis XIV. Your collage could reflect the geography of France, the King and his lifestyle, fashions of the day, and theatre practices of the day. Try to show how all these elements fit together and how theatre reflects the society of its day.

Drawing, Sketching, or Painting: This choice is similar to making a collage, but here you create from scratch your own original work. Be sure the final product is one that everyone will be able to see when you display it.

Movie Review: Watch a movie or documentary that contains elements of theatre history and write a review, commenting fully on its historical accuracy/inaccuracy. For example, you could compare/contrast different film versions of *Hamlet.* You could also watch the movie *Moliere* or *Shakespeare In Love* and examine them for theatre history elements.

REFLECTION PAPER

Your creative product must be accompanied by a reflection paper that reflects the research that was done, why the student made the creative choices s/he did, challenges the student faced, what the student felt s/he learned, and other details or topics the student feels are of interest. This reflection paper must also contain a "Works Cited" page in correct MLA format. **This project must be fully research based, and must reflect appropriate academic rigor.** This project must also focus on theatre history events that take place within our time frame (Greeks to 1915). The paper must be typed, 12 point font, double-spaced, and in correct MLA format.

Include a general summary of your topic and its focus. Identify and explain the concepts, terms, topics, and themes you included in your work. You should also reflect upon the option and topic chosen (why it was chosen, how it "fits" in our time frame, why you chose your particular option, the direction you took it in, etc.). Describe the item itself in written detail, examining each component, what it says/symbolizes/why you chose each item, etc. Be specific and provide examples. Explain the benefits of this opportunity to demonstrate your understanding in a different way than usual. Did the completion of the option help you better learn and understand the material?

Examine the research you completed in order to create your project. **You must utilize a minimum of THREE sources.** Examine a variety of primary and secondary sources in your research, including not just books but journal articles as well. Technology has opened up a whole new avenue for student research. Therefore, internet sources, with few exceptions, may also be used. *Students should **NOT** utilize the following as source materials:*

- Any textbook, including the Wilson/Goldfarb book
- Wikipedia
- Any encyclopedia, including Encarta

All sources must be cited. Failure to do so is plagiarism. Plagiarism is more than a technical deficiency; it is dishonest. It involves the theft of words, ideas, or conclusions from another writer. If a paper gives the impression that the writer is

himself/herself the author of words, ideas, or conclusions that are in fact the product of another person's work, the writer of that paper is guilty of plagiarism. Plagiarism need not be deliberate, however; it may be committed unintentionally through carelessness or ignorance. Be alert! Information that is "of common knowledge" need not be noted, but when in doubt, make a note! Plagiarism is a serious offense. Students found to have committed deliberate and flagrant plagiarism (as defined by the instructor) may be given a <u>failing grade for the entire course</u>, and may face more drastic penalties. (See the Student Handbook for additional information).

It may be very helpful to have someone else read your paper to see if what you've written is understandable. Two (or more!) sets of eyes are better than one in sighting potential spelling errors and the like. Students will find the college has many tools useful in creating a successful paper, including the Learning Lab. If given enough lead time, the instructor will take a look at rough drafts as well.

<u>HERE ARE THE GUIDELINES FOR THE PAPER:</u>

- The essay should be <u>at least</u> 3-5 pages. Two and a half pages do NOT equal three pages. Papers that are not of sufficient length may be awarded a grade of F for failure to meet basic guidelines. If you need to go beyond 5 pages in order to be thorough, you may, but do not pad the paper just to increase the number of pages.
- Make sure your essay is well-organized and uses correct grammar, punctuation and spelling.
- You must use three sources. You may use your textbook as a source <u>in addition to</u> your three sources. One source must be from an academic journal or database. You may NOT use Wikipedia or other encyclopedias or encyclopedia websites. You may NOT use classroom notes as a source.
- All sources must be cited using proper MLA format. The paper should be typed, double- spaced, 12-point font (black on white), one-inch (1") margins.
- The preferred submission method is that you submit by handing in a printed copy in class. If you forget to bring your essay to class, you may submit it via Angel by 11:59 p.m. on the due date and it will not be late. Any paper submitted after the due date is late and subject to penalty.
- Papers should be proofread and spell-checked.
- Title page should use proper MLA format.

- A Works Cited page must be included. All information on the Works Cited page must be in proper MLA format. Follow all MLA guidelines.
- Italicize play titles.
- Capitalize words in play titles.
- All play quotations must be properly cited.
- Do not simply spout facts or string quotes from sources together. Ask questions, pose answers, make connections, and use your imagination. Use the vocabulary of the theatre.
- Be specific.
- Backup your assertions with examples and support your ideas.
- Emphatic "quotes," boldface, *italics* and underlining should be used sparingly, that is, reserved for actual quotations, titles and documentation.
- Standard business fonts are best with Times New Roman preferred.
- Papers should be written with an academic tone. Overly familiar phrases, slang or texting phrases (LOL) are inappropriate.
- If you are discussing a play, assume the reader has read the play. Some background information might be useful but do not pad your paper with a plot synopsis or play summary.
- MLA format is required. If you are not familiar with MLA format, help is available at the Learning Lab, through a Library workshop, online, or through the instructor.
- If writing is not your strong suit, go to the Learning Lab for help.
- Plagiarism is unacceptable and will result in a grade of "F."

PRESENTATION
Each student will give a short (5 minute) presentation in which s/he shares his/her project with the class. Presentations should be well-planned. Students are expected to be articulate and well-organized.

COLLABORATION
Students who wish to collaborate on a project must have permission from the instructor. Collaboration should be limited to performance events which require more than one performer. Each student must submit his/her own written paper.

DUE DATES
Please note that papers are due prior to the presentations. This is to insure that students have completed necessary work. Penalties regarding late papers will

apply. All students are expected to attend class during the final exam period as presentations will be given in lieu of a written exam.

GRADE SCALE:

Project: 75 points
Reflection Paper: 50 points
Presentation: 25 points
Total: 150 points
(Source: Henry, Jeanine and Janet E. Rubin. "Assignment Guidelines for the Research Project." Eastern Florida State College, 2014.)

Projects and presentations were presented during the final exam period. Earlier in the term, however, e-mails were sent by the Department Chair and others charged with assessment noting that our course had not yet been assessed. Regular reminders that this was a final project were necessary replies. Further, the late placement of the project impacted its usefulness for college-wide scoring. A third challenge was in trying to keep assignments and course content in sync for students enrolled at both the Palm Bay and Cocoa campuses.

Ultimately, the Performing and Visual Arts Cluster assessment results showed the 90% of the students in History of the Theatre I met or exceeded the benchmark. According to the college's assessment report for the arts courses as a whole, "The faculty teams reported that the students were given sufficient time to "practice" the core ability." This determination was made at the May 9, 2014 college-wide assessment meeting. (Eastern Florida State College Office of Institutional Effectiveness, Assessment Cycle Review, Spring 2014, p. 16)

STRATEGIES/CREATIVE WAYS OF SOLVING/REACHING THE OBJECTIVE

One of the most successful strategies for achieving the desired objectives was ongoing communication. Both the full-time and part-time faculty members teaching the course were in regular communication regarding the assessment procedure. In addition, the full-time instructor traveled to Palm Bay on the day that those students presented their projects. She took photographs of the projects and listened to student presentations. While the Palm Bay instructor graded her students' work, the Cocoa faculty member merged those assessments with those of her own students to create a more comprehensive assessment picture. A third strategy that led to the successful assessment of the course was the rubric (see above) that both instructors used to make the process more uniform.

Lessons Learned/Changes Made/Accomplishments

One purpose of this comprehensive assignment is to help students develop and implement research skills. Our assessment indicates that our students can do this, although with varying degrees of success. Both faculty members had hoped to see projects that reflected more unique connections and independent thinking, but were satisfied that students could apply research skills to content studied in class.

One important lesson learned was that assignments leading up to the research project did not have to be the same on both campuses; only the assessed assignment had to be identical for both sets of students. Earlier assignments in the class are designed to help students improve their writing and research skills. Based upon feedback from her students, this author changed or modified some of these assignments for the Fall 2014 semester. For this semester, this author's students used the following assignments to practice the necessary skills prior to undertaking the assessed project:

1. Interview: Select a playwright from Unit 1 (Greece, Roman, or Medieval period). Write a three page interview with the playwright in the format of a script. For example, see below.

 Interviewer: What points were you trying to make in *Lysistrata*?

 Aristophanes: I was trying to show the foolishness of war. I condemn war. I also think that while women were considered foolish in my day, they were intelligent people and had important things to say.

 Use research to craft your questions and answers. You must have at least one question that addresses each of the following: (1) biography of the playwright; (2) the original staging of his play that we are reading in class; and (3) the social and/or historical context which frames his work. Include a Works Cited page with your three page script. We may stage some interviews in class. Please turn in two copies in case your interview is selected to be staged in class. **50 points**

2. Essay #1: Select a play or playwright that we have studied in Unit Two and write a short (3 pages) essay about the play or playwright. You must use appropriate research and include a Works Cited page that has a minimum of three sources. Your Works Cited page will be page 4. Cite your sources using MLA style. Write a well-organized essay using

correct grammar and composition techniques. Guidelines will be available on Canvas. **100 points**

3. Essay #2: Select a play or playwright that we have studied in Unit Three and write a short (3 pages) essay about the play or playwright. **If you wrote about a playwright in Essay #1, you must write about a play in Essay #2; if you previously wrote about a play, this time you must write about a playwright.** You must use appropriate research and include a Works Cited page that has a minimum of three sources. Your Works Cited page will be page 4. Cite your sources using MLA style. Write a well-organized essay using correct grammar and composition techniques. Guidelines will be available on Canvas. **100 points**

4. Optional Essay*: Selecting **a different** play or playwright, you may re-write either Essay #1 or Essay #2 (not both) to try to improve your score. Follow the guidelines for the essay you are writing. **100 points**

Fall 2014 semester students seem to prefer these assignments to those required as preparation in the Spring 2014 term. In addition, the college-wide assessment committee determined that they could be more helpful "by giving clear directions to adjunct faculty and by reviewing the benchmarks set for the course." (Eastern Florida State College Office of Institutional Effectiveness, Assessment Cycle Review, Spring 2014, p. 17)

FACTORS THAT CONTRIBUTED MOST TO THE SUCCESS OF YOUR ASSESSMENT

Allowing students to explore topics and create projects which reflected their interests was a hallmark of success. While certainly some projects were better than others, all were reflections of students' knowledge and talents. This wide range of options helped to engage students while fostering opportunities for them to "process information," the assessed core ability.

The other, less tangible factor that led to success was the cooperation and communication between the two faculty members. From the onset, the determination was made to keep the classes as closely aligned in terms of content studied, assignments, and evaluation as possible. There was never a sense of competition to see whose class was better able to meet the core ability; there was only a desire to work in tandem for the benefit of the students and the institution.

CONCLUSION AND SUMMARY

It was interesting to see the diversity of subject matter in student projects. Research led to explorations of Shakespeare's works, Moliere's plays, commedia dell'arte, Greek theatre through Mindcraft, and an analogy between Pink Floyd's *The Wall* and Hamlet, just to name a few. On the whole, the projects were more successfully executed than the reflection papers in which students discussed their work, but all three components of the assessed project indicated that students could "process information," which was the objective. In doing this initial assessment, EFSC faculty learned about crafting assignments which prepare students for the assessed project and about the skill levels of the EFSC students regarding development and application of research. Further, we learned about the importance of communication and shared goals when assessing student abilities. Our work on this initial assessment initiative will better prepare us and our students for future History of the Theatre I college-wide evaluations.

CHAPTER 9

Case Study in Film, Video, and Recording Arts

MDU111 *Storytelling for Contemporary Media*
Ian Dixon
SAE Institute, Melbourne and Australia-wide

Subject Matter: creative assessment, media, screenplay treatment, industry workplace practices.

INTRODUCTION

Creativity in the arts can prove difficult to reconcile with assessable academic standards. Add to this, the specificity of media such as film, television, digital animation and games design in conjunction with real-world imperatives and the question arises: can a tertiary culture undergo significant transformation to render assessment 'authentic' for all courses including screenplay writing? More importantly, can this occur while still observing academically sound criteria and without quashing student creativity (Knowles, 1984)? In answering these questions, this case study draws upon andragogical teaching and assessment for screenplay treatment writing, but also goes 'one step beyond andragogy' to suggest a heutagogical model in action. The paper utilizes qualitative and quantitative survey results at SAE Institute to explore the issue. Further, it details the nationwide delivery of a unit in screenwriting within tertiary academic study as a microcosm of a real-world problem: the structuring and delivery of professionally formatted treatments to industry standard for contrasting media, namely games design, animation, film and television. In the pursuit of this, a single learning outcome will be explored: 'Apply the principles of narrative in the context of entertainment applications'. The unit aims for MDU111 include an imperative to apply established narrative theories to the students' original writing projects, treatment exercises and analytical concerns.

Storytelling for Contemporary Media is the result of ongoing regeneration of screenwriting courses for SAE Institute and Qantm College for seven campuses Australia-wide. The course serves to arm the student with skills for professional workplace practice as well as nurture the creative and structural efficacy of their assessable projects in heutagogical fashion. Although students submit two drafts

of their screenplay treatments, the emphasis for this course is on open-ended practice rather than delivery of final draft and, as such, concentrates on formative learning methodologies, although summative learning is also assessed.

THE ASSESSMENT STORY

Translating emphasis from the memorization of principles as traditional learning and, conversely, from amorphous creativity to an 'authentic assessment' context became the stated aim of course re-design for SAE Institute in 2011. Further, changes in governance demanded more rigorous academic standards and greater influence of industry scenarios within learning. Having stated this, it should be noted that as a private education provider SAE Institute's integration with industry and observation of Australian Quality Framework (AQF) standards was a decade ahead of the public tertiary education sector. [14] SAE nonetheless overhauled its screenwriting courses to further accommodate contemporaneous 'task-oriented', adult practitioners aiming for real-world placements within industry (Knowles, 1984), while consulting student feedback on 'truly self-determined learning' (Hase & Kenyon, 2001).

In the pursuit of this, course reconstruction further transformed bias-based pedagogy into industry-relevant andragogy and beyond to the heutagogical model. This was vital to the refurbishment of course content and structure (Mueller, 2006). Course redesign necessitated understanding of Hase and Kenyon's model for heutagogy, that: 'discipline based knowledge is inappropriate to prepare for living in modern communities and workplaces'. Thus recognizing the 'deficiencies of pedagogical and andragogical methods', heutagogy anticipates a future in which 'knowing how to learn will be a fundamental skill given the pace of innovation' (2001, p. 2).

As is the case with contemporary public education in Australia, this required more than just: 'Educational technologies enabling experiential learning and teaching in cost-effective ways in professional and vocational fields of study' (Authentic Assessment, 2008). It required that students direct their self-determined learning and that teachers relinquish any pretension to status for the enhancement of the student's learning within their 'structure of the self' (Hase & Kenyon, 2011, p. 2). For example, students in MDU111 demanded to know why they were learning principles of dramatic structure and were therefore engaged in

[14] 'Universities have had difficulty in the absorption of the creative arts since [...] the Dawkins reforms' (Marcellino, personal communication 2014).

role play exercises, practical execution of assessment tasks, peer-based research and class feedback processes in order to reinforce heutogogical, student-centered learning (Authentic Assessment, 2008). Further, students requesting industry relevance were encouraged to create professional standard documentation and to debate the process in an experiential context. This involved not only writing screen-based media, but also the making of film, television, games and animation as formal experimentation with screenplay form.

Given the changeable nature of screenplay form, course assessment design required industry relevance and media-based research to be conducted through submitted survey results. Accordingly, reinvented courses were designed in reverse, based on consultation within the film and television industry with its flexible delivery formats and fashionable prejudices. Students indicated their need to learn principles not specific to a single medium, but adaptable to many differing formats and products, while still focusing on their preferred medium. This created opportunity for further historical reflection on why the principles of screenwriting followed their particular trajectory (Karetnikova, 1990). Students were subsequently engaged in formal and informal feedback processes to attain unimpeded knowledge of the efficacy of the new learning environment and the ongoing culture of assessment. This information was collated through teacher-student and peer observation, informal feedback and formal, anonymous surveys rendered via quantitative score accruals. This involved questions of examination, both formative and summative, based on generating professional treatments written to industry criterion as derived from the enforced standards of government funding bodies to help simulate real-world concerns. Surveys indicated that greater student satisfaction and relevance of learning was achieved along with more efficient and standardized teacher communication via the implementation of learning outcomes. Processing such feedback also involved teacher-designed Google docs to record qualitative student observations and improve courses as well as updated communication via Skype, phone and e-mail across seven campuses Australia-wide.

BACKGROUND ON THE INSTITUTION

SAE Institute began in 1976 as a school of audio engineering in Sydney and evolved into a global network of tertiary status education providers currently measuring over fifty campuses internationally. By strategic arrangement, a global partnership with Middlesex University, England was initiated in 1998 and with Southern Cross University, Australia in 1996. Thus, SAE Institute became a private education provider given reestablished laws in Australia, allowing for the

provision of tertiary education through private resources. The revised status of SAE involved continued accreditation according to AQF standards: a national regulatory body adjudicated by the Australian Universities Quality Agency (AUQA) and subsequently Tertiary Education Quality and Standards Agency (TEQSA).

In 2004, as adjunct to their preexisting film and audio program, SAE Institute acquired Qantm College, an animation, games development, web and graphic design course established in 1996 under the pedigree of the Universities of Queensland and Southern Queensland, James Cook and Griffith Universities. In 2011, both companies were brought under the auspices of Navitas: an Australian education provider with vast experience in vocational and tertiary education for certificate, diploma and degree status courses. Navitas caters to over 80,000 current students in over 100 colleges worldwide.

In the process of overhauling SAE's Australian-based arts courses in 2011, team leaders from each campus and discipline were chosen to address benchmarking research and accrue information globally. This material was subsequently collated and affected the design and implementation of new courses. Faculty members were expectedly divided in welcoming the new outlines: resistance from certain teachers defending old curriculum and outmoded qualitative assessment notions on the one hand and enthusiastic embrace by those championing student-centered, self-determined learning and authentic assessment on the other. This could naturally be assumed to be the case within an institutional culture, which originally trained at vocational level for audio students by practitioners unfamiliar with formal pedagogical processes.

In particular, MDU111 *Storytelling for Contemporary Media* faced the unwieldy challenge of aligning screenplay education across contrasting schools, states, disciplines and media forms, while accommodating personal and sometimes solipsistic or 'guru' approaches from teachers (Hase & Kenyon, 2001, p. 6). The course was the result of benchmarked research into industry and academic standards involving summative and formative assessment practices. It eventually proved to be popular and successful, not the least part of which was assessment form and criteria.

DESCRIPTION OF THE PROBLEM/OBJECTIVE

With such disparate influences acting upon SAE Institute, especially given the advent of the new governance, degree and assessment standards had to evolve. Especially, new structures had to reconfigure some popular misapprehensions based on prior appraisals of unit needs. The general objective was to incorporate

greater academic diligence in assessment for new courses. More specifically, the problem regarding implementation of assessments for the refurbished screenwriting course MDU111 funneled down to four main issues: misconceptions regarding the industry as benchmark standard; biased appraisals of student work by teachers ranging from rigorous to myopic; questionable assumptions regarding film grammar's relationship to writing for games and animation; and cursory understandings of genre-specific rules. Accordingly, Mueller's (2006) 'Adjust Instruction' principle had to be implemented for effective assessment to emerge.

All courses at SAE Institute were fundamentally restructured to encourage academic excellence, relevance to industry and the necessity for international benchmarking. To provide for this, PhD and higher ranking lecturers were placed in advisory and leadership positions under an initiative entitled, 'Blue Skies', which referred to the unimpeded nature of quality inquiry sought. The open-ended investigation was subsequently aligned under a defined cross-lateral and interdisciplinary structure appropriate to teaching tightly enmeshed disciplines. Although any number of these refurbished courses might make interesting performance and review observations, this case study concentrates on the problem of assessing screenwriting and treatment documentation within media culture exemplary of the transfiguration.

In MDU 111, altering teachers' view of assessment for screenwriting across all related media proved arduous. The craft had been taught as a qualitatively assessed subject for filmmakers at SAE and alternatively as a spurious adaptation of cinematic conventions through Qantm College to service an amalgam of games designers, programmers and animators working in 2D and 3D digital formats.

Further, the problem for screenwriting assessment in the pre-2011 format was exacerbated by academia's deference to an industry, which was itself divided. Nevertheless, research suggested that the problem of consensus between interstate lecturers boiled down to different teachers placing differing importance on relevant subjects. Consequently, consultation was arranged with industry experts, which elevated the industry itself as benchmark standard. Thus an emphasis on entertainment imperatives and audience expectation ensued, which carried a further set of problems: the shifting hegemony of television and online gaming within a teaching framework culturally dominated by cinematic conventions. Indeed, screenwriting practice in Australia was mostly situated within television prototypes. Further, while assessment paradigms should be free from bias (Authentic Assessment, 2008), this could not be guaranteed under the old standard. Thus, genre rules, not judgment of product, should be considered.

For example, students creating oft-criticized horror film fare should demonstrate understanding of the conventions pertinent to that genre regardless of any prejudiced arbitration on the part of the assessor (Cleary, 2013; McKee, 1999).

CHALLENGES TO SOLVING THE PROBLEM/REACHING THE OBJECTIVE

The culture of the school was metamorphosing and new governance encouraged teachers with bachelor degrees and graduate diplomas to undertake higher degree study such as Master's and PhD and many complied. However, individual teachers' methodology for their own creative practice varied and met with some resistance to change. In the absence of an assessment 'absolute' value, an arts practice frequently defined by 'industry' standards struggled to know its own objectives clearly.

To further compound the problems, the school in general faced a unique set of problems, including impediment to intra-state benchmarking due to the rapid expansion of the school's infrastructure. This created challenges to communication efficacy between state lines, involving assessment templates, moderation practices, reportage and revamping protocols. There was a variance in staff training, experience, ethical standards and student-centered awareness. This precipitated teachers adopting contradictory opinions of industry protocol and relevance preferring personally administered aesthetic and qualitative approaches to rubric and criterion-based assessment. Further, teachers applying modernist and cinematically appropriate answers to post-modernist and games-related issues were reconsidered. In this way, therefore, Mueller's (2006) 'Adjust Instruction' principle had to be implemented.

STRATEGIES/CREATIVE WAYS OF SOLVING/REACHING THE OBJECTIVE

The reinvention of assessment for this trimester one screenwriting course involved four strategic processes. Firstly, there was the realignment of assessment for storytelling, which then necessitated a secondary process of incorporating formal narrative theories into course structure. This was designed to aid 'authentic assessment' in a reverse design process. Thirdly, consultation with industry experts became mandatory for real-world simulation and, finally, student-centered and experiential learning were reinforced to guarantee formally assessable measures for this creative unit.

Primarily then, some retraining and embrace of a heutagogical culture were required. This was implemented such that the teacher-learner relationship

nurtured the development of 'capable people' and such that we might 'enable capability to express itself' in our organization (Hase & Kenyon, 2001, p. 3). Thus, in the process of realigning 'authentic assessment', course developers and lecturers with film and television experience were encouraged to integrate practice and professional development by attending contemporaneous, international games forums and playing electronic games. In this way, familiarity with the literacy of games, both ludological and narratological, assisted film-based lecturers to teach concepts such as agency and immediacy in conjunction with their traditional cinematic ingenuity. This innovation rose directly from student requests for clarified information on conceptual gaming, which reinforced the information technology savvy learner to decide 'what and how' to learn (Hase & Kenyon, 2001, p.1). Further, exemplary animation texts were integrated into the textual viewing lists. Animation-expert staff imbibed the lessons of live action and vice versa.

With teachers retrained in such understanding, prior assessments for the now outmoded forerunner course were strategically replaced. Previously, students were required to write an entire feature film treatment to industry standard (which in Australia meant twelve to fifteen pages of detailed plotting and character development). They were also expected to submit an accompanying essay stipulating research into just one specific mainstream theorist who at that time dominated the course.[15] This was deemed untenable for marking workloads and inappropriate for a course where students would be involved in shooting shorts as real-world simulation and thus developers circumvented the oppressiveness of the larger format. The feature treatment was therefore eschewed in favor of the more amenable short film format: this meant creative structuring was possible with the influence of many theorists and more manageable blended and one-on-one tutorial feedback from lecturers to assist formative learning. Varied screenwriting conventions could be observed with this greater spread of theorists rather than individually preferred template structures. In particular, the genre specific and story structuring principles of neo-Aristotelian theorists Michael Brindley (2009), Stephen Cleary (2013), Robert McKee (1999) and John Truby (2005) were incorporated. This involved their finessed research into: folkloric adaptation in storytelling through Vladimir Propp and Joseph Campbell; the categorizing prowess of such experts as Georges Polti, Norman Friedman and Johann Goethe; and specific, national standards of industry.

[15] Christopher Vogler's (1992) *The Writer's Journey.*

In this manner, industry's imperative to entertain was acknowledged amidst the discipline of advanced structuring within formalized 'principles of narrative', thus gainsaying any nebulous notions of creativity.

In this process, teachers across the country were consulted in and provided constructive reflection. This had the added advantage of facilitating communication between otherwise alienated staff over the distinctly Australian 'tyranny of distance'. Thus criteria for assessment could be discussed and agreed upon under the guidance of the team leaders. Although resistance was inevitable, the newly opened lines of communication allowed for greater debate via readily accessible Google documentation and strategic phone calls. Rubric-based marking plans were submitted for commentary and, after 'intuitive' ostention was balanced against the refinement of narratological concerns, a rubric specific to MDU111 was implemented. Teachers were encouraged to utilize this in criteria-based marking, but at this stage, they were not forced to use rubrics if individual feedback was still preferred. In this way, as Gulikers, Bastiaens, and Kirschner (2004) suggest, marking criteria was more closely aligned to learning outcomes. Finally, in the interest of greater applicability, diversity and media-specificity, the course was renamed: *Storytelling for Contemporary Media* from an original *Screenwriting and Character Development.*

NARRATIVE THEORIES CONTRIBUTING TO 'AUTHENTIC ASSESSMENT'

Since industry consultation placed emphasis on screenwriting knowledge from government based funding bodies, their theoretical recommendations were accommodated alongside those of independent industry experts. This necessitated the introduction of standardized theoretical frameworks (Cleary, 2013; McKee 1999), which resulted in assessable criteria fashioned toward treatment writing for screenplays as 'authentic assessment'. In applying two learning outcomes from MDU 111: 'apply the principles of narrative in the context of entertainment applications' and; 'apply the basic concepts of character development', it was suggested that specific narratology, screenplay instruction and genre expertise should be adhered to, even in the rendering of character construction. Research for this involved: nationwide consultation; attendance at screen editorial conferences; training in heutagogical teaching-learning; and encouragement for all staff to contribute to reading lists.

For the student, therefore, creativity could be molded around established industry-based story forms rather than the uncreative adoption of formulaic approaches to writing or, conversely, untenable formlessness, derivative or contradictory pastiche in storytelling. Content was given priority, but encouraged

toward genuine thematic concern and appropriate form. Key narrative theories were therefore applied within the students' writing projects, while paying close attention to the students' intuitive contribution and unconscious learning (through many years of game play and cinema viewing). Treatment exercises and analysis of stories within their own chosen discipline necessitated research into the basic structural elements of story and genre rules as well as media-specific suitability. It was decided that the school's restrictions regarding television should abolish training in the medium altogether abiding instead by the philosophy that able students could transfer skills from film tuition to television once established in the workplace. This followed research into international benchmarking of world-renowned film schools.

Further, an inventive approach was established by allowing a draft-shoot-redraft structure (or draft-make-redraft in the case of games) for experiential learning. Students therefore wrote draft one of a short film treatment (six minutes in length) then, before restrictive editorial was imposed, they were encouraged to shoot their initial draft. Thus, eagerness to enter production phase met with story problems on set and in the editing room, which then informed their creative and structural overhaul for draft two of the writing process literally in post-production. All drafts and films contributed to assessable summative learning. For the students, lessons learned experientially were therefore of greater value to restructuring efforts than any prohibitive instruction on the part of their teachers. Students discovered for themselves what was amiss in writing by problem solving through directorial challenge rather than the abstraction of screenwriting, and then reapplying that to their rejuvenated screenplay stories. This proved a very effective self-instructional process, and reinforced the basic structural elements learned in screenwriting class without oppressive repetition. However, the process tended to favor animation and film students over games writing, where non-linearity influenced game play in alternative fashion and where digital compositing required longer pipeline timeframes to completion. In this way, any outmoded memorization of principles or simply amorphous creativity was gainsaid by practical story experimentation (Knowles, 1984). Through shooting then rewriting after production, greater self-reflection and, indeed, an Aristotelian 'inside-out' problem-solving technique emerged (Cleary, 2013).

CONSULTATION WITH INDUSTRY EXPERTISE

In the interest of course integration, industry and academic expertise was consulted in a series of meetings and formally prepared documentation. As such, real workplace skills were integrated and reinforced within the new course

(Deakin). This ensured that 'authentic assessment [drove] the curriculum' Poikela (2004). Professional screenwriters and producers exterior to the institute were invited to comment on required competencies and student ethos in various media for real-world placement (Gulikers, Bastiaens, and Kirschner, 2004). Indeed, relevance to industry is major concern for students as verified in surveys. For this reason, Screen Australia's preferred recommendations for treatment writing were consulted for instruction and criteria-based assessment for the course (Brindley, 2009).

Editorial process, enforcement of stipulated lengths, industry savvy documentation, formatting and basic storytelling rules were measured against general creativity to strict deadlines, in a manner simulating a professional writer's room. Thus Mueller's (2006) suggestion that graduate proficiency should replicate challenges encountered in real-world scenarios was observed. These were also measured in such marking criteria requirements as a ten point structural analysis utilizing contemporaneous terminology to accompany story treatments. Although apparently resembling structuralism, this bifurcated documentation ensured quantifiable standards. Thus, reverse design for assessment had been applied.

Consultation within film and television industry also emphasized audience and marketing considerations. Again, surveys rendered via quantitative score accruals assured the ongoing relevance of the course. Further, student-centered workshops, 'pitching' role-play and peer feedback in class were implemented in tandem. In this way, formative group work incorporated learning principles, treating class as a cross-section of a unique demographic with sensitivity to gender, age and predilection as a general observance of EEO standards. Thus, 'cost-effective' 'self- and peer-assessment strategies' contributed toward quality of student learning and was incorporated in assessment (Deakin).

REINFORCE STUDENT-CENTERED AND EXPERIENTIAL LEARNING

By encouraging such role-play and theatre games in class student-centered and experiential learning was reinforced. This assisted comprehension of such concepts as line crossing, dramatic beat placement, kinaesthetic understanding of plot point, character status, the peripeteia and emotional authenticity (Cleary, 2013). Further, roles played as creative producers, test audiences, script editors, audience members and investors were encouraged. In a more advanced heutagogical sense, honest and insightful feedback according to students' actual demographic and viewing preferences were also acknowledged. This facilitated student learning to augment more cerebral activities such as analysis and written

documentation and ultimately effected assessment positively (Marich, 2009). Although assessment was subsequently rendered in printed form, kinaesthetic and role-play experience aided the assessment conduit through a reverse design approach and engendered both formative and summative learning (Authentic Assessment, 2008). As discussed, this involved not only writing screen-based media, but also the making of films and television as formal experimentation with screenplay form.

As stated above, marking criteria was also more closely aligned to learning outcomes for this unit. For example, the new learning outcome: 'Apply the principles of narrative in the context of entertainment applications' required that students recognize, apply or reject post-modernist appraisals of screen culture and realize the necessity for structural learning. The assessment refurbishment aided self-determination as a result of student demand to accommodate the differing media involved. Thus, in games, post-modernist pastiche was deemed more appropriate than in cinematic culture where modernist principles still largely prevail for commercial product. Further, teachers' familiarization with formats and standards other than their own predilection was implemented. This was subsequently assessed by inter-disciplinary consultation with teachers from other industries. Industry experts' analysis of audience polls and market research were consulted and assessment format altered accordingly. Further, in response to their requests from industry relevance, students were encouraged to undertake their own media-specific research when pitching, writing and redrafting their work. In neo-Aristotelian manner, form was studied as arising from content and thus structural thinking dominated the confusing differences in media needs including episodic forms such as web series and television. This was all assessed in a ten point analytic document, which accompanied the first treatment, such that both creative and analytical skills were tested in summative fashion. In this way the learning criteria.... apply ... was made specific within student's respective industries and reflected in the marking criteria as a capacity to not only construct narrative but identify the tools of the construction analytically.

LESSONS LEARNED/CHANGES MADE/ACCOMPLISHMENTS

In reconfiguring assessment for MDU111 and other dovetailing courses, we observed that the culture of the school changed rather slowly, especially when involving external arbitration and new governance. To the credit of Navitas, no wholesale interjection was applied once they acquired SAE Institute. Rather a gentle integration of amenable transformations over a period of years was implemented.

Since professional writing for contrasting media is frequently a personal endeavor, assumptions as to the agreeability and generic nature of writing instruction is not only problematic from a pedagogical point of view, but also represents areas where teachers become defensive. Therefore, engendering change must be treated diplomatically.

Further, it cannot be assumed that teacher expertise in one medium implies transferable skills to another and therefore staff retraining and professional development was also applied. Thus, persuasive intra-state conversation; more organized and rigorous criteria; the exigencies of media-specific agency and immersion as functional aspects of game play were all embraced. Further, gaming conventions for screenplay writing with their ludological implications should not come under the hegemony of film writing, but rather establish its own media-specific focus. In the absence of any benchmark 'absolute' for creativity, industry sanctioned audience and story focus should be employed within tertiary screenplay assessment.

FACTORS CONTRIBUTING MOST TO THE SUCCESS OF ASSESSMENT

MDU 111 has become a popular and industry compatible course strategically introducing fresh talent to the timeworn traditions of screenwriting and its interdisciplinary practicalities. In retrospect, it appears that conversation between team leaders and teaching staff was more vital than at first assumed. Thus leadership and strategic introduction of university standard rigor developed in tandem. Further, lateral applications of the production pipeline for differing media, observation of relevant industry sectors as effective benchmarking process established solid foundation for reverse designed assessment tasks. Thus, student self-assessment and role-play became the inevitable result of the write-shoot-rewrite model to facilitate effective screenwriting. Again, student consultation resulted in effective unit and assessment design.

CONCLUSION

Although the case study for MDU 111 has been considered as a microcosm of the whole institute's challenges involved in the overhaul of new degree assessment, it nevertheless represents a typical scenario for resistance and celebration alike. Spurious, solipsistic or niche-based approaches to assessment represented by academically resistant teaching staff were overcome by importunate conversation and reverse design course structure. None of this renders the screenwriting process un-creative, but rather correctly researched principles contribute to

ostension and assessment should rise accordingly. In this way, rigorous assessment standards provided academically sound criteria is in place.

REFERENCES

Authentic Assessment (2008). Retrieved from: http://www.deakin.edu.au/itl/assets/resources/pd/tl-modules/assessment/authenticassessment.pdf

Brindley, M. 2009. 'What Is A Synopsis? An Outline? A Treatment?' Retrieved from: http://www.screenaustralia.gov.au:80/cmspages/handler404.aspx?404;https://www.screenaustralia.gov.au:443/getmedia/d4e1476e-33e5-4aad-b9d9-9696819b4b98/WhatisaSynopsis.pdf

Cleary, S. March 2013. 'Time and Emotion'. Paper presented at Victorian College of the Arts, Melbourne, Victoria.

Gulikers, J., Bastiaens, T. & Kirschner, P. June 2005. 'Perceptions Of Authentic Assessment And The Impact On Student Learning'. Paper presented at Hong Kong, Polytechnic University, Hong Kong.

Hase, S. & Kenyon, C. 2001. 'Moving From Andragogy To Heutagogy: Implications For VET', *Proceedings of Research to Reality: Putting VET Research to Work: Australian Vocational Education and Training Research Association (AVETRA)*, Adelaide, SA, 28-30 March.

Karetnikova, I. 1990. *How Scripts Are Made*. Carbondale and Edwardsville: Southern Illinois University Press.

Knowles, M. 1984. *Andragogy In Action*. San Francisco: Jossey-Bass.

Marich, R. 2009. *Marketing To Moviegoers: A Handbook Of Strategies And Tactics* (2nd ed.). United States of America: Southern Illinois University Press/Carbondale.

McKee, R. 1999. *Story: Substance, Structure, Style And The Principles Of Screenwriting*. Great Britain: Methuen Publishing Limited.

Mueller, J. 2006. Authentic Assessment Toolbox. Retrieved from: http://jonathan.mueller.faculty.noctrl.edu/toolbox/whatisit.htm#looklike

Poikela, E. 2004. Developing Criteria for Knowing and Learning at Work: Towards Context-Based Assessment. *The Journal of Workplace Learning*, *16*(5), 267-274.

Truby, J. 2005. 'Truby's Story Structure: A Two-Day Intensive Course For Writers, Directors, Producers And Executives'. Paper presented at Australian Centre for the Moving Image, Melbourne, Victoria.

CHAPTER 10

Case Study in Architecture, Landscape, and Interior Design

Assessment and Improvement: *The Interior Design Program at SUNY Buffalo State*
Bhakti Sharma
State University of New York, Buffalo State

Subject Matter of the Case Study
Program Analysis and Assessment

INTRODUCTION

Established in 1871, The State University of New York, Buffalo State offers a wide array of liberal arts and professional visual arts studio disciplines within the Bachelor or Fine Arts (B.F.A.) degree program resting within the three separate departments of Design, Fine Arts, and Interior Design. The Department of Interior Design at Buffalo State offers students a specialized studio-oriented education in preparation for advanced or graduate studies or for beginning careers as professional interior designers, educators, or researchers. The goal of the department is to create a globally diverse and contemporary program that helps students compete and collaborate with their peers from other schools and design fields. To reach this educational goal - aesthetics, critical thinking, visual literacy, creative problem-solving, and integrated theory and practice-based design education – are implemented throughout the program.

Buffalo State has offered courses in interior design since 1968 through a Bachelor of Science (B.S.) degree. However in 1993, owing to the Foundation for Interior Design Education Research (FIDER) accreditation, a major revamp of the program started as is shown in table 1. The existing B.S. degree was eliminated and replaced with a new program curriculum under a Bachelor of Fine Arts (B.F.A.) degree. But our work was far from done. This cycle was to be repeated yet again... in 2010!

Table 10.1: Historic Timeline of the Program

Year	Milestone
1968	BA (Design) with concentration in Interior Design
1972	BS (Design) with concentration in Interior Design
1984	BS (Design) with concentration in Interior Design
	BFA (Design) with concentration in Interior Design
1993	Begin FIDER accreditation review
1995	Official approval of new BFA (Design) coursework
1999	First senior class of revised BFA program; allowed for the Department to apply for accreditation
2003	FIDER accreditation received through 2010
2006	Department of Interior Design created; separate from Design department
2010	CIDA accreditation visit

As shown in table 10.2, the Department of Interior Design follows several assessment cycles for the various accreditation bodies and self-studies. Among these are the Council for Interior Design Accreditation (CIDA) 6-year assessment and reaccreditation cycle, National Association of Schools of Arts and Design (NASAD) 5-year assessment and reaccreditation cycle, and the college-wide Middle States Commission on Higher Education's 10-year assessment and reaccreditation cycle. In addition, all applied student projects culminating in capstone projects and student portfolios serve as an evaluation tool for systematic program assessment and improvement. The department highly relies on internships sponsors that includes members of the architecture and interior design community, and the Interior Design Advisory Board (IDAB) to guide the department on industry trends and requirements to reconfigure courses to suit industry needs.

Table 10.2: Accreditation Body and Cycle of Assessment

Accreditation Body	Level	Last Review	Next Review
Middle States Commission for Higher Education	College-Wide	2013	2023
National Association of Schools of Art and Design (NASAD)	Visual-Arts (Fine Arts, Design, Interior Design, Art Conservation, Art Education)	2012	2016
Council for Interior Design Accreditation (CIDA)	Interior Design	2013 (Interim Visit)	2016

The 2010 evaluation of the program by CIDA, followed by NASAD evaluation in 2011, and the Middle States visit in 2013... followed by an interim visit by CIDA in 2013 was definitely a complex cycle of assessments and accreditations. But it was also pivotal in the improvement of the program and in 2010 the hard-working faculty members of the department set on an arduous task of a self-study and assessing each standard and finding courses to exhibit evidence of these standards. Prior to 2010, the assessment was primarily a review of the senior thesis project and the following student learning outcomes (SLOs) were assessed through that course:

- Utilize and demonstrate a mastery of traditional design process
- Apply and demonstrate mastery of industry specific regulations and codes
- Produce competent presentation communication across a range of appropriate media
- Apply appropriate furniture, fixtures, and equipment (F.F.E.), and finish materials

The 2010 CIDA review and departmental self-study revealed the need for assessing the courses through out the program and not just at the capstone level. Below is a detailed account of the journey that the department undertook in 2010... a journey of restructuring our program for quality assurance in our very creative discipline of interior design.

THE PROBLEMS AND THE SOLUTIONS

Guided by the CIDA standards, in 2010, the department began the implementation of several student-learning outcomes (SLOs) throughout the program. These standards included global perspective for design, human-centered design, design process, communication, professional and business practices, history, space and form, color and light, furniture, fixtures, equipment, and finish materials, environmental systems, building construction and materials, and regulations.

Typically, SLOs are included in one-two courses, but it was imperative for the department to look at the program as a whole during assessment and improvement. Not every standard can be implemented in every course, but one can find an 'awareness', an 'understanding', or an 'application' of the standards in one form or the other as when progresses through the program. This is

illustrated in the curriculum maps (table 3) that detail the courses with the standards and the student achievement.

Table 10.3: Curriculum Matrix

Critical Thinking, Professional Values, and Processes.					
These standards describe the framework of interior design practice					
COURSES	Global Perspective for Design	Human-centered Design	Design Process	Communication	Professional and Business Practices
INTERIOR DESIGN COURSES					
IDE 101 Introduction to Interior Design	A	A			A
IDE 103 Digital Presentation Methods			A	U	
IDE 104 Elements and Principles of Interior Design	A		A		
IDE 151 Mechanical and Perspective Drawing			A	U	
IDE 152 Introduction to Color Rendering			A	U	
IDE 153 Spatial Explorations and Model Building			A	U	
IDE 201 Interior Design I			U	C	
IDE 202 Construction Fundamentals I					
IDE 203 Furniture Theory and Application	U				
IDE 204 Materials, Specifications, and Construction Documentation				C	C
IDE 205 History of Interior Design and Architecture I	U				
IDE 251 Interior Design II		U/C	U/C	C	
IDE 252 Construction Fundamentals II	U				
IDE 254 History of Interior Design and Architecture I	U				
IDE 301 Interior Design III			U/C	C	
IDE 302 Computer Applications for Interior Design I				C	
IDE 303 Interior Detailing		U	U/C	C	A
IDE 351 Interior Design IV	U	U/C	U/C	C	
IDE 352 Computer Applications for Interior				C	

COURSES	History	Space/ Form	Color/ Light	F.F.E. Materials	Environmental Systems	Bldg. Systems	Regulations
Design II							
IDE 355 Lighting Design					U/C	C	
IDE 403 Professional Practice							U/C
IDE 401 Interior Design V					C	C	
IDE 451 Interior Design VI			U	C	C	C	
IDE 488 Internship						C	C
ART/ DESIGN COURSES							
FTT 206 Introduction to Textiles				A			
FAR 250 Art History I		A					
FAR 251 Art History II		A					
A - Awareness (familiarity with specified data)							
U - Understanding (a thorough comprehension of concepts and their interrelationships)							
C - Apply/ ability (competent entry-level skills)							

Core Design and Technical Knowledge.

These standards describe historical, theoretical, and technical contents of interior design practice

COURSES	History	Space/ Form	Color/ Light	F.F.E. Materials	Environmental Systems	Bldg. Systems	Regulations
INTERIOR DESIGN COURSES							
IDE 101 Introduction to Interior Design	A		A	A	A	A	A
IDE 103 Digital Presentation Methods	A						
IDE 104 Elements and Principles of Interior Design	U						
IDE 151 Mechanical and Perspective Drawing							
IDE 152 Introduction to Color							

Course	1	2	3	4	5	6	7
Rendering							
IDE 153 Spatial Explorations and Model Building		A/U	A				
IDE 201 Interior Design I	A	A/U	A				
IDE 202 Construction Fundamentals I					U		
IDE 203 Furniture Theory and Application	U			U			
IDE 204 Materials, Specifications, and Construction Documentation				U	U	U/C	U
IDE 205 History of Interior Design and Architecture I	U						
IDE 251 Interior Design II	C	C	U	U/C		U	
IDE 252 Construction Fundamentals II					U		
IDE 254 History of Interior Design and Architecture I	C						
IDE 301 Interior Design III	U	C	U	C		U	
IDE 302 Computer Applications for Interior Design I							
IDE 303 Interior Detailing							
IDE 351 Interior Design IV	U	C	U	C		C	
IDE 352 Computer Applications for Interior Design II							
IDE 355 Lighting Design			U/C	C	U	C	
IDE 403 Professional Practice							U
IDE 401 Interior Design V	U	C	U	C		C	
IDE 451 Interior Design VI	U	C	C	C	C	C	C
IDE 488 Internship							
ART/ DESIGN COURSES							
FTT 206 Introduction to Textiles	U		A				
FAR 250 Art History I	U						
FAR 251 Art History II	U						

These standards might be in use by several CIDA- accredited schools for assessment. But for the department, the self-study of 2010 revealed that even though the standards for CIDA were met, there was a lack of a continuous thread that ties all the courses together. While the standards were being met in individual courses, a lack of documentation did not exhibit student understanding.

Some key areas that required strengthening in the curricula were:

- Communication - Digital presentation skills and Construction Documentation
- History
- Design process

DIGITAL COMMUNICATION

At the time, only two courses in digital communication were offered. These were beginner level AutoCAD 3D courses. As a result, student work examples did not showcase a high level of presentation skills. The Department added the IDE 103 Digital Presentation Methods course integrating basic research methods, digital file management, presentation techniques, and three-dimensional massing models. In addition, the Department revised the course content for the two AutoCAD courses IDE 302 and IDE 352 so that the instruction focused on creation and manipulation of the three-dimensional virtual built environment including lighting and rendering techniques to create presentation-level graphics and the introduction of Building Information Modeling (BIM) systems.

But that only took care of the presentation part. In order to present ideas coherently in a creative field, one must possess not only digital presentation skills, but also the know-how of creating competitive construction documents. The existing IDE 204 Materials and Colors course was re-written to include the study of a) interior finishes, materials, and various interior components; b) professional specification, code restrictions, and environmental concerns of materials; and c) understanding and creation of construction documentation of interior spaces.

HISTORY

Up until 2010, the students of interior design took courses in history of craft and theory of objects in other departments on campus. In the 2010 CIDA review, it was found that the students were unable to identify movements and traditions in architecture and stylistic movements in furniture and interior design. This deficient standard was primarily due to the lack of evidence. By introducing the IDE 205 and IDE 254 History of Interior Design and Architecture I &II, the department not only covered the CIDA standards, but also was able to cover the Intellectual Foundations (IF) requirement for 'Western Civilization' and 'Writing Intensive' through the two courses. These courses are a comprehensive survey of the major historical periods of architecture and interiors from antiquity to the

advent of the Industrial Revolution to present day, which was in line with the educational goals of critical thinking.

DESIGN PROCESS

True to its name, design process is indeed a process. While the students are constantly exposed to design problems ranging from small residential projects to large-scale office buildings, due to lack of digital documentation, the design process on yellow trace paper and cocktail napkin sketches was seldom preserved. As much as this was an administrative issue, another vantage point at this problem revealed that the teaching of design process should be part of teaching the design alphabet and not a methodology that is introduced when a design problem presents itself. So even though through skill building courses such as IDE 151 Mechanical and Perspective Drawing, IDE 152 Color Rendering, and IDE 153 Spatial Explorations and Model Building, the ideation skills were learned, the implementation of these skills in a design studio was not visible. To curtail this problem and to make the switch from learning the ideation skills to using these ideation skills in the design process, an elements and principles of interior design course was introduced within the department. This course helped students to develop a comprehensive interior design vocabulary and introduce design theories and concepts, including spatial definition and organization while maintaining sketch journals with rapid prototyping sketch exercises.

But as these changes were being implemented, courses needed to be moved around in the sequence. The courses in the department are offered only once a year and should be taken in sequence. All students follow the same course roadmap, which details the sequence of courses and graduate with their cohort in four years. This posed as a challenge in some instances. Take for example the IDE 204 construction documentation course. It was important that this course should be offered before the students started taking design studios, so that they could apply the knowledge from this course in creating competent contract documents for their designs.

Similarly, till 2010, students only took the IDE 101 Introduction to Interior Design course within the major in the first semester of Freshman year. With the addition of the IDE 103 Digital Presentation Methods course and the IDE 104 Elements and Principles of Interior Design course, the courses that students took in other departments had to be eliminated to stay within the total credit hours required for graduation. The Freshman sequence at the department is a strong program with the inclusion of these courses and it prepares the students for not

only a stronger design process through the studios but also for the qualification exam at the end of the Freshman year known as the Skills Competency Exam. The changes in curriculum are reflected in table 10.4

Table 10.4: Changes made to curriculum (Interior design courses)

Curriculum in Fall 2009	Curriculum in Fall 2014
Freshman Year	**Freshman Year**
Fall semester	*Fall semester*
IDE 101 Introduction to Interior Design	IDE 101 Introduction to Interior Design
	IDE 103 Digital Presentation Methods (New)
	IDE 104 Elements & Principles of Interior Design (New)
Spring semester	*Spring semester*
IDE 151 Mechanical & Perspective Drawing	IDE 151 Mechanical & Perspective Drawing
IDE 152 Introduction to Color Rendering	IDE 152 Introduction to Color Rendering
IDE 153 Spatial Explorations & Model Building	IDE 153 Spatial Explorations & Model Building
INTERIOR DESIGN ADMISSION EXAM	**INTERIOR DESIGN ADMISSION EXAM**
Sophomore Year	**Sophomore Year**
Fall semester	*Fall semester*
IDE 201 Spatial Experiments	IDE 201 Spatial Experiments
IDE 202 Construction Fundamentals I	IDE 202 Construction Fundamentals I
IDE 203 Furniture Theory and Application	IDE 204 Materials, Specifications, and Construction Documentation (Revised & changed in sequence)
Spring semester	*Spring semester*
IDE 204 Materials and Color	IDE 203 Furniture Theory and Application
IDE 251 Residential Design	(change in sequence)
IDE 252 Construction Fundamentals II	IDE 251 Residential Design
	IDE 252 Construction Fundamentals II
Junior Year	**Junior Year**
Fall semester	*Fall semester*
IDE 301 Retail Design	IDE 301 Retail Design
IDE 302 Interior Design Computer Applications	IDE 302 Computer Applications I (Revised)
IDE 303 Interior Detailing	IDE 303 Interior Detailing
Spring semester	*Spring semester*
IDE 351 Public Buildings	IDE 351 Public Buildings
IDE 352 AutoCAD for Interior Design	IDE 352 Computer Applications I

IDE 353 Professional Practice & Specifications	(Revised) IDE 355 Lighting Design (Revised & changed in sequence)
Senior Year	**Senior Year**
Fall semester	*Fall semester*
IDE 401 Office Planning	IDE 401 Office Planning
IDE 402 Lighting Design	IDE 403 Professional Practice (Revised & changed in sequence)
	IDE 488 Internship (changed in sequence)
Spring semester	
IDE 451 Senior Thesis	*Spring semester*
IDE 488 Internship	IDE 451 Senior Thesis

SKILLS COMPETENCY EXAMINATION

The Department of Interior Design does not require a portfolio of work upon admission. But in order to move forward after the freshman year, students must demonstrate an exemplary skill set. The exam that measures the student's preparedness to attempt the more rigorous project assignments found in upper level Interior Design studios tests the students' ability to visualize space and learn key skills that are needed in the rigorous program. The test is used to provide a quantitative way of knowing a student's ability to:

- retain the skills that they previously applied in the 3 skills studios leading up to the exam (IDE 151, IDE 152, IDE 153)
- apply the skills in a timed scenario, which evaluates a students' ability to manage their time to produce the required deliverables package.
- experience the short term deadline stresses which they will face in each of the succeeding program studios and ultimately in the field.

Interior design is a highly subjective field in which the designs liked by one person may or may not be appreciated by the other. In this case, however, the department is only testing the skills required for success in the field (the alphabet for the lack of a better word). If the student is lacking the knowledge of the interior design alphabet, one cannot expect them to write a novel aka design.

Needless to say this is a highly stressful exam for the students. But with the addition of the two studios IDE 103 and IDE 104, students are better prepared for meeting deadlines and a culture of excellence is instilled in them from the Freshman year.

MEASURES

The combination of programmatic improvement, including our ongoing assessment of the extent to which the program is meeting institutional and interior design aspirations for excellence is ongoing. Evaluation of student work is accomplished through variety of methods. In the Freshman year where students are learning the alphabet of design and an 'awareness' is required, students are evaluated through quiz questions, exams, written papers, sketch journals, drafting and rendering assignments, and mode-making projects. In the Sophomore year design studios, students have to show competence in design process for projects under 2500 square foot (S.F.) while developing F.F.E. packets and construction documentation. In upper design studios, students have to demonstrate an 'application' of the skills learned including but not limited to mastery of design process and industry specific regulations, codes, and standards. In addition, they must produce competent presentation drawings to communicate across a range of appropriate media.

CONCLUSION

The next step for the Department is to analyze the data. The parameters that will be taken into consideration will be grades, students securing jobs upon graduation, retention and recruitment data etc. The 2012 NASAD accreditation review stated 'the degree program appears to meet the intended purpose. The work exhibited seems to be professionally competent and the structure of the degree program appears to provide abundant information on progress and development to the faculty and the students'.

The program is rigorous and comprehensive, resulting in professional and innovative designers actively sought after by regional and national employers. But the impact of the changes is visible only through qualitative methods such as direct quotes from internship sponsors, participant observations of faculty members, interviews with current students etc. The Department plane to a more robust quantitative study of the impact of the changes made in Spring 2016.

However, the one important lesson that goes a long way in academia especially in creative fields is to document and organize the work. Because it is only through documentation that a thorough assessment and improvement can be done.

CHAPTER 11

Case Study in Product and/or Industrial Design

Learning Design Wisdom By Augmenting Physical Studio Critique With
Online Self-Assessment
Chinmay Kulkarni and Scott Klemmer
Stanford University

ABSTRACT

Accurately assessing the quality of one's work is a crucial skill for professional
designers and design students alike. This paper describes teaching materials that
help students self-assess their work in a design course at a large university in the
US. Using these materials, students have been successful in evaluating
themselves—in 69% of all weekly student submissions, self-assessed scores
matched independent staff-assessments. Self-assessment accuracy also improved
through the term ($F(1; 1332) = 31:72$; $p < 0:001$). This submission introduces a
novel workflow for integrating studio feedback with self-assessment in design
education and describes our experiences using this approach for the last three
years with more than 400 students. Student success in self-evaluation suggests
that techniques from these materials can be integrated into design environments
elsewhere. We outline our plans to extend these materials for use with peer-
evaluation and for assessments in large online design classes.

INTRODUCTION

What is good design? Learning the answers to this question is a key part of
student's design education. Furthermore, the ability to accurately assess the
quality of one's work is a useful skill for the designer [3] and, perhaps, for all
creative professions. Unfortunately, students (especially in engineering schools)
often struggle with both these issues. In part, this is because design places
"emphasis on synthesis rather than predominantly on analysis" [3] but also
because design often has no clear right or wrong answers. What educators need,
then, are techniques that help students learn the characteristics of good design,
and enable them to examine their own work for these characteristics.

Self-assessment is an effective technique for building a conceptual model of 'good' work in a domain [3]. Prior work has demonstrated that self-assessment also improves learning and student performance. In critical writing, students exposed to self-evaluation outperformed those who weren't. Furthermore, these gains were larger for weaker students [11]. In engineering design, self evaluation has been demonstrated to help students accurately gauge their own strengths and weaknesses [3]. Student feedback also suggests that self-evaluation changes the role of the teaching staff, making them coaches rather than evaluators. This paper describes materials built around self-assessment for an introductory HCI course at our university. The goal of these materials is to help students learn to evaluate their own design work. These materials comprise five main components: 1) a set of detailed weekly assignments that help students learn human-centered design through actual practice of the technique; 2) a set of rubrics students use to evaluate their work in these weekly assignments; 3) an online submission system that encourages students to look at each others' work to encourage collaborative learning; 4) an assessment system that combines self-assessment, which encourages reflection, with independent staff assessment that provides critical feedback; and 5) an analytic toolset that enables us iterative improvement of the other components.

The next section describes this self-assessment system. Later sections describe how it has helped improve the class, and some challenges we have faced. We conclude with plans for the future, including how these self-assessment materials could be used for other applications, such as online HCI education.

SELF-ASSESSMENT IN ACTION

This paper describes an introductory project-based HCI class. In 2011, the class had 156 enrolled students (both undergrad and graduate) from 22 majors (Figure 11.1). Students participate in a 10-week user-centered design process by designing and implementing a working prototype of a mobile web application of their choosing. Creating a mobile web-app allows students to pursue ideas that are fairly unique, yet sufficiently constrained that they provide homogeneity that enables students to learn from each other. This homogeneity also helps in grading.

This class has introduced a number of components over the last three years that support self-assessment and peer learning, that we describe below.

Weekly Studios

12-15 person weekly studios supplement class lectures. Stu- dents present their work over the past week and share ideas. Studios last 50 minutes and are held by TAs throughout the day every Friday. Besides providing students an opportunity to interact and learn from each other, studios provide a plat- form to receive critical feedback from peers [12].

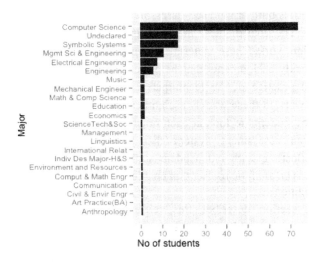

Figure 11.1. Course enrollment: while a large fraction of students (47%) major in Computer Science, other majors are well-represented.

Weekly Assignments and Online Submissions

Weekly assignments guide students through the design and implementation of a mobile web-app of their choosing. Early assignments are individual, while those in the later half of the term are performed in teams.

All assignments are submitted online. When assignments include paper prototypes or other physical artifacts students exhibit these in studio, and upload pictures online. Online sub- missions (but not the grades) are visible to all students in the class, along with students' name. Informally, we have noticed that public visibility helps grading to be seen as fair. More importantly, it enables students learn from each other's online work and incentivizes higher quality work. For instance, in the 2011 version of the class, several student teams developed projects using mobile development frameworks like jQuery- Mobile

and PhoneGap. Though course-staff did not provide any support for these frameworks, these teams taught them- selves the frameworks in a completely community-supported fashion.

Rubrics

Evaluation that is performed with the help of well-defined rubrics leads to students developing a deeper understanding of what constitutes high-quality work and makes the grading seem more fair and transparent [1]. Rubrics also provide students with more detailed and easily understandable feed- back [2] with minimal staff effort.

Every assignment in this course includes a rubric (see Table 11.1 for an example). We think that a clear understanding of the rubric is essential to the success of self-assessment. There- fore, at the end of each studio, a teaching assistant walks stu- dents through the goals and expectations of the next assignment, describes each rubric item in detail and answers any student questions.

SELF-ASSESSMENT AND STAFF GRADING

Self-evaluation occurs at the end of each studio session, after all students have presented and discussed their work with other students. Performing self-evaluation immediately after discussion helps students gain understanding through self- reflection. Discussion with peers enables them to see the relative standing of their work [7].

Once students have submitted their self-evaluation, teaching staff grade the students using the same rubrics that students used for self-assessment. This grading is done blind to the grades the students gave themselves. Our online submissions system automatically calculates the student's final grade as the self-assigned grade if the self-assigned and staff-assigned grades are close (the 2011 version of the class allowed a 3% difference between the grades). If the grades are not close, then the student is automatically assigned the teaching staff grade. Grades are then released to students, such that feed- back from the staff can inform work on the next assignment.

Incentivizing Accurate Self-assessment

The ability to self-assess is a useful skill in its own right, so we incentivize students to self-assess accurately. For the 2011 year, students were awarded credit based on how close their self-evaluation was to staff grades, with the maximum

bonus worth 2.5% of the points from all assignments. Be- sides incentivizing a useful skill, this also mitigates the effect of "gaming" self-evaluation, by providing students close to the maximum a student could gain by consistently grading herself above the staff-grade. In practice, no student evaluated themselves more than 2.5% above the staff grade across the quarter.

How Accurately do Students Self-assess?

Having two independent measures of a student's performance (self- and staff-assessment) enables us to measure the effectiveness of self-grading. Overall, for the 2011 year, 69% of all student submissions got their self-assigned grade. Even when students didn't get their own grade, these grades correlated well with the staff assigned grades. The overall Pearson correlation between the two measures for all submissions was 0.91 (t(2028) = 103.32, p < 0.0001).

Making Rubrics more Flexible

Because the class involves a project of a student's own choosing, implementation tasks for projects vary widely. As such, it is not possible to come up with a reasonable single rubric that would fit all possible projects. Could students develop their own rubric for evaluating their projects?

Guiding questions	Bare minimum	Satisfactory effort & Performance	Above & Beyond
Point of view. Does your point of view relate to the design brief, clearly express a problem / opportunity, and clearly con- vey what a good solution needs to accomplish? (Max 20: 10 for the problem, 10 for the solution requirement)	0-7: The problem is unclear / missing, the solution requirement is unclear / missing, or the point of view is unrelated to the design brief.	8-15: The point of view relates to the brief and the problem and solution requirement are clearly stated, but the solution requirement is either too general (anything that solves the problem meets the requirement) or too specific (only one partic- ular implementation meets the requirement).	16-20: The problem and solution requirement are clearly stated. The re- quirement provides focus without demanding one specific implementation.
Storyboards. Do they both address your point of view? Do they diverge in the solutions? (Max 40: 20 per story- board)	0-16: The storyboards are hard to follow or do not address the point of view.	17-33: The storyboards reasonably address the point of view, but either a reader may have lingering questions about the situations depicted or the solutions don't diverge much.	34-40: The storyboards are easy to follow and have diverging solutions. Some- one else could come up with distinct pro- totypes just from looking at your story boards.
Paper prototypes. Did you explore two clearly different interfaces	0-16: The prototypes are incomplete in significant ways.	17-33: The prototypes are mostly complete. The purpose of each screen is	34-40: The prototypes explore two different

implementing the same idea? How was the quality of paper prototype? Does it feel dynamic, like a working application? Were you creative when implementing the interactions? (Max 40: 20 per prototype)	Many screens refer to screens that are not prototyped, and it's often unclear what a certain screen does.	clear. But maybe the interfaces are not that distinct and share many similarities. Or maybe a user looking at the proto-type may sometimes have a question about how to navigate between screens, how to use a form on a screen, or what some element on a screen is doing there	interfaces and are detailed enough so that (1) a user can get a good feel for how the application works and flows and (2) a programmer can use the prototypes to implement a skeleton web-application that has working forms and links.

Table 11.1. Rubric for assignment in Week 3: Prototyping. Rubrics are detailed, and provide objective measures of performance wherever possible.

Figure 11.2. A sample submission by students. Staff and students used the rubric in Table 1 to evaluate this submission. Only one of the two storyboards the students submitted is shown, along with its prototype-screens.

We experimented with this idea by splitting the rubric for project progress into two parts. The first part of the rubric asks students to create an implementation schedule for their project, and assesses how realistic it is. The second part assesses week-to-week progress according to the schedule developed by the students. In order to allow flexibility, this weekly assessment rubric also allows students to add, remove or postpone tasks.

Splitting the rubric into these two separate components has worked well: for the 2011 year, course-staff assessed 98% of students as making "adequate progress" at all their mile- stones, and 42% as going "above and beyond" at all mile- stones (milestones were weekly, excepting holidays). Stu- dents were considered to make "adequate progress" if they met most, but not all, their goals for the milestone, and going "above and beyond" if they achieved all planned tasks, and had advanced tasks from later weeks.

This success suggests that such a split approach involving students in their own evaluation could allow rubrics to be used even when the evaluation task is not well-defined. Further- more, Andrade [2] suggests involving students in creating a rubric as a way to help them understand pedagogical goals more clearly; this split-rubric method may make such collaboration practical in large classes.

IMPROVING EDUCATION THROUGH DATA ANALYTICS

Online submissions of assignments lead to a large amount of data in an analyzable form—the time assignments are turned in, how students grade themselves (and how staff grade them), even the actual text of the submission. At our university, we use this data towards three main goals: 1) to en- sure that the course is meeting goals that are hard to measure through other means such as student feedback; 2) to identify problems early and to discover potential areas for improving teaching; and 3) to help staff identify and focus on students that may need help.

Below, we offer vignettes of each of these applications. All numbers are from the 2011 class.

Do Students get Better at Self-assessment?

Answering this question is difficult based on student feedback—formal University feedback doesn't ask about self-assessment, and students themselves may not be able to accurately gauge themselves.

However, using assignment submission data, we see that students indeed improve. We performed a repeated measures ANOVA on the accuracy of the self-evaluations across the term and found that accuracy improves across the course of the term $F (1, 1332) = 31.72$, $p < 0.001$ (Figure 11.3).

Improving Rubrics and Teaching

Analyzing submission data also enables us to improve rubrics by identifying items that are confusing. For instance, we see that given the general trend of decreasing differences between self evaluated and staff assigned scores (Figure 11.3), Assignment 7 (User Testing 1) has an unusually poor correlation between self-assessed and the staff-assessed scores (Pearson $= 0.86$, vs. the mean 0.91). Looking deeper, we see that the rubric item in assignment 7 which has the lowest self-and- staff correlation asks students to come up with a list of "who did what" that week toward the quarter-long project. This is the first time in the quarter that

such a status update was required, and the data suggest that students did not understand requirements clearly.

Student feedback at the end of the quarter echoed this concern about this assignment "Our group knew what we had to accomplish, and wrote the implementation plan to the level that we needed to, but it never seemed to be good enough..."

Formal student feedback is always helpful, but it is often obtained too late to improve the course for the current term. Using submission data directly, staff could identify the problem, solicit informal feedback, and improve rubrics later in the quarter that asked the "who did what" question.

Similarly, looking at grade distributions for rubric items across the class helps identify areas to improve teaching. For instance, for the 2011 year, a rubric item on a need-finding assignment had the lowest grades. This item required students to list the ideas they brainstormed to solve a user need they'd identified. The rubric graded students exclusively on the number of ideas brainstormed, and did not give more credit to more "insightful" ideas (following Osborn's advice on brainstorming that "quantity is wanted" [10]). However, students seem to have not understood why credit was given to quantity: one student complained in end-of-quarter feedback, "Generate 20 good ideas instead of 25 silly ones? Expect to lose points."

Identifying Students Who May Potentially Perform Poorly

The studio model of education relies particularly heavily on engaged students who can contribute meaningfully to their design team. Engagement is affected by two ingredients: the student's commitment to work on class assignments and the student's grasp of concepts taught in class. Can we identify students early on who are struggling to acquire these ingredients?

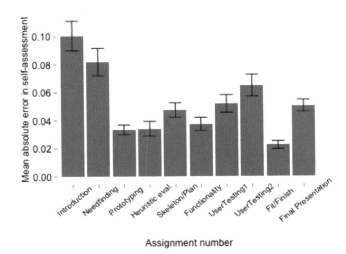

Figure 11.3. Mean absolute error of self-evaluation over staff assigned grades improves over the term (lower is better)

Based on student submissions for the last two years, we have identified questions in early assignments that are predictive of poor performance toward the end of the term. We identify such questions by looking at correlations between the student's grade on the assignment, and her final grade in the course. For the 2011 class, the three most predictive questions asked students to (a) brainstorm ideas for their project, (b) create storyboards for the use of their application, and to (c) create paper prototypes of their application. In general, questions with high predictive power test both the student's commitment to work on class assignments (such as number of prototypes created) and the student's grasp of concepts taught in class (e.g., storyboards should show the prototype being used in context).

Based on the above features and student major and year, we have built a random-forest classifier [4] to identify students who may perform poorly. We plan to use this classifier to identify students who are not sufficiently engaged or who may need help understanding course material.

FUTURE DIRECTIONS

Challenges

The biggest challenge to building a successful self- assessment system is building effective rubrics. To create rubrics that help learners improve, requires one to

articulate heuristics for excellence that are concrete, but not limiting. Experience, student feedback and data analytics help, but the tension between concrete and limiting may be inherent to all creative domains.

Second, self-assessment also changes the role of the teach- ing staff. Instead of simply being graders, TAs are viewed as allies and advisors who help students do well on the rubric. This new role places greater responsibility on TAs, and is often unfamiliar.

Peer Evaluations

Prior work has established that given clear grading criteria, students "can make rational judgments on the achievements of their peers" [13]. For our online class, it is impractical for teaching staff to evaluate every student's submission. There- fore, we plan to use peer-assessment to supplant assessment by the teaching staff. Rubrics developed for the offline course will be used both for self- and peer-assessment. Rubric-based feedback also addresses a challenge inherent in international audiences: language differences that make it challenging for students to provide written feedback to peers.

Since peer-review is used to supplant staff evaluation, consistency of grading is also a potential concern. Calibrated peer review [6] offers a way to mitigate inconsistency by first training the peer-grader on a number of training assignments, and only allowing them to grade other students once they grade training assignments close enough to staff grades. Such a calibrated peer review system has been used successfully at other universities, e.g., for the Distributed Cognition class at UC San Diego by Edward Hutchins.

Figure 11.4. The upward trend in CS enrollment units at our University

While the importance of user-centered design has long been recognized [9], there is now increasing awareness of its importance in industry. This has led to a greater need and demand for design education. Enrollment in this course has increased every year since 2007, even considering the general upward trend in CS enrollment at our university (Figure 11.4). As another example, the recently launched online version of this class has enrollments in the tens of thousands. With classes getting larger, the ability of traditional staff- driven evaluation to accurately assess and help the student learn is being challenged. However, online design education offers powerful opportunities for building cross-cultural empathy and collaboration.

Self-assessment and related evaluation mechanisms (like peer assessment) offer one of the few hopes of scaling design education. Unlike other engineering disciplines, evaluating de- sign is an inherently human endeavor. Jonathan Grudin writes that "A central tenet of HCI is that we cannot design interaction of any complexity by the application of formal rules. It is always necessary to try interfaces out with people. . . " [8]. How then could we automate, say, the evaluation of a proto- type? Could the storyboard for a new interactive system be evaluated by algorithm?

Unlike other hard-to-automate problems, however, design evaluation may also be difficult to crowdsource. Tohidi et. al. warn that ". . . design and creativity are specialized skills. There is no reason to expect them to be spontaneously manifest in those not trained in the field" [14]. Leveraging plat- forms like Mechanical Turk can thus be both invalid and also potentially harmful. Peer-

evaluation may solve this problem by using evaluators who, though non-expert, are interested in acquiring relevant skills and in learning the practice of design.

Flipping the Design Studio

An exciting opportunity for future work is to better under- stand the possibilities for a "flipped classroom" in design education. In a "traditional" classroom, students listen to lectures in class, and do problem-sets at home. In a flipped class- room, students do problem-sets in class instead, listening to lectures at home [5]. Given design's emphasis on in-studio work and collaborative work, design seems like a natural fit for this model.

CONCLUSIONS

This paper introduced a novel workflow for augmenting studio-critique based design education with online self-assessment. Results over the past year demonstrate that this method enables students to accurately evaluate themselves. The accuracy of these evaluations improved over the term, which suggests that this method to be an effective means for teaching this important professional skill.

REFERENCES

Andrade, H. The effects of instructional rubrics on learning to write. *Current Issues in Education 4*, 4 (2001).

Andrade, H. Teaching with rubrics: The good, the bad, and the ugly. *College Teaching 53*, 1 (2005), 27–31.

Boud, D. *Enhancing learning through self assessment*. Routledge, 1995.

Breiman, L. Random forests. *Machine learning 45*, 1 (2001), 5–32.

Brown, B. Flipping the classroom (abstract only). In *Proceedings of the 43rd ACM technical symposium on Computer Science Education*, ACM (2012), 681–681.

Carlson, P., and Berry, F. Calibrated peer review and assessing learning outcomes. In *FRONTIERS IN EDUCATION CONFERENCE*, vol. 2, STIPES (2003).

Dow, S., Fortuna, J., Schwartz, D., Altringer, B., Schwartz, D., and Klemmer, S. Prototyping dynamics: sharing multiple designs improves exploration, group rapport, and results. In *Proceedings of the 2011 annual conference on Human factors in computing systems*, ACM (2011), 2807–2816.

258 *Reframing Quality Assurance*

Grudin, J. Ai and hci: Two fields divided by a common focus. *AI Magazine 30*, 4 (2009), 48.

Kelley, D., and Hartfield, B. The designer's stance. In *Bringing design to software*, ACM (1996), 151–170.

Osborn, A. *Applied imagination; principles and procedures of creative problem-solving*. Scribner, 1963.

Ross, J., Rolheiser, C., and Hogaboam-Gray, A. Effects of self-evaluation training on narrative writing. *Assessing Writing 6*, 1 (1999), 107–132.

Scho"n, D. *The design studio: An exploration of its traditions and potentials*. RIBA Publications for RIBA Building Industry Trust London, 1985.

Stefani, L. Peer, self and tutor assessment: relative reliabilities. *Studies in Higher Education 19*, 1 (1994), 69–75.

Tohidi, M., Buxton, W., Baecker, R., and Sellen, A. Getting the right design and the design right. In *Proceedings of the SIGCHI conference on Human Factors in computing systems*, ACM (2006), 1243–1252.

CHAPTER 12

Case Study in Fashion Design and Merchandising, Illustration, Accessory Design, Textile and Fibers, Jewelry, Costume Design

Applying Design Principles and Elements to a Visual Display
Ashley Hasty, PhD
Indiana University, Department of Apparel Merchandising and Interior
Design

Students are asked to apply design principles and elements to a visual display, followed by an analysis of the display strategy.

INTRODUCTION

The Department of Apparel Merchandising and Interior Design (AMID) consists of programs that examine consumer-oriented and aesthetic components of the near environment.

Dr. Ashley Hasty is a lecturer whose work focuses on fostering creativity and collaboration through innovative uses of technology. Her courses include active learning techniques, cooperative learning, and service-learning. These methods encourage the student to take a central role in their learning process, use their peers as resources, and opportunities to immediately apply course material to real-world scenarios.

DESCRIPTION OF THE PROBLEM/OBJECTIVE

The National Survey on Student Engagement shows that the deepest learning tends to happen outside of the classroom through "high impact practices" with "opportunities such as learning communities, service-learning, research with a faculty member, study abroad, internships, and culminating senior experiences" (NSSE Annual Results, 2012).

This service-learning assignment was designed to resemble these high-impact practices. In groups of three or four, students are required to design and implement a visual display for a local business or non-profit agency. This occurs on four separate occasions during a semester. They are to apply curriculum, such

as design principles and elements including line, color, shape, texture, balance, etc.

The instructions for the assignment are as follows:

> Upload a full image of your visual display and answer the following questions thoroughly using VoiceThread. Feel free to use all of the features available on VoiceThread, including the option to videotape your response, draw on the photo, etc.

Course-Focused Questions:

1. How did our in-class activities (tours, field trips, in-class worksheets, etc.) guide, direct or influence your design decisions at your service site?
2. Explain how your display is appropriate for your service site brand and target market.
3. Describe your display in terms of design tools and rules.
4. Compare the two spaces for which you designed a display. How are they similar and different? What was challenging about each space?
5. What did you learn about visual displays from completing displays at two different sites?

Self-Focused Questions:

1. Compare your experience at the service site with your previous experiences such as jobs, working in groups, volunteering in the community, or other class assignments.
2. What personal qualities have you developed through service-learning? In what ways do you anticipate these qualities will help you in the future?
 *Note: For more information about how to use VoiceThread, please visit this site: http://uits.iu.edu/page/bduw (Links to an external site.)

The course outcome that this assignment addresses is to evaluate visual promotion strategies as forms of human expression. The related Student Learning Objective is: Recognize and verbally explain visual merchandising design as a means of communication in the cultural context of the store's target consumer. The rubric for assessing this assignment is found at the end of this case study.

Service-Learning has proven to do a number of things (Eyler, Giles, Stenson, & Gray, 2003):

- Positively impact the personal development of students through enhancing the student's sense of personal efficacy and identity.
- Positively impact interpersonal development, the ability to effectively work with others, leadership proficiency, and communication skills.
- Positively impact on students' academic learning, as reported by students and faculty.
- Improve students' ability to apply curriculum in practice.
- Improve the students' complexity of understanding, problem analysis, critical thinking, and cognitive development.
- Contribute to career development.
- Develop stronger faculty relationships.
- Improve students' satisfaction with their undergraduate experience.

CHALLENGES TO SOLVING THE PROBLEM/REACHING THE OBJECTIVE

In evaluating this assignment over the course of two years, I noted that successful implementation of a visual display did not ensure mastery of curriculum. Students drawn to this field often have a natural eye for design, but they do not understand why successful designs are attractive. They are not able to articulate the design process or identify characteristics of poorly designed displays.

Also, as is common with group work, some students would stand as free-riders, relying on group members who did the majority of the work and fully understood course concepts.

Additionally, students were often concerned when the managers/owners of service-learning community partners requested changes to the display, conflicting with strategies learned in class. Sometimes this resulted in students declining to make changes to their displays.

Fall 2013: I took out the in-class presentation and instead asked students to write a letter to the next group scheduled to do a display explaining what they had learned and what advice they have for the next group. Students were graded on how well they implemented the window display and how well they wrote their letter.

Fall 2011: First time I taught the course. Students participated in service learning and were graded on how well they implemented the display.

Fall 2012: After two full semesters and one summer session, I changed the assignment to add in a student presentation of their work. They were then graded on how well they completed their window display and how well they presented their work.

Fall 2014: Continuing the same VoiceThread assignment.

Summer 2014: After completing a fellowship for service-learning, I took out the letter assignment because students didn't find it helpful and were choosing not to read the letters from the previous groups. I added the VoiceThread reflection and stopped grading students on how well they implemented the window. For the first time, I graded students individually as opposed to giving the whole group the same grade.

Strategies/Creative Ways of Solving/Reaching the Objective

In response to these challenges, a reflection assignment was added. In this assignment, students are asked to individually answer six questions:
Course-Focused Questions:

- How did our in-class activities (tours, field trips, in-class worksheets, etc.) guide, direct or influence your design decisions at your service site?
- Explain how your display is appropriate for your service site brand and target market.
- Describe your display in terms of design tools and rules.
- Compare the two spaces for which you designed a display. How are they similar and different? What was challenging about each space?
- What did you learn about visual displays from completing displays at two different sites?

Self-Focused Questions:

- Compare your experience at the service site with your previous experiences such as jobs, working in groups, volunteering in the community, or other class assignments.
- What personal qualities have you developed through service-learning? In what ways do you anticipate these qualities will help you in the future?

Students are no longer graded on how well they implement the display. This eliminates conflict between satisfying the community partner and fully demonstrating an understanding of course concepts. This assignment also ensures those with a natural affinity for design are required to demonstrate mastery of curriculum . Finally, the assignment is completed individually. While students may be able to rely on group members to complete the display, they must be able to demonstrate their understanding of course concepts on an individually in order to achieve a passing grade.

Lessons Learned /Changes Made / Accomplishments

This assignment can be implemented using a paper and pen, but I've found that using a program called VoiceThread improved the quality of answers. In VoiceThread, students are able to upload an image of their display and verbally

respond to the questions provided. As they record their answers to the questions, they can use the Doodle Tool to draw on the image of their display in order to illustrate the concepts they are discussing (see example below.)

Factors That Contributed Most to the Success of Your Assessment

The most important factor of this assessment was disconnecting the work students were doing for the community from the grade they received in class.

Conclusion/Summary

All parties involved (myself, the students, and the community partners) were satisfied with the new assignment that disconnected the community work from their grade. The community partners were concerned when their requests conflicted with course content or had any effect on the student grade. Students preferred individually earned grades as opposed to receiving a common grade with their group. This improved flexibility and mitigated arguments between group members. As the professor, I was able to create a stronger rubric that truly evaluated students' knowledge and understanding of course content. In addition,

the reflections are interesting to hear and I enjoy listening to students answer the questions. Grading has become less tedious and more enjoyable.

Categories	Exemplary	Intermediate	Beginning
Self-disclosure	Openly examines personal experiences in the past as they relate to the service-learning. Demonstrates an ability to self-appraise, discussing both progress and frustrations as they relate to the service-learning assignment.	Cautiously examines personal experiences in the past as they relate to the service-learning assignment. Sometimes defensive or one-sided in the analysis.	Little self-disclosure, minimal risk in connecting concepts from class to personal experiences. Self-disclosure tends to be superficial and factual, without self-reflection.
Window description	In-depth description of window using vocabulary introduced in the book, lectures, and class	Goes into some detail describing the window using vocabulary introduced in the book, lectures, and class	Identifies a general description of the window using some vocabulary introduced in the book, lectures, and class
Connection to class discussions and course objectives	Synthesize, analyze and evaluate thoughtfully selected aspects of ideas or issues from the class discussion as they relate to the service-learning assignment.	Synthesize clearly some directly appropriate ideas or issues from the class discussion as they relate to the service-learning assignment.	Restate some general ideas or issues from the class discussion as they relate to the service-learning assignment.

*Rubric was adapted from a rubric created by Betsy Albert-Peacock for a Human Diversity course at the University of Minnesota Duluth. (Albert-Peacock, 2014)

REFERENCES

Albert-Peacock, B. October 29, 2014. *Grading Rubric for Reflection Assignments.* Retrieved from

http://www.d.umn.edu/~balbert/humandiversity/grading_rubric.html

Eyler, J. S., Giles, D. E., Stenson, C. M., & Gray, C. J. 2003. At a Glance: What We Know About the Effects of Service-Learning on College Students, Faculty, Institutions, and COmmunities, 1993-2000, Third Edition. In *Campus Compact's Introduction to Service-Learning Toolkit* (pp. 15-20). Boston: Campus Compact.

NSSE Annual Results. 2012. Retrieved November 5, 2013, from National Survey of Student Engagement: http://nsse.iub.edu/NSSE_2012_Results/pdf/NSSE_2012_Annual_Results.pdf

CHAPTER 13

Case Study in Digital, Graphic, and Game Design

Designing an Assessment Program in Digital Arts
Michael Martin
Kathleen Broome Williams
Karen Keister
Cogswell Polytechnical College

INTRODUCTION

Cogswell Polytechnical College is a private, for-profit college located in Sunnyvale, California. The College holds accreditation through the The WASC Senior College and University Commission (previously Western Association of Schools and Colleges). Cogswell has a small student body of approximately 550 full-time students in 2014.

The College was founded in 1887 as a high school in San Francisco, California, offering technical classes for boys and business classes for girls. In 1930, it became a technical college, and in 1985 the College moved to Cupertino to serve the software and high tech industry with an evening engineering program.

In 1994, the College responded to the need for artists and technicians in the fast growing field of computer graphics and animation by offering a Bachelor's degree in Computer and Video Imaging. At the time, there were a handful of institutions offering a degree in computer animation, partly due to the lack of available faculty in this area of expertise, and partly to the difficulty larger established programs face when responding to developments in new disciplines. Our location, near a concentration of animation and graphics houses in the Bay Area, provided a ready adjunct workforce, and the niche specialization attracted students could not readily find this course of study elsewhere. The programs provide a foundation in fine arts because, while it is relatively easy to teach computer graphics, the artistry that the industry demands require a solid grasp of traditional fine arts. In 1999, the program was renamed Digital Arts and Animation.

Today, Cogswell offers Bachelors degrees in Digital Arts and Animation, Digital Audio Technology, Game Design and Development, Engineering, and Digital Media Management. Students are prepared for the disintermediating global industries of computer animation, video games, digital audio, software engineering, and digital arts engineering. A bachelor's degree in Digital Media Management program was added in 2010.

DESCRIPTION OF THE PROBLEM/OBJECTIVE

The assessment program in place before 2005 was not consistent with emerging best practices. There was little measurable data driven evaluation of student work, and little guidance or administrative assistance. The College employed no assessment staff.

The new leadership of the College identified the need to develop a five-year assessment cycle that was meaningful to faculty and satisfy emerging regional accreditation standards. The faculty worked closely with the Academic Dean to identify a consultant to guide the College through development of an assessment program that would consider the narrow focus of our degree programs, our small size, and the unique fusion of art and technology degree programs.

The program needed to launch with few resources, a small faculty, and to directly lead to a recommendation for institutional support that could be built into institutional planning over the first annual assessment cycle or two, culminating in a five year program review cycle for each degree program.

CHALLENGES TO SOLVING THE PROBLEM/REACHING THE OBJECTIVE

Lack of formal institutional experience capturing assessment data and evidence was one of our biggest challenges. The prior longtime Dean had supplied piecemeal literature and a draft procedure, but with insufficient support or training, the momentum stalled. The small faculty and staff had little expertise with assessment outside of the classroom and the College did not allocate resources to develop training. There was a large, committed adjunct faculty, but they would need training and compensation to take on the additional duty of assessment.

Our survey of assessment literature revealed a lack of material dedicated to assessment of creative fields.

STRATEGIES/CREATIVE WAYS OF SOLVING/REACHING THE OBJECTIVE

The first order of business was to identify someone who could help. A faculty survey of assessment literature led to Mary Allen's book entitled *Assessing Academic Programs in Higher Education*. The Academic Dean arranged for Mary to present a full-day assessment workshop to the entire full-time faculty (13 at the time) and assorted stakeholders. The workshop provided a thorough overview, a large selection of sample documents, a supply of templates, and a discussion of the informal assessment the faculty already conducted. Administration charged the faculty to create and lead assessment policies and procedures, and to write the first assessment plan and to begin writing learning outcomes. The Faculty Senate created a standing Assessment Committee, composed of program directors from each degree program, the General Education program Director, the Registrar/IR Director, Librarian, and Academic Dean. This committee met monthly to develop an assessment plan template for all programs, share documentation, present progress reports, and provide feedback.

LESSONS LEARNED /CHANGES MADE / ACCOMPLISHMENTS

We quickly realized that faculty buy in was the key to success, and that our small size allowed us to move quickly and iterate easily. A small faculty allowed regular face-to-face meetings to conduct assessment activities, such as selecting the two annual PLOs, writing rubrics for course and program learning outcomes, gathering student work samples, evaluating and scoring the samples, writing and disseminating annual assessment reports, and determining learning improvement actions items. Each program easily gathered all full-time and key adjunct faculty (with token compensation) together, which accelerated rubric calibration and scoring, viewing work samples, and enhanced inter-rater reliability. The discussions (and sometimes heated debates) in these meetings provided rich and meaningful action items that were not only documented, but were immediately returned to the classroom with each instructor.

Adjuncts must be included in the group assessment meetings. They provided context for the student work samples and they came away with a better understanding of the scaffolding of the program classes. We are faced with the common problem of engaging adjunct instructors, but these meetings provided immediate feedback and an elevated appreciation of PLOs and learning improvement action items. It was also important to compensate adjuncts for the addition of assessment meetings to their schedule. We received feedback that

these meetings were useful and worth the effort because they had never been asked to evaluate artwork or contribute to important decisions.

Our IR Director aggregated the data and returned it to the programs within a few days. The culmination of the process was the annual assessment report, which was typically submitted by May 31 of each year.

The first problem in the new process was at the annual culmination – in closing the loop. The action items were clear, faculty vetted, and transparent, but did not have a single capstone document or MOU to point to. While the learning improvement actions items were instituted, the materials and reports were not narrowed down to a single document, and the results did not have a pipeline to institutional planning and resource allocation. Additionally, during this period the college experienced several changes in leadership that resulted in disruption and uncertainty. Support for assessment varied, and in some cases even impeded progress.

Presenting assessment materials proved to be a challenge. We moved from three ring binders to an online wiki. While the wiki allowed universal access and collaboration capacity, many faculty members were initially overwhelmed by the technology and required assistance. We also overlooked the importance of simple hard copy documents; when our WASC accreditation team visited campus, we learned that they had difficulty understanding our structure. The information was available, but hard to follow.

After two assessment cycles (two years) The College again engaged Mary Allen to present a half-day diagnostic workshop. This workshop lead to a revision of the program review plan and the adoption of a conventional annual assessment report template. We also learned that small corrections or revisions to the process between program review cycles are normal. Rubrics, in particular, require fine-tuning after initial application. Many of our initial attributes were not applicable to each student sample or were too difficult to measure. Many were helpful for grading, and most faculty began using rubrics to grade class projects – unusual for most art classes.

The biggest error was attempting to complete multiple program reviews in one semester, at the end of the five year program review cycle. The visiting WASC team recommended staggering the reviews, and we revised the schedule to stagger each program review to provide more sustainable program review cycle.

In late 2014, the Institutional Research Director was assigned to lead the administration of the assessment program, leaving the faculty to lead the assessment of student learning and improvement plans. The assessment

committee recognized the need for an automated, comprehensive delivery tool that was more robust than a wiki, so in late 2014 the College selected TaskStream software for all assessment management and reporting.

FACTORS THAT CONTRIBUTED MOST TO THE SUCCESS OF YOUR ASSESSMENT

Besides enthusiastic faculty buy-in, the most important factor in our success was the exercise of writing the program learning outcomes and then the PLO rubrics. The practice of asking a dozen creative, strong willed artists to identify the dozen or so most important learning outcomes was productive and motivating. The faculty settled on eleven PLOs.

Arts instructors have always relied on the group critique as the primary means to assess an assignment or project. The process is timeless: students gather around a students' artwork(s) and the instructor leads discussion about what the work means, how to interpret it, its place in the world, and how it addresses (or doesn't) the project criteria. Sometimes the criteria are carefully laid out, but sometimes it is surreptitious. In any case, students and instructors articulate these ideas without much struggle.

Faculty initially hesitated over imposing rubrics ("how are we supposed to impose objective restraints on a subjective, creative exercise?" etc.), but after debating the criteria, and then descriptors (particularly the descriptors – what do we mean when we say "expressive characters" or "creativity" or "craftsmanship") in program rubric writing sessions they began to see the value of the process. The process worked best when a faculty or two presented a draft rubric to the group and opened the floor for discussion. The faculty with subject area expertise had the final edit, but every faculty member was asked to provide input.

The DAA faculty gathered at the end of each semester to assess the student work samples for the two target PLOs. The target class instructor presented midterm and final project student samples and the faculty used the PLO rubric to first discuss, and then score the samples. The scores were used to determine how each class level performs at each PLO. The goal was for each successive level to score higher, culminating with eighty percent of the senior level work to score at the highest score. The discussion centers on how students at each class level measured against the rubric, and ends with a draft improvement action plan for each target class. The action items are included in the annual assessment report and shared with the program and administration.

While most of the College's programs include core visual and performing arts classes, we benefit from aligning our assessment criteria with animation and

game industry standards, providing a benchmark for faculty and students as they matriculate through the program.

Another important factor contributing to our success was ongoing faculty attendance at WASC workshops and conferences. Besides the presentation of sound methods and best practices, these events introduced us to a peer network to share good work and resources. The openness of peers to share their work saved us countless hours of reinventing the wheel, and the appearance of common challenges provided a welcome relief.

CONCLUSION/SUMMARY

The first few years were challenging, and often frustrating, but productive. Faculty shared the burden of building an assessment program, and came together to produce surprising results; we didn't expect rubrics to be embraced to the extent that most instructors use them for grading projects. Adjuncts reported that they better understand the program and how their course learning outcomes flow to successive classes.

We learned that there are ways to effectively assess creative production, and the faculty had been doing this all along, but did not consider it in the context of an institutionalized assessment program.

We learned that we were farther along than many institutions, and we made many of the same mistakes. Interactions with peers relieved some stress and provided a wealth of "open source" materials.

The increased emphasis on core competencies and institutional learning outcomes has provided momentum to reexamine course leaning outcomes to ensure there is a clear map up through institutional learning outcomes.

Our next challenge will be how to share learning outcomes with students in a meaningful way. We have presented the ILOs and PLOs in various formats, and instructors present CLOs at the start of each class, but there is little evidence that students are considering the outcomes the way we would expect them to.

2010-11 DAA LEARNING OUTCOMES

DAA PROGRAM GOALS	LEARNING OUTCOMES
Students learn and practice the concept to delivery pipeline.	1. Students will identify the most critical components of a project by evaluating the contributing factors. 2. Students can develop a production plan that includes concepts, technology, and a schedule. 3. Students produce a senior reel that integrates the principles, techniques, and skills acquired in their coursework.
Students use technology creatively and proficiently.	4. Students can utilize the most appropriate existing and emerging software technology in their work. 5. Students create computer-generated images that convey messages and emotions.
Students possess proficient artistic skills.	6. Students can apply the elements of design and color to their work. 7. Students use drawing and rendering techniques to invent expressive characters, sets, and props.
Students collaborate with others effectively.	8. Students can define and fill the role of each member of a group project. 9. Students will effectively contribute their expertise to a collaborative project.
Students are creative, they explore, and they play.	10. Students develop a final project concept through experimentation and iteration. 11. Students design and implement a project that exhibits inventive combinations of ideas, techniques, and materials.

DAA106 Digital Imaging Concepts

Project 2: FACE COMPOSITE

Timeline: Tuesday Oct 14: Assign Face Composite and take headshots.
Thursday Oct 16: Color Match Faces homework exercise due
Tuesday Oct 21: Homework due from *HTCAPCC:*
1. Page 110 Matching colors with curves
2. Page 114 Selective hue and saturation
Tuesday Oct 28:
1. Critique Face Composite
2. Bob's Face exercise due
!

Assignment Composite a photorealistic head shot from your face and <u>five</u> of the provided
headshots so that no one would notice it is a composite. I must be able to disable
layer masks and find an unedited headshot on each image layer. Use non-
destructive tolls and techniques only.

Sources: DAA106/sources/your section/faces

Specifications: Size: Use the size as provided
Color: RGB color
Resolution: As is = 2000 on the longest side
Layers: Layers named after person, Groups named after body part.

Objective: This project will challenge you to:
- create a realistic image from multiple sources.
- use layer masks.
- name, rename, and group layers.
- use dodge and burn layers.
- use adjustment layers to correct color and contrast

Remember:
- Use your face as the host file; bring five other entire faces into it – not just
 parts of the face. If your face is not the host file you must use your face in the
 stack.
- Use a layer mask to hide unwanted parts of the layer: to start with a black
 mask (hide all) hold down *alt* when you click the layer mask icon
- Use an adjustment layer to change the color and contrast of a layer
- To clip an adjustment layer (make an adjustment layer effect only the layer
 directly below): hold down alt key and click in between the layers
- Use a Dodge and Burn D&B layer to lighten and darken the image
 nondestructively
- To make a Dodge and Burn layer create a new layer and fill with 50% neutral
 gray. Change the blend mode to Soft Light, You can use the Dodge and Burn
 tools on this layer instead of the image.
- Crop the image without deleting any info: Check the *hide* button in the

options bar with the crop tool rather than *delete* option
- Organize and name layers, layer named after the person, group named after the part of the face.
- You may need to go back to some of the self-portrait painting techniques to make skin match: slight washes of color, skin pores, etc.

Hints	Get the files, masks, and layers into place, color and contrast correct at the end. Do not sharpen or blur any layers until the very end.
Presentation	We will critique the image on screen
Grading	You will be graded using the attached rubric.

DAA106 Digital Imaging Concepts	Poor 1 point	Average 2 points	Good 3 points	Excellent 4 points	score
Layers and Groups named clearly and logically	Layers and groups are not all named. Groups not used.	Most layers are named, and groups are named	Layers and groups are named but some are confusing or illogical	All layers named logically and correctly, easy for viewer to understand	
Masks In layers, adjustment layers, and alpha channels	No use of adjustment layers. Color and contrast are clearly not consistent	Some adjustment layers, some permanent adjustments. Contrast and color differences are apparent	Some levels adjustments layers are used, color balance and Brightness and Contrast are used instead of levels/curves. Color and contrast are acceptable	Adjustment layers are used effectively, including their layer masks. They are clipped. Perfect color and contrast consistency	
Colorization	Color is not believable or sensible. Fake looking or missing.	Color methods are too obvious – too opaque, desaturated, not realistic etc.	Color is approaching natural but still too noticeable. Slight fine tuning would make a big difference.	Color is natural looking and very believable. Convincing images	
Layer Blending	Normal layers only turned down in opacity to blend. Layer masks absent or sloppy	Some blend modes attempted, masks still not finished	Blend modes and masks used, masks reviewed and cleaned up.	Layer blend modes, blending options, and opacity are used effectively. Layer masks elegant and crafted perfectly	
Layer Blending Modes	Blending modes are not used to create textures and blends	Layers contain unmatched textures and colors	Layers blended but are too obvious or distracting	Layers blended to produce effective textures and effects	
Realistic	Does not look like a real photo	Some major problems with size or proportions of some items, texture, contrast mismatches.	Some areas are not convincing, others are not quite correct, give away the secret	Looks like a real, unmanipulated photograph	
Critique	Present for entire critique (absent means 0)	Responds only when called on, minimum responses	Some clever observations	Participates in discussion, offers observations,	
Student Name				Total	

Fake Photo Rubric

DAA106 Digital Imaging Concepts

Project 6 – TIME WARP

Timeline:
Tuesday Dec 2:
- Assign time warp project
- In-class cloning demo and follow along tutorial.

Thursday Dec 4:
- Keyboard shortcut quiz 2
- Tutorials from HTCAP due:
 o Page 166 Vanishing Point Filter 1
 o Page 168 Vanishing Point Filter 2
 o Page 318 Paper: folding and crumpling
 o Page 322 Simulating and old photo
- Assign Final Project

Tuesday Dec 9: Time Warp project critique at the beginning of class. We will look briefly at the results – it will not be a regular full critique.

Assignment
Use non-destructive tools to:
1. Age a modern photo
2. Modernize a vintage photo

Process:
Work must be entirely non-destructive using layer masks, retouch layers, and the retouch and stamp tools, adjustment layers, and color modes.

Sources:
DAA106/sources/your section/time warp

Specifications:
Use the provided images as is – don't change the size or resolution.
Found images should be a minimum of 1200 px in the shortest dimension.

Objective:
This exercise will combine the color correction/alteration and cloning from the previous projects with the blending and displacement tricks in the demos and tutorials to manipulate the appearance of time.

Hints
- Create a layer or more as needed and be sure your edits are made on a new layer. DO NOT edit original pixels.
- Colorize using color layer blend modes and/or adjustment layers
- Small additions and removals from the images will contribute to the believability of the images
- Displacement maps can be used, but don't over do it. They're hard to pull off.

Page 1 of 3

References | The following sites will provide useable images and research.
Shorpy Historical Photo Archive: http://www.shorpy.com/
Rare Historical Photos: http://rarehistoricalphotos.com/
Photo Tampering Throughout History: http://www.fourandsix.com/photo-tampering-history/
Textures: http://www.mayang.com/textures/
Celebrities: http://commons.wikimedia.org/wiki/Main_Page
Politicians/government/military: http://www.defense.gov/photos/
Government/historical: http://www.photolib.noaa.gov/

Presentation | We will critique the image on screen. Submit a copy in layers.

Grading | Your project will be graded using the following rubric

SECTION THREE

CHAPTER 14

Quality Assurance in Creative Disciplines in the Institutional Context

Consider... the university professor. What is his function? Simply to pass on to fresh generations of numskulls a body of so-called knowledge that is fragmentary, unimportant, and, in large part, untrue. His whole professional activity is circumscribed by the prejudices, vanities and avarices of his university trustees, i.e., a committee of soap-boilers, nail manufacturers, bank-directors and politicians. The moment he offends these vermin he is undone. He cannot so much as think aloud without running a risk of having them fan his pantaloons.

--H. L. Mencken (1956, p. 181)

This quote by satirist Mencken captures the sentiments of some faculty in the academy in regards to assessment, and how it has been, in the views of some, a mandated activity from administration or board to appease accreditors. And in some ways changes in higher education happen as an example of Newton's First Law (1846): Every object persists in its state of rest or uniform motion in a straight line unless it is compelled to change that state by forces impressed on it. A number of the case studies in chapters six through thirteen of this book mentioned how departmental, program, or institutional assessment activities were formed in response to accreditation demands.

This chapter reviews the requirements of the national and regional accreditors in the United States and specialized accreditors in creative disciplines relative to assessment and quality assurance in student learning. Accreditors discussed include the National Architectural Accrediting Board (NAAB), the Council for Interior Design Accreditation (CIDA), the National Association of Schools of Art and Design (NASAD), the National Association of Schools of Music (NASM), the National Association of Schools of Theatre, and the National Association of Schools of Dance (NASD). This chapter also reviews trends in higher education that affect quality assurance and the assessment of creative disciplines, including competency-based education, the flipped classroom, and refers briefly to advances in accreditation of online programs in creative disciplines, addressed more thoroughly in Chapter two.

WHAT IS ACCREDITATION?

Ikenberry (2014) refers to accreditation as the "linchpin" that holds the United States' "highly decentralized and incredibly diverse academic enterprise together" (p. xix). In many countries around the world, academic quality is overseen by or directly controlled by a government agency. While the U.S. has a Department of Education and many of its federal policies have shaped higher education, direct oversight of colleges and universities is split between state authority (agencies that license or authorize colleges to operate), thousands of independent boards, and accreditors who have been empowered by and have to answer to the Department of Education.

Accreditation, according to the U.S. Department of Education website, is "the recognition that an institution maintains standards requisite for its graduates to gain admission to other reputable institutions of higher learning or to achieve credentials for professional practice. The goal of accreditation is to ensure that education provided by the institutions of higher education meets acceptable levels of quality." (US Department of Education, 2015). Quality is determined by evidence of the processes of teaching and the outcomes of student learning, and "the use of assessment to improve institutional performance" (Ikenberry, 2014, p. xxii). The Council of Arts Accrediting Associations (2009) in their paper "Tough Questions and Straight Answers About Arts Accreditation" clarifies that through peer performance review, accreditation "facilitates innovation, encourages improvement, creates baselines of commonality for academic practices and credentials, and provides the public with indicators of basic quality" (p.1). While accreditation, during its history and now, is voluntary, institutions need it for their students to be eligible for federal financial aid monies.

CHEA, or the Council of Higher Education Accreditation, is the non-governmental coordinating agency in the United States that carries out the recognition of accrediting agencies. But the agencies themselves are "owned and operated by member colleges under the leadership of boards that are elected by members and composed of individuals from those colleges and members of the public" (Suskie, 2014, p.12) which is part of the reason accreditation in the U.S. has come under fire in recent years as some see it as an industry regulating itself. Eaton (2012) explains that CHEA recognizes four types of accreditation organizations in the United States. Each type is explained more thoroughly below.

- **Regional accreditors.** Accredit public and private, mainly nonprofit and degree-granting, two- and four-year institutions.

- **National faith-related accreditors.** Accredit religiously affiliated and doctrinally based institutions, mainly nonprofit and degree-granting.
- **National career-related accreditors.** Accredit mainly for-profit, career-based, single-purpose institutions, both degree and non-degree.
- **Programmatic accreditors.** Accredit specific programs, professions and freestanding schools, e.g., law, medicine, engineering and health professions. (Eaton, 2012, p. 2)

NATIONAL ACCREDITORS

National accreditors accredit whole institutions, often ones not eligible for regional accreditation, including institutions such as career schools or schools who offer certificates but not degree programs (because they lack the liberal arts, general education core requirements).

The following Table 14.1 is a brief summary of national accrediting agencies recognized by the U.S. Department of Education, according to their website at http://www2.ed.gov/admins/finaid/accred/accreditation_pg6.html.

Table 14.1:National Accrediting Agencies Recognized by the US Department of Education

Agency	Description
The Accrediting Commission of Career Schools and Colleges	Recognized by the Department of Education since 1967 to accredit primarily those non-degree and degree-granting institutions that educate students for occupational, trade, and technical careers, including those that do so through distance education.
The Accrediting Council for Continuing Education and Training	Recognized by the Department of Education since 1978 to accredit continuing education and vocational programs (only these are eligible for Title IV funding) that confer certificates or occupational associate degrees.
The Accrediting Council for Independent Colleges and Schools	Recognized by the Department of Education since 1956 to accredit private, postsecondary institutions that offer certificates or diplomas (up to the master's level) that prepare students for professional, technical, or occupational careers.
The Council on Occupation Education	Recognized by the Department of Education since 1969 to accredit institutions of occupational schools that offer certificates and applied associate degrees in specific career and technical fields.

The Distance Education Accrediting Commission (DEAC), formerly Distance Education and Training Council (DETC)	Recognized by the Department of Education since 1959 to accredit non-degree and degree granting institutions that educate their students primarily through distance education or correspondence education, up through the doctoral degree level.

Source: US Department of Education,
http://www2.ed.gov/admins/finaid/accred/accreditation_pg6.html.

Table 14.2: National Faith-Based Accreditors

Agency	Description
Association for Biblical Higher Education	Institutions and programs in the United States, Canada and related territories that offer certificates, diplomas, associate, baccalaureate or graduate degrees aimed at preparing students for Christian ministries through Biblical, church-vocational and general studies. (2007)
Association of Advanced Rabbinical and Talmudic Studies	Advanced Rabbinical and Talmudic institutions in the United States and Canada which meet its standards, and which grant postsecondary degrees such as the baccalaureate, master's, doctorate, and First Rabbinic and First Talmudic degrees. (2001)
Association of Theological Schools	Accredits free-standing seminaries and academic units of larger institutions in the United States and Canada, that engage in graduate professional and graduate academic theological education. (2012)
The Transnational Association of Christian Colleges and Schools, Accreditation Commission	Accreditation and pre-accreditation of Christian postsecondary institutions in the United States, U.S. territories and other locations determined by the Accrediting Commission that offer certificates, diplomas, and associate, baccalaureate, and graduate degrees. (2011)

Source: Adapted from CHEA. http://www.chea.org/Directories/faith.asp#rabbinical

REGIONAL ACCREDITORS

Regional accreditors accredit institutions with a wide range of histories, missions, and sizes and "are not generally prescriptive about how to comply with their requirements" (Suskie, 2014, xxvii). The United States has seven regional accreditors that are the gatekeepers for the federal Department of Education's Title IV (financial aid) funding for students, and they have all been recognized as

the accrediting bodies since 1952. The general period for accreditation at the conclusion of each review cycle for institutions is between seven to ten years.

The following table summarizes the jurisdictions of each regional accreditation agency. All programs at any accredited institution within the geographical areas, including those offered by correspondence and distance education, are under the purview of these regional accreditors. Several of the regional accreditors also accredit institutions internationally; for example, WSCUC-Senior accredits several institutions in Mexico, the Middle East, and Eastern Europe.

Table 14.3: Summary Table of U.S. Regional Accreditors

Agency	Geographic Scope of Accreditation
Middle States Commission on Higher Education	Delaware, the District of Columbia, Maryland, New Jersey, New York, Pennsylvania, Puerto Rico, and the U.S. Virgin islands
New England Association of Schools and Colleges, Commission on Institutions of Higher Education	Connecticut, Maine, Massachusetts, New Hampshire, Rhode Island, and Vermont
North Central Association of Colleges and Schools, The Higher Learning Commission	Arizona, Arkansas, Colorado, Illinois, Indiana, Iowa, Kansas, Michigan, Minnesota, Missouri, Nebraska, New Mexico, North Dakota, Ohio, Oklahoma, South Dakota, West Virginia, Wisconsin, and Wyoming
Northwest Commission on Colleges and Universities	Alaska, Idaho, Montana, Nevada, Oregon, Utah, and Washington
Southern Association of Colleges and Schools, Commission on Colleges	Alabama, Florida, Georgia, Kentucky, Louisiana, Mississippi, North Carolina, South Carolina, Tennessee, Texas, and Virginia
Western Association of Schools and Colleges, Accrediting Commission for Community and Junior Colleges	Pre-baccalaureate colleges in California, Hawaii, the United States territories of Guam and American Samoa, the Republic of Palau, the Federated States of Micronesia, the Commonwealth of the Northern Mariana Islands, and the Republic of the Marshall Islands
Western Association of Schools and Colleges, Senior Colleges and University Commission	Four-year and advanced degree institutions in California, Hawaii, the United States territories of Guam and American Samoa, the Republic of Palau, the Federated States of Micronesia, the Commonwealth of the Northern Mariana Islands and the Republic of the Marshall Islands

The regional accreditors in recent years have been approached by many non-U.S.-based universities that are interested in going through the accreditation process. For these types of institutions, the accreditors have documents available online, such as the New England Association's *Becoming Accredited: A Guide to Eligibility, Candidacy, and Initial Accreditation for Free-Standing Institutions Abroad* (n.d.). Institutions abroad choose to seek American accreditation for a number of reasons, including because the institution wants to adopt assessment processes to ensure the meeting of certain quality standards and to identify areas in need of improvement, as the Provost of Thompson Rivers University in British Columbia, Canada, declared (Tamburri, 2013). The CHEA database shows thirty-three countries outside the United States and its outlying islands and territories that have regional or specialized U.S. accreditation. Three art and design schools included in the list are in Paris, France; Florence, Italy; and Doha, Qatar (http://www.chea.org/search/actionProg.asp).

In addition to the seven regional accreditors, the U.S. Department of Education also recognized the New York State Board of Regents and the Commissioner of Education to accredit degree-granting institutions within the state of New York.

Specialty Arts Accreditors

The third type of accreditation is done by specialty accreditors that often have links to professional organizations. Specialty accreditors may accredit an entire institution, a program or department, or school within a larger institution. Requirements of specialty accreditors may be more prescriptive than that of national accreditors because of the nature of the professions or disciplines they represent (Suskie, 2014). For example, results could be deadly if a licensed doctor or nurse hasn't mastered a particular competency (Suskie, 2014).

Some specialized accreditors are Title IV gatekeepers, others are not. While all recognized accreditors expect a culture of evidence regarding student learning, some emphasize the outcomes of student learning in their standards more than others (who still look a lot at the inputs, such as facilities and faculty credentials) (Suskie, 2014).

In art and design fields, The Council of Arts Accrediting Agencies (CAAA) is comprised of representation from four specialty accreditors, the National Association of Schools of Art and Design (NASAD), the National Association of Schools of Music (NASM), the National Association of Schools of Theatre (NAST), and the National Association of Schools of Dance (NASD). Rather than

duplicating the work of regional accrediting bodies (though the CAAA organizations do sometimes accredit whole institutions), these specialty accreditors target student learning and competencies through peer review within arts-related discipline-specific and professional areas. Let's explore each of these organizations a bit more in-depth.

The National Association of Schools of Art and Design was founded in 1944 and (nasad.arts-accredit.org) is based in Reston, Virginia, and it accredits approximately 323 primarily collegiate level arts and design schools, according to its website. Institutional initial membership is granted for a period of five years when an institution or program is found to meet all of the standards of accreditation; subsequent renewal of membership is for ten year time periods upon reaccreditation. The NASAD Handbook spells out twenty-two standards on which NASAD peer reviewers evaluate an institution or program (*NASAD Handbook 2014-2015*, 2014).

The National Association of Schools of Music was founded in 1924 (nasm.arts-accredit.org) is also located in Reston, Virginia, and is an organization comprised of approximately 647 schools, conservatories, colleges, and universities, according to its website. Its twenty-two standards cover everything from curriculum and non-degree and degree requirements to facilities, admissions, and operational guidelines (*NASM Handbook 2014-2015*, 2014). Initial membership is granted for five years when an institution is found to meet the standards, and then reaccreditation periods are for ten years.

The National Association of Schools of Theatre was founded in 1965, is also headquartered in Reston, Virginia, and has approximately 177 accredited institutional members, including schools, colleges, departments and programs with universities, and conservatories. (nast.arts-accredit.org). The NAST Handbook has twenty standards that institutions must meet that cover everything from governance and facilities to curriculum and degree requirements. Initial membership is granted for five years when an institution is found to meet the standards, and then reaccreditation periods are for ten years.

The National Association of Schools of Dance is the youngest of The Council of Arts Accrediting Agencies as it was founded in 1981. It, too, is located in Reston, Virginia, and has approximately 80 accredited member institutions (nasd.arts-accredit.org). Membership is gained through peer review of how well a dance program or school meets NASD's twenty-one standards. The standards cover everything from governance and administration to admissions, to degree requirements and community education.

Other American specialty accreditors in arts and design cover landscape architecture, interior design, and architecture. The American Society of Landscape Architects' Landscape Architectural Accreditation Board (LAAB) is based in Washington, D.C. and its mission is "to evaluate, advocate for, and advance the quality of education in landscape architectural programs" (http://www.asla.org/accreditationlaab.aspx). LAAB has been recognized as an accreditor of bachelor's and master's programs in the United States and abroad since 2003 by the Council for Higher Education Accreditation, and the LAAB handbook outlines seven standards programs must meet, spelling out mission and objectives; administration and governance; curriculum; student and program outcomes; faculty qualifications; outreach; and facilities, equipment, and technology (*LAAB Accreditation Standards and Procedures*, 2013). LAAB's accreditation process is more granular than some as it specifies number of full-time faculty in a program, ratio of faculty to students, and expected professional curriculum. Accreditation with LAAB lasts for approximately six years before another review.

Located in Grand Rapids, Michigan, The Council for Interior Design Accreditation (CIDA) has been recognized by the Council for Higher Education Accreditation since 2013 as an accrediting body of interior design programs that award bachelor's and master's degrees programs located in the United States and abroad. The CIDA website, http://accredit-id.org/, says, "CIDA-accredited programs assure the public that interior design education prepares students to be responsible, well-informed, skilled professionals who make beautiful, safe, and comfortable spaces that also respect the earth and its resources" (2015, homepage). CIDA is currently undertaking a rewrite of their standards, with a new version being available in 2017, and soliciting feedback from the interior design community in an effort to strengthen their design standards. See http://accredit-id.org/standards-development/ for more information or to participate in their process. The current sixteen standards ask about the program's mission, goals, and curriculum; students' critical thinking, professional values, and processes; students' core design and technology knowledge; and the program's administration. Reviews are required to maintain accreditation every eight to ten years. (*Professional Standards 2014*, 2014).

Since 1940, The National Architectural Accrediting Board (NAAB), located in Washington, D.C., has been accrediting professional architecture education. Self-assessment and student performance (learning) have been emphasized since 1975 as central to the NAAB accreditation process, according to www.naab.org. While NAAB's website says it tries not to be prescriptive when it comes to

curriculum, their peer teams do review the program or school's self-study looking at its curriculum and its development and how it prepares students for entering professional practice, including evidence of student learning; policies; administration; physical, financial, and information resources; faculty credentials; and the information the program provides to the public. The accreditation cycle at NAAB is approximately six years.

The last few pages of accreditation agencies and processes overview shows one of the challenges of assessment and accreditation to institutions and programs: with multiple accreditation agencies and cycles, faculty can feel like they are caught in a continuous loop of activities done to appease the accreditors. Add to that some of the more prescriptive specialty accreditors and licensing agency requirements and faculty may feel like they no longer own the curriculum. Cowdroy and Williams (2006) wrote that taking specialty accreditor guidelines and converting them into student learning outcomes is often expressing "holistic attributes of a (hypothetical) practitioner" (p.107) and that those may not reflect the reality of life for a beginning professional in the design industry. Finding the balance between what graduates should know and be able to do as educated people, what they need to know and to be able to do for their future careers, and how to assess them to prove where they are competent is the battle/journey in which we are all engaged. And that is why some institutions have moved from a move everyone in a cohort along at the same pace style of education to one more individually based, in the method of competency-based education.

COMPETENCY-BASED EDUCATION

The U.S. Department of Education's website on competency-based learning or personalized learning (http://www.ed.gov/oii-news/competency-based-learning-or-personalized-learning) says that the structure of competency-based learning allows students to progress as they master academic content, not based on the time the students spend in class (or on seat-time), where the learning takes place, or at some uniform pace on course with other classmates.

Since 1893, most higher education in the United States has been based on the credit hour, roughly one hour of class time or "seat time" per week for a twelve to fifteen week term (Kamenetz, 2013). As the process of education has moved from being teaching-centered to more student and learning-centered, institutions have focused on creating processes to assess student work. Institutions, such as Western Governors University, founded by a consortium of 19 states in 1997, have structured entire degree programs around assessments of learning, as

opposed to credit hours or class time. Other universities around the world have also started competency-based programs.

Frederick M. Hurst, at Northern Arizona University's Personalized Learning Program says that competency-based learning transcripts do a better job at communicating to potential employers what skills students have mastered (Kamenetz, 2013). A transcript that shows three art history classes and two painting studio classes doesn't reflect the skills the student has mastered in writing, analysis and critical thinking, and understanding color, light, pigment, and composition.

But Chappell, Gonczi, and Hager (2000) point out there are different interpretations of the concept of competence, which they call positivist, humanist, and critical. "The positivist perception of competence focuses on the technical aspects of work and has a narrow view of competence in the workplace. The humanist orientation emphasises the social and cognitive aspects of work. The critical perspective suggests that competency based education and training operates within a social, political and economic environment characterised by an exploitative set of power relations which shape learning" (p. 191). Tradition and current arts and design curriculum takes in all three perspectives.

Two challenges inherent in competency-based education include that since the entire program has to be built around assessments, those assessments must be high-quality (and many of our programs are a bit embryonic with our assessment methods or morph and adjust our assessment methods almost yearly based on assessment of their effectiveness) and that since much of art and design curriculum is collaborative in nature it becomes difficult for students to work together and then for instructors and peers to evaluate students' competence levels when the students are working at paces that may not always be the same. A concern expressed by Deborah Bushway, vice president of academic innovation at Capella University, is that competence may be defined too narrowly as skill, instead of the higher order taxonomy that integrates knowledge, skills, and abilities (Kamenetz, 2013). Regardless of the concerns and challenges inherent to assessing competency-based education, learning in art and design, since the disciplines' inception with the master-apprentice model, has always evaluated how competent students are and required mastery of lower skills and ability before students have progressed to more advanced techniques.

FLIPPED CLASSROOMS

Another current trend in higher education is the flipped classroom. The phrase "flipped classroom" has become a buzzword, in part because of mass media, as

The New York Times (Fitzpatrick, 2012), *The Chronicle of Higher Education* (Berrett, 2012), and *Science* (Mazur, 2009), have all written articles about this style of teaching and learning. Bishop and Verleger (2013) call the flipped classroom "a new pedagogical method, which employs asynchronous video lectures and practice problems as homework, and active, group-based problem learning activities in the classroom" (p.1). The flipped classroom is not only about the structure of the work and where it takes place but it is a combining of learning theories (constructivism, for example), cognitive activities as ranked on Bloom's revised Taxonomy, and behavioral principles including the works of Piaget (1967) and Vygotsky (1978) (Lage, Platt, and Treglia, 2000; Bishop and Verleger, 2013; Brame, 2014).

Bloom's Revised Taxonomy is discussed in Chapter Three of this book; in terms of the flipped classroom, students do the lower level cognitive work (gaining knowledge and comprehensive) outside of the classroom and then focus on higher order cognitive skills (application, analysis, synthesis, evaluation, and in the case of art and design education, creation) within the classroom with the support of and in conjunction with their peers and instructor. As Kulkarni and Klemmer (2012) write at the end of their case study in Chapter Eleven of this volume, studios are a "natural fit for this model" (p.6).

Bishop and Verleger (2013, p. 7) created a Venn diagram of student-centered learning theories and methods that are often found in flipped classrooms:

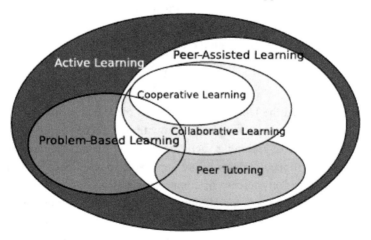

We've already discussed many of these teaching and learning styles in chapters two and three of this book. Peer-assisted, cooperative learning, collaborative learning, peer tutoring, and problem-based learning are all forms of active

learning, which Prince (2004) defines as "any instructional method that engages students in the learning process" (p. 223). Most atelier or studio educational environments are naturally constructed to foster active and interactive learning. Many papers have been written on assessment methods in flipped classrooms in K-12 and in a post-secondary education environment (Jeffries, Huggett, & Szarek, n.d.; Lorenzettti, 2013; Brame, 2014). Some of the most applicable to art and design flipped classrooms include the dry lab—giving students an in-class opportunity to design something that shows understanding of concepts learned in lecture or readings outside of class, writing a one-minute paper on group discussion or out of class learning, and having student generate the assignment for the group and then do it in-class based on the readings, outside of classroom lecture, gallery visit, etc.

ADVANCES IN ACCREDITATION OF ONLINE SCHOOLS AND PROGRAMS

We noted in Chapter four that professional practice in a number of creative disciplines has moved strongly into digital-based practice, and that arts accreditors such as CIDA (the Council for Interior Design Accreditation) and the NAAB (National Architectural Accrediting Board) are now accrediting qualified online programs. At the national level, the Distance Education Accreditation Commission (DEAC) already accredits a number of institutions that offer online programs in creative disciplines. As information technology, memory capacity, and graphics capabilities continue to advance, we can expect to see wider recognition of online programs within creative disciplines.

SUMMARY

This chapter explored the United States' process of voluntary national, regional, and specialty accreditation processes and how they have helped drive and shape assessment of student learning activities. Two trends, competency-based education and the flipped classroom, are applicable to and being used in art and design education, and in the case of competency-based education, has been part of the curriculum since art and design education's master-apprentice models. Competency-based education and the flipped classroom present their own assessment challenges and may force adaptation of current techniques or innovations in how we assess our students' learning. The next chapter puts all of the previous chapters content into an international context.

REFERENCES

Bishop, J.L. and Verleger, M.A. 2013. The Flipped Classroom: A Survey Of Research. Paper presented at 120th ASEE Annual Conference and Exposition. 23-26 June 2013.

Brame, C.J. 2014. Flipping the Classroom. Center for Teaching, Vanderbilt University.
http://cft.vanderbilt.edu/guides-sub-pages/flipping-the-classroom/

Chappell, C, Gonczi, A &; Hager, P. 2000. Competency-based education. *Understanding Adult Education and Training, 2nd edition.* Griff Foley. 191-205.

Competency Based Learning Or Personalized Learning. U.S. Department of Education. http://www.ed.gov/oii-news/competency-based-learning-or-personalized-learning

Council for Higher Education Accreditation 2015. Directory of CHEA-Recognized Organizations 2014-2015. Washington, D.C.: Author. http://www.chea.org/Directories/index.asp, accessed 1/19/2015.

Council of Arts Accrediting Associations. 2009. Tough Questions and Straight Answers About Arts Accreditation.
http://nasad.arts-accredit.org/site/docs/CAAA_PAPERS/CAAA-Tough_Questions-2009.pdf

Cowdroy, R. and Williams, A. 2006. Assessing Creativity In The Creative Arts. *Art, Design, & Communication in Higher Education.* 5(2): 97-117. Doi: 10.1386/adch.5.2.97/1.

Eaton, J. 2012. *An Overview of U.S. Accreditation.* Washington, D.C.: Council for Higher Education Accreditation.

Ikenberry, S. 2014. Foreword in Suskie, L. *Five Dimensions of Quality: A Common Sense Guide to Accreditation and Accountability.* San Francisco, CA: Jossey-Bass.

Jeffries, W.B., Huggett, K.N., and Szarek, J. (n.d.) Adapting Classroom Assessment And Other Techniques To A Flipped Classroom. The University of Vermont School of Medicine.
https://www.uvm.edu/medicine/mededucation/documents/FlippedClassroom.pdf

Kamenetz, A. 2013. Are You Competent? Prove It. *The New York Times*. 29 October 2014.

http://www.nytimes.com/2013/11/03/education/edlife/degrees-based-on-what-you-can-do-not-how-long-you-went.html?pagewanted=all&_r=1&.

Lage, M.J., Platt, G.J., and Treglia, M. (2000). Inverting The Classroom: A Gateway To Creating An Inclusive Learning Environment. *The Journal of Economic Education*, 31(1): 30-43.

Landscape Architectural Accreditation Board Accreditation Standards And Procedures.

2013.ahttp://www.asla.org/uploadedFiles/CMS/Education/Accreditation/STANDARDS%20PROCEDURErevised2013.pdf

Lorenzetti, J.P. 2013. How to Create Assessment for the Flipped Classroom. *Faculty Focus*. 4 October 2013.

http://www.facultyfocus.com/articles/instructional-design/how-to-create-assessments-for-the-flipped-classroom/

Lulkarni, C. and Klemmer, S. 2012. Learning Design Wisdom By Augmenting Physical Studio Critique With Online Self-Assessment. *Technical Report*. Stanford University. 2 Jul 2012.

Mencken, H.L. 1956. *Minority Reports, H.L. Mencken's Notebooks*. New York: Knopf.

NASAD Handbook 2014-2015. 2014.

http://nasad.arts-accredit.org/site/docs/Handbook/NASAD_HANDBOOK_2014-15.pdf.

NASD Handbook 2014-2015. 2014. http://nasd.arts-accredit.org/site/docs/NASD%20HANDBOOK%20AND%20ADDENDA/NASD_HANDBOOK_2014-15.pdf

NASM Handbook 2014- 2015. 2014.

http://nasm.arts-accredit.org/site/docs/Handbook/NASM_HANDBOOK_2014-15.pdf

NAST Handbook 2014-2015. 2014.

http://nast.arts-accredit.org/site/docs/HANDBOOK/NAST_Handbook_2014-15.pdf

New England Association of Schools and Colleges. (n.d.) *Becoming Accredited:A Guide to Eligibility, Candidacy, and Initial Accreditation for Free-Standing Institutions Abroad*.

https://cihe.neasc.org/sites/cihe.neasc.org/files/downloads/PUBLICATI
ONS/Inst_Abroad_Becoming_Accredited_Guide_2013.pdf

Newton, I. 1846. *Principia Mathematica Philosophiae Naturalis.*Translated by A.
Notte. New York: Daniel Adee.

Piaget, J., Elkind, D., and Tenzer, A. 1967. *Six Psychological Studies* New York:
Random House.

Prince, M. 2004. Does Active Learning Work? A Review Of The Research.
Journal of Engineering Education—Washington, 93: 223-232.

Professional Standards 2014. 2014. Council of Interior Design. http://accredit-
id.org/wp-content/uploads/2010/03/Professional-Standards-2014.pdf

Suskie, L. 2014. *Five Dimensions of Quality: A Common Sense Guide to
Accreditation and Accountability.* San Francisco, CA: Jossey-Bass.

Tamburri, R. 2013. More Canadian Universities Seek American Accreditation.
University Affairs/Affaires Universitaires.
http://www.universityaffairs.ca/news/news-
article/more-canadian-universities-seek-us-accreditation/

Vygotsky, L.S. 1978. *Mind and Society: The development of higher mental
processes.* Cambridge, MA: Harvard University Press.

CHAPTER 15

Quality Assurance in Creative Disciplines in the International Context

Man's struggle to be rational about himself, about his relationship to his own society and to other peoples and nations involves a constant search for understanding among all peoples and all cultures—a search that can only be effective when learning is pursued on a worldwide basis.

--J. William Fulbright (Johnson and Culligan, 1965, Forward)

In section one of this book we explained why this book was written; discussed a variety of approaches to quality assurance; explored the links between quality assurance and teaching and learning; delved into taxonomies of learning including affective, cognitive, psychomotor, intrapersonal, interpersonal, and conative domains; and articulated promising practices in the area of online creative disciplines learning and assessment.

Section two of this book presented case studies broken into eight broad disciplinary categories (performing arts; fine art; art and music history and education and art therapy; film, video, and recording arts; architecture and interior design; industrial/product design; fashion design, illustration, accessory design, textile and fiber, jewelry, costume design; digital and graphic design).

Section three of this book began with the previous chapter, which covered accreditation in the United States and how it has been a driving force behind the assessment of student learning and quality assurance (QA) movements. The chapter also touched on two topics relevant to the changing landscape of higher education: competency-based learning and the flipped classroom. This chapter wraps up the topic of quality assurance in creative disciplines by moving the discussion into an international context, where the growth in quality assurance activities has been most pronounced and where national qualifications frameworks and guidelines take center stage.

To begin, several definitions are in order. Quality Assurance itself is a multi-faceted construct, encompassing at minimum the development of relevant competency frameworks that describe the desirable outcomes of student learning by the end of a program of study; the internal quality assurance system

comprising those structures, practices and procedures within institutions that serve to maintain quality and rigor and the external quality assurance system; and the system set up to define principles, approaches and standards for quality assurance, usually under the auspices of governmental quasi-governmental, or accreditation agencies (AEC, 2015). Several models for QA can also be discerned. Kinser (2014) articulates differentiates three models, according to the basic purpose: the summative judgment of institutional quality through accreditation models; the quality improvement perspective of an assessment model; and the relative standing of institutions on predetermined criteria as featured in rankings models. Yet in practice, varied combinations of summative and formative elements coexist in external QA reviews given the multiple purposes typically inherent in an external review.

Kinser (2014) traces the adoption of accreditation standards in the United States back to its roots over a century ago, but notes that QA systems have grown significantly since the 1980s around the world, reflecting the increasing diversity of higher education institution, the emergence of the private sector as a global phenomenon, greatly increased student demand, and importantly the growing internationalization of higher education. Reasons for the global growth of QA systems in higher education are not hard to fathom. The bottom line are that educators want their students to reach a specific level of competency and knowledge; employers want workers who possess knowledge, can work in teams and groups, who can communicate, and who can deliver results. Students want the chance to prove themselves to the world and to obtain employment. Those and legislative bodies' wishes to meet broad public policy goals through the provision of higher education opportunities (Kinser, 2014) are the impetus behind the construction of these frameworks.

Beginning with the work of the International Network for Quality Assurance Agencies in Higher Education, this chapter encompasses Quality Assurance (QA) frameworks such as the United Kingdom's Quality Assurance Agency, the Bologna Process and its disciplinary corollary the Tuning Project, the Australian Quality Framework, and the Lumina Foundation's Degree Qualifications Profile, in addition to other countries' quality frameworks have sought to collectively define and shape what a degree conferred upon a student means the graduate knows and can do.

The International Network for Quality Assurance Agencies in Higher Education (INQAAHE) was established in 1991. Similar to the umbrella function for accreditation and quality assurance played by the Council for Higher

Education Accreditation (CHEA) in the United States, INQAAHE is the global network of over 200 quality assurance agencies in higher education. It exists to:

- Enable quality assurance agencies to share information and experiences;
- Lead the theoretical and practical foundations of the profession;
- Develop and promote standards of professional practice in QA; and
- Encourage and assist continuous improvement in member agencies, including professional development and capacity-building for the benefit of HE institutions, their students and their societies (INQAAHE, 2015).

The organization has developed and promulgated best practices for external quality assurance in higher education on an international scale. As reflected in the *INQAAHE Strategic Plan 2013-2017*, the organization's goals are "to maintain and enhance INQAAHE's role as world leader in quality assurance and umbrella organization for quality assurance agencies; to develop a global quality assurance community; to advance the body of knowledge in, and ensure continued effectiveness of, quality assurance; and to advocate and promote the concept of quality assurance as the driving force for continuous improvement of tertiary education" (2013, p.5).

UNITED KINGDOM QUALITY CODE FOR HIGHER EDUCATION

Developed by the Quality Assurance Agency for Higher Education in conjunction with the United Kingdom higher education sector, the United Kingdom Quality Code provides a shared starting point and language "for setting, describing, and assuring the academic standards of their higher education awards and programmes and the quality of the learning opportunities they provide." (QAA, 2014, Quality Code landing page). The Code is broken into three sections—parts A, B, and C—that cover threshold academic standards (with qualifications frameworks and benchmark information, nineteen expectations, and indicators of sound practice), academic quality, and academic provision.

Briefly described, the academic standards, Part A, are those set by individual education institutions and may be beyond the threshold standards set in the Quality Code and by the two parallel national frameworks, the Framework for Higher Education Qualifications in England, Wales, and Northern Ireland (FHEQ) (QAA, 2008), and the Framework for Qualifications of Higher Education Institutions in Scotland (FQHEIS) (QAA, 2001). Academic quality, Part B, refers to how and how well an institution supports students in their quests to achieve their degrees or awards. Academic provision, Part C, addresses how institutions

produce accessible, trustworthy, and purposeful information. QAA reviewers and external reviewers use this guide and its standards when they review institutions throughout the United Kingdom.

Part A, Setting and Maintaining Academic Standards, is divided into six chapters: the national level, the subject and qualification level, the program level, approval and review, externality, and assessment of achievement of student learning outcomes (QAA, 2014). Specific student learning outcomes are found in benchmark documents, written by the QAA for many bachelor's and master's degree disciplines. For example, for bachelor's degrees with honors in Art and Design, the QAA has released a benchmark document that lists the competencies holders of this degree will have demonstrated:

- Self-management - students will have the ability to:
 - ➤ study independently, set goals, manage their own workloads and meet deadlines
 - ➤ anticipate and accommodate change, and work within contexts of ambiguity, uncertainty and unfamiliarity.
- Critical engagement - students will have the ability to:
 - ➤ analyse information and experiences, formulate independent judgements, and articulate reasoned arguments through reflection, review and evaluation
 - ➤ source and research relevant material, assimilating and articulating relevant findings
 - ➤ formulate reasoned responses to the critical judgements of others
 - ➤ identify personal strengths and needs, and reflect on personal development.
- Group/team working and social skills - students will have the ability to interact effectively with others, for example through collaboration, collective endeavor and negotiation.
- Skills in communication and presentation - students be able to:
 - ➤ articulate ideas and information comprehensibly in visual, oral and written forms
 - ➤ present ideas and work to audiences in a range of situations
 - ➤ use the views of others in the development or enhancement of their work.
- Information skills - students will have the ability to:

> ➤ source, navigate, select, retrieve, evaluate, manipulate and manage information from a variety of sources
> ➤ select and employ communication and information technologies.
- Personal qualities - students will have an enthusiasm for enquiry into their discipline and the motivation to sustain it. (QAA, 2008a, p. 8)

The arts and design benchmarking document also discusses teaching, learning and assessment methodologies (p. 10) recommending self, peer, and tutor or instructor assessment in studios; formalized individualized negotiated learning agreements; formative, summative, and diagnostic assessments on individual and team work; and written and oral feedback on assessed work, all of which are areas discussed in section one of this book with examples of each within the case study chapters in section two.

The QAA frameworks and the Quality Code align with the European Frameworks, often called The Bologna Process or the European Higher Education Area (EHEA), as the United Kingdom is a member country of the Bologna Process. So let's explore that framework next.

BOLOGNA PROCESS AND EUROPEAN HIGHER EDUCATION AREA (EHEA)

Over the last fifty years, the European Commission has increased its involvement in higher education, first under the banner of vocational training and the recognition of professional qualifications, eventually expanding its interest to include all university-level study (Corbett, 2005; Keeling, 2006). In 1999, Ministers of Education from 29 European countries signed a document called the Bologna Declaration. The main crux of the document was an agreement to:

1. adopt a system with two main cycles (undergraduate/graduate) and establish a system of credits (to make degrees easily readable, understood, and comparable)
2. promote mobility by overcoming legal recognition and administrative obstacles
3. promote European co-operation in quality assurance
4. promote a European dimension in higher education (European University Association, 2014).

In the fifteen years since the original document was signed, additional countries have joined the Process, making the total 47 countries at the time of press,

according to the EHEA website, www.ehea.info, and more action lines have been added, including the inclusion of lifelong learning strategies, the involvement of higher education institutions and students as essential partners, the promotion of the attractiveness of the European Higher Education Area, and language regarding doctoral studies and the promotion of young researchers. Also, deadlines were set for adopting a system with two main cycles and for providing regular quality assurance updates. In 2010 the EHEA was officially launched to improve transparency between higher education systems, as well as implement tools to facilitate recognition of degrees and academic qualifications, mobility, and exchanges between institutions (European University Association, 2014).

The qualifications framework for the European Higher Education Area includes generic learning outcomes for bachelors, masters and doctoral degrees, which the EHEA refers to as three cycles, and this framework has provided the basis for each member country creating and adopting their own frameworks. The table of the EHEA framework follows:

Table 15.1 EHEA Quality Framework

	Outcomes	ECTS Credits
First cycle qualification	Qualifications that signify completion of **the first cycle** are awarded to students who: • have demonstrated knowledge and understanding in a field of study that builds upon their general secondary education, and is typically at a level that, whilst supported by advanced textbooks, includes some aspects that will be informed by knowledge of the forefront of their field of study; • can apply their knowledge and understanding in a manner that indicates a professional approach to their work or vocation, and have competences typically demonstrated through devising and sustaining arguments and solving problems within their field of study; • have the ability to gather and interpret relevant data (usually within their field of study) to inform judgments that include reflection on relevant social, scientific or ethical issues; • can communicate information, ideas, problems and solutions to both specialist and non-specialist audiences; • have developed those learning skills that are necessary for them to continue to undertake further study with a high degree of autonomy.	Typically include 180-240 ECTS credits

Second cycle qualification	Qualifications that signify completion of **the second cycle** are awarded to students who: • have demonstrated knowledge and understanding that is founded upon and extends and/or enhances that typically associated with the first cycle, and that provides a basis or opportunity for originality in developing and/or applying ideas, often within a research context; • can apply their knowledge and understanding, and problem solving abilities in new or unfamiliar environments within broader (or multidisciplinary) contexts related to their field of study; • have the ability to integrate knowledge and handle complexity, and formulate judgments with incomplete or limited information, but that include reflecting on social and ethical responsibilities linked to the application of their knowledge and judgments; • can communicate their conclusions, and the knowledge and rationale underpinning these, to specialist and non-specialist audiences clearly and unambiguously; • have the learning skills to allow them to continue to study in a manner that may be largely self-directed or autonomous.	Typically include 90-120 ECTS credits, with a minimum of 60 credits at the level of the 2nd cycle
Third cycle qualification	Qualifications that signify completion of **the third cycle** are awarded to students who: • have demonstrated a systematic understanding of a field of study and mastery of the skills and methods of research associated with that field; • have demonstrated the ability to conceive, design, implement and adapt a substantial process of research with scholarly integrity; • have made a contribution through original research that extends the frontier of knowledge by developing a substantial body of work, some of which merits national or international refereed publication; • are capable of critical analysis, evaluation and synthesis of new and complex ideas; • can communicate with their peers, the larger scholarly community and with society in general about their areas of expertise; • can be expected to be able to promote, within academic and professional contexts, technological, social or cultural advancement in a knowledge based society.	Not specified

Source: European Higher Education Area, 2005

One can easily discern how each cycle builds upon the lower one, much in the manner of Bloom's revised taxonomy (Anderson and Krathwohl, 2001), and how this framework could support "the reforms of degree structures, credit transfer, quality assurance and curricular development" (Keeling, 2006, p. 203). The EHEA framework clearly describes and differentiates generic learning outcomes

and competencies, however much more sector-specific description is needed for programs of study within creative disciplines, an area to which we turn next.

TUNING PROJECT

Two recent and highly relevant developments for assessment and quality assurance in creative disciplines within the European Community (EC) include the emergence of sectoral qualifications frameworks for creative and performing disciplines through the Tuning Project, and the appearance of arts sector-specific quality assurance groups.

The Tuning Project is predicated on the collaboration of universities from across the EC in achieving an understanding of similarities among learning outcomes and competencies, the results of education. It is not intended a means of forcing any national arts traditions or curricula into regimentation or common uniformity. As noted in *Towards a European SQF for the Creative and Performing Disciplines and the Humanities* (Tuning Project, 2012), "The name *Tuning* was chosen for the project to reflect the idea that universities do not look for uniformity in their degree programmes or any sort of unified, prescriptive or definitive European curricula but simply for points of reference, convergence and common understanding" (2012, p.1).

From the outset, the differences that set creative disciplines apart from other fields of study were recognized and specifically included in the framework. Not only does this lend tremendous face validity to the framework, it also acknowledges the arts as a unique form of expression, communication, and research.

> The ideas, methods and priorities of the Creative and Performing Disciplines constitute a distinct network of knowledge, using its own language and procedures, which functions in order to describe, understand and engage in different forms of experience. This network of knowledge also develops distinct notions of artistic and other forms of research, in particular those where visual experience, creating, performing and making form part of the research process itself (Tuning Project, 2012, p.8).

Over a number of years and multiple meetings, the group of experts from various arts fields working on the project came to consensus on a set of common elements within the European Quality Framework categories of knowledge, skills and competence that span the arts disciplines:

- Making, Performing, Designing, Conceptualising Creation (Skills/knowledge);
- Re-thinking, Considering and interpreting the Human (competences);
- Experimenting, innovating & Researching (skills/knowledge);
- Theories, Histories and Cultures (knowledge);
- Technical, environmental and Contextual issues (skills/knowledge);
- Communication, Collaboration & Interdisciplinarity (skills/competence);
- Initiative & Enterprise (skills/competence). (Tuning Project, 2012, p.6).

These elements are defined at multiple levels of expertise within the framework, using descriptors appropriate to each cycle/degree level. Within each arts discipline, further work has taken place over the past several years to describe aspects of specialized knowledge, skills and competencies that should be expected of a program graduate at each of three cycles/degree levels. For example, the *Tuning Document Fine Art Education* produced by Paradox, the European Fine Art Forum, describes a set of learning outcomes and competencies appropriate to 2^{nd} Cycle graduates (analogous to a Master's degree) in Fine Art as follows:

Table 15.2: Tuning Project 2^{nd} Cycle Fine Arts Learning Outcomes and Competencies

An ability to:
• Further develop and evaluate working processes appropriate to individual creative practices;
• Acquire independent research skills and utilise them effectively;
• Display evidence of professional competencies required for individual creative practice;
• Evolve further strategies and utilise expertise, imagination and creativity in appropriate media;
• Develop own criteria for evaluating and directing work: question and contextualize individual practice and that of others;
• Articulate an informed position in the fields of art and culture;
• Create, sustain, manage, administer and present an art practice professionally;
• Articulate intentions, values and meanings of works produced to relevant audiences as well as non specialised audiences;
• Consider and evaluate available relevant pathways to progress. (Paradox, n.d., p. 9)

The advancement of relevant frameworks for quality assurance in creative disciplines that acknowledge and respect the differences distinct from other fields

of study is a welcome step forward. An understanding of how to develop an internal quality assurance system and how to conduct an external quality review in the context of creative disciplines are also needed to enable a contextually-appropriate review of the effectiveness of individual schools and arts institutions.

ARTS SECTOR-SPECIFIC QUALITY ASSURANCE

The European League of Institutes of the Arts (ELIA) is the primary independent network organization for higher arts education within the European Community, comprised of over 300 members in 47 countries and representing over 300,000 students (Dean, n.d.). Arising out of ELIA and emerging from it in 2014 as an independent group of Quality Assurance reviewers, EQ-Arts has developed and tested a Quality Assurance methodology through their experience conducting institutional and discipline-specific reviews across nine European countries. (Dean, n.d.). The group is an affiliate member of ESEA. A notable example of sector-specific higher education QA developments exists in Music, where a qualifications framework for music in higher education been developed by the Polifonia Group under the auspices of the Association Européenne des Conservatoires, Académies de Musique et Musikhochschulen (AEC). Guidelines for internal quality assurance in higher education music schools have been developed (Boele, 2007), and the AEC project, Accreditation in European Professional Music Training, has focused on the development of a sector-specific approach to external quality assurance and accreditation in Music.

From these and other developments, it is abundantly evident that the creative disciplines sector within the EC has been highly active in quality assurance, seeking to define its elements in common, to preserve and articulate the uniqueness of each arts discipline, and to ensure that the arts are not disregarded in national conversations on higher education, but rather are recognized for what they contribute to vitality, humanity and culture.

AUSTRALIAN QUALITY FRAMEWORK (AQF)

Similar to the EHEA framework, but introduced many years before the European model, is the Australian Quality Framework. First introduced in 1995 to underpin the Australia national system of qualifications for schools, training, vocational education, and higher education, the Australian Quality Framework has morphed over time mostly recently being revised in 2011 under the tutelage of the AQF Council who reconfirmed its importance to Australia's educational system. The objectives of the AQF are to provide a contemporary and flexible framework that:

- accommodates the diversity of purposes of Australian education and training now and into the future
- contributes to national economic performance by supporting contemporary, relevant and nationally consistent qualification outcomes which build confidence in qualifications
- supports the development and maintenance of pathways which provide access to qualifications and assist people to move easily and readily between different education and training sectors and between those sectors and the labour market
- supports individuals' lifelong learning goals by providing the basis for individuals to progress through education and training and gain recognition for their prior learning and experiences
- underpins national regulatory and quality assurance arrangements for education and training
- supports and enhances the national and international mobility of graduates and workers through increased recognition of the value and comparability of Australian qualifications
- enables the alignment of the AQF with international qualifications frameworks (Australian Qualifications Framework Council, 2013, p. 8-9).

The comprehensive, in-depth framework reaches these objectives by providing numerous standards for qualifications, including: "the learning outcomes for each AQF level and qualification type; the specifications for the application of the AQF in the accreditation and development of qualifications; the policy requirements for issuing AQF qualifications; the policy requirements for qualification linkages and student pathways; the policy requirements for the registers of organisations authorised to accredit AQF qualifications, organisations authorised to issue AQF qualifications, AQF qualifications and qualification pathways; the policy requirements for the addition or removal of qualification types in the AQF; and the definitions of the terminology used in the policy" (p. 9).

The framework's basic structure is one of fourteen AQF qualifications across all types of education, expressed as learning outcomes that are defined in depth and complexity by ten taxonomic levels in what knowledge or skills a graduate possesses. The summary wheel looks like this:

Figure 15.1: Australia Qualifications Framework

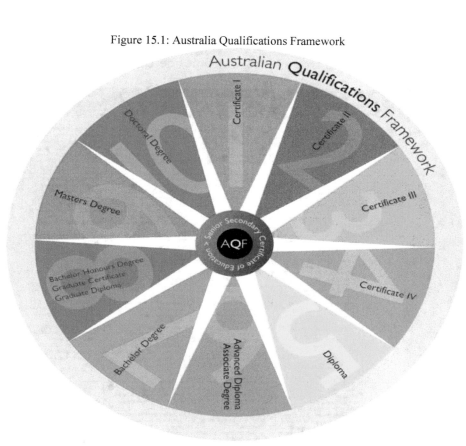

Source: Australian Qualifications Framework, 2013, p. 19.

The AQF specifies that accrediting authorities (in this case state and territory governments, the Australian Skills Quality Authority, the National Skills Standards Council, the Tertiary Education Quality and Standards Agency, and self-accrediting universities and higher education providers) will ensure that graduates of each institution reach the required level (7 for bachelor's degree, 9 for master's degree, and 10 for a doctorate) with the onus of the assessment on the degree-awarding institution. The table given as an example below spells out the learning objectives for Bachelor's, Bachelor's Honors, Graduate Certificate, and Graduate Diploma.

Table 15.3: AQF Qualification Type Learning Outcomes Descriptors (Example)

AQF qualification type learning outcomes descriptors

Qualification type	Bachelor Degree	Bachelor Honours Degree	Graduate Certificate	Graduate Diploma
Level	Level 7	Level 8	Level 8	Level 8
Purpose	The Bachelor Degree qualifies individuals who apply a broad and coherent body of knowledge in a range of contexts to undertake professional work and as a pathway for further learning	The Bachelor Honours Degree qualifies individuals who apply a body of knowledge in a specific context to undertake professional work and as a pathway for research and further learning	The Graduate Certificate qualifies individuals who apply a body of knowledge in a range of contexts to undertake professional/highly skilled work and as a pathway for further learning	The Graduate Diploma qualifies individuals who apply a body of knowledge in a range of contexts to undertake professional/highly skilled work and as a pathway for further learning
Knowledge	Graduates of a Bachelor Degree will have a broad and coherent body of knowledge, with depth in the underlying principles and concepts in one or more disciplines as a basis for independent lifelong learning	Graduates of a Bachelor Honours Degree will have coherent and advanced knowledge of the underlying principles and concepts in one or more disciplines and knowledge of research principles and methods	Graduates of a Graduate Certificate will have specialised knowledge within a systematic and coherent body of knowledge that may include the acquisition and application of knowledge and skills in a new or existing discipline or professional area	Graduates of a Graduate Diploma will have advanced knowledge within a systematic and coherent body of knowledge that may include the acquisition and application of knowledge and skills in a new or existing discipline or professional area
Skills	Graduates of a Bachelor Degree will have: • cognitive skills to review critically, analyse, consolidate and synthesise knowledge • cognitive and technical skills to demonstrate a broad understanding of knowledge with depth in some areas • cognitive and creative skills to exercise critical thinking and judgement in identifying and solving problems with intellectual independence • communication skills to present a clear, coherent and independent exposition of knowledge and ideas	Graduates of a Bachelor Honours Degree will have: • cognitive skills to review, analyse, consolidate and synthesise knowledge to identify and provide solutions to complex problems with intellectual independence • cognitive and technical skills to demonstrate a broad understanding of a body of knowledge and theoretical concepts with advanced understanding in some areas • cognitive skills to exercise critical thinking and judgement in developing new understanding • technical skills to design and use research in a project • communication skills to present a clear and coherent exposition of knowledge and ideas to a variety of audiences	Graduates of a Graduate Certificate will have: • cognitive skills to review, analyse, consolidate and synthesise knowledge and provide solutions to complex problems • cognitive skills to think critically and to generate and evaluate complex ideas • specialised technical and creative skills in a field of highly skilled and/or professional practice • communication skills to demonstrate an understanding of theoretical concepts • communication skills to transfer complex knowledge and ideas to a variety of audiences	Graduates of a Graduate Diploma will have: • cognitive skills to review, analyse, consolidate and synthesise knowledge and identify and provide solutions to complex problems • cognitive skills to think critically and to generate and evaluate complex ideas • specialised technical and creative skills in a field of highly skilled and/or professional practice • communication skills to demonstrate an understanding of theoretical concepts • communication skills to transfer complex knowledge and ideas to a variety of audiences
Application of knowledge and skills	Graduates of a Bachelor Degree will demonstrate the application of knowledge and skills: • with initiative and judgement in planning, problem solving and decision making in professional practice and/or scholarship • to adapt knowledge and skills in diverse contexts • with responsibility and accountability for own learning and professional practice and in collaboration with others within broad parameters	Graduates of a Bachelor Honours Degree will demonstrate the application of knowledge and skills: • with initiative and judgement in professional practice and/or scholarship • to adapt knowledge and skills in diverse contexts • with responsibility and accountability for own learning and practice and in collaboration with others within broad parameters • to plan and execute project work and/or a piece of research and scholarship with some independence	Graduates of a Graduate Certificate will demonstrate the application of knowledge and skills: • to make high level, independent judgements in a range of technical or management functions in varied specialised contexts • to initiate, plan, implement and evaluate broad functions within varied specialised technical and/or creative contexts • with responsibility and accountability for personal outputs and all aspects of the work or function of others within broad parameters	Graduates of a Graduate Diploma will demonstrate the application of knowledge and skills: • to make high level, independent judgements in a range of technical or management functions in varied specialised contexts • to initiate, plan, implement and evaluate broad functions within varied specialised technical and/or creative contexts • with responsibility and accountability for personal outputs and all aspects of the work or function of others within broad parameters
Volume of learning	The volume of learning of a Bachelor Degree is typically 3 – 4 years	The volume of learning of a Bachelor Honours Degree is typically 1 year following a Bachelor Degree. A Bachelor Honours Degree may also be embedded in a Bachelor Degree, typically as an additional year	The volume of learning of a Graduate Certificate is typically 0.5 – 1 year	The volume of learning of a Graduate Diploma is typically 1 – 2 years

Source: Australian Qualifications Framework, 2013, p. 16.

The AQF publication (2nd Edition, 2013) concludes with some bullet points on the benefits of having a national framework, such as the facilitation of transparency and reliability about qualifications, a knowledge and understanding of various quality assurance systems, assisting in the international mobility of students and

skilled workers, and improving employers' understanding of qualifications. This summary is the basis of the push for more quality assurance systems within the academy in almost every country. Similar frameworks exist in Canada http://www.ehea.info/Uploads/QF/Canadian-QA-Statement-2007.en.pdf, New Zealand http://www.nzqa.govt.nz/studying-in-new-zealand/understand-nz-quals/nzqf/ (which in 1992 created one of the first higher education quality frameworks in the world), South Africa http://www.che.ac.za/focus_areas/higher_education_qualification_sub_framewor k/overview, and Malaysia http://www.mqa.gov.my/mqr/english/ePengenalanMQF.cfm.

THE DEGREE QUALIFICATIONS PROFILE (DQP)

In the United States, the push for a national framework is not being led by a government agency but by the Lumina Foundation. The Degree Qualifications Profile (DQP), a "learning-centered framework for what college graduates should know and be able to do to earn the associate, bachelor's, or master's degree" was originally published in 2011 by the Lumina Foundation and underwent revisions with the DQP 2.0 model being released in 2014 (DQP cover title subheading, 2014).

Jamie P. Merisotis, president and CEO of the Lumina Foundation, writes that the DQP was created in response to the United States' need for talent in the workforce, to institutions needing to be clearer about what learning outcomes and values they add to their students' lives, that credentials needing to be clear and transparent, and that students need "a clear path to success" (2014, p. 2).

The DQP divides learning into five broad categories:

1. specialized knowledge, or what students should demonstrate, beyond vocabulary, theories, and skills, in any specialization;
2. broad, integrative knowledge, or how students construct bridges between subject matter and areas of learning;
3. intellectual skills, includes cognitive skills such as information literacy, analysis, reasoning, quantitative fluency, communications, understanding and reasoning in diverse perspectives;
4. applied and collaborative learning, or what students can do with what they know;
5. civic and global learning, or using their knowledge and skills to engage with the world on a variety of platforms and levels.

More than four hundred institutions (Schneider, Gaston, Adelman, and Ewell, 2014, p. 7) across the United States have been using the DQP to design or redesign curriculum and/or learning outcomes; as a guidepost to help align department or program learning objectives with institutional learning objectives; as a framework for a shared vocabulary both within a single institution and across institutions; especially those with transfer agreements; as a resource for strengthening accreditation self-studies; and as a guide to explain structure and coherence of the curriculum to students (Schneider, Gaston, Adelman, & Ewell, 2014). The example below is from intellectual skills, one of the five broad areas of learning within the DQP.

Figure 15.2 Learning Outcomes in the DQP: Intellectual Skills

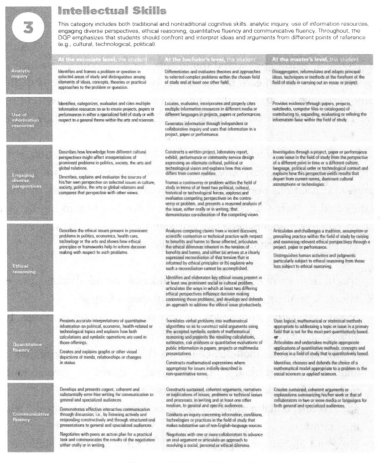

Source: DQP, 2014, p. 30

While none of the national frameworks or the Degree Qualifications Profile gets into the granularity of discipline requirements and competencies as do the accrediting bodies as we saw in Chapter 14, or as are represented in the sectoral QA frameworks developed within the European Community discussed above in this chapter, there are a number of common elements, such as expectations for competence in cognitive abilities, creativity, synthesis, communications, working in teams, and proficiency within the graduates' discipline.

SUMMARY

Quality and setting up policies and frameworks to assure quality in higher education is a borderless topic, and has been tackled in the United Kingdom, throughout the European Union, in Australia, Canada, New Zealand, South Africa, Malaysia, and the United States. Institutions themselves and the faculty and administration within them are tasked with assessing student work as an educational tool for the students themselves and as a tool for program, school, institutional, and worldwide educational betterment. All of the quality frameworks show how connected higher education is around the world, how it has the same goals, and how its aim is to provide a skilled, educated workforce and population that contributes to the betterment of society. To paraphrase the Fulbright quote at the beginning of this chapter, we all are more effective when we learn from each other.

REFERENCES

Anderson, L. W. (Ed.), Krathwohl, D. R. (Ed.), Airasian, P. W., Cruikshank, K. A., Mayer, R. E., Pintrich, P. R., Wittrock, M. C., Pintrich, P. R. 2001. A Taxonomy for Learning, Teaching, and Assessing: A Revision of Bloom's Taxonomy of Educational Objectives. New York: Addison Wesley Longmann.

Association Européenne des Conservatoires, Académies de Musique et Musikhochschulen (AEC), 2015. Retrieved 1/24/2015 from http://www.aec-music.eu/about-aec/work--policies/quality-assurance.

Australia Qualifications Framework Council. 2013. *Australian Qualifications Framework*. Second Edition. http://www.aqf.edu.au/wp-content/uploads/2013/05/AQF-2nd-Edition-January-2013.pdf

Boele, E. 2007. *Handbook: Internal Quality Assurance in Higher Music Education.* Brussels, Belgium: Association Européenne des Conservatoires, Académies de Musique et Musikhochschulen

Corbett, A. 2005. Universities and the Europe of Knowledge: Ideas, Institutions and Policy Entrepreneurship in European Union Higher Education, 1955–2005 London: Palgrave Macmillian.

Dean, A. n.d. Sector-specific Quality Assurance (HE Arts). Amsterdam, The Netherlands: EQ-Arts. http://www.elia-artschools.org/activities/eq-arts?domain=eq-arts.org.

European University Association. 2014. What is the Bologna Process? http://www.eua.be/eua-work-and-policy-area/building-the-european-higher-education-area/bologna-basics.aspx.

European Higher Education Area. 2005. http://www.ehea.info/Uploads/qualification/QF-EHEA-May2005.pdf

INQAAHE Strategic Plan 2013-2017. http://www.inqaahe.org/main/about-inqaahe/strategic-plan. Barcelona, Spain: Author.

International Network for Quality Assurance Agencies in Higher Education. 2015. http://www.inqaahe.org/.

Johnson, W. and Culligan, F.J. 1956. *The Fulbright Program: A History.* Chicago, IL: The University of Chicago Press.

Keeling, R. 2006. The Bologna Process and the Lisbon Research Agenda: the European Commission's expanding role in higher education discourse. *European Journal of Education.* 41(2), p. 203-223.

Kinser, K. 2014. Questioning Quality Assurance. In Portnoy, L and Bagley, S. (Eds.), Critical Perspectives on Global Competition in Higher Education. *New Directions for Higher Education*, No. 168, Winter, 2014. San Francisco: Jossey-Bass/Wiley.

Merisotis, J.P. 2014. It's time to define quality—for students' sake. Degree Qualifications Profile. Foreward. http://www.luminafoundation.org/files/resources/dqp.pdf.

Paradox, the European Fine Art Forum. n.d. *Tuning Document Fine Art Education.* Retrieved from http://www.elia-artschools.org/activities/eq-arts?domain=eq-arts.org.

QAA. 2008. The framework for higher education qualifications in England, Wales, and Northern Ireland.

www.qaa.ac.uk/Publications/InformationAndGuidance/Pages/The-framework-for higher-education-qualifications-in-England-Wales-and-Northern-Ireland.aspx.

QAA. 2001. The framework for qualifications of higher education institutions in Scotland.
www.qaa.ac.uk/Publications/InformationAndGuidance/Pages/FHEQ-Scotland.aspx

QAA. 2008a. Subject benchmark statement: art and design.
http://www.qaa.ac.uk/en/Publications/Documents/Subject-benchmark-statement---Art-and-design- .pdf

QAA. 2014. The UK Quality Code for Higher Education.
http://www.qaa.ac.uk/assuring-standards-and-quality/the-quality-code.

Schneider, C.G., Gaston, P., Adelman, C. & Ewell, P. 2014. The Degree Qualifications Profile 2.0
http://www.luminafoundation.org/files/resources/dqp.pdf .

Schneider, C.G., Gaston, P., Adelman, C. & Ewell, P. 2014. The Degree Qualifications Profile 2.0. Defining U.S. Degrees Through Demonstration and Documentation of College Learning. *Liberal Education* 100(2).

Tuning Project. 2012. *Towards a European SQF for the Creative and Performing Disciplines and the Humanities.* Bilbao, Spain: Universidad de Deusto

INDEX

A

Adelman, C., 313
affective, 5, 28, 33, 36, 42, 44, 47,
 72, 97, 296
Alexander, 26, 28
Alice in Wonderland, 64
alumni, 55, 65, 83, 160, 165, 168,
 174
American Association of Higher
 Education (AAHE), 55
assessment, ix, x, xi, 1, 2, 3, 4, 5, 6,
 7, 9, 10, 11, 12, 13, 15, 16, 17,
 18, 19, 20, 21, 22, 23, 24, 25, 26,
 27, 28, 29, 33, 34, 35, 36, 39, 43,
 44, 45, 46, 47, 49, 52, 54, 55, 56,
 57, 58, 59, 60, 61, 62, 63, 64, 65,
 66, 67, 68, 69, 70, 72, 73, 74, 76,
 78, 80, 81,82, 83, 95, 96, 97, 98,
 99, 100, 101, 102, 107, 108, 109,
 110, 111, 112, 127, 128, 130,
 137, 145, 146, 147, 148, 149,
 150, 152, 153, 154, 156, 157,
 158, 159, 161, 163, 167, 168,
 169, 171, 175, 176, 178, 179,
 188, 189, 190, 192, 193, 194,
 195, 198, 199, 201, 202, 205,
 208, 209, 210, 212, 217, 218,
 219, 220, 221, 222, 223, 224,
 225, 226, 227, 228, 230, 231,
 232, 233, 236, 237, 240, 245,
 265, 269, 270, 271, 272, 273,
 281, 282, 286, 288, 289, 290,
 292, 296, 297, 299, 300, 303,
 307
Assessment, ix, x, xi, 1, 2, 5, 7, 8, 9,
 13, 15, 17, 18, 20, 22, 24, 25, 27,
 28, 29, 31, 32, 47, 50, 51, 52, 54,
 55, 56, 59, 60, 61, 62, 63, 64, 66,
 67, 68, 69, 75, 76, 77, 79, 80, 81,
 82, 83, 84, 93, 99, 107, 109, 110,
 111, 112, 114, 115, 116, 127,
129, 137, 143, 144, 145, 146,
 148, 156, 157, 159, 160, 167,
 169, 170, 176, 198, 199, 201,
 203, 208, 209, 210, 211, 217,
 219, 222, 225, 228, 231, 232,
 233, 235, 236, 268, 270, 293,
 294
assessment methods, x, 10, 20, 33,
 59, 62, 63, 64, 65, 66, 290, 292
assessment model, 57
Association of American Colleges
 & Universities, 2
atelier, 5, 10, 12, 22, 23, 27, 64, 292
*Australian Qualifications
 Framework*, 87, 88, 90, 306, 307,
 308, 311

B

Benjamin Bloom, 33, 39
Bologna Process, 297, 300, 312

C

Chase, ix, 3, 9, 26, 28, 29, 33, 36,
 44, 45, 50, 51, 71, 76, 83, 111,
 114
cognitive, 1, 2, 5, 26, 28, 33, 36, 37,
 38, 39, 40, 42, 44, 47, 72, 97,
 110, 261, 290, 291, 296, 309,
 311
Cognitive, 28, 31, 33, 36, 37, 38, 39,
 40, 47, 50, 51
Competency-Based Education, 289
constructivist, 5, 9, 22
Council for Interior Design
 Accreditation (CIDA), 7, 72, 236,
 281, 288
Creativity, 3, 29, 30, 50, 68, 119,
 121, 129, 221, 293

CPSIA information can be obtained at www.ICGtesting.com
Printed in the USA
LVOW02s0245180615

442930LV00006B/127/P